A conservative is one who believes in the
existence of the truth and holds that it was
discovered a long time ago. A revolutionary is
one who believes in the existence of the truth and
holds that it was discovered yesterday.

W. H. AUDEN

All the pondered arts develop insoluble problems.
Prolonged contemplation engenders an infinity of
difficulties, and this production of imaginary
obstacles, of incompatible desires, of scruples and
pentimenti, is proportional, or much more than
proportional, to the intelligence and knowledge
one possesses. How to choose between Raphael
and the Venetians, to sacrifice Mozart to Wagner,
Shakespeare to Racine? Such problems have
nothing tragic about them for the art-lover, nor
for the critic. For the artist, they are torments of
consciousness, renewed whenever he considers
what he has just done.

PAUL VALÉRY
Degas Danse Dessin

DEGAS

By Robert Gordon and Andrew Forge

With translations from the French by Richard Howard

Abradale Press
Harry N. Abrams, Inc., Publishers

To Alexandre Rosenberg

FRONTISPIECE:
Portrait de l'Artiste (Self-Portrait). c. 1854–56

PROJECT DIRECTOR: *Robert Morton*
EDITOR: *Beverly Fazio*
DESIGNER: *Judith Michael*
RIGHTS AND REPRODUCTIONS: *Barbara Lyons*

THE LIBRARY OF CONGRESS HAS CATALOGED THE ABRAMS EDITION AS FOLLOWS:
Gordon, Robert, 1946–
Degas.

Bibliography: p. 280
Includes index.
1. Degas, Edgar, 1834–1917. 2. Artists–France–
Biography. I. Degas, Edgar, 1834–1917. II. Forge,
Andrew. III. Title.
N6853.D33G67 1988 709'. 2'4 [B] 88–70252
Abradale ISBN 0–8109–8107–6

Printed and bound in Hong Kong

10 9 8 7 6 5

Abradale Press
Harry N. Abrams, Inc.
100 Fifth Avenue
New York, N.Y. 10011
www.abramsbooks.com

Abrams is a subsidiary of

LA MARTINIÈRE
G R O U P E

EDITOR'S NOTE: *Titles for Degas's works throughout the book are those given by the artist himself
or by the museum collection in which they are held, as they appear in the catalogue raissoné
by Paul André Lemoisne, or as assigned at the sale of the artist's collections after his death.
Titles for Degas's prints are as they appear in* Edgar Degas *by Loys Delteil. Accompanying
the illustrations and in the complete list of works at the back of the book, titles are shown first
in French and then parenthetically in English; where the English title differs from a simple
translation of the original, it does so because the museum or collection prefers the form given.*

Contents

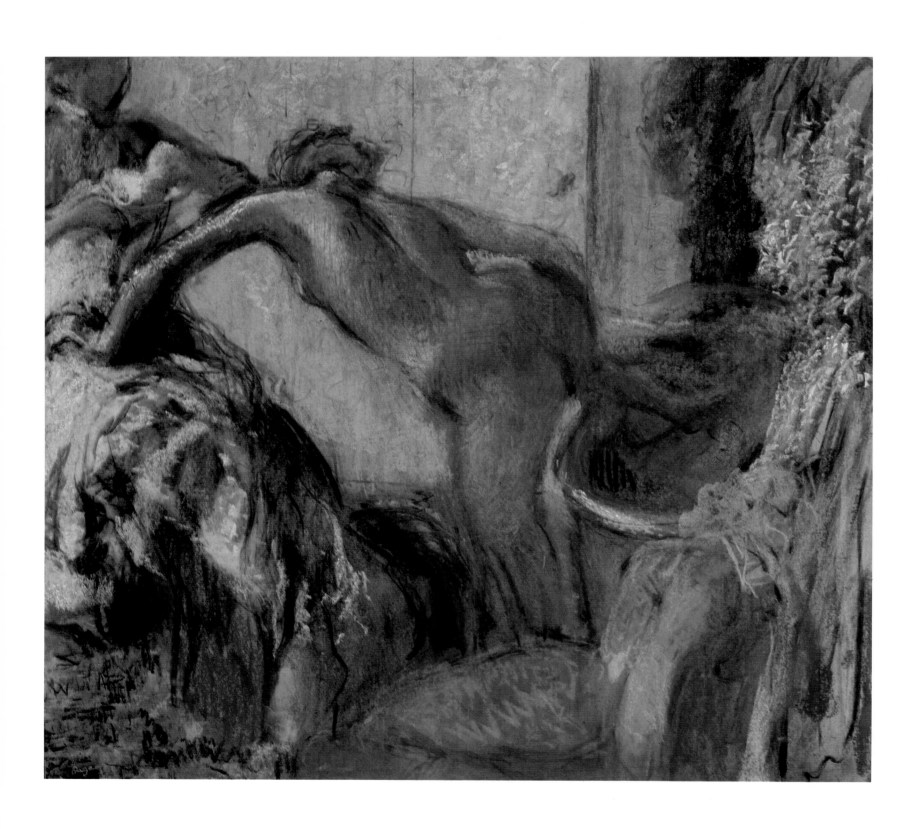

For Clair

In a letter written from New Orleans where he was visiting relatives in the autumn of 1872, Edgar Degas wrote to a painter friend: "Art does not reach out, it sums up." Degas was thirty-eight. He had been painting since his teens. It was already nearly ten years since he had given up his early ambitions to paint historical compositions and had taken to modern subject matter. He had turned his back on the Salon. He was on the brink of a decade of intense independent effort, as rich in its results as any during that extraordinary epoch and as daring in its experimentalism as anything that was to come in the twentieth century. The contrast between his expressed opinions—almost always quietist, aristocratic, and antimodern—and what happened in the studio is at the heart of his enigma. He is the most mysterious of artists.

It is precisely this enigma that makes him of such compelling interest now. For of all the great innovators of the nineteenth century, it was he who was able to ask more intelligently than any other the question that has haunted all artists since the time of Romanticism and will not go away: What does it mean to *go on* in latter days?

For Degas, painting was founded upon drawing, the tradition of drawing descended from Florence, of which Jean-Auguste-Dominique Ingres was the greatest recent exemplar. This tradition was, of course, centered on the figure; every value and every pictorial structure it encompassed derived from and returned to the human figure. When Degas made his entrance as a young painter—he was born in 1834—High Art was on its deathbed. The society that had sustained heroic painting no longer existed. What Degas inherited was not a profession but an ideal residue, an aesthetic, a belief in the timeless grandeur of the great tradition. "What is it these so-called artists want who preach the discovery of the 'new'?" Ingres had angrily demanded. "What is new? Everything has been done, everything has been discovered. Our task is not invention, but continuity."

The narrative of modern art as it has been handed down to us says the opposite. It gives an unequivocal slogan: Forward! Degas's colleagues the Impressionists, Claude Monet above all, were in no doubt as to their destiny. They responded to the crisis of High Art by turning to a lesser branch of painting, landscape. Monet was able to tell himself that he had shaken the dust of the past off his feet. He claimed that he was addressing nature and his own sensations in front of nature as if the schools of painting had not existed. Supremely confident in the originality of what he was doing, his attack was headlong. It involved a total renunciation of the drawing tradition, which is to say, of the centrality of the figure. Every value, every nuance of feeling, and every pictorial structure in his painting derived from and returned to the experience of landscape through the eye.

There is a significant polarity between these two painters, Degas and Monet. If it

Femme Sortant du Bain
(After the Bath). c. 1895–1900

7

had not been for the historical accident that they showed together in some of the Independent exhibitions and became known under the vague heading of Impressionists, they might be seen as one of those representative opposing pairs out of which so much of the working history of painting has been constructed: Raphael–Titian, Poussin–Rubens, Ingres–Delacroix, Degas–Monet.

A certain kind of painter cannot just work. In order to work he must *tell* himself painting. The telling involves the posing of opposites, of alternatives—north and south, line and color, style and nature, and so on. The argument was never silent in Degas's studio, and in this continual inner dialogue there is no doubt that one necessary pole was occupied by his younger contemporary, Monet.

I write "necessary" because I believe that over the years Degas used Monet to help himself define himself. His imaginative intimacy with painting's past was far too close for him not to have seen the opposition between himself and the younger painter in dramatic, even legendary terms: the dutiful heir in whose hands the destiny of the line is vested opposed to the carefree youngster tramping away into the wide world. The relationship has mythic dimensions. In their study of the mythology of artists' lives, Ernst Kris and Otto Kurz point out that the opposition of style and nature, of learning and inspiration is the oldest of all plots in the telling of artists' lives. The idea that nature could teach appears in an account of the youth of Lysippus given by his contemporary Duris of Samos and repeated by Pliny. In counterpoint to this are accounts of artist's lineage from master to pupil: "The autodidact represents one side of the polarity . . . the other side reflects the urge to anchor the individual's achievement in the dynastic succession."

Typically the autodidact receives his first lesson as a revelation. "It was as if suddenly a veil had been torn asunder: I had understood, I had realized what painting could be," Monet once said, weaving the strands of his own legend for the benefit of a visiting journalist. He was telling him about his first experience of painting in the open air in the company of Eugène Boudin.

Degas started not with an epiphany in front of nature but with permission to copy in the Cabinet des Estampes. In his own mythic recollection the equivalent to Monet's outing into the countryside with Boudin was the moment in his youth when he held the fainting Ingres in his arms. He started and ended in love and wonder at the grandeur of past art. His search for freedom—from feeble teachers, from the banal conventions of the Salon—his drive to distinguish himself from the general drift of his generation, was less for the sake of his own autonomy than in order to set free the masters themselves. His dazzling originality was on their behalf. Again and again, aspects of his work present themselves as a transformation of some aspect of the tradition, an aspect that is so deeply understood that he is able to dismantle it, split it from its context, and, in reconstructing it, infuse it with meaning and freshness.

Clearly this is traditionalism of a completely different order from the antics of the popular painters of the Salon. For Monet, in permanent revolt against the past, the present corruption of former values was a matter of indifference; the time-serving *pompiers* who stood for established power were his opponents in a worldly sense only. For Degas they were false witnesses, not merely his opponents but spiritual enemies to be excoriated, along with every other influence in the modern world that brought publicity, sensationalism, competition, and inflated prices intrusively to bear upon the secret and distinguished activity of true painters.

Both Degas and Monet had long and productive careers that ended in near-blindness. Monet's was propelled by a single-minded and continuous impulse; Degas's

by introspective argument and driven this way and that by an almost unmanageable surfeit of ideas. Although Degas worked in the studio, in contrast to Monet's heroic travels, his compositions were far more various in scale, in style, in technique, and in subject matter, ranging from tightly painted oils of an entirely traditional kind to prints and pastels more daring in their condensations than anything else produced in the nineteenth century. This is to say nothing of his activity as a sculptor—nor as a poet or a photographer.

When Degas turned toward the world around him for his subjects it was in no sense a turn toward the natural. He delighted in mocking the landscape painters and their claims to probity: to paint a "sincere farm"—what could be more ridiculous? "Don't tell me about those fellows cluttering the fields with their easels," he told Etienne Moreau-Nélaton. "I'd like to have a tyrant's authority to order the police to shoot down every one of them . . . the stupid fools, crouching out there over their stupid shields of white canvas." Art is a lie, he would insist. He loved the artificiality of art. The painter Georges Jeanniot remembers a visit to the Louvre: "Did you notice," Degas asked him, stopping in front of the Medici *Venus*, "that she's off balance? She's in a position she couldn't maintain if she were alive. By this detail . . . the Greek sculptor has imparted a splendid movement to his figure, while preserving its calm attitude, the tranquility which distinguishes masterpieces." And there are numerous stories of Degas gleefully explaining the artifice in his own work. "One day when someone was praising the 'truth' of a screen in one of his pictures," according to Paul Jamot, Degas "took a calling-card, folded it twice, and said: 'That was my model.'" Another witness remembers him talking about the *Bains de Mer; Petite Fille Peignée par Sa Bonne* in the National Gallery, London, a painting obviously conceived with the open-air painters in mind. "It's very simple," Degas explained, "I spread my flannel vest on the studio floor, and sat my model down there"; and he added, in a formulation of which he was particularly fond, "The air you breathe in a picture is not the same thing as the air you breathe outside!"

His works were prepared, calculated, practiced, developed in stages. They were made up of parts. The adjustment of each part to the whole, their linear arrangement, was the occasion for infinite reflection and experiment. He held it against the landscape painters—and one suspects that Monet was always their representative—that their pretensions to "sincerity" and "spontaneity" led them toward a deliberate philistinism that cut them off from the craft as well as from the culture of painting.

Degas aspired to total consciousness in his painting, as if to be able to repeat Nicolas Poussin's boast to have "neglected nothing." Intelligence must rule. But there was a side that was far from rational. His attachment to painting, to Art, was jealous and obsessive. He was like a man in love. His earliest training was founded on copying. He continued to copy insatiably until well into his middle years, long after most painters would have left the practice behind. For him to copy was not merely to learn but also to reach into and touch, to surrender to another mind and sensibility. Copying like this is tinged with overtones of magic: the rival or the loved one consumed.

As Degas grew older he became obsessed with the idea of lost secrets, of techniques and recipes that had once been passed on from studio to studio and were now, in the general decay, forgotten. This half-superstitious belief in technique was a constant motif in his work. No painter has used pencil or charcoal or the characteristics of oil paint with a greater consciousness of how the medium is shaping his thought. He

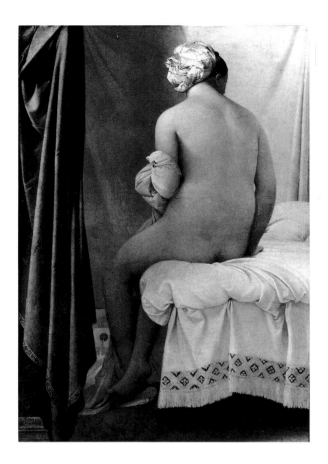

experimented constantly with new materials and unwonted mixtures of traditional materials. Reviewing the different states of some of his most important prints—*La Sortie du Bain, Au Louvre: La Peinture (Mary Cassatt)*, and others—one cannot avoid the impression that the changes from one state to another, each change resulting from a different procedure, have been made as much for their own sake as for the advancement of the image.

There was nothing antiquarian about his researches into traditional methods. Whatever procedure or idea he isolated, he put it to immediate use, bringing it actively into his current practice, and in doing so, he gave it a meaning that was very different from its original one. Ernest Rouart tells a story of Degas setting him to copy a Mantegna in the Louvre, using no colors except bright red and green. Rouart explains that these instructions were based on Degas's eccentric interpretation of something he had read in Cennino Cennini. "Of course the result was not brilliant." But this was exactly the way that Degas was thinking himself in some of the late dance pastels, and there are examples, for instance a pastel in the National Gallery of Scotland, in which the composition is developed in red and green and nothing else.

"When you can shade well," Cennini writes in his instructions on how to draw drapery on colored paper, "take a drop or two of ink . . . then find the depths of the folds, seeking the very bottom of them—always remembering, while shading, your three divisions: the first consists of shades, the second the color of the ground, and the third the lights." Cennini, pupil of Agnolo Gaddi, son of Taddeo Gaddi, pupil and son-in-law of Giotto, is describing exactly the principles by which a young painter of Degas's generation would still have been taught the *ébauche*, a preparatory study on a toned ground. This was an aspect of traditional practice that would have been under intense critical discussion in the circle around Edouard Manet. The toned ground was inimical to the landscape painter's search for chromatic luminosity. Monet and

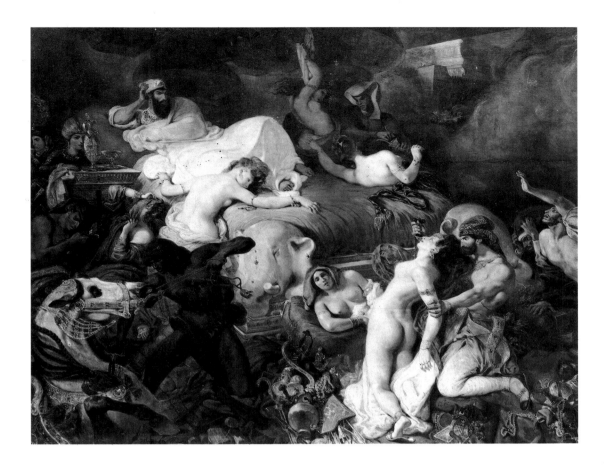

EUGÈNE DELACROIX
La Mort de Sardanapale
(The Death of Sardanapalus). 1827

Auguste Renoir abandoned it during the seventies. Above all they would have rejected the conceptualized attitude to form that it implied. Degas, on the other hand, cleaves to it, brings it into the foreground, wonders at it. "Paint a monochrome plane," he told his friend Daniel Halévy, "absolutely flat and even, and you put a little color on it, a touch of this, a touch of that, and you'll see how little it takes to produce life." When he makes a heightened drawing of a ballet dancer in gouache or pastel, using a paper of an extraordinary color such as a deep greenish-blue, a salmon pink, or an intense apple green, it is as though to force attention onto the *ébauche* technique and to wonder at the mystery of its operation. His game is irrepressible and opaque. The dancer's curving cheek is apple green and the wall behind her is too.

The antithetical relationship between Degas and Monet was, I believe, of far more importance than mere rivalry, at least as far as Degas was concerned. His verbal attacks on open-air painting were endless. The substantial collection that he formed during the second half of his life included works by Camille Pissarro, Paul Cézanne, and Vincent van Gogh—all *plein air* painters—but nothing by Monet. He cannot have been indifferent to the quality of Monet's work; it must have been a studied exclusion. I imagine him gaining conviction from his opposition to the younger painter and supposing that through it he was able to develop more clearly the dialectic of his own work.

The dialectic here is in the contradiction between drawing and painting: Florence : Venice, Ingres : Delacroix; in Degas's lifetime it could be expressed as Figure : Landscape. The Florentine tradition to which he was heir was based on the power of line to divide a form from that which was formless. Thought is conveyed in convexities, the convexities of the figure. The figure animates and controls its surroundings with its forms, and also its gestures, its glances, its strides. Surroundings are always subordinate. Drawing in these terms is closer to sculpture than to

painting; it aspires to the condition of sculpture on a flat plane. The figure is its center, a paradigm of wholeness.

But landscape, in contrast, goes on and on. The landscape painter and the figure painter take opposite views of a picture's unity. To the Impressionists, to Monet in particular, the ensemble was everything: the paradigm of pictorial unity found in the oneness of a condition of light, the oneness of landscape space that spreads unframed in every direction. It was a unity that was both descriptive and decorative. Monet's last huge, all-enveloping water-lily decorations were the apotheosis of the ensemble. But "There is no ensemble," Degas is said by Julie Manet to have protested furiously during the hanging of a posthumous exhibition of pictures by her mother, Berthe Morisot. He wanted them hung on screens so that they could be looked at closely, so that there was no overall effect.

Degas's interest in vision took him in the opposite direction from an overall effect. His observation was shaped by drawing and was inevitably a kind of un-picking or unraveling of the web of appearances, not a weaving together as it was to those whose observations were shaped by the palette. Nowhere in his work does one feel Degas caught up in sensations of deep space, in spite of the fact that he is so often fascinated by the oddities of scale and juxtaposition that perspective offers his observation. His interest in these phenomena was a graphic one. They fall into the background and can be plotted like a diagram on a flat plane.

Much of Degas's most ambitious work before the mid-eighties is extremely small in scale. *Classe de Danse* (*The Dancing Class*) at The Metropolitan Museum of Art in New York is a mere 27 cm in width, and *Portraits dans un Bureau (Nouvelle-Orléans)*, with its thirteen portraits, is less than a meter wide. There is no use looking at painting like this from across the room; it has to be scanned in detail, as one must look at a predella to make out its story. Even after Degas had begun to work in broader techniques such as monotype or the combination of monotype and pastel, the picture is often so small that one needs to view it from very close range.

This is the opposite case from a roughly painted Monet in which, as they say, everything falls into place when you step far enough away from it. With your nose almost touching a tiny Degas—I am thinking of *Le Café-Concert—Aux Ambassadeurs*, 36 × 28 cm—you cannot avoid becoming absorbed in the marks, the scribbles, the layerings of pastel and monotype, the contrasts of definition and openness, of things named and things suspended and unnamed. You are projected into the studio and into Degas's decisions and the movements of his hand.

Of course, something like this holds true for any sketch or freely brushed painting. The onlooker has been invited into the studio ever since the high noon of Venetian painting in oil. What is specific to Degas's sketchiness is its consciousness and the sense that he too is watching it with something like one's own wonder. Un-finish is aestheticized and bracketed out from its first function, shown as a process in its own right, a kind of magic. Not even the graphic process itself can be taken for granted but has to be looked at aslant.

Working from drawing to painting as Degas did involved thinking of figures and background separately. The method reinforced the division between figures and background that was inherent in his drawing. Thinking of the work in stages, he invested each stage with meaning. "All kinds of backgrounds run through my head," he wrote to Gustave Moreau when he was preparing for what was to be his youthful masterpiece, *La Famille Bellelli*. By the time he had finished working on it, he had demonstrated to himself how the room that he had placed his sitters in, its

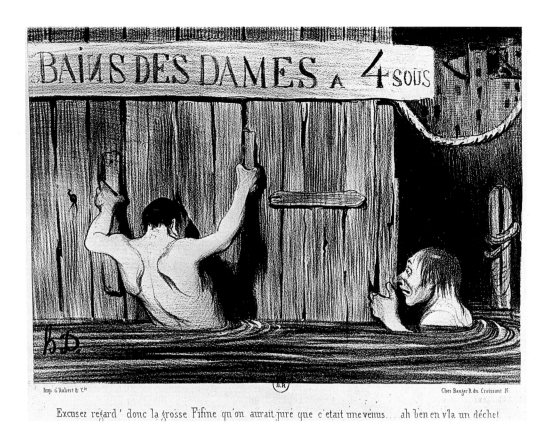

HONORÉ DAUMIER
"Excusez Regard' donc la Grosse Fifine . . ."
("Just Take a Look at that Fat Fifine . . ."). 1840

furnishings, and the divisions of its architecture could support and augment the figures, giving them a psychological frame as well as a physical one.

During the sixties and seventies he evolved an extraordinarily complex pictorial language out of his attention to separate aspects of his subjects, from facial expression to physical type, from gesture to deportment, from clothes and possessions to the finest points of compositional geometry. Meaning is woven into the picture at every level, incorporating a novelist's sense of social behavior, an illustrator's eye for the typical and the idiosyncratic, a dramatist's flair for situation and *mise-en-scène*. This command of signs, which stems from the basic premise of his working, the separation of one operation from another, is the aspect of his work that for obvious reasons has attracted the attention of the majority of Degas scholars.

As he grew older he began to lose interest in the illustrational. Or, to put it another way, he began to demand a more ambitious unity than the illustrational mode permitted. Many factors flow together: his failing eyesight, his experience with monotype and with sculpture, and, no doubt, his awareness of the achievements of his Impressionist colleagues. He seems to draw physically closer to his work and to engage with it more directly. Perhaps with his use of broader drawing tools such as charcoal or pastel, or perhaps through his habit of making repeated tracings, a subtle change affects his drawing. His bounding lines are felt to have two sides, to face outward as well as inward. The flatness of the background invades the figure and the hatched relief invades the background. In the late pastels of bathers, his greatest works, in which the timeless dignity of ancient sculpture is rediscovered in the terms of an altogether modern perception of individual mortality, identities flow back and forth. Walls and towels embrace the bather, whose nakedness spreads to the extremities of the picture. Degas's long, colored hatchings that cross and recross from figure to background carry our reading as does the continuity of the stone in an antique relief. Or, one might say, the continuity of landscape.

He was the artistic conscience of his age. This man who insisted on being no one and nothing, who never showed himself, who discouraged interviews and had no pulpit of any kind, was heeded like an oracle. He was an authority. He constituted a sort of taste-police, and was the terror of charlatans.

LOUIS GILLET, *Revue des Deux Mondes*

Edgar Degas was born in Paris in July 1834, the eldest son of a banker. His family was large and complicated, and it was important to him all his life. Its keystone at the time of his birth was his paternal grandfather, René-Hilaire Degas, a banker and rentier in Naples. In his youth, before the Revolution, René-Hilaire had been a corn merchant in France. According to family legend, he had become engaged to a well-born woman who had gone to the guillotine during the Terror. He had escaped and, after adventures in the Eastern Mediterranean, had settled in Naples, where he had prospered as a banker, helping to finance both the Napoleonic and the Bourbon regimes. He took an Italian wife, Aurora Freppa, who came of an old Genoese family. She bore him seven children, four of whom later married into the Italian minor nobility. By the time his grandson came to know him, René-Hilaire was a formidable old patriarch presiding over a palazzo in the Piazza della Gesu Nuovo and an equally splendid villa in San Rocco di Capodimonte.

Auguste De Gas, René-Hilaire's eldest son, had moved to Paris in the early 1830s to establish himself as a banker. Soon after his arrival he met and married an American girl from New Orleans called Célestine Musson. She too had a remarkable father. Germain Musson had been born in Port-au-Prince, capital of what was then the French possession of Saint-Domingue, now Haiti. He was a member of the small slave-owning white population that presided over a prosperous economy. He had left Saint-Domingue after the revolution of Toussaint-Louverture and had found his way to New Orleans, then on the eve of its greatest prosperity. Within a few years he had built a commercial empire with interests in cotton, shipping, and silver mining in Mexico. His wife died suddenly in 1819. He took his five children to Paris to be educated. Before long his eldest daughter had married the Duc de Rochefort. His eldest son, Michel, went back to New Orleans to continue the family business. Finally his youngest daughter, Célestine, married Auguste De Gas, newly arrived from Naples. Both sides of the painter's family were thus from the wealthy upper bourgeoisie, the class that had gained the most from the Great Revolution and which was to dominate France throughout the nineteenth century.

It was not unusual for the new rich to want to give the impression of a landed background. This was the case with members of Degas's family, who began to spell their name "De Gas" or "de Gas" only in his father's lifetime, and even to make a

Bains de Mer; Petite Fille Peignée par Sa Bonne
(Beach Scene). c. 1877

15

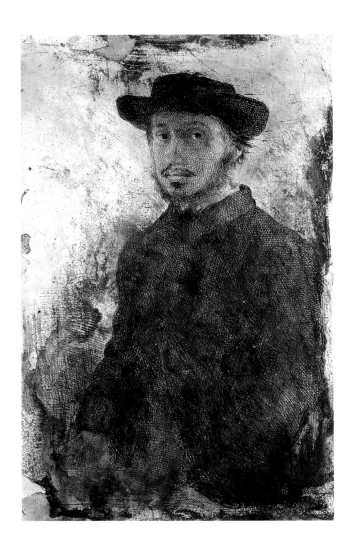

Edgar Degas, par Lui-Même,
also known as Portrait de l'Artiste
(Self-Portrait). 1857

*Degas made this remarkable etching while he
was in Italy. It reveals not only his mastery of
the medium but also some of the introspective
spleen that is reflected in the following letter to
Gustave Moreau, his friend and guide:*

*I remember the conversation we had in Florence
about the melancholy which is the lot of those who
are dedicated to art. There was less exaggeration
than I had supposed in what you said. Such
melancholy has no compensation, it is true. It grows
with age and progress, and youth is no longer there
to console you with its illusions and hopes. Whatever
affection one has for one's family and one's art, there
is a void which even they cannot fill. . . . But what
can you expect to hear from a man alone, left to
himself? Before him he has nothing but himself, sees
nothing but himself, thinks of nothing but himself.
He is a great egotist.*

dubious claim to an ancient coat of arms. Degas reverted to the original spelling when
he was in his thirties.

The painter's mother died when he was thirteen. His father never remarried, and
Degas and his three siblings grew up in the company of his father and various
bachelor uncles. Banking was far from being Auguste De Gas's major interest; he was
a man of taste, an *amateur*. He loved music and numbered among his friends many
professional musicians and composers. Pictures were equally important to him. At the
Louvre, to which he often took his eldest son, he particularly admired the Italians of
the fifteenth century. His own collection included drawings by Pierre-Paul Prud'hon
and Maurice-Quentin de La Tour. In his circle were some of the greatest collectors of
the time: Dr. Louis La Caze, for example, whose collection ended up in the Louvre,
possibly the greatest donation in its history, and which included Rembrandt's
Bathsheba, eight Watteaus, including *Gilles*, Frans Hals's *Gypsy Girl*, thirteen
Chardins, and much more. Other friends included François Marcille, who specialized
in Prud'hon, Chardin, and Fragonard, and Prince Grégoire Soutzo, who was later to
give Degas his first lesson in printmaking. Of particular importance was Edouard
Valpinçon, whose son Paul was at school with Degas and became a lifelong friend. It
was through Valpinçon that Degas met Ingres.

Degas was educated at Louis-le-Grand, the most prestigious *lycée* in France. Not
long before Degas's arrival, Charles Baudelaire had been winning prizes there, before
he was expelled. Eugène Delacroix and Théodore Géricault were alumni; so were
Victor Hugo, Voltaire, and Molière. It was a spartan establishment in a crumbling
seventeenth-century building near the Sorbonne. The uniformed boarders were

organized on semimilitary lines, their instruction based on the classics: Latin, Greek, rhetoric, and French literature of the seventeenth and eighteenth centuries. This traditional, highly disciplined education shaped Degas. He continued to read Latin and Greek until his eyesight failed him.

Among the extra subjects at Louis-le-Grand were music and drawing. Drawing, practiced from casts from the antique and engravings from the old masters, was supervised by a professional artist, Léon Cogniet, a pupil of Guerin, the teacher of Géricault, Delacroix, and Ary Scheffer. Cogniet had become well known for a composition, *Tintoret Peignant Sa Fille Morte*, that had been shown at the Salon of 1845. It was a subject that Degas was to consider himself some years later.

Degas passed his Baccalaureat in 1853. This made him eligible for higher education and placed him in a small elite even within his social class. Only Cézanne among his future colleagues had an equal level of education. Within two weeks of graduation Degas had applied for permission to copy at the Louvre and the Cabinet des Estampes. He set up a room to work in his father's house. Ingres, applied to through Valpinçon, recommended one of his pupils, Louis Lamothe, as a teacher. Presumably as a gesture to his father, Degas registered as a student at the Faculté de Droit and began studies in law. These were soon dropped. His father sighed a little, Degas said later. The decision to study painting seems to have been made with the least fuss. Few painters can have found parental support so easily or in such a well-informed, cultivated form. His painless entry was in marked contrast to the bitter struggles that Cézanne was to face with his banker father, a bully and a philistine. Monet at the same age, nineteen, had left home and was living the art-student life in

A friend of Degas, Paul Lafond, described the artist in a reminiscence published in 1918:

On the short side . . . the head powerful, the expression quizzical, the forehead broad, high, bulging, crowned by silky, chestnut hair, the eyes bright, sly, questioning, deep-set under high-arched brows, the nose slightly snub, the nostrils open, the mouth delicate, half-hidden by a light beard that a razor has never touched—such was Degas in his youth and maturity. As he grew old, the beard whitened naturally, the hair too, and grew scantier, but the eyes remained as piercing and alive, the mouth as humorous.

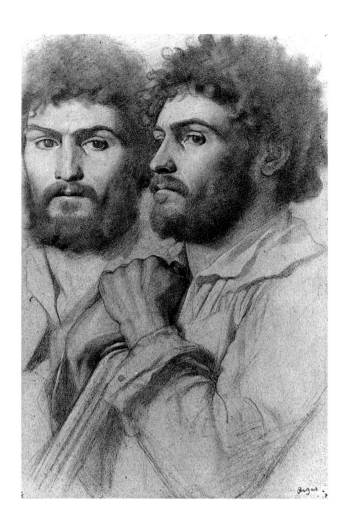

Deux Etudes d'une Tête d'Homme
(Two Portrait Studies of a Man). c. 1856–57

While he was in Italy, Degas made a number of portrait studies from professional models, essays in the tête d'expression, *in which he explored the structure of the head and endowed it with a specific expression. The bearded man is drawn from the front and the left side on the same sheet as if in preparation for a sculpted portrait. The two versions match exactly in the deep carving of the features and in their fierce, gloomy expression. With the boy the mood is different in the two versions—dreamy in the symmetrical view from the front, alert and curious as he looks away from the side.*

As time went on Degas became increasingly interested in drawing the same figure from different points of view, and the practice that began as a student discipline became, for the mature artist, an obsession.

Paris, and when the time came for his military service, his father tried to bring him into line by refusing to buy him a substitute. Degas had no such worries.

For a short while Degas enrolled at the Ecole des Beaux-Arts to work under another Ingres pupil, Hippolyte Flandrin, but this hardly interrupted his regime of copying and he did not renew the enrollment at the end of the year.

He spent the summer of 1855 traveling for the first time by himself. He visited Lyons, the hometown of his teacher Lamothe, who gave him introductions. He copied in the museum and from casts from the antique in the Ecole des Beaux-Arts. Then he traveled down the Rhone to Avignon, Arles, Nimes, and Montpellier. In Avignon he made a copy in oils of Jacques-Louis David's *Mort du Jeune Bara.*

The following spring he set off for Italy. A period of study in Italy was still regarded as an essential ingredient in an ambitious painter's training. This conviction was institutionalized in the Prix de Rome. To win the Prix meant not only a period of study at the Villa Medici, but also almost certain professional recognition on one's return to Paris. Ingres had been the director of the Académie de France in Rome from 1835 to 1841. All of Degas's teachers had either won the Prix de Rome or had worked in Rome independently. In contrast, few of his future colleagues had considered the journey necessary. To James Abbott McNeill Whistler, Alphonse Legros, and Henri Fantin-Latour, Holland and Spain were far more important than Italy. Neither Monet nor Renoir went there as students; neither Camille Pissarro nor Cézanne went there at all.

Degas was to describe the years in Italy as the most wonderful period of his life. He was secure, without financial worries. He was devoted to his Italian family, whom he had already visited as a child. He spoke perfect Italian and the Neapolitan dialect as

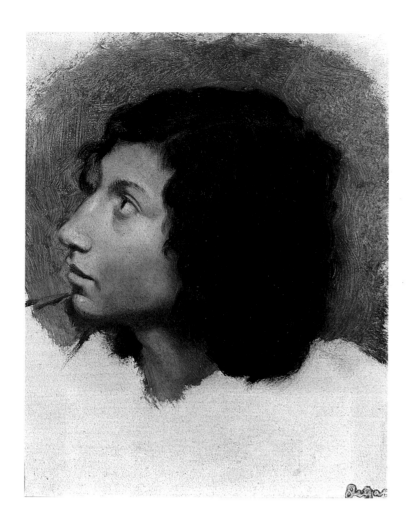 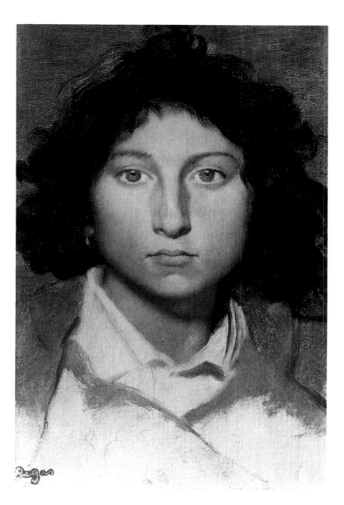

Jeune Garçon, Italie
(Young Boy, Italy). c. 1856–57

Jeune Garçon, Italie
(Young Boy, Italy). c. 1856–57

well. His study in the museums was impelled by a profound love for its object, the sculpture and architecture of antiquity and the painting of the Italian Renaissance.

After spending the summer with the family at the villa in San Rocco di Capodimonte, he moved to Rome, where he introduced himself at the Villa Medici, then presided over by a genial and slightly eccentric painter called Jean-Victor Schnetz, who welcomed nonlaureates and gave them free access to the Académie. Degas was able to work from the model there. Among the laureates were several painters who had already made their debut in Paris: Elie Delaunay, a pupil of Flandrin; Camille Clère, a pupil of Cogniet; and the sculptor Henri Chapu.

The summer of 1857 he was back in Naples and working at portraits of his uncles and cousins and the powerful portrait of his grandfather now in the Musée d'Orsay. Back in Rome the following winter he found that an old school friend from Louis-le-Grand, Léon Bonnat, had arrived at the Villa Medici. The novelist-critic Edmond About was in Rome, as was Joseph-Gabriel Tourny, an established painter who became a particular friend. Tourny, who was in Rome to make copies on commission from Adolphe Thiers, encouraged Degas in his first serious etchings, one of which is a portrait of Tourny in the manner of Rembrandt.

But by far the most significant new connection that Degas made at this time was with Gustave Moreau. The future teacher of Georges Rouault and Matisse was then thirty-two, nine years older than Degas. He had already exhibited at the Salon and had a certain reputation in Paris. Having failed to win the Prix de Rome, he was now turning himself back into a student and traveling in Italy independently. Degas had never met anyone quite like Moreau. Immensely knowledgeable, intense, and energetic, Moreau was his first direct link with the forbidden territory of Romanticism. Moreau

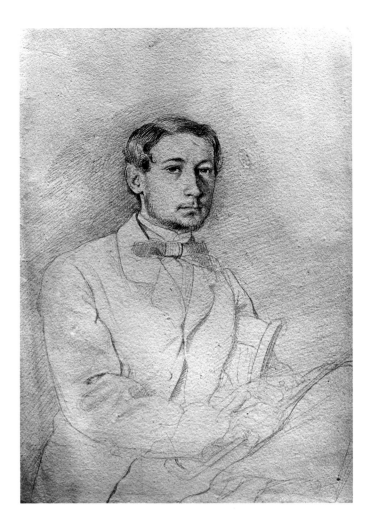

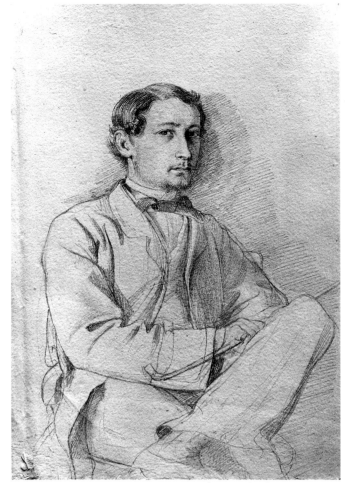

Portrait d'Homme (Adelchi Morbilli)
(Portrait of a Man). 1857

Portrait d'Homme (Adelchi Morbilli)
(Portrait of a Man). 1857

Based on the model of the portrait drawings of Ingres, these by Degas have features that are already distinctively his own: the crisp, cutting line, the assertive directions, an extreme refinement in the relation of details to the whole. He is sharply aware of the shapes that clothing makes, of how a cuff sticks out from a sleeve or how a coat collar encircles the neck. The head, the point and purpose of the drawing, is realized with an intense regard that embraces the fall of the hair or the location of the rather large ear as well as the characteristic proportions of the features. These are brilliant drawings in which signs of brilliance are suppressed. The hatching that serves both to model the form and to color it is restrained, slowed down, formalized. Notice the controlled patterning of parallel lines that make the sleeves and cuff in the watercolor drawing, and also the wall behind the sitter.

had studied with and been deeply influenced by Théodore Chassériau, the star pupil of Ingres who had "betrayed" the master and gone over, not without guilt, to Delacroix. Moreau had remained on close terms with Chassériau until the latter's death the year before.

Degas became greatly attached to Moreau. In his company he was able to experience firsthand, and in their full complexity, the issues at stake in the Ingres-Delacroix controversy. Degas and Moreau worked together in the museums and churches, shared models and excursions in the Campagna. Under Moreau's tutelage, he began to look at all kinds of painting from which his Ingrist training had hitherto shielded him: the Venetians, Rembrandt, Rubens, and of course Delacroix himself. He was not the only traveler to Italy to discover northern art in a new light.

The drawings in his notebooks of this year indicate widening interests and increased confidence. The copies are more robust, suggesting that he was able to visualize their subject matter, rather than merely address himself to the externals. There are landscape drawings, compositional sketches along Claudian lines, and some closely observed notations of landscape effects inscribed with hours and dates. A comic element also appears: there are drawings in which mischievous near-caricatures of his friends are side by side with grotesque inventions. There are many drawings of action, of naked figures swinging swords, climbing trees, dancing, whipping, gesticulating crazily, that leap off the page with an energy that is new. There is an increasing number of compositional studies in pen and ink and wash rather than in pencil, reminders that Degas was continually involved in a search for subjects for the figure compositions that one day he would prepare for the Salon.

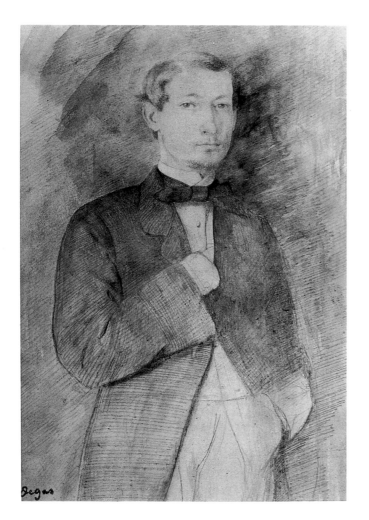
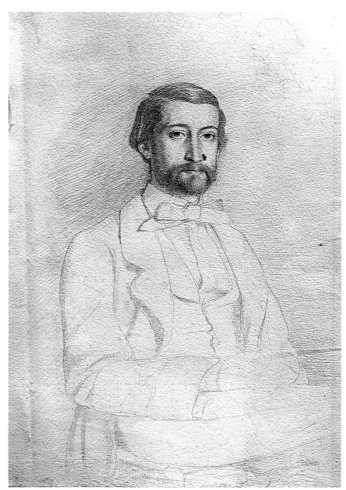

In the summer of 1858, instead of going back to Naples, Degas embarked on a new phase of his Italian journey, traveling northward through Umbria. His destination was Florence, which was where his aunt Laura lived. She had married a Neapolitan, Baron Bellelli, who had played an active part in the abortive revolution of 1848. As a result, he had been expelled from the kingdom of Naples and was now living in frustrated exile with his wife and family in the Tuscan capital. Degas loved Laura, and he had plans to paint her with her two daughters.

He broke his journey northward at Viterbo, Orvieto, Città della Pieve, and Perugia. Here he turned aside to travel on foot to Assisi like a pilgrim. He looked at the Giottos and to his surprise found himself caught up in an intense religious experience.

He spent the winter in Florence with the Bellellis, making drawings for the family portrait, which had now become extremely important to him. Moreau was with him in Florence during the autumn, then left for Venice, promising to come back in the winter. Degas's letters to him betray alternations of boredom and euphoria and an anxious need for his company. The years of study were coming to an end. Degas was gripped with doubt about himself and his artistic identity.

Not that he was entirely alone. Jacques Joseph (James) Tissot, whom Degas may have already known, as they were both students of Lamothe, was in Florence. Also of importance were the contacts he made with Italian painters, in particular a group known as the Macchiaioli ("spot-painters"), who occupied a position roughly equivalent to that of the painters of the 1840s in Paris. The Macchiaioli were interested in landscape and scenes of everyday life. They were the first artists he had met who questioned the authority of tradition. Although there are no signs of any

direct influence on him of the work of Telemaco Signorini or Giovanni Fattori, the two leading Macchiaioli, there can be no doubt that this winter in Florence was his induction into discussions among colleagues in which the topics were not the rival claims of Florence and Venice, Ingres and Delacroix, but rather a new, specifically modern definition of painting that claimed independence from the past.

The studies for the Bellelli portrait continued. His father was urging him to come home. Then, his enthusiasm aroused by news of the ambitious family portrait, he warned Degas against hurrying, and against shortcuts that he associated with the dubious influence of Romanticism: "You know that I am far from sharing your opinion of Delacroix, a painter who has abandoned himself to the chaos of his notions and unfortunately for himself has neglected the art of drawing, that keystone on which everything depends."

The Bellelli portrait could not be completed in his host's small apartment. Degas wrote asking his father to look for a studio and set out on his homeward journey, stopping in Genoa, where he admired the Van Dycks in the Palazzo Rosso.

He arrived in Paris on April 5, 1859, having been away for two years and nine months. The search for a studio produced one on the Left Bank. He continued to live in his father's house. He set to work on the great family portrait and on a history painting for the Salon.

Quite soon after his return to Paris, Degas began to find new connections among the younger painters associated with Courbet. It had been in Courbet's Pavillon du Réalisme in 1855 that he had first met Henri Fantin-Latour. Now through Fantin-Latour he came to know Félix Bracquemond, Legros, Whistler, and, a little later, Manet, all of whom were interested in alternative traditions to the Italian. They were looking at Dutch and Spanish painting of the seventeenth century and at contemporary English genre and sporting painting and finding there a way of framing their interest in modern life and in subjects that did not depend upon the heroic and the ideal.

Degas's first moves in this direction—other than portraits—were stimulated by his discovery of the world of horses and horse racing. He had made this discovery on a visit to the Valpinçon property in lower Normandy at Ménil-Hubert, not far from the famous stud farm of Haras du Pin. It was an unfamiliar landscape, green and lush, and his descriptions of his visit make it clear that he saw it reflected in the mirror of English novels. In the same way, when he began to paint the new subjects suggested by visits to the racecourse, he saw them in the mirror of English sporting painting.

Degas stayed in the security of his father's house until he was thirty-one. In 1865, he took premises in the Rue de Laval (now Rue Victor-Massé). Since his return from Italy, he had worked on a succession of complex history paintings, five in all, only one of which was submitted to the Salon. This was the mysterious picture entitled *Scène de Guerre au Moyen Age*, also called *Les Malheurs de la Ville d'Orléans*, mysterious because no one has yet been able to identify its subject. This was his last history painting. From now on, everything that he painted, with the exception of copies from other artists, was to be from contemporary life.

It had been ten years since Gustave Courbet's Pavillon du Réalisme, two since Baudelaire's essay on Constantin Guys, which had given currency to the idea of modern life as a source of heroic subject matter. One of Degas's closest friends in the circle into which he was now being drawn was Edmond Duranty, a pioneer of the realist novel and a perceptive critic. Duranty's precocious rival Emile Zola made his debut as an art critic and a promoter of his friends' work with his Salon reviews in

L'Evénement in 1866. The people whom Zola was writing about mostly had their studios in the Batignolles district. From the mid-sixties their social focus was the Café Guerbois in the Grand Rue des Batignolles. The central figure was Manet, whose *Guitarrero* had been the sensation of the Salon of 1861 and the occasion for a famous *hommage* when a group of young painters and poets—Baudelaire among them—had visited his studio to pay their respects.

Degas met Manet in 1864. Appropriately enough, they met in the Louvre, where, according to legend, they were both copying a Velasquez portrait. Degas was drawing it directly onto an etching plate, to Manet's astonishment. The two painters had much in common. Of the same high bourgeois background, both were pictorially educated, had copied widely, and had breathed the air of the great tradition. They were studio painters; their intentions focused on the figure. Both were men of the city.

At the time of their meeting, Manet was already a well-known, even notorious figure. His *Déjeuner sur l'Herbe* had been seen the year before, a scandal at the Salon des Refusés. Degas had yet to make his debut. Later, when an intimate rivalry had developed between them, Manet would remind his listeners that Degas was still with Sémiramis when he had met him.

Manet was the compelling influence on Degas's move toward "modern" subjects. Once Degas had begun to explore the contemporary world he was often a step ahead of Manet, who followed him to the racetrack, the theater foyer, the *café-concert*, the bath. On the other hand, Manet's attack, his understanding of what painting was capable of on its own terms, was far in advance of Degas's. With Manet, painting and sensation were inseparable. Everything he ever did was definitive. Nothing Degas ever did was definitive. Manet's art was public in every sense. Stories abound of him at work, chatting, surrounded by friends and beautiful women; not so with Degas, whose work was a task to be shared only with trusted colleagues.

The reserved quality of Degas's mind is reflected in the way that his pictures give themselves up to our attention at their own speed, slowly. Often we will feel that we are looking in on them, that the picture is a version of an event that is happening elsewhere. With Manet, the pictures address us boldly, as though in full, joyful awareness of their visibility.

Manet was a reluctant independent. He was determined to gain recognition and rewards through the existing institutions and he never took part in the Independent exhibitions that were organized during the seventies. Degas, on the other hand, although he had been accepted by the Salon on all six times from 1865 to 1870 that he had submitted, came to see the Salon as a breeding ground for vulgarity and careerism, and his contempt for it became increasingly bitter. He held it against Manet that he took public success seriously. Without family responsibilities and with private means, Degas could afford a lofty detachment. Far too driven ever to be mistaken for a dilettante, he seems never to have considered that success as a painter had much meaning beyond the studio.

Degas was close to his family. Its importance to him is reflected in the number of portraits he painted of its members. The fortunes of his family cannot be ignored in the story of his working life.

While he was still living with his father, his aunt Musson had arrived in Paris, accompanied by two of her daughters. New Orleans, in the hands of the Union army, was in turmoil. Michel Musson, Degas's uncle, had sent his wife and two of his three daughters to France to wait for better times. Degas attended them faithfully, his chivalrous spirit aroused particularly by Estelle Balfour, his eldest cousin, who had

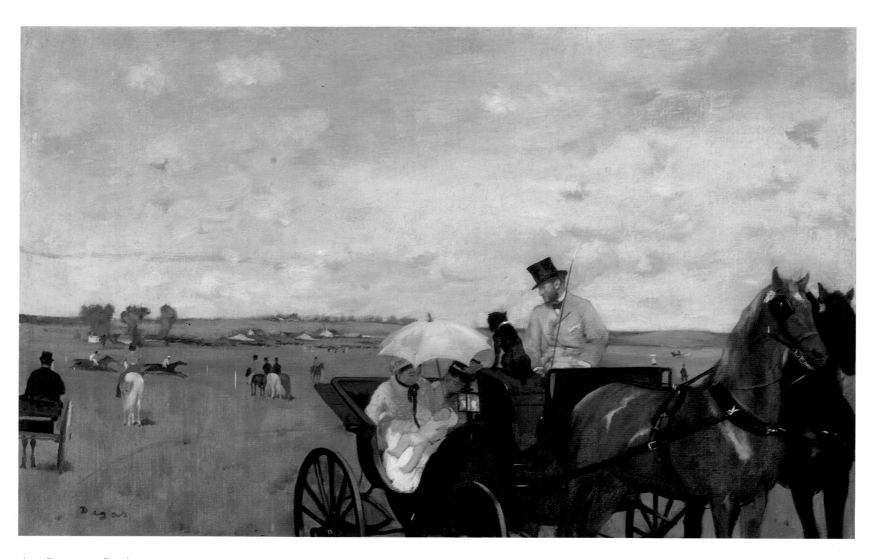

Aux Courses en Province
(Carriage at the Races). 1869

lost her young husband in the war and had borne him a child after his death. The three women stayed in France for two years. Estelle Balfour was to be hounded by misfortune. She was ill as well as bereaved and had begun to show signs of failing eyesight. She was soon to be incurably blind. Worse was to come.

When Mme. Musson and her daughters finally went home in 1865, the painter's brother René went with them. He had fallen in love with Estelle Balfour and, in spite of her blindness and the opposition of her father, married her by a special dispensation. For a while, René worked in his uncle's business, then he set up on his own, importing French wine. He borrowed the necessary capital from his father's bank. Degas did not see him again until after the war of 1870–71.

Degas was thirty-six when the Franco-Prussian War started in the summer of 1870. During the preceding five years, he had made a thorough redefinition of himself as an artist, turning his back on history painting and committing himself to the modern world. He had established certain subjects that would continue to occupy him for the rest of his life: the racetrack, the theater, dancers. He had set himself to rethink portraiture and the question of meaning in figure pictures that did not depend upon a commonly understood text. He had defined a position for himself that was altogether distinct from that of any of his contemporaries—profoundly traditional in that it was based on studio practice, centered on the human figure and on a Florentine conception of drawing; innovative in that it looked at every aspect of that tradition from a completely fresh angle. He was a presence among his

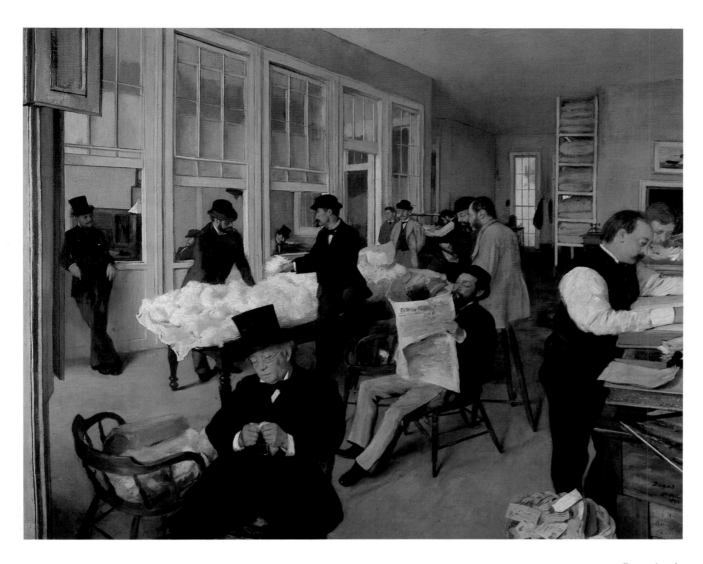

Portraits dans un Bureau (Nouvelle-Orléans),
also known as
Bureau de Coton à la Nouvelle-Orléans
(Portraits in an Office [New Orleans]). 1873

contemporaries; his intelligence and the fertility and originality of his ideas were recognized and respected. And yet he was somewhat to the side of them. He does not appear in either of the two group portraits in which his old friend Fantin-Latour celebrated the existence of the Batignolles painters, neither in his *Hommage à Eugène Delacroix* of 1864, in which the central figure was Whistler, nor in *Un Atelier aux Batignolles*, dominated by Manet, a Manet surrounded by the regulars of the Café Guerbois.

The Franco-Prussian War began in a frenzy of unrealistic popular enthusiasm. Within two months, the emperor had surrendered to the Prussians at Sedan. The Second Empire had come to an end. A republican government of National Defense was formed. Huge new armies were raised, inspired by memories of 1792. But before they could be equipped or trained, the Prussians were closing on Paris; they completed its encirclement on September 25. Almost every able-bodied man in the city was enrolled in the national guard, producing a vast force of some 350,000 men, few of whom had military training. But patriotic and republican fervor ran higher in Paris than in the rest of the country. The capital would hold the enemy at bay while the new armies were prepared. The Prussians settled down to wait.

Both Manet and Degas enlisted in the national guard. Manet served in the artillery through the autumn months, then was transferred to a staff position, where he discovered that his immediate superior was the Salon painter Ernest Meissonier. Degas had expected to be in an infantry unit, but in the course of rifle training it was

This picture is both a genre scene and a family portrait. Painted in New Orleans when Degas was staying with his cotton-merchant uncle, it was the first of the artist's works to enter a public collection. Achille De Gas leans against a window on the left. In the foreground, his top-hatted uncle, Michel Musson, examines a sample. In the center behind a newspaper is the artist's younger brother, René de Gas, recently married to his first cousin Estelle Musson.

Degas with his nieces

For several years around the late 1880s and early 1890s photography was a passion with Degas. Whoever actually made these exposures, Degas certainly set them up. Often his friends were conscripted as models. His photographs do not reflect the slightest interest in the snapshot effects that are often claimed to be present in his painting. On the contrary, his photographs were carefully, strenuously composed, as the following eyewitness account makes clear:

From that moment, the evening's fun was over; Degas raised his voice, became dictatorial, ordered a lamp to be brought into the little salon, and anyone who wouldn't pose had to leave. . . . There was no evading Degas's terrible will, his artist's ferocity. At such moments, all his friends speak of him with terror. . . .

"Taschereau! hang that leg over your right arm, now pull on it—there, there. And now stare at the young person beside you. More affectionately than that—more!—come on! You can smile so nicely when you want to. And you, Mademoiselle Henriette, lean your head over—more, more! all the way! Lean on your neighbor's shoulder." And when she didn't do just as he asked, he would grab her by the nape of the neck and place her the way he wanted her to pose; then he seized Mathilde in her turn, and turned her face toward her uncle. Then he stepped back and exclaimed delightedly: "Ready now, here we go!" . . .

At eleven-thirty, everyone left: Degas carrying his camera, proud as a boy with his rifle, surrounded by the three girls, whom he sent into gales of laughter.

discovered that his eyesight was defective. He joined the artillery, serving in one of the bastions that was part of the defensive system that ringed Paris. His post was in Bastion 12, to the east of the city, just north of the Bois de Vincennes, a good distance away from his home in the Rue de Laval. Here, his commanding officer turned out to be an old school friend from Louis-le-Grand, Henri Rouart, a remarkable man who was to become the most intimate of all the painter's friends. Rouart was a man of outstanding ability in several fields. He was an engineer, an industrialist, and an inventor, specializing in refrigeration. He was also a collector with wide-ranging taste and an amateur painter of some quality.

With the approach of winter—a particularly hard one—shortages of fuel and food became acute. When conditions were at their worst, the Prussians began to bombard Paris with massed artillery. The city surrendered on January 28. National elections were held soon thereafter. The resulting victory for Thiers and the Orléanists made it clear that the rest of the country had turned its back on the republican capital. The Prussians made a token occupation of Paris for a few days in March. Meanwhile, the National Assembly, sitting in Bordeaux, concluded a peace treaty ceding Alsace and half of Lorraine to the Germans and undertaking a massive indemnity of five billion francs.

Degas had lost two friends in the fighting for Paris, Henri Regnault, a brilliant and popular young academic painter, and the sculptor Joseph Cuvelier. He himself had seen virtually no action. He was deeply affected by the defeat. There is even a story that he helped to organize a demonstration with banners protesting the surrender.

At some time during the immediate aftermath of the war, Degas painted several small group portraits of men who had been involved in the siege, including his fellow gunners from Bastion 12, and one of two men who had played a distinguished role in the ambulance service, General Mellinet and Rabbi Astruc.

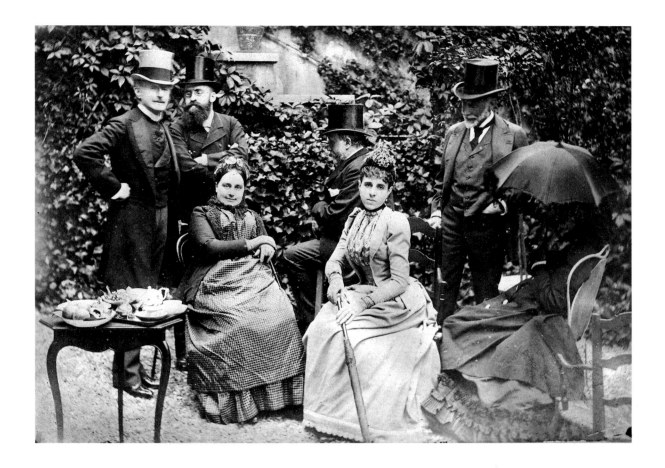

Degas and friends in the garden of Mme. Meredith Howland. c. 1885–86. Standing are Charles Haas, Léon Ganderax, Degas, and Albert Boulanger-Cavé; seated are Mme. de Granval, Mme. Straus, and Mme. Hallez-Claparède.

In mid-March, Degas went to the Valpinçons' estate in Normandy for a long recuperative holiday. Here life followed its usual placid course. Degas drew horses and enjoyed his friends' children, painting the beautiful portrait of Hortense Valpinçon, the girl leaning on the corner of a table covered with an embroidered cloth, a quarter of an apple in her hand; and a portrait of the new baby, Henri, in a carriage at the races.

Meanwhile, the age-old division between Paris and the rest of the nation, exacerbated by recent events, had reached a crisis. The capital, both further to the left and inspired by a much stronger militant spirit than the legitimist government, felt betrayed. Thiers attempted to disarm the national guard but failed. He established his administration at Versailles and prepared to take the capital by force. Paris held its own elections, and a radical republican city government was elected, calling itself the Commune de Paris. Toward the end of May, the Versailles troops entered the city. The Communards reacted with despair, killing hostages and burning public buildings. Street fighting culminated in a massacre. Something like twenty thousand workers were executed in an atmosphere of hysterical revenge.

Degas—and Manet, who had also been in the country recuperating from the privations of the winter—returned to the capital in the last days of the Bloody Week. Several of their colleagues were implicated in the Commune, among them Courbet, Théodore Duret, and Tissot. Berthe Morisot's mother, who had remained in Paris throughout these events and had followed the defeat of the workers with satisfaction, described both Degas and Manet as Communards. Manet was in fact a staunch republican. He was the only artist of his circle to allow his feelings about the Bloody Week to be reflected in his work. Degas, much further to the right, seems to have felt a similar indignation, but for patriotic rather than political reasons. He admired the people of Paris for not accepting the peace with Prussia. His later opinions, and in

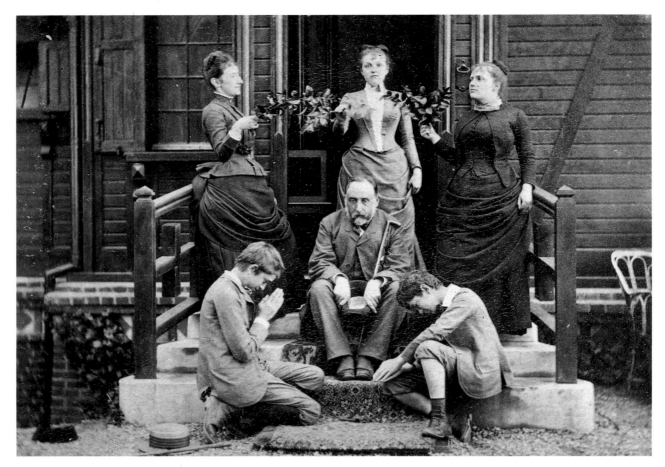

The Apotheosis of Degas
(parody of *Apothéose
d' Homère* by Ingres). Photograph
by Barnes. 1885. Standing
are an unidentified woman and
Catherine and Marie Lemoinne;
seated in front of Degas
are Elie and Daniel Halévy.

*Several of the photographs that Degas set up
reflect his playfulness, as does this one, in which
he poses himself as an antiheroic Homer in a
parody of the famous composition by Ingres.*

particular his anti-Dreyfus position twenty years later, were almost certainly inspired by his anger at the defeat of France in 1871, as well as by an unquestioning loyalty to the honor of the French army. The army continued to fascinate him. When after a few years reminiscences and campaign histories of the war began to appear in print, he read them voraciously.

One of the unforeseen consequences of the war was that the art dealer Paul Durand-Ruel, who had evacuated part of his business to London, became interested in the Batignolles painters. He had met Pissarro and Monet, both of whom were in London, and was now buying and showing their work. Degas visited London in the autumn of 1871, when Durand-Ruel was showing a number of the independent painters. He was there again the following year. In November 1872 the critic Sidney Colvin reviewed one of his ballet pictures that was being shown by Durand-Ruel; this was the most enthusiastic notice his work had yet received.

Degas was interested in further opportunities to exhibit in London. Several of his friends of the sixties—Legros, Tissot, who had been compromised during the Commune and was now on the brink of a brilliant career in London, and Whistler—were now living there, and Fantin-Latour was a frequent visitor with many contacts.

He made the trip to London in the autumn of 1872 on his way to America. René de Gas, who had been home on business, had persuaded the painter to travel back with him to New Orleans for a visit. The brothers crossed the Atlantic from Liverpool, then traveled south from New York by train.

Everything in New Orleans was strange to Degas. His letters to Tissot in London, and to Henri Rouart, Lorentz Frölich, and Désiré Dihau in Paris, are filled with enthusiastic descriptions of the new sights, the tropical Louisiana light, white babies in the arms of black nurses, white houses, white cotton, magnolias, orange trees, and

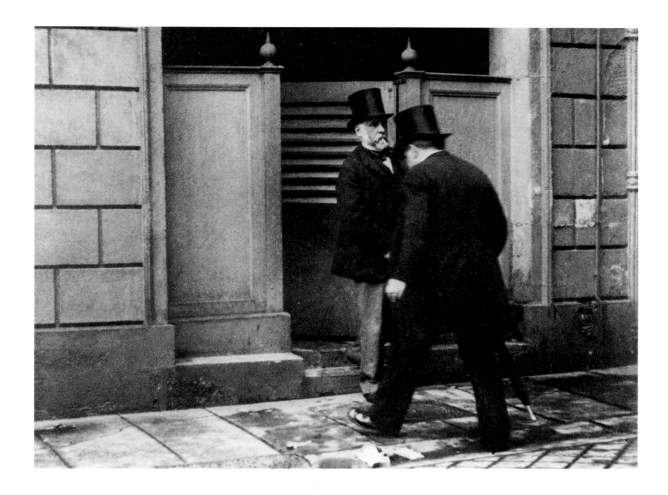

Degas making his exit from
a public urinal. Photograph by
Comte Giuseppe Primoli. 1889

steamboats at the end of the street, their funnels as tall as factory chimneys. But, he
tells his friends, these exotic novelties are all very well. "The new will bore you just as
often as it delights." He would need to stay for a very long time to understand what
he was seeing—"Momentary exposure is nothing more than a photograph"—but he
missed Paris and was home by the end of March. He brought with him the portrait of
his now almost totally blind sister-in-law, Estelle, and the *Portraits dans un Bureau
(Nouvelle-Orléans)*, a painting that he half-hoped to be able to sell to a Manchester
cotton magnate. This painting was later bought by the museum at Pau, the first work
by Degas to enter a public collection.

"The lack of an Opera is a real privation," he had written to Rouart from New
Orleans. Back in Paris that autumn, he suffered a further privation. The Opera House
in the Rue le Peletier, the site of so many of his studies, was burnt to the ground. But
a new house—Garnier's building in the Place de l'Opéra—was already under
construction.

That winter the painter's father, Auguste, fell ill on his way to Naples. Degas
immediately joined him in Turin and nursed him until the old man was fit to
continue his journey, after which the son went back to Paris. Arrived in Naples,
Auguste relapsed and died. As soon as his affairs began to be examined, they were
found to be in extremely bad shape. There were many debts, including some that had
been made on René's behalf. Degas was now thrust into negotiations for which he had
little appetite. He was the eldest son. His name was at stake. His younger brother,
Achille, came home from New Orleans and for a while attempted to keep the bank
afloat. This proved an impossible task, and within a year, Degas, Achille, and their
sister Marguerite found themselves saddled with substantial obligations. For the first
time in his life, Degas was under real pressure to sell his work.

Photographs from the voyage from Paris
to Diénay and back. Autumn 1890

In the spring of 1878, the news reached him that René had abandoned Estelle and left New Orleans with a new companion. Degas broke with him and attempted to communicate with Estelle, but his letters were returned unopened. Michel Musson severed all connections with the Degas family and changed René's children's surname to his own. Within a few years, three of Estelle's children by René had died, as did her daughter by Captain Balfour. René later returned to France, married his companion, and had a second family. He became the managing editor of *Le Petit Parisien*. There was a final reconciliation with his eldest brother in the nineties.

The decade following his father's death—the decade of Degas's forties—was the most active of the painter's life. He was closely involved in the series of eight exhibitions that gave Impressionism its name. He was exploring new subjects in his work, subjects that had never before been treated by an ambitious painter—the *café-concerts*, life behind the scenes at the Opera, milliners' shops, brothels, women bathing or having their hair combed. He was exploring new techniques, not just in painting, which included *peinture à l'essence*, distemper, and complicated mixtures of mediums, but also in pastel, which he transformed, making out of a minor and ephemeral medium something as substantial as oil paint. Printmaking in all its forms absorbed him. By the end of the decade, he was as much a sculptor as a painter. At the deepest level, his work was going through an evolution that would take it from brilliant, cool-headed illustration to passionate form-making.

He exhibited in all but one of the eight Independent exhibitions. When the first was being organized in 1874, Degas made great efforts to rally the painters with whom he felt most sympathy—Fantin-Latour, Manet, Whistler, Tissot. "See here, my dear Tissot," he wrote to his old friend in London, "no hesitation, and no escape. You have to exhibit on the Boulevard. It will do you good . . . and us as well. Manet seems

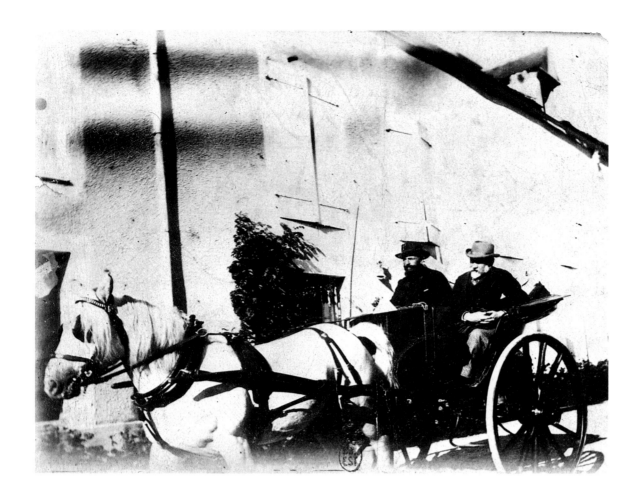

determined to keep out of it; he may well regret it. . . . I run around and manage the business with a firm hand, and a certain success, I do believe."

In the event, the exhibitions became identified with the more obviously radical Impressionists. Degas had hoped for something else. As he explained to Tissot: "The realist movement no longer needs *to oppose* the others. *It is, it exists,* it must *reveal its separate existence*—there *must be a realist salon.*"

He found himself continually at odds with the landscape painters. He deplored the scandal that surrounded the exhibitions and the publicity and advertisement that his colleagues quite naturally looked for. He objected violently to the label Impressionist that the press had hung on them. The artists whom he recruited—Bracquemond, Mme. Bracquemond, Ludovic Lepic, Rouart, Giuseppi de Nittis, Frederigo Zandomeneghi, Jean-François Raffaëlli—were only marginally acceptable to the Impressionist wing. Raffaëlli, particularly heavy-footed in his self-promotion, was to be the cause of bitter quarrels among the original group.

By the time of the Fifth Exhibition of 1880, the divisions among the Independents were extreme. Renoir and Monet had turned to the Salon, arousing Degas's anathema. On the other hand, Degas's protégé Raffaëlli had flooded the exhibition with thirty-seven works. "The little chapel has become a commonplace school," Monet told an interviewer, "which opens its doors to the first dauber to come along."

Degas's most redoubtable opponent on the Impressionist side was Gustave Caillebotte, a collector of the whole group as well as a distinguished painter, if anything even more disinterested than Degas and a happier, less complicated man. In a much-quoted letter to Pissarro in which he reviewed the prospects for a Sixth Exhibition, Caillebotte blamed Degas squarely: "Degas has produced chaos among us. It's really too bad for him that he has the unfortunate character he does. He spends

Georges Jeanniot later gave his account of Degas's arrival in Dienay:

It was here that Degas and Bartholomé came to see us one day, making the trip in a hooded two-wheeler, by stages, from Paris to Dienay. Bartholomé was the chief of staff in charge of stopping and starting, and Degas let himself be driven. When they were in sight of Dienay I happened to be riding in the vanguard, and since they were coming through Moloy and Courtivron, I galloped ahead to inform the populace! Baskets of flowers had been prepared, the young girls—there were a dozen in their finest outfits (and young women as well)—took up their posts at the doorways on each side of the road, and when the carriage reached the center of this swarm of beauties, both horse and travelers were instantly covered with flowers!

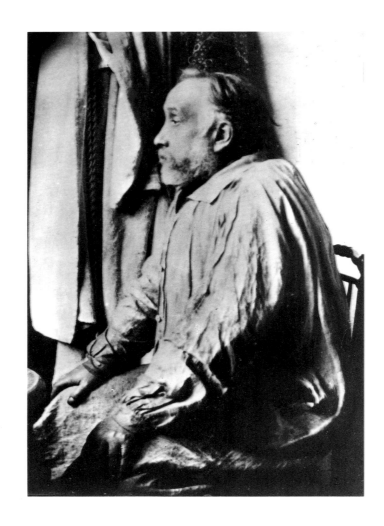

Photograph of Degas in his studio,
Rue Victor-Massé,
attributed to Bartholomé. c. 1898

*There are several eyewitness descriptions of
Degas's studio in the Rue Victor-Massé. Here is
Paul Lafond:*

*In the studio where he lived longest, on the fifth
floor of the house in the Rue Victor-Massé, previously
occupied by Toulmouche, reigned an indescribable
chaos. . . . Here you saw many easels loaded with
canvases or pastels in various stages of execution;
other paintings, turned against the walls, leaning
one against the other; sculptors' pedestals, tables
covered with lumps of clay; wax studies already
crumbling; lithographic and etching presses, boxes
of engravers' sand; objects that had served the artist
as props were all over the place—cellos, violins, tubs,
dancers' skirts and slippers, a cast of a woman's
body; an orchestra conductor's podium, a piano,
even a theater's revolving staircase. And again,
everywhere, were boxes of pastels, paints, copper
and zinc engraving plates, lithographic stones,
stools, broken-down chairs, old velvet-covered
armchairs with the stuffing coming out, cartons
half-tied with string, filled to bursting. To reach the
place where Degas was working, between a desk
covered with letters, books, and scattered papers,
and the stove, became a regular journey where you
had to take every precaution not to knock something
over.*

all his time in diatribes at the Nouvelle-Athènes or in society. He would be better off
doing a little more painting. . . . Of course there's a lot of truth and a lot of wit in
what he says, no one doubts that (in fact, isn't that what his reputation really comes
down to?). But it's just as true that a painter's real arguments are his paintings."

A theme that runs through Caillebotte's letter is the unreliability of Degas: "To top
it all, this man who has talked so much, and made such great claims, has always
been the man who has personally given the least." An instance that must have been at
the back of Caillebotte's mind was the planning and abandonment of the periodical *Le
Jour et la Nuit*.

The exhibition of 1879 had left the exhibitors with a small profit of a few hundred
francs each. Degas, who had been absorbed in printmaking for the last few years,
conceived of the idea of a periodical in which he and his friends would publish their
prints. Pissarro, Cassatt, Bracquemond, and Marcellin Desboutin were his immediate
collaborators; others were to follow. Ludovic Halévy promised to contribute text.
Caillebotte and the banker Ernest May, who was interested in Degas's work, agreed to
underwrite the budget.

The title, so appropriate for a publication devoted to prints, had been borrowed
from a column in the daily *Moniteur Universel* that contained reports and comments
on every aspect of the news in the city. Degas's magazine was to do the same in
pictures, covering many facets of social life. After a year of planning and preparation,
during which both Cassatt and Pissarro produced prints, the plan was suddenly
dropped. "As usual with Degas," Mary Cassatt's mother wrote, with some bitterness,
"when the time arrived to appear, he wasn't ready. . . . Degas never is ready for
anything—This time he has thrown away an excellent chance for all of them." There

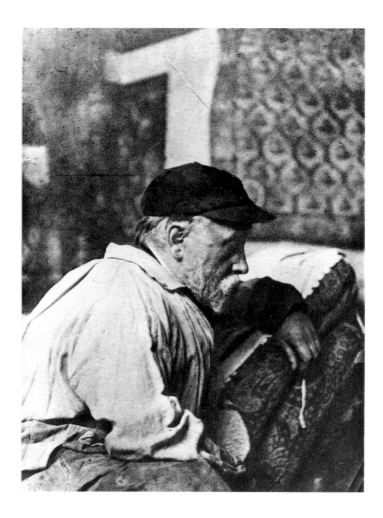

probably had been good reasons for scrapping the plan. Georges Charpentier's *La Vie Moderne*, an illustrated publication aimed at a similar audience, was known to be losing money, and Caillebotte and May must have been aware of this. But it is certain that the closer things moved toward a commitment to production, the less enthusiastic Degas became. Production, he must have felt, threatened the endless experimentation that had absorbed him and which had become an emotional end in itself.

In theory, he may have thought of *Le Jour et la Nuit* as a way toward enlarging his sales. There was an economic recession, and Durand-Ruel was forced to stop buying. Degas complained of hardship. He made various experiments in the decorative arts with an eye to sales, notably the many fans that he painted at this time. But he greatly overstated his insecurity. He had, by now, a circle of devoted collectors. The real problem was his own state of mind. He could never adjust to the facts that he was no longer a gentleman artist and that he was under pressure to produce works for sale. He began to refer scornfully to his pictures as *mes articles*, a term that a tradesman would use for his wares. Above all he could not finish a piece that had been commissioned and paid for. The singer Jean-Baptiste Faure had to threaten to take him to court to recover certain paintings that Degas had promised to finish; but this was only after Faure had waited for thirteen years.

In Degas's eyes, nothing was ever finished. He never outgrew his youthful tendency to tinker; in fact it got worse. When he had written an open letter to the Salon authorities in 1870, telling them how they should arrange the exhibition, one of his recommendations had been that artists should have a few days' grace after the exhibition had been hung to decide whether they wanted to show their work or not. Understandably, this madly impractical suggestion was ignored.

Paul Valéry, who knew Degas in his old age, describes the artist's house and studio:

I would ring his bell not at all certain of my welcome. He would open defiantly; then he would recognize me: it was a good day. He showed me into a long room under the eaves with a broad bay window (the glass unwashed), where the light and the dust were equally happy. Here, helter-skelter, were the filthy zinc bathtub, the wrinkled bathrobes, the wax dancer with her gauze skirt in her cage of glass, and the easels loaded with charcoal creatures, snub-nosed and twisted, clutching a comb around their thick hair pulled tight by the other hand. A narrow shelf ran the length of the vaguely sun-streaked windows, cluttered with boxes, bottles, pencils, pieces of chalk, stubs, and those nameless things that might always come in handy. . . .

As for Degas's room, it was as neglected as the others, for in this household everything came down to the notion of a man who cared for nothing but life itself, and who clung to life only in spite of everything, in spite of himself. There was some sort of Empire or Louis Philippe furniture here. A desiccated toothbrush in a glass, the bristles tinged a dull pink, reminded me of what you can see of Napoleon's intimate possessions at the Carnavalet, or elsewhere. . . .

I am let into the studio. Here, dressed like a poor man, his trousers tied loosely around his waist and never fastened, Degas putters about. A door ajar reveals, in the distance, the most secret places of all.

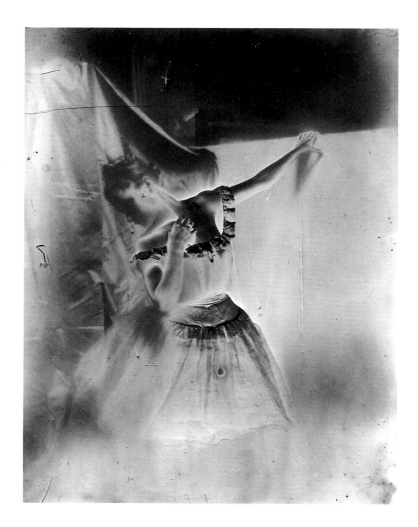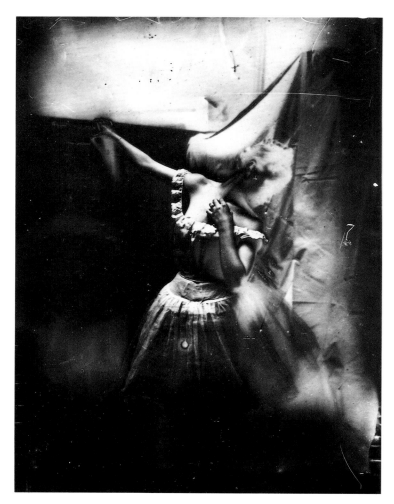

Dancers of the Corps de Ballet
(four photographs). c. 1896

These photographs were probably taken or at least arranged by Degas, as the model is in poses that appear repeatedly in his late pastels, and he certainly worked from them. The originals are on glass plates developed by the collodion process, which was popular in the early years of photography but long abandoned by the 1890s. Had they been in the artist's possession for years or did he deliberately revive an archaic method? In any case the plates have a curious affinity with his practice. They can be looked at from either side; the light and shadow are rendered in pale green and deep orange; and through some imperfection in the photographer's technique the light behaves in a way reminiscent of his monotypes.

Later, during the Independent exhibitions, Degas acted in the spirit of his own suggestion, promising work that never materialized or adding work during the course of the exhibition. Perhaps the most dramatic instance of this was at the Fifth Exhibition when he announced his sculpture *Petite Danseuse de Quatorze Ans* and actually set up on a stand a glass case which stood empty for the duration of the exhibition. The sculpture made its appearance a year later.

As Caillebotte had noted with some sarcasm, Degas had a reputation as a talker. The Nouvelle-Athènes had replaced the Café Guerbois as the favored meeting place for artists. It was from here that Degas's aphorisms about art, his paradoxes, and his terrible demolitions of his colleagues issued into circulation.

A comedy called *La Cigale* by Henri Meilhac and Halévy appeared on the Paris stage in 1877, at the height of the excitement about the new painting. One of the main characters in the play was a painter who is seen in one act to be painting from a model posed as a laundress. Some of his lines parody aphorisms by Degas that were already in circulation. There is evidence that Degas supplied some of the inside jokes and helped with the decor of the studio scene. His public persona was deliberately constructed.

Remembering evenings in the nineties, when he was a newly married member of the Rouart household, Paul Valéry wrote: "Every Friday Degas, faithful, scintillating, unendurable, enlivened Monsieur Rouart's dinner table. He scattered wit, gaiety, terror. He mimicked and he struck home, lavish with his maxims and his taunts, his tirades and his tales, all the traits of the most intelligent injustice, the surest taste, the narrowest and indeed the most lucid passion. . . . I can hear him now."

Degas lived alone, looked after by a succession of housekeepers. As far as was known, he had no intimate relations with anybody. There are letters in which he reflects wistfully on the rewards and comforts of family life, but as the years passed, he settled into bachelorhood, defending his solitude, harrowing his friends with his complaints of loneliness. His reputation as a misogynist was partly of his own making—his sarcasms about women made the rounds—and partly a projection on the part of those who were nonplussed by the absence of coquetry in his nudes. On the other hand, he was capable of deep friendships with women. The greatest of these was with Mary Cassatt, to whom Joseph Tourny had introduced him in 1877. They already knew each other's work. "There is someone who feels as I do" had been Degas's comment on seeing a portrait by her in the Salon. Indeed, they had a great deal in common. Ten years younger than Degas, Cassatt was herself unmarried. Extremely intelligent, with an astringent tongue, she had a degree of moral seriousness that equaled his own. On his invitation she began to show with the Impressionists. Later her influence on American collectors was responsible for the building of several of the greatest collections of Impressionism.

Mary Cassatt is represented in a number of Degas's images of the late seventies and early eighties, most famously in the prints that show her in the galleries of the Louvre. She dressed with great elegance and played a leading part in his pictures of women trying on hats. The friendship between them was probably the deepest that either enjoyed with a member of the opposite sex.

By the time he was approaching fifty, Degas had begun to draw in. Like all artists, he feared nothing so much as the passage of time. As he became more celebrated he

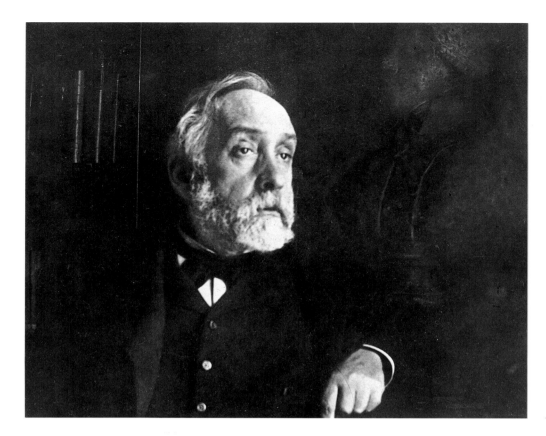

Portrait of Degas,
attributed to his brother René de Gas.
c. 1895–1900

Degas. c. 1895–1900

also became more reclusive, guarding his working hours jealously. Many of his
utterances reflect disappointment—a chagrin that is consonant with his vast
ambition. "You blank out everything around you," he wrote to a friend not long after
his fiftieth birthday, "and once you're alone, you annihilate yourself, you actually kill
yourself with disgust. I've made too many plans, and here I am absolutely blocked,
impotent. I've lost the thread. I thought I still had time: what I wasn't doing, what I
was kept from doing, amidst all my troubles and despite my bad eyesight, I never
gave up the hope of getting down to it one fine day. I piled up all my plans in a closet
and always carried the key around with me, and now I've lost that key."

He was a devoted friend to those who had his confidence, and to the growing
families of the Valpinçons, the Rouarts, and the Halévys he was like an uncle. He
spent the late summer of 1884 with the Valpinçons in Normandy, and it was on this
visit that he became obsessed with making a bust in clay of their daughter, whom he
had painted years before as a child. He worked on it for weeks and then impatiently
tried to cast it with builder's plaster, and the whole thing fell to pieces. He spent
several lighthearted summers near Dieppe *en famille* with the Halévys, on one of
which he made the wonderful group portrait in pastel now at the Museum of Art,
Rhode Island School of Design, in Providence. On these summer holidays, so different
from the punishing working campaigns that took Monet all over France during the
same years, Degas traveled widely. In 1890 he made a trip to Spain and Morocco, in
the company of Giovanni Boldini, the virtuoso Italian portrait painter. He spent
several summers at Cauterets, a small but fashionable watering place near the
Pyrenees. Other journeys took him to Switzerland, where his brother Achille lived, and
to the south. In the autumn of 1890, he made a three-week tour of Burgundy with
Paul-Albert Bartholomé, in a gig pulled by a white horse. This trip, which was
recorded in hilarious letters to Ludovic Halévy and his wife, Louise, was particularly
memorable because his destination was the summer house of a young painter, Georges
Jeanniot, where Degas made a series of colored monotypes of landscape subjects,

Photograph of Degas with Zoé Closier,
attributed to René de Gas. c. 1895–1900

allegedly recollections of the countryside through which the two travelers had passed. These mysterious dream images, unintelligible as representations, pleased Degas so much that he went on with them in Paris, printing more and working into them with pastel. To general astonishment, he showed them at Durand-Ruel in the winter of 1892, the only exhibition of his work alone held in France in his lifetime.

As his fortunes had improved he had become a fanatical collector. His collection was one of the most substantial ever to have been assembled by an artist, worthy of those he had known in his father's circle. There was nothing haphazard about it. He searched galleries and sale rooms. His collecting had that obsessive, imperious character that only true collectors know. He was haunted by the objects he desired. He would lose sleep over an Ingres drawing and persuade himself that it was necessary to him. His most important holdings were of his three idols, Ingres, Delacroix, and Daumier. In the final inventory of his collection, there were twenty paintings and eighty-eight drawings by Ingres, thirteen paintings and almost two hundred drawings by Delacroix. There were hundreds of lithographs by Daumier. His contemporaries were well represented—with the exception of Monet, by whom he had nothing. There were eight Manets, seven Cézannes, and paintings by Pissarro, Cassatt, Morisot, and many others. There were ten Gauguins, and two Van Goghs, including a *Sunflowers.*

Important though his collection was, the idea of market values being placed on works of art was abhorrent to him, as the following reminiscence by the critic Emile Bergerat illustrates:

I have always suspected Hilaire of having gone into artistic seclusion with all his might and main . . . following the scandal of Millet's *Angelus,* for which the master received 1200 francs on the easel, and which, as soon as he was dead, was hustled back and forth between France and America, America and France, by millionnaires crazed by snobbery. I remember one evening, at one of those dinners at the house of Giuseppi de Nittis . . . a lively discussion arose

Paul Valéry offers the following account of Degas and his housekeeper, Zoé Closier:

In this upstairs apartment was a dining room where we had any number of gloomy meals together. Degas lived in mortal fear of intestinal inflammation and blockage. The overcooked veal and the macaroni boiled in plain water and served by old Zoé with extreme deliberation were of the most rigorous insipidity. Then you had to consume a sort of Dundee marmalade which I couldn't bear, though I ended up by doing so, and which I believe I no longer loathe, on memory's account. If I can still, at this moment, taste that jam shot through with carrot-colored fibers, then I find myself sitting once more opposite a dreadfully solitary old man given up to lugubrious reflections, deprived, by the state of his eyesight, of the work that was his entire life. He would offer me a cigarette tough as a pencil, which I rolled between my hands to make it smokable; and this gesture, each time, would fascinate him. Zoé brought in the coffee, leaning her huge belly on the table, and talked. She talked very well; apparently she had been a schoolteacher; the huge round glasses she wore imparted a rather learned look to her broad, frank, invariably serious face.

concerning this same *Angelus* and its adventures. Edmond de Goncourt, Alphonse Daudet, and Emile Zola, all of whom were quite familiar with popular success by then, did not regard as excessive the auction-bids, which had already reached half a million. . . . But in the adverse camp, Marcellin Desboutin, master of the drypoint and a splendid talker besides, and Edgar Degas seemed outraged by the discussion and hesitated to take part in it.

"There's no picture," the engraver said at last, "even if it is a masterpiece, and one by Rembrandt himself, which is worth so Californian a sum. This is no more than a simple conflict of bourgeois ostentations, whose object could just as well be an old shoe as a painted canvas." "And your opinion?" De Nittis asked Degas. "In front of these men of letters? Don't even think of such a thing, they'd repeat it everywhere." "No, no, say what you think," Daudet said, screwing in his monocle. "Very well then, here is what I think—entirely among ourselves, if you please. It is a dishonor to painting. That's what it is." And standing up, he flung down his napkin and walked out, without another word. When Desboutin, who had followed him from the room, returned: "Well," we all said, "what's got into him?" "Leave him alone, he is a great artist, of the old style, and he is in tears."

Degas made plans to leave the collection to the nation, then changed his mind. In the end, it was sold after his death in a series of auctions held in 1918.

In the catalogue of the last Independent exhibition of 1886, the exhibition that ushered in a new phase in French painting with Georges Seurat's *Un Dimanche à la Grande-Jatte*, Degas announced a suite of ten pastels, naked women bathing, drying themselves, combing their hair, or being combed. These bathers were based on studies from the model made in his studio, where baths and curtains were rigged up for the purpose. This was the last new subject that he took up and he persisted with it for the remaining twenty-five years of his working life. Pastel had largely supplanted oil. Except for one extended foray into lithography, he had dropped printmaking. Sculpture went on continuously.

He had committed himself to an extreme specialization, reducing the range and variety of his work, concentrating on the permutation and refinement of a limited number of poses. He was, however, still capable of being carried away by new enthusiasms. For several years at the end of the eighties he became absorbed in writing poetry. Eight of his sonnets are known, and there may have been more, now lost. They are in the formal and highly wrought manner of the Parnassians. Valéry took them seriously.

A few years later it was the camera that claimed his spare moments. There are accounts of long evening sessions when he posed his friends among elaborate arrays of artificial lights. Of the many photographs that he must have taken during the years when the enthusiasm lasted, only about forty survive.

The development of his late work—large in scale, broad in form, rough in surface—is generally connected with his declining eyesight. Ever since the discovery on the rifle range of the national guard that he had a weak eye, Degas had been afraid of blindness. He had complained that bright light hurt his eyes and had worn tinted glasses for years. He used the weakness of his eyes for excuses of all sorts. He said that it was caused by sleeping in a draft. He told Walter Sickert, the English painter, that he had a blind spot and could not see what he looked at directly. Other accounts vary. It is clear that his habit of meeting trouble halfway had become ingrained. His niece, who cared for him during the last few years of his life, stated in her memoir that even at the end he was not completely blind. Descriptions of him during his last years, when walking was his main occupation, do not picture him as a blind man.

Coming from the sale of the collection of Henri Rouart, Daniel Halévy met up with Degas, then in his late seventies. Some months earlier Degas had been forced to leave his studio of twenty years on the Rue Victor-Massé for new premises. Halévy shared the following memory of their walk homeward:

I met him on the sidewalk of the Rue de la Ville-l'Evêque, and accompanied him. Or rather, he accompanied me, walking for its own sake, the way he does now. He talked a little, and always in that remote, gentle, musical voice, made fainter by the weight of eighty years:

"You're going to be quite annoyed with me," I told him (taking my precautions); "You're going to think I'm really one of the literary tribe, but I can't help regretting that no one has written down what Rouart had to say about Corot, Millet, or old Martin, the dealer. . . ."

He stopped and in that distant voice of his, as though repeating something he had remembered, seeming not so much annoyed as sad:

"Ah, literature. . . . Men of letters . . . no, no, that sort of thing is nobody's business. . . . There has to be a certain mystery; you must leave a mystery around the works. . . ."

And we walked on. "You see," he said, "my legs are all right, I'm feeling fine . . . I don't work anymore, since I've moved. . . .

We were walking past the Nouveau Cirque. *"That used to be the* Bal Valentino," *he said. . . . "One evening, I took off a young woman's mask. . . . I had been to the* Bal, *I had taken her there, I was dressed up as a Pierrot—I was very young then, I was very young. . . ." And he kept on walking. He walked along the sidewalks, up and down, crossing the streets quite successfully. I was in constant fear for him, but I was wrong. You cannot tell how much he sees or doesn't see. He suddenly stopped—that was always his way, as though to tell me something important: "I sleep—actually, quite well, eight or nine hours a night. . . . I've still got that: sleep and my legs."*

He's not in the least in his second childhood. But his higher faculties are growing dim, and he's quite concerned by the life of his body, from which he gets those impressions of well-being. Besides he's interested in everything—in the Balkan War . . . but from such a distance! Always those eighty years. . . . It's a huge distance between him and us.

But he had been bewailing the weakness of his eyes for decades. His lamentations were theatrical; whatever their basis in fact, they were also material for an impersonation of himself as a curmudgeon, much put upon by fate. He had used his aggressive wit to turn himself from a shy, introspective, complicated youth into an old man whose temper and tongue were dreaded. Part of this transformation involved picturing himself as the victim of far grander and more baneful influences than the vulgar pygmies that surrounded him could conceive: the downfall of his family, the loss of honor, blindness—a declension that was itself ennobled, idealized, becoming at some level linked with the decline of art, the Death of the Gods.

Another part involved an acute sense of his own shortcomings, self-criticism exaggerated by solitude to the point of self-hatred. "Anxious figure of the tragicomedy of Modern Art," Valéry calls him, "divided against himself. . . ." Vollard remembers Renoir telling the following story: "One day he said to me, 'Renoir, I have a terrible, invincible enemy.' 'Who is that?' 'You old fool,' he said, pounding his chest, 'you should know better than anyone else; my enemy is myself!'"

Degas knew the effect his bitter tongue had on those upon whom he turned it. He attempted to excuse himself in a revealing letter to one of his oldest friends, Evariste de Valernes:

Here I want to ask your forgiveness for something that frequently comes up in your conversation and even more frequently in your thoughts: I want to ask your forgiveness for having been, in the course of our long relationship as artists—or for seeming to have been—*hard* on you.

Degas in the garden of Paul-Albert Bartholomé.
Photograph by Bartholomé. 1915

Jacques-Emile Blanche published in January 1913 this description of the aged Degas:

A great peace, a look of health had moderated the long, heavy features of that concave physiognomy, with its vermilion explosion of the sensuous lips. The heavy eyelids fell over eyes which had once been so piercing and now distinguished no more than a fraction of the objects that had once been the agonizing preoccupation of this energetic observer. He stood up to leave, and suddenly the entire outline of his body was silhouetted in front of me: at certain moments Monsieur Degas's posture was that of a great leader giving orders; if he made a gesture, that gesture was determined and imperious, expressive as his drawing; but he soon assumed a more yielding attitude, almost that of a body collapsing into itself—the habit of a solitary man who conceals or protects his personality.

I was especially so on myself, you must remember that, since you even reproached me for it and expressed some surprise that I had so little confidence in myself. I was, or I seemed, hard on everyone, out of a kind of inurement to brutality which came from my doubt and my bad humor. I felt so poorly constituted, so ill-equipped, so flabby, while it seemed to me that my *calcuations* as an artist were so accurate. I resented everyone, and myself most of all. I ask your forgiveness if, on the pretext of this damned art, I have wounded your noble and intelligent spirit, perhaps even your heart.

He was intractable in his prejudices. Part of him lived by them and the stiff, unbending defense they presented to his time. In the great fracture of the Dreyfus affair, Degas unthinkingly took his place on the side of the army. Far easier to look for treason on the part of Jews, Freemasons, Protestants, and the likes of Zola and Gide than to look for it on the part of the High Command. If this meant sacrificing his lifelong friendship with Ludovic Halévy, he had broken with those he loved before. When the affair had run its course and it was clear that the army had lied, dishonor fell upon dishonor.

In 1890 Degas had taken a lease on a house in the Rue Victor-Massé, the old Rue de Laval. He arranged the whole building to accommodate his needs. His collection had been growing steadily, and the whole second floor of the house was made over to it. The living quarters were on the floor above, run by a new housekeeper, Zoé Closier. Above, on the top floor, was his studio. Degas lived here for twenty-two years; then the landlord decided to demolish the building. Suzanne Valadon, the painter and a friend of Degas's for many years, found him new quarters in the Boulevard de Clichy. His collection and the contents of his studio were packed by Durand-Ruel's workmen and carefully transported.

Degas. c. 1915

He was to live another five years. He was letting himself go. He stopped trimming his beard or caring for his dress. He had bladder trouble and chronic bronchitis. He had continued to work as long as he was in the house in the Rue Victor-Massé, but "It's odd," he told Daniel Halévy, whom he had met at the auction of the collection of his old comrade Rouart, months after the move. "I haven't put anything away, it's all still there, against the walls. . . . I don't care, I'm leaving everything. . . . It's astonishing, old age—how indifferent you become."

Indeed he had become indifferent:

Suddenly I see in my mind's eye the familiar figure of Degas, his long hair and his disheveled beard, standing in his studio. "How simple it would be, if only they would leave us in peace. . . . The journalists bore the public with our works, they bore us with their articles, their fine phrases. . . . They want to explain everything, always explaining. . . . You can't explain anything. . . . How stupid it is, to make people come and stand in front of what we are doing. . . . Beauty, beauty is a mystery." He spoke without violence, almost in despair, dirty, dishevelled, a sordid Prospero in his studio, where strange sculptures, dried wax figures crumbled and fell into dust amid the dust, where the blank canvases were turned to the wall— a bare wall, unpapered; the whole place constituted the most melancholy setting. That was how he lived, in filth, in darkness, turning his canvases away from the light; that was how he lived until his exhaustion and a tremendous indifference overwhelmed his spirit and extinguished his desires; he died in that indifference, in that poverty, on the top floor of a tall building where he was faded out among all his drawings and his canvases.

During the last years of his life he was to be seen walking, walking through the streets of Paris, ignoring the traffic. He died on September 27, 1917.

Daniel Halévy went to see Degas when the painter was confined to his bed:

One of his nieces, who's taking care of him, lets me in and takes me to his room, a bare room, new, with no past. Degas on his bed, motionless, receives me with two welcoming words. I sit down on a chair. No conversation. At a certain moment, the niece comes over to him and straightens the pillow. She's wearing a light, shortsleeved dress. All of a sudden Degas grasps her arm in both hands with a strength I didn't think he had. He moves the arm into the light from the window. He stares at it with a passionate attention. How many women's arms has he looked at that way, and caught off guard, so to speak, in the light of his studio. I had imagined his power was defeated, and here he is, still working.

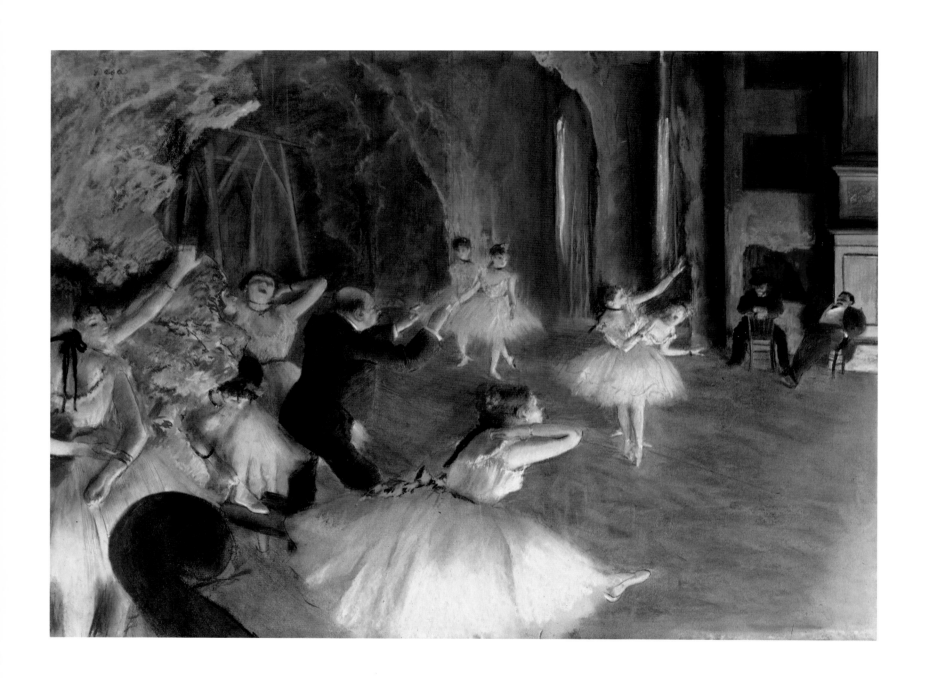

The distinctive sign of "modernity" frequently being artifice, and the most specific feature of our age being the substitution of mechanical for natural agents, the more one chooses to give an acute sensation of modern life, the more one is led to represent artifices. . . . On stage . . . the lighting of the faces is doubly artificial: in color and in value. . . . It flattens very noticeable relief, vigorously models imperceptible planes, inflames what it touches like a torch, leaving points in complete shadow; in short, confuses and betrays human forms in a continual shimmer of indiscretions, exaggerations, and deceptions, like a worldly gossip. Degas is the master of such luminous spells.

ROBERT DE LA SIZERANNE, *Revue des Deux Mondes*

From his first years as a student Degas never doubted that he was a figure painter. He saw his destiny in the most demanding and historically ambitious rank of the art. All the time that he was in Italy he was thinking of subjects for compositions, the type of historical narrative subject that represented ideas.

There are notes and drawings for *Tintoret Peignant Sa Fille Morte, Saint Jean-Baptiste et l'Ange, La Femme de Candaules, Dante et Virgile, David et Goliath, Oedipus Rex, Mary Stuart Departing from France*, and many others. Both *Saint.-Jean-Baptiste* and *David et Goliath* were pondered for months and produced highly developed studies, but in the end they were dropped.

The five subjects that were realized during the first years back in Paris were *Alexandre et le Bucéphale*, and *La Fille de Jephté*, both worked on during the year 1859–60; *Sémiramis Construisant Babylone* the year following; *Petites Filles Spartiates Provoquant des Garçons*, which he probably started in 1860 and then continued to rework, possibly as late as 1880; and finally the painting known as *Les Malheurs de la Ville d'Orléans*, the only one of the five to reach the walls of the Salon. *Alexandre et le Bucéphale* and the *Fille de Jephté* were well-known subjects. *Sémiramis* is thought to have been inspired not by known pictures but by the revival of a Rossini opera of the same name, and in a more general way by an interest in the current work of French archaeologists on sites in ancient Mesopotamia. The *Petites Filles Spartiates* had a specific source in a book that Degas would have read at school and which remained a favorite with him in later life. This was the *Voyage du Jeune Anacharsis en Grèce* by the Abbé Barthélemy, an imaginary travel book through ancient Greece in which a certain passage derived from Plutarch describes the games of the Spartan youth. On the other hand, the subject of *Les Malheurs de la Ville d'Orléans* is a mystery. No one has yet suggested a literary source for this scene of medieval violence in which mounted archers pick off beautiful naked women as if they were so many wild pigs.

All these compositions are ambitious and tentative. They are the paintings of a brilliant tyro who is casting about, inspired by his calling, unsure. *Jephté* is unique

La Répétition sur la Scène (The Rehearsal on the Stage). 1874?

Etude pour Alexandre et le Bucéphale
(Study for Alexander and Bucephalus).
1859–60

Etude pour Alexandre et le Bucéphale
(Study for Alexander and Bucephalus).
1859–60

OPPOSITE:

Etude pour La Fille de Jephté
(Study for The Daughter of Jephthah).
c. 1859–60

in all Degas's work in that it openly tells a known story of high emotional intensity. The story is from the Book of Judges: a great captain has sworn to the Lord that if he is successful in battle with the Ammonites he will sacrifice whatever living being comes out of his house to greet him on his return. The picture shows Jephthah's homecoming and the women welcoming him, first among whom is his own daughter.

Degas brings all his pictorial erudition to bear on the scene. "Try for Mantegna's wit and feeling with the verve and coloring of Veronese," he tells himself. He draws almost every figure from his vast storehouse of images, quoting from sources as far apart as the Parthenon reliefs and Géricault. Yet in spite of the force of the story and all Degas's efforts to condense it into a single grand image, the picture is unfocused and tame.

Sémiramis is quite different. It does not illustrate a dramatic moment within a story; instead, everything supports an atmosphere of suspension and stillness. The queen and her ladies stand motionless as if under a spell. Their friezelike placement suggests that Degas is invoking the stillness of antique relief as a metaphor for a distant past.

The last two historical paintings do not illustrate known stories. The *Petites Filles Spartiates* is an imaginary scene from everyday life, an historical genre scene. *Les Malheurs* relates to no known event in history or literature. It may be that one of the impulses that inspired it was Degas's response in fantasy to the terrors that his female relatives had endured in New Orleans. Erotic excitement, sadism, and pity mingle disturbingly here and make the picture far more than an essay in bland medievalism.

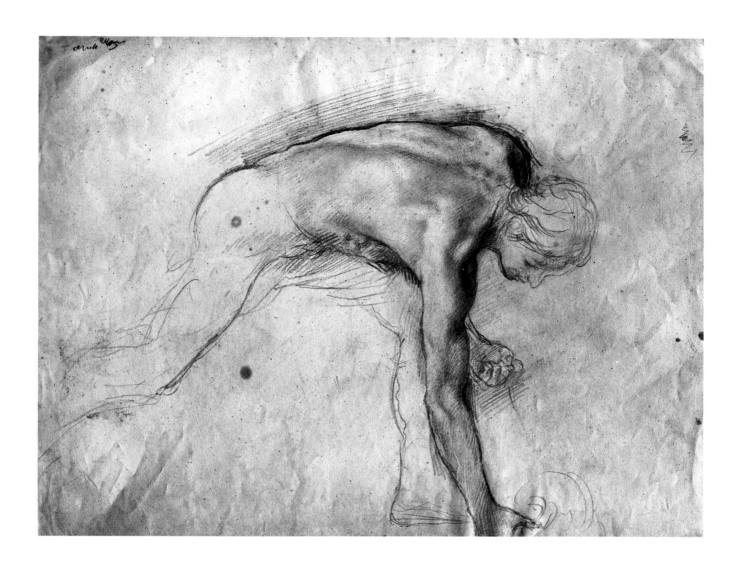

The *Petites Filles Spartiates* is by far the most important of Degas's historical pictures. He worked on it over a period of years, the very period during which he was discovering himself as a painter. The discoveries are rehearsed in the painting itself. Not surprisingly, he treasured it in later years.

There are two full-scale versions of the *Petites Filles Spartiates*, one in monochrome and the other, on a slightly larger canvas, painted in a full palette. There is at least one oil sketch of the composition, and numerous studies from models. When we compare the two full-scale versions it is at once clear that while he was working on the picture, Degas went through a profound change of outlook. In the grisaille sketch the figures are set in a conventional "classical" setting. There is a little temple in the middle distance and a grove of trees on the right, and the scale of the figures to their surroundings is the scale of museum pictures, a Poussin *Baccanal*. X rays have shown that trees and temple were once in the final, colored version too. At some point Degas painted over them, opening the landscape into a wide plane, distancing the mountain and turning the figures from nudes inside a certain type of picture to naked youths exposed.

The athletes of the grisaille have straight "Grecian" noses and almond eyes, and we can hardly tell one from another. Their limbs are sexless. In the last version each head is irregular and alive. They are kids off the street, and their bare limbs are particularized.

At the time when he was working on the *Petites Filles Spartiates*, Degas had been looking at people in the open air and under wide skies at the races. Back in Paris, as

These drawings from the model were made in preparation for historical figure compositions, the seated figure for Alexandre et le Bucéphale *and the stooping figure for* La Fille de Jephté. *The stooping pose was borrowed from a figure by Ingres in* Martyre de St. Symphorien *who bends down to pick up a stone to throw at the martyr. Degas had him in the foreground of his Jephthah picture, although it is not clear what he was doing there. He later changed his mind and turned him into a bounding dog.*

In these drawings Degas indicates some parts of the figure with a few experimental lines and then bears down with intensity where his eye is aroused and his need for information is greatest. It is the arms and the shoulders that command his closest attention, both in the depth and firmness of the modeling and in the incisiveness with which he carves them out as flat shapes. Notice how he emphasizes the silhouette of the seated model's arm, shoulder, and neck, drawing it flat; at the same time he models the form vigorously. Already in the tenor of this one passage we can make out an attitude, a state of feeling that we recognize as his alone. It will recur throughout his life, and as often as not it will be the movement of arms that precipitates it.

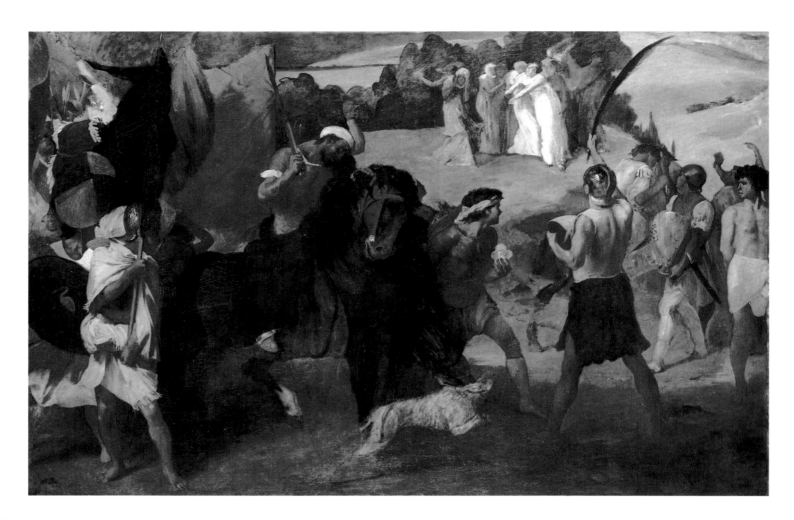

La Fille de Jephté
(The Daughter of Jephthah). c. 1859–61

Among the notes that he made when he was working on La Fille de Jephté *Degas wrote: "Show him defeated, embracing his daughter. I don't know if I would ever change places with him for all the money in the world." He was deeply involved with the story and searching for equivalents in gesture and emblem for his reading of it: "The woman sitting on the donkey cloaked in a warm pink drapery; on the donkey a lion skin . . . make the young man dividing the flags wear a wreath of laurel leaves . . . palms, a sign of gaiety among the women, one at the feet of the girl holding an emblem of martyrdom . . . put a harp in the hand of the king's daughter held captive." Degas was also looking for equivalents of a more purely pictorial kind: "Find a bright, harsh color for the grass. Fade it so that you can feel that the girls will climb up to the mountains to weep, gazing at their home below them." There are several pages of these notes, each one provoking a vivid concrete image, often calling up comparisons and associations.*

As so many painters have done, before and since, he invokes his models: "Try for Mantegna's wit and feeling with the verve and coloring of Veronese." Almost every figure in the picture is borrowed from art.

an habitué now of the Café Guerbois, he would have been a party to endless discussions among the Batignolles painters about the incompatibility of the ideal and the real.

There are some amusing lines in Duranty's article "La Nouvelle Peinture" that must be reminiscences of these discussions. He pretends to have received a letter from an "observant painter" who scathingly describes the behavior of some artists. These men each have a wife or mistress whose appearance delights them. She has a pug nose and tiny eyes and she is slender and delicate and lively. "What they love about her are precisely these 'defects.'" She is the "ideal of their hearts, of their minds, who has awakened and incarnated the truth of their taste, of their sensibility and their *invention* since they have found her and chosen her." But when these gentlemen go to their studios they paint Greek types, dark, severe, with straight noses and thick necks. "The pug nose they delight in every evening they betray every morning in the studio." The "observant painter" whom Duranty is quoting was certainly Degas, whom he must have heard again and again on the subject of Grecian profiles and pug noses.

The final reworked version of the *Petites Filles Spartiates* is like a manifesto of Degas's position. It is flooded with light. The space that the figures occupy is broad and airy. An idyll of a pagan past comes over to us unshrouded. Nothing lies between us and Degas's dream, incarnated by the immediate, firsthand quality of his drawing. It may have been the first composition that Degas made in which he could fully believe; the first moment at which his relationship to the masters, stripped of dutifulness and nostalgia, becomes vivid.

Twenty years later Degas planned, surprisingly, to exhibit the painting at the Fifth Independent Exhibition of 1880. It was announced in the catalogue but in the end

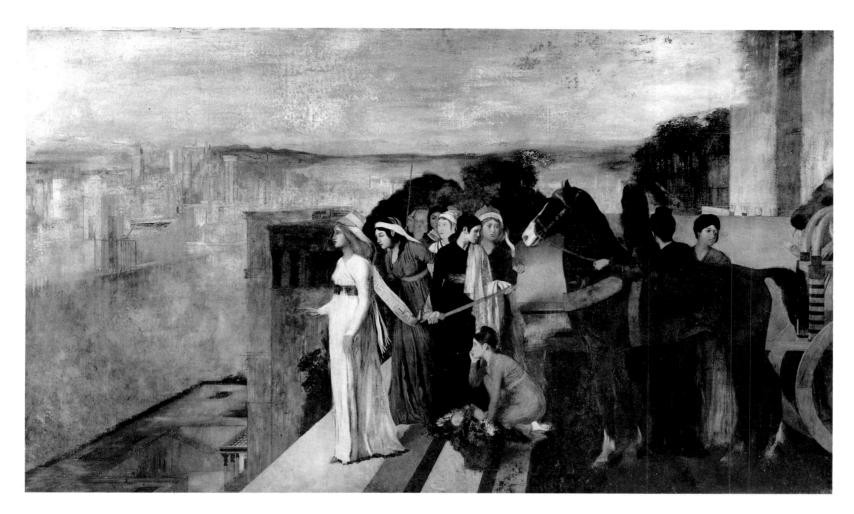

Sémiramis Construisant Babylone
(Sémiramis Building Babylon). c. 1860–62

It is not a climactic moment that we see in
Sémiramis *but a scene of stillness that we can
imagine drawn out in time. The motionless queen
and her ladies look out from their terrace over a
city that is like a city in a dream. Their stillness
becomes the artist's metaphor for a distant past,
a past that he evokes more directly through the
suggestions of relief in the row of figures and the
horse, borrowed from a sculpture of the fifth
century.*

did not appear. If it had been shown it would have been as a manifesto of a very
different kind, for during the intervening years Degas had made his reputation as a
realist, a chronicler of modern Paris. Alongside the other works that Degas showed in
1880, an *Examen de Dance* or a monotype heightened with pastel of a woman
undressing, the *Petites Filles Spartiates* would have been seen as a vehement reminder
of his commitment to the art of the museums.

Les Malheurs was shown in the Salon of 1865. The following year Degas was
represented by a scene from modern life. *Scène de Steeple-Chase* is a large canvas,
larger than the *Petites Filles Spartiates*. It is an abrupt departure, owing little to the
old masters.

Degas had been visiting the racecourse for several years. The notes he made of his
first impressions invoke English novels and English horse painters. He was seeing the
races through their eyes. With the *Scène de Steeple-Chase* he steals permission from
this minor branch of painting to approach his subject and at the same time shatters
the convention from which he is taking. The picture is like a detail from Herring,
redrawn with a sense of classical form and enlarged to monumental proportions.

The picture represents a split second of time: this is what he is monumentalizing.
The upper part of the canvas is filled with horses at full stretch, dashing from right
to left. The two nearest—so close that their extremities reach outside the canvas—are
riderless. Beyond them, silhouetted against the sky, still just inside the picture, are the
heads and shoulders of two jockeys. Their mounts are barely glimpsed. The ground
over which the horses are galloping occupies nearly half the height of the canvas.
Horses' bodies arch over it, spanning the width of the canvas, and inside this arch,
supine in the shadow of their bellies, lies the fallen jockey.

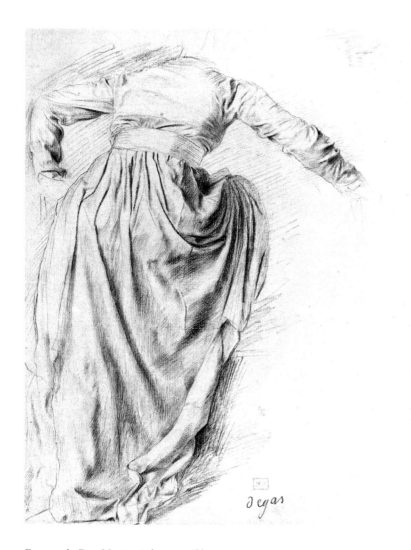

Femme de Dos Montant dans un Char,
étude pour *Sémiramis* (Woman Seen from Behind,
Boarding a Carriage, *study for Sémiramis*).
c. 1860–62

Femme Debout, Drapée, Vue de Dos, étude pour
Sémiramis (Standing Woman, Draped,
Seen from Behind, *study for Sémiramis*). c. 1860–62

*In classical art drapery plays a special role,
mediating between the human figure and the
abstract forms of architecture. Following in the
footsteps of Mantegna and Leonardo, Degas in
his drapery studies brings drawing into
association with carved relief: the crisp folds of
the drapery rise and fall, standing in strength
like a fluted column, falling in a slow cascade
over the model's bulk.*

Femme Debout, Vêtue d'une Longue Robe,
étude pour *Sémiramis* (Standing Woman, Dressed in
a Long Gown, *study for Sémiramis*). c. 1860–62

Etude de Draperie pour Sémiramis
(Drapery Study for *Sémiramis*). c. 1860–62

Draperie, étude pour *Sémiramis* (Drapery, *study for Sémiramis*). c. 1860–62

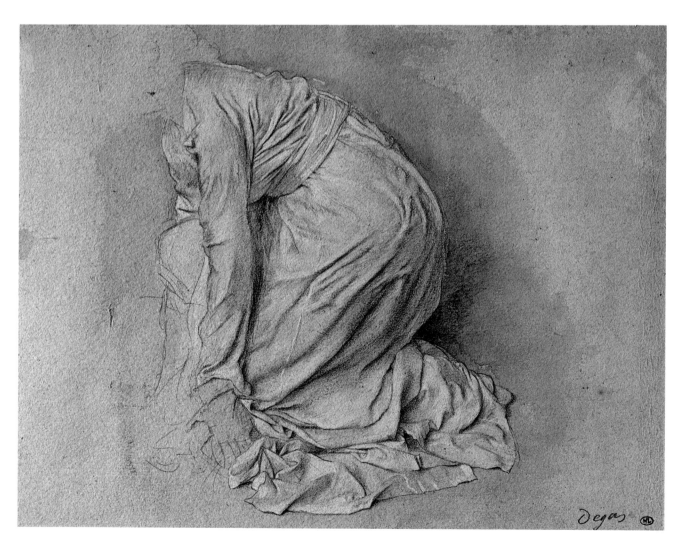

Draperie, étude pour *Sémiramis* (Drapery, *study for Sémiramis*). c. 1860–62

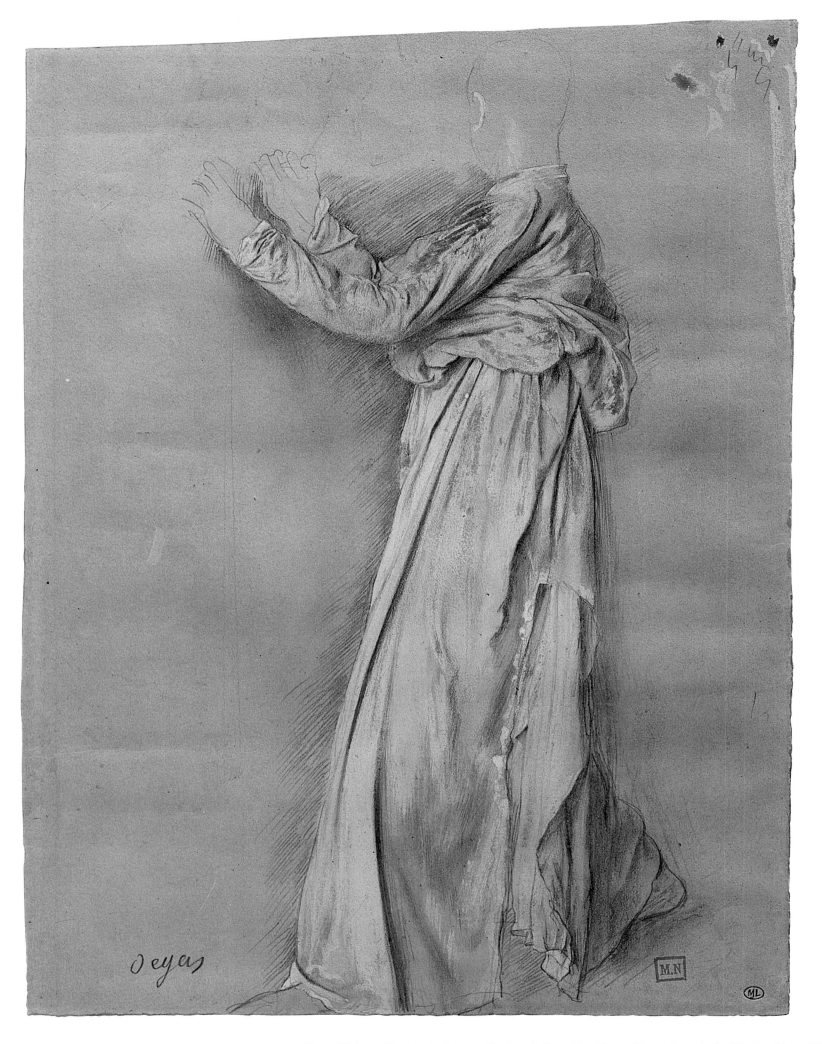

Figure Debout, Drapée, étude pour *Sémiramis* (Standing Figure, Draped, *study for Sémiramis*). c. 1860–62

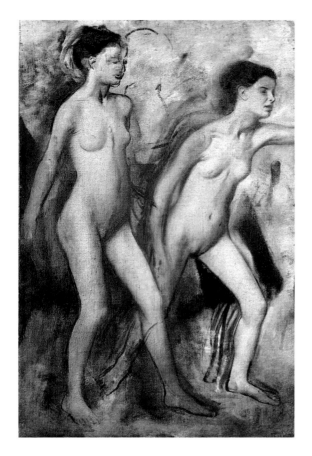

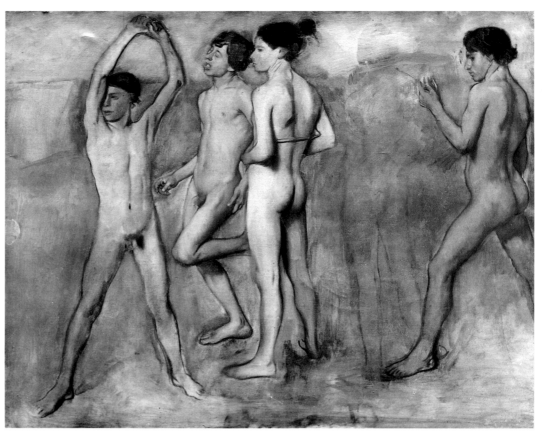

Petites Filles Spartiates Provoquant des Garçons,
also known as *Jeunes Filles Spartiates S'Exerçant
à la Lutte* (Spartan Girls Provoking Boys).
c. 1860–62

Petites Filles Spartiates Provoquant des Garçons,
also known as *Jeunes Spartiates S'Exerçant*
(Spartan Girls Provoking Boys). c. 1860–62

OPPOSITE:
Petites Filles Spartiates Provoquant des Garçons,
also known as *Jeunes Spartiates S'Exerçant
à la Lutte* (Young Spartans). c. 1860

There are features here that Degas would continue to work at in one form or
another for the rest of his life: the slow composing of fast movement, the calculated
reconstruction of a moment in time, the pondered drawing of significant elements in
terms of parts cut by occlusion, the splitting and decentering of attention.

Degas saw very clearly that a change of subject matter implied a change of procedure,
but he was far too deeply enmeshed in the culture of pictures to be able to accept the
realist project as a release from the past. Many of his contemporaries working under
the banner of "nature" were prepared to elevate the direct study to the position of a
finished picture, but Degas was far too reflective, too aware of the ramifications to
move easily in that direction. In the past the essential purpose of working from
observation was to gather information. Nature, Delacroix had declared, was a
dictionary—implying that the poem was written somewhere else. The best painters of
Degas's generation were inclined to think otherwise: perhaps nature could yield the
poem itself. Monet, Cézanne, Pissarro were all in due course to become inspired by
the relation of pictures to looking. Degas remained a traditionalist in his methods,
working selectively, composing his pictures from drawings. Looking was relevant in
the special sense of viewpoint. Alone among his contemporaries he saw that viewpoint
as subject yielded material that was both geometric and social, both compositional
and iconographic. This radical insight was the product of his conservatism.

The full title of Degas's 1868 Salon picture was *Portrait de Mlle. E. F., à propos du
Ballet de la Source*. When it was shown, Emile Zola, who was just making his debut
as an art critic, took notice in his review of the Salon in *L'Evénement Illustré*. He
described the picture as though it were some kind of imaginary genre scene. He
praised the painting of the horse and the women's dresses and proposed an alternative
title: *Une Halte au Bord de l'Eau*. Perhaps he had been in too much of a hurry to

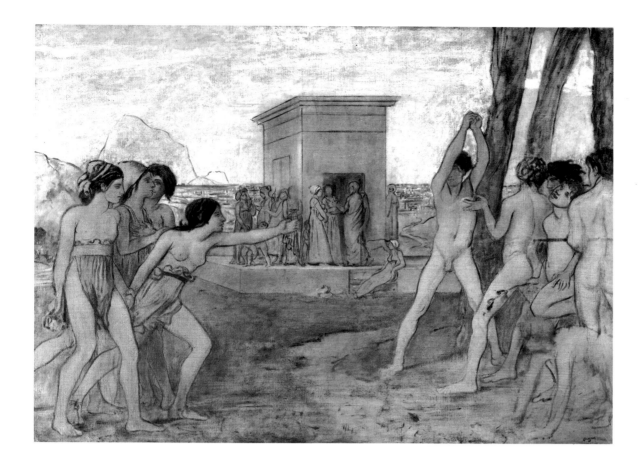

read the full title of the picture. It was not a flight of fancy at all, but a portrait of a well-known dancer named Eugénie Fiocre playing in *La Source*, a spectacular "Oriental" ballet with music by Ludwig Minkus and Léo Delibes that had had its first night at the Opera in November 1866. The elaborate sets and props had included a spring of running water, a real pool, and a real horse.

Zola's misreading, whether intentional or not, brings out a vital point whose importance stretches far beyond this particular picture. *La Source* could legitimately be read as a fictional scene; it could also be read as a portrait and as a description of an actual event. In other words, it reconstructs the ambivalence of the theater itself, where our attention can alternate, if we let it, between the "illusion" of the drama and the "reality" of the actors as real people going about their work.

The high tradition of figure composition assumed a connection between pictures and the theater. For Diderot, perhaps the most articulate recent spokesman for this connection, a picture was a frozen scene, a tableau; and a play, if it was well conceived, unfolded as a series of pictures—tableaux.

A tableau, painted or acted, was organized around a central axis. Its ideal viewing point was in the stalls on a line perpendicular to the proscenium arch or to the frame. That frame contained important things. Everything within it was organized and had meaning. Everything that lay outside it was formless, unnamed and insignificant. And of course, the belief that sustained the privileged world within the frame was not based upon a total illusion but upon understanding of the terms of that world. The viewer's contract with the tableau was assumed to be binding.

This—the theatrical tableau—was the strongest metaphor that existed for figure painting. This is why Degas's choice of the real theater as a theme was of such importance to the future of his art. It allowed him to broach the unity of traditional painting, to daringly intersect the tableau with his present viewpoint, and by doing

When he was making his historical pictures Degas prepared them in the traditional way, with compositional sketches, studies from life of individual figures, and, in the case of the Petites Filles Spartiates Provoquant des Garçons, *a full-scale sketch that preceded the picture itself. An historical composition was presumed to illustrate an exemplary event in human history and to challenge the artist's erudition as much as his skill, his knowledge of pictorial rhetoric as much as his inventiveness. By the early 1860s many of Degas's contemporaries were moving in the opposite direction, prizing directness and improvisation. But for the rest of his life, long after he had given up all thought of historical composition, Degas went on practicing his own version of academic preparation: "No art is less spontaneous than mine," he would say. "What I do is the result of reflection, of the study of the masters." And he would urge young painters to repeat their drawings again and again.*

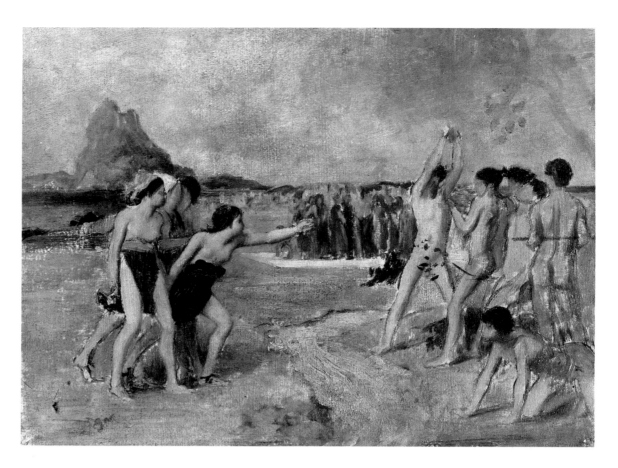

so, to open up a far wider field for his naturalism than mere description.

Degas's history paintings had not allowed for anything like this complexity. We have to take *Jephté* at its face value, at its own feeble level of conviction. With *La Source* we are at once released from this contract, free to see its central figure "as" Mlle. Fiocre or "as" the Oriental princess that she is playing. The mental shift is mediated by a physical shift of viewpoint. Degas shows us the stage obliquely, from the viewpoint of his box. The "correct" aspect of the stage from which both the actors and the scenery achieve their strongest address is twisted out of true. The illusion of the set is only just preserved. Soon Degas would penetrate the frontal plane of the stage more deeply, looking into it from the side. In doing so he was of course discovering novel compositions. Far more important to him, I believe, than mere novelty was the compelling fantasy that he was entering and exploring *pictures* from the side.

In *L'Orchestre de l'Opéra* Degas invites us to move outside of the theatrical illusion by moving the frame down from the proscenium arch. It is both a picture of the theater and a group portrait. The bassoonist in the center is Degas's close friend Désiré Dihau, who had given the painter his entrée to the inner workings of the Opera. The bass player with his back to us is M. Gouffé in his real-life role. The arrangement of the players is of course invented. No orchestra could work this way.

The footlights draw a sharp frontier between the orchestra and the stage. The hard brilliance of the stage and the dim, warm glow of the houselights on the musicians define a sense of heightened attention, of audiencehood. We can see the picture now as a spectacle, now as a series of portraits, now as an account of theater-going.

The dancers themselves are shown only in parts, cut off at the shoulders, even though it is they who make the occasion. They are painted quite differently from the rest of the picture, without surface finish. This can be thought of as a way of

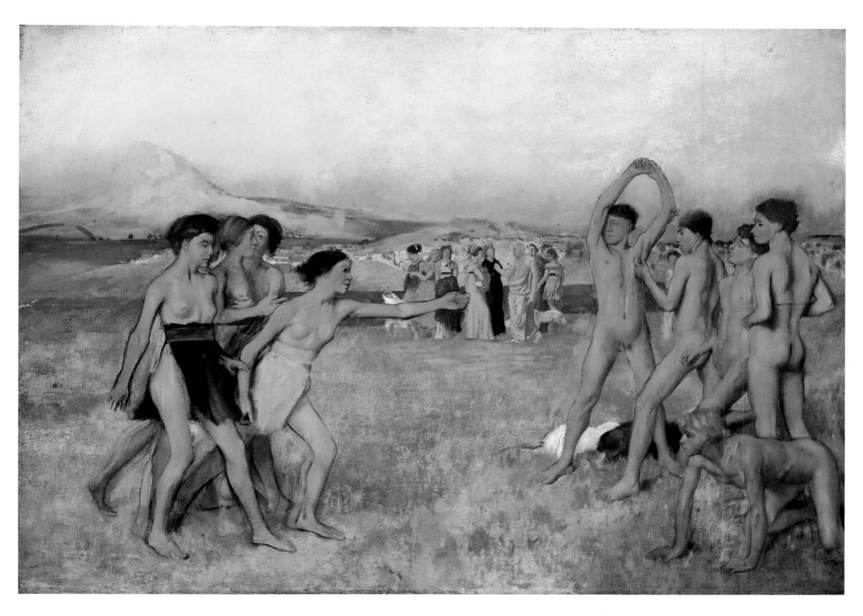

Petites Filles Spartiates Provoquant des Garçons,
also known as *Jeunes Spartiates S'Exerçant à la Lutte*
(Young Spartans). c. 1860–62;
taken up again before 1880

*Degas had a classical education and read Latin and Greek all his life. He
would have known the original description of Spartan youth in Plutarch
as well as the eighteenth-century French* Voyage du Jeune Anacharsis en
Grèce, *from which the following is extracted:*

*The girls of Sparta were not educated like those of Athens: they were not
obliged to remain at home, to spin, to abstain from wine and from rich food:
rather, they were taught to dance, to sing, to wrestle with one another, to race
along the beach, to hurl the javelin or throw quoits, to perform all their
exercises unveiled and half-naked, in the presence of the kings, the
magistrates, and all the citizens, including the boys whom they stimulated to
glory, either by their example, or by flattering praise, or by stinging sarcasm.*

55

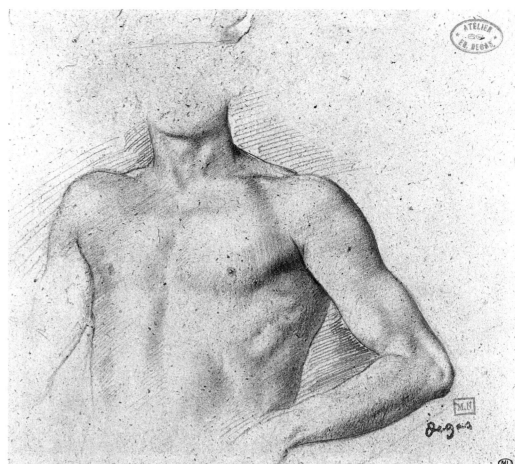

Etude pour Petites Filles Spartiates
Provoquant des Garçons
(Study for Young Spartans). c. 1860

Buste de Jeune Homme Nu
(Half-length Study of a Young Male Nude).
c. 1860–65

introducing their movement, their flittering, ephemeral positions in contrast to the seated musicians. But they play a substantial part in the composition. The broken raw brushstrokes that make them are given strong, formal parts to play in an ensemble that in other passages is conceived quite differently. "Unfinish" is on the way to becoming a kind of finished statement, incorporated into the structure of the picture.

From this point onward Degas will often juxtapose scumbled or scribbled half-statements with tighter passages where the form is quite closed up. It is an insider's argot that he insists upon, demanding that the viewer share the language of the studio. In the little portrait *Mademoiselle Marie Dihau*, the head is painted with drum-tight modeling worthy of Ingres and the carpetbag is scraped in with a few strokes. It is a condition of unity that is entirely his own. One is reminded again and again of the way he treats the stage scenery in his theater pictures, for this seems to be the model for all his sketchiness. From his sideways view of the theatrical illusion the flats that are meant to look like forest glades look more like odd screens streaked and daubed with green and brown paint. As the theatrical illusion is broached, so is the pictorial illusion. We see his brushing as brushing, as well as what it stands for.

The composition of *L'Orchestre de l'Opéra* had not derived from the old masters but from the popular illustrated press—almost certainly from a comic image by Honoré Daumier called *L'Orchestre Pendant la Représentation d'une Tragédie* that had appeared in 1852. Degas's admiration for the illustrators, particularly for Paul Gavarni and Daumier, was unbounded. He collected their prints by the thousand. He ranked Daumier on a level with Ingres and Delacroix.

All the subjects from contemporary life with which Degas is associated—the racecourse, the theater, the ballet behind the scenes, laundresses, hat shops, women at

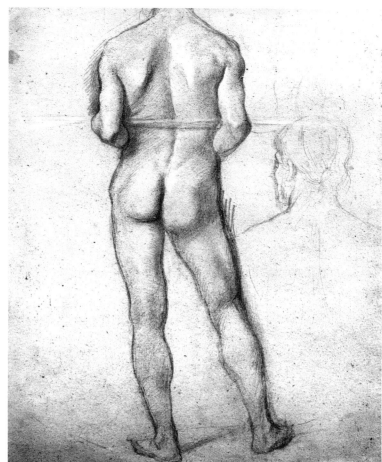

their toilet, the *café-concerts*, and so on—had been treated first by the illustrators, who looked everywhere, uninhibited by precedent. But it was not just the novelty of subject matter that made the illustrators' influence so significant. Even more important was their secular and satirical viewpoint, which allowed them to look aslant at conventions and institutions.

In Daumier's image of the theater orchestra, the actor's legs—which is all we can see of the stage—are caught in a high-minded antique pose; the musicians are yawning their heads off. The contract with the tableau onstage is hilariously and irreverently broken; the spectator is returned to himself with a bump. Daumier's laughter acts as a solvent, breaking down the boundaries that frame the stage off from mundane experience. Elsewhere in his illustrations Daumier will repeatedly bring in the onlooker as the focal point on which the joke turns. It is the man in the audience, the man in the crowd, on the street, at the Salon, in the country, misreading or absurdly suffering the way things are, who allows him the vantage point from which to laugh.

Daumier's humor becomes Degas's critique, the germ from which his pictorial demolitions grow. His laughter is silent, delighting in the oddities of the world seen as visual phenomena. As soon as he had made his swerve in the direction of modern life, he began to notice in a new way. The motif of the onlooker, whether placed within the picture as one of its actors or present implicitly through the configuration of perspective, is essential to his revision of composition.

In the *Danseuse au Bouquet* at the Museum of Art, Rhode Island School of Design, we see the star making her curtsy over the top of a spread fan immediately in front of us. The fan fills nearly a quarter of the whole picture. The star's head is no larger

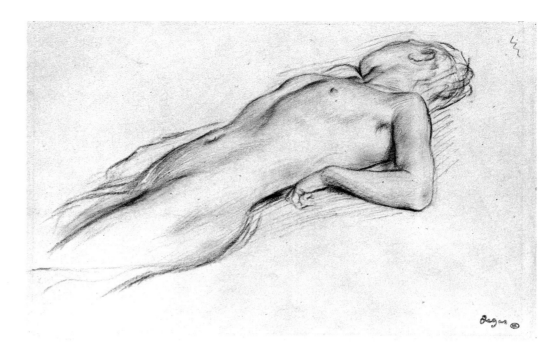

Femme Nue, Allongée sur le Dos,
étude pour *Scène de Guerre*
(Female Nude, Reclining on Her Back,
study for Scène de Guerre). 1865

Femme Demi-Nue, Allongée sur le Dos,
étude pour *Scène de Guerre*
(Female Seminude, Reclining on Her Back,
study for Scène de Guerre). 1865

Femme Nue, Allongée sur le Dos,
étude pour *Scène de Guerre*
(Female Nude, Reclining on Her Back,
study for Scène de Guerre). 1865

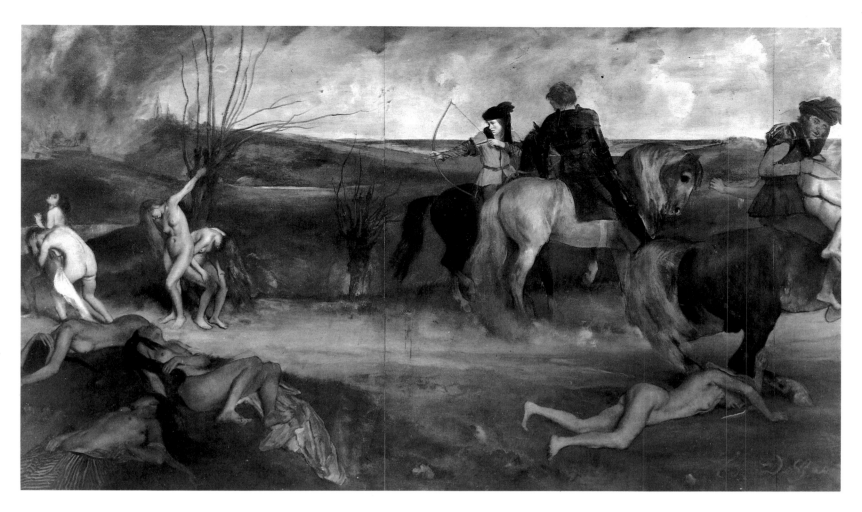

Scène de Guerre au Moyen Age, also known as
Les Malheurs de la Ville d'Orléans
(Medieval War Scene). 1865

than the nose of the woman holding the fan. The yellow dancers at the back of the
stage are no larger, from head to toe, than the star's head. Degas's excitement with
the data of observation puts him on the track of new ways of joining things. He sees
the effects of occlusion not as an interruption, but as a connective system.

In the composition called *La Répétition sur la Scène* we are looking down on the
stage from a box on the left of the proscenium. The front of the stage is to the right,
outside the picture. We can sense the axis of the audience's attention in the direction of
the light and in the long diagonal corridor that runs from the bottom right corner
into the gloom of the left. Below us the ballet master is rehearsing some dancers in
the center of the stage, leaning forward, beating time. Behind him, filling the left of
the canvas, five dancers stand waiting to be called, leaning on the scenery, stretching,
tying a shoe, adjusting a strap. The eye moves hesitantly among them, picking up a
part here and a clue there.

A comparison with one of his contemporaries from the Salon makes the quality of
Degas's invention stand out. In his *Friedland, 1807*, the popular military painter
Ernest Meissonier—whom Degas happened to admire enough to have copied—shows a
troop of cavalry charging toward us in a melée of flying plumes and flashing helmets.
Each soldier's face in the first plane is fully described. The gaps between each face are
neatly filled with another whole face in the second plane, as in a group photograph of
a football team. He fills in the remaining gaps with a blur. Degas's image is no less
synthetic than Meissonier's. In a sense their methods are the same. But the horizons of
their subject are worlds apart. What the *pompier* spells out as if for children, Degas
lets slip in a series of challenging asides. Far from being taken out of ourselves by the

*There was a dark side to Degas, a side that
found correspondence in his love for Delacroix. It
was a side that he rarely revealed; there are
hints of it, somewhat masked by humor, in the
black brothel prints, and it reappears
transformed in the bronzes. The one occasion
when he allowed it full rein was in the last of his
history pictures, Les Malheurs. What makes the
picture disturbing and moving is not the
melodramatic action, the make-believe rape and
abduction, but the power and quality of the
naked figures. They, and the drawings upon
which they are based, betray a degree of erotic
tension that he rarely allows. He is drawing with
uncanny specificity, out of desire, his desire
impelled by the fantasies of violence and death.*

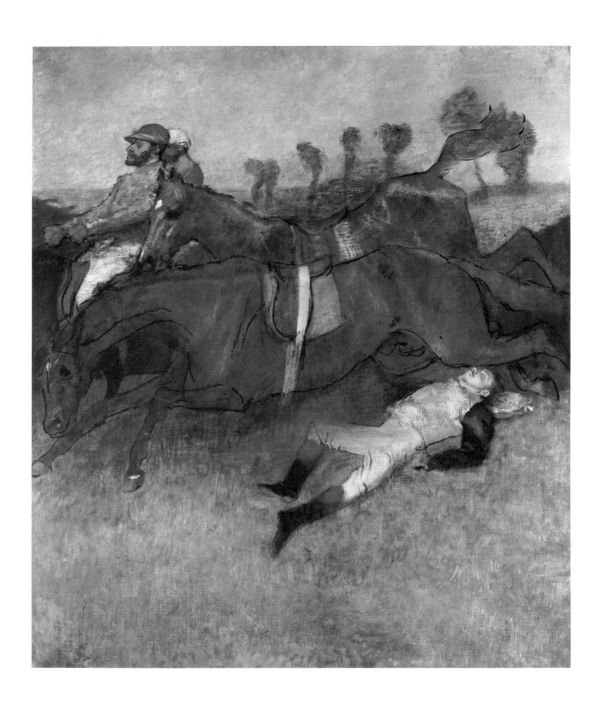

story his picture tells, we are put into ourselves by the task of reading it.

These asides always remind us that we are audience and the wholeness of the picture is contingent on our reading of it. In breaking the spell of the theater, looking at the theater from the side, he breaks the spell of pictorial composition. The center of the canvas is, in his hands, no longer the center of interest or the locus of the picture's authority—at least not in a way that corresponds with the subject. A particularly vivid example of this displacement of the center is *La Répétition de Danse*, where the key figure, the *maître de ballet,* is the smallest figure of all, half-hidden behind the bonneted mother in the foreground, and where the center is emptied out, a bare dance floor. Our attention is driven to the edges of the picture, left and right, where the spiral staircase and the standing dancer promise containment. But here matters are even more disturbingly dispersed. All heads on the right focus their attention at points outside the frame, and the standing dancer is cut by the frame so drastically that her point of balance, the center of her pose, is outside the frame too. The center of the picture is held not by events but by alignments that span the empty floor, turning it into a pyramid, a geometrical void.

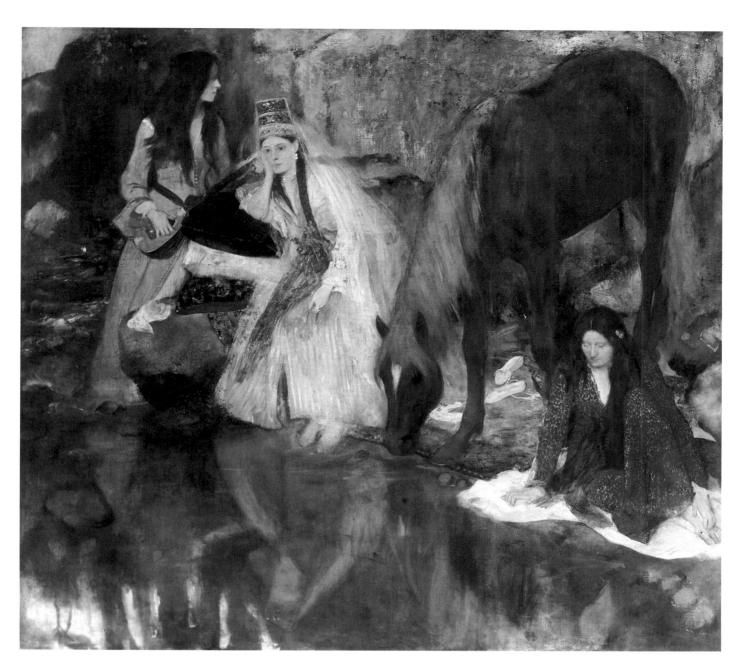

At the *café-concert*, theatrical illusion was attacked by the subject itself. The *café-concert* was a kind of anti-opera: "She opens her huge mouth and out comes the most crudely, the most delicately, the most wittily tender voice you ever heard." In the great image *Le Café-Concert—Aux Ambassadeurs*—great in spite of its tiny dimensions— the ideal centered relationship to the stage is splayed open, not only by our oblique placement but by the behavior of audience and performer. Only the standing singer in her red gown is performing. Her companions onstage are other singers waiting their turn. They are in lively contact with the audience all the same, a dumb show of glances and fans. In the immediate foreground a well-dressed man exchanges glances with a young woman to his right, ignoring the stage; beyond them, the orchestra, the tall scroll of the double bass cutting into the singer's red dress; in the center, his head turned away from the stage, a half-bald, ginger-haired man with an appearance of unspeakable villainy. The singer in red, lit from below by the footlights, flings out her left arm to some victim in the audience outside the picture. She is framed by the rich columns of the building, and the line of her arm is extended behind her by a line of gaslights reflected in the plate-glass windows.

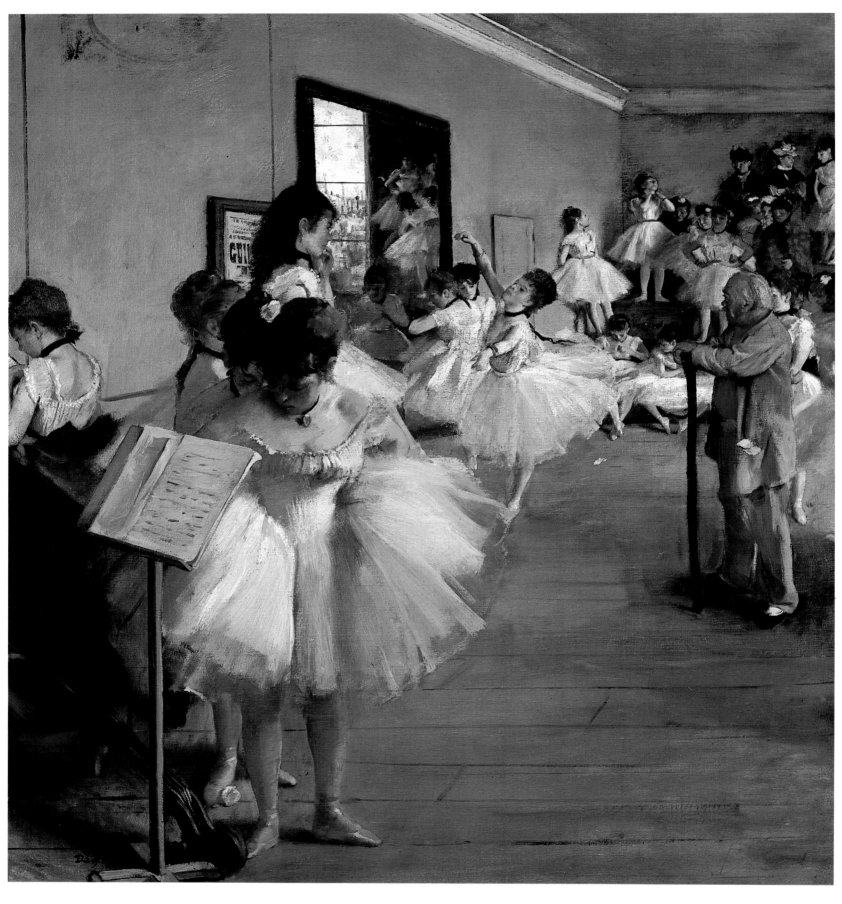

Examen de Danse
(The Dance Class). 1874

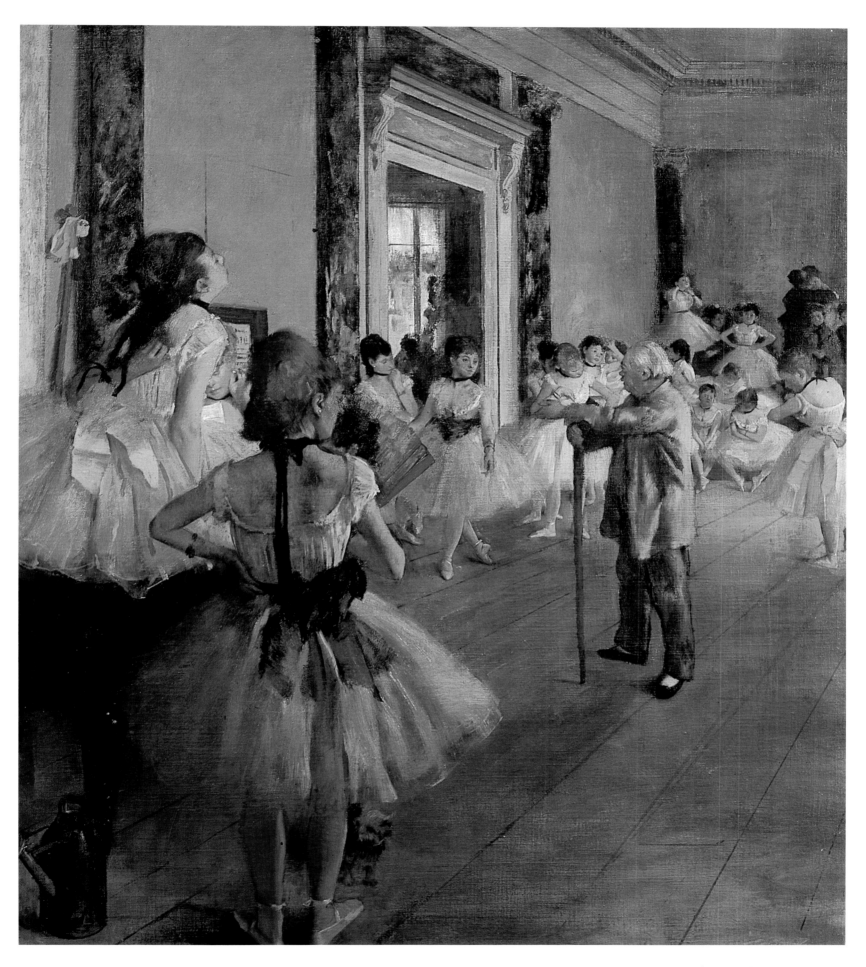

La Classe de Danse (The Dance Class).
Begun 1873, completed 1875–76

63

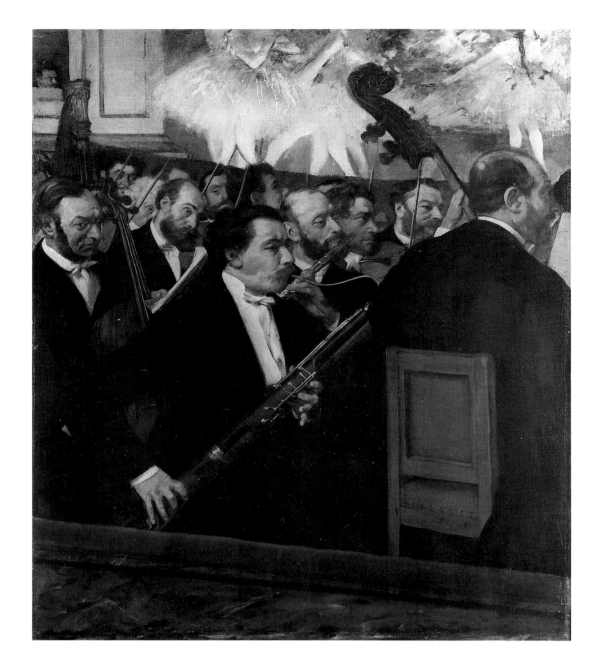

L'Orchestre de l'Opéra,
also known as Les Musiciens à l'Orchestre
(The Orchestra of the Opera). c. 1870

*In February of 1874 Degas received a visit from
Edmond de Goncourt, who recorded the events in
his journal:*

*Spent yesterday in the studio of a bizarre painter,
Degas by name. After many efforts and attempts,
false starts in all directions, he has become
enamored of the modern, and within the modern, his
choice has fallen upon laundresses and ballet-girls.*

*One of the pictures Degas showed his visitor
was the one reproduced opposite, which Goncourt
described as follows:*

*The rehearsal room, and the fantastic outline of the
dancers' legs against the light from a window,
coming down a tiny staircase with the bright-red
patch of a tartan amid all these puffy white
clouds. . . . And before our eyes, caught in the act,
the charming twists and turns of these little
monkey-girls. The painter shows us his pictures,
occasionally illustrating his commentary by the
imitation of a choreographic gesture, by
mimicking—to use the expression of the girls
themselves—one of their arabesques. And it is really
very entertaining to see him, on his toes, his arms
curved, mingling the aesthetics of the ballet-master
with those of the painter, invoking Velasquez's tender
mud and Mantegna's silhouettes. An original fellow,
this Degas, sickly, neurotic, near-sighted to the point
of losing his vision altogether; but thereby eminently
sensitive to the repercussions of things, responsive to
their character. Till now, I've seen no man better
equipped to capture, in the presentation of modern
life, its very soul.*

Every relationship in the whole composition has something of this fortuitous
quality, a random connection with the central event. It is an occasion made up of
accidents, a jangling frivolous scene, yet there is something here that resonates at a
deeper level, making it darker and more compelling than a mere illustration of
nightlife entertainment. Is it the memory of the outthrust, taunting arm of the
Spartan girl that haunts the red singer's gesture, turning the *Ambassadeurs* into a
hellish parody of the idyllic playing fields, Spartan nakedness exchanged for
suggestiveness and trade? Or, perhaps in a more general way, a perverse reminiscence
of some scene of preaching from Raphael or Poussin where an apostle stands between
pillars to exhort a skeptical crowd? The foreground, to the edge of the footlights, is
dimly lit. Faces and hats glow there, light against dark. On stage all is incandescence,
almost dissolving the white figures, and only the singer is firm, red against white. At
the center, on the very threshold of these two zones, is the ginger-haired man, the
point of his bald head at the center of a web of connections that stretches from corner
to corner, drawing darkness from below and the blinding white from above into a
single, momentary order—an order that turns not on a secure and stable point but on
a diabolical caricature.

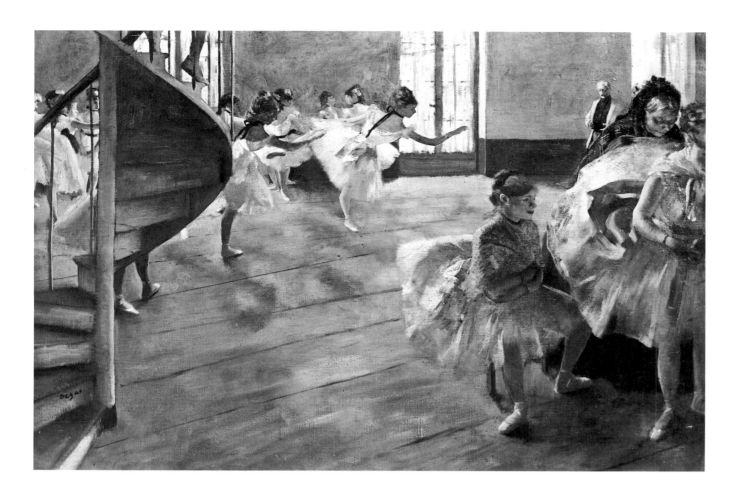

La Répétition de Danse
(The Rehearsal).
1874

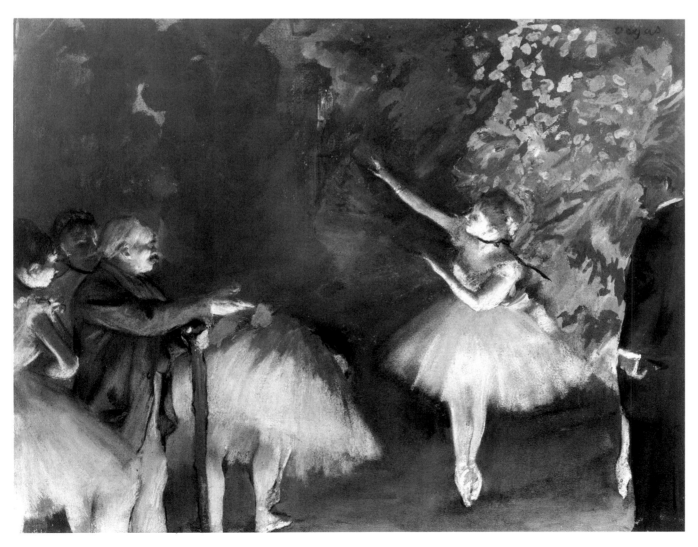

Répétition de Ballet
(Ballet Rehearsal).
1876–77

65

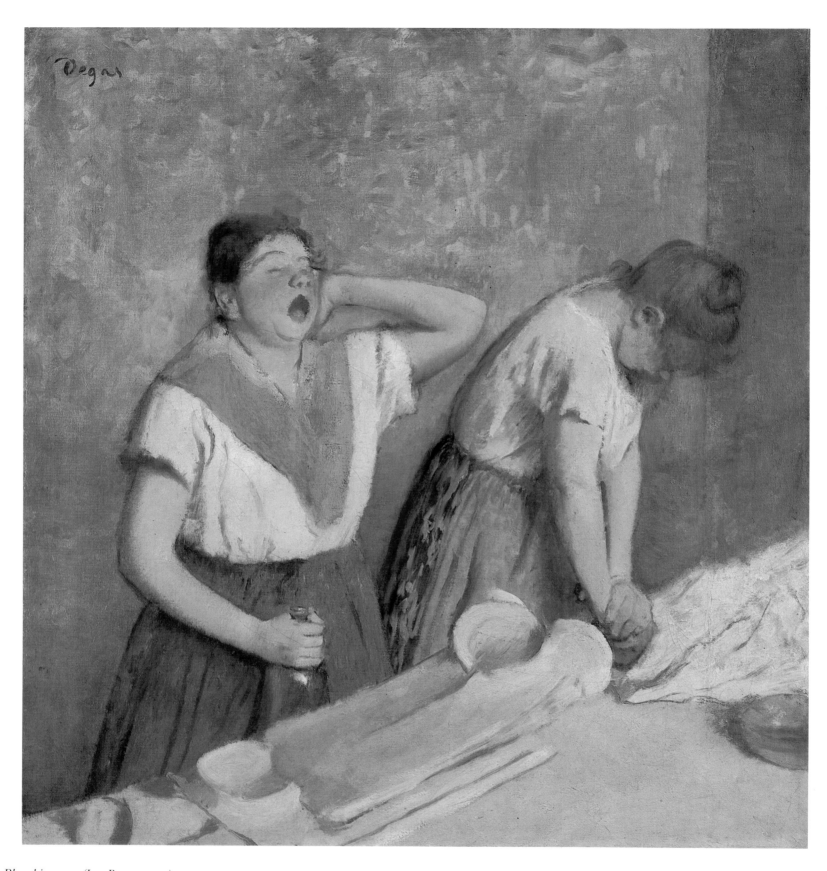

Les Blanchisseuses (Les Repasseuses)
(Laundresses [Ironers]). c. 1874–76

66

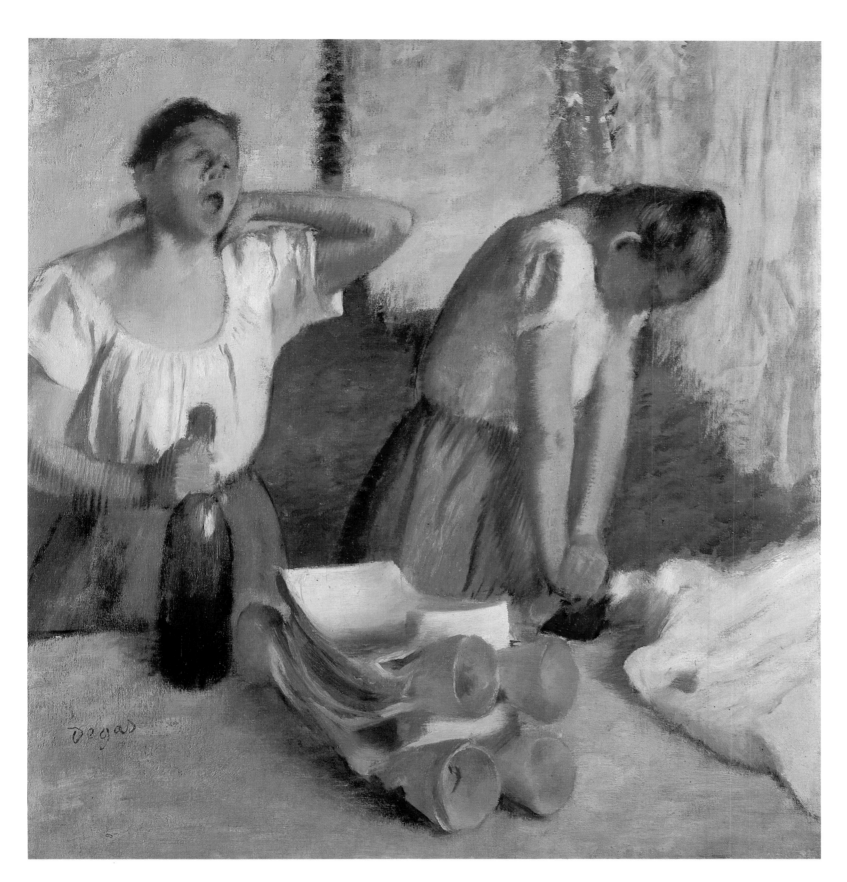

Les Repasseuses
(The Ironers). c. 1884–85

Daumier had painted laundresses with pathos, as long-suffering monumental representatives of the working poor. Degas saw them without sentiment but with intense interest in their skill and in how their work shaped their movements. When Goncourt visited his studio he was astonished at his understanding: "He shows us, in their attitudes and foreshortenings, laundresses and more laundresses . . . speaking their language and explaining to us quite technically the iron used for pressing, the circular stroke, etc."

The discipline of the work would fascinate Degas and attract a respect that amounted to love. Overwhelmed by new impressions on his visit to New Orleans, he wrote to his friend James Tissot that "everything" was beautiful there. But, he added, he would exchange it all for one Paris laundry girl with bare arms.

67

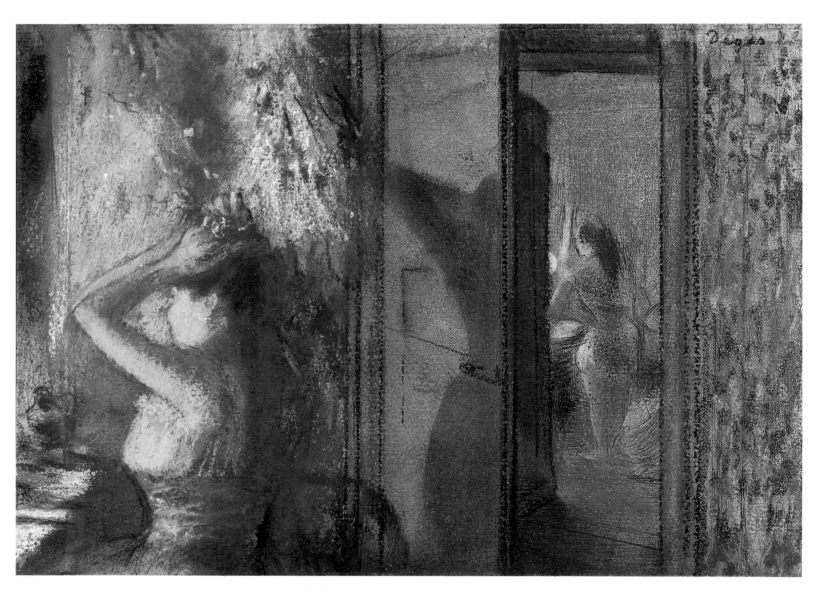

Loges d'Actrices
(Actresses in Their Dressing Rooms). 1879–85

68

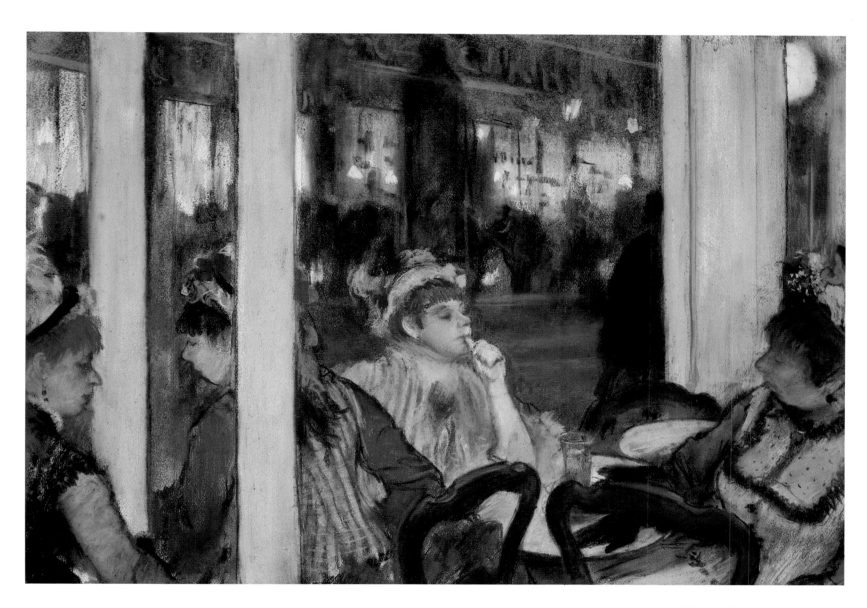

Femmes Devant un Café, le Soir,
also known as
Femmes à la Terrasse d'un Café, le Soir
(Women in Front of a Café, Evening). 1877

It was a new kind of theater that Degas was devising in images like
Femmes Devant un Café, le Soir *and the* Loges d'Actrices, *a theater in which our entry as audience is oblique and secretive. Once he had committed himself to the present as the field of his subject matter, Degas began to discover the terms of a world that was infinitely more layered and mysterious than anything he had been able to construct directly from his study of pictures. The effects of artificial light, reflections in plate-glass windows or mirrors, views through doors, divisions imposed by chance—these were among the phenomena that he began to notice as the possible determinants of an entirely novel pictorial order.*

69

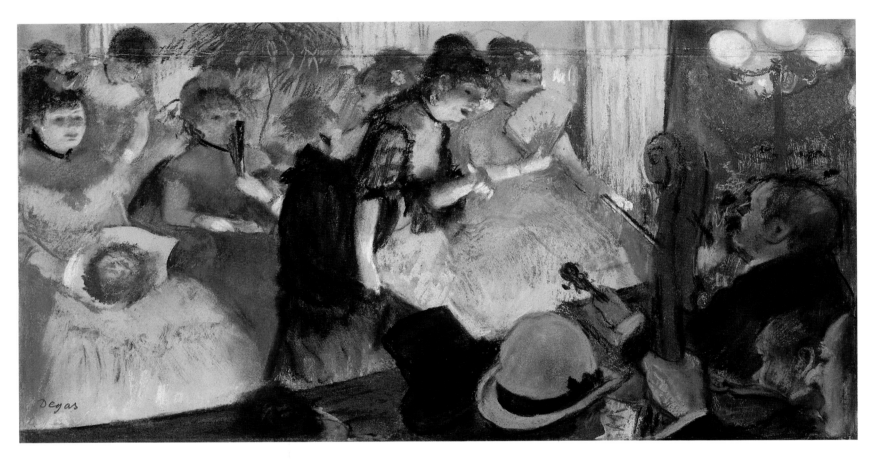

Café-Concert
(Cabaret). 1876–77

In his article on Degas published in L'Art dans les Deux Mondes, *Gustave Geffroy describes the atmosphere of the café-concerts and the singer who appears*

armed in blue satin, singing of the spring and of her country, imitating the nightingale that sings in the morning, deploring the abandon of lovers, explaining the charge of Reischoffen, demanding the return of Alsace and Lorraine. Behind her are seated her kind in a circle, posing in order to arouse the sextagenarians, cooling pink faces and blue bosoms with their fans. When one gets up, approaches, and leans down over the public, smiles, sings, she exhibits in patches of light and shadow the underside of her eyelids, her nostrils, her chin, her herculean arms and reaper's legs, her pushed-up breasts, and her tawny armpits. They exhibit their sex, the tilt of their torso, the jiggling of their pelvis. They are in their place, artificial and serpentine, in that setting of foliage pierced by electric lights, between trees of a harsh green that seem reduced to servitude and brushed in as stage-sets.

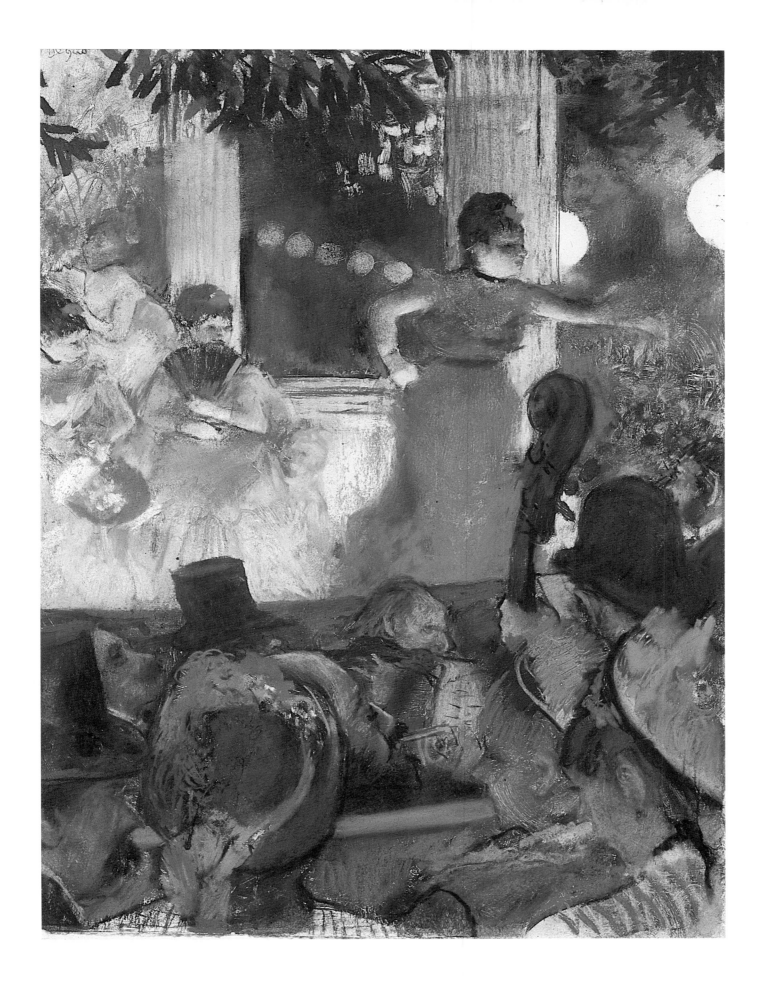

Le Café-Concert—Aux Ambassadeurs,
also known as
Café-Concert or *Le Café-Concert des Ambassadeurs*
(The Café des Ambassadeurs). 1876–77

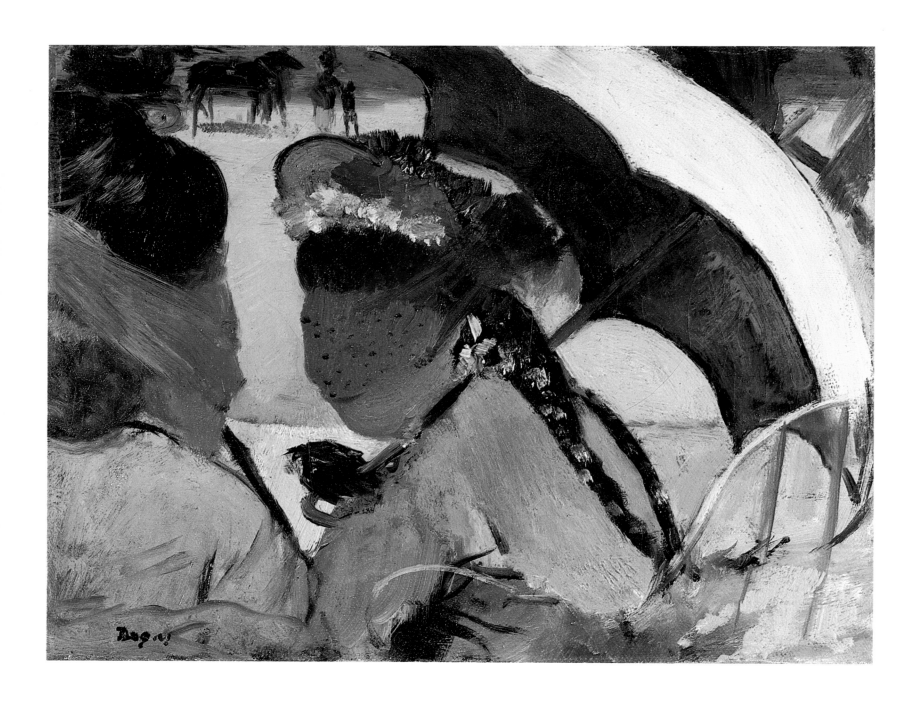

Horses and Riders

Many of the subscribers to the Opera—the men whom Degas observed hanging about behind the scenes—would have also been members of the Jockey Club. Horse racing was the height of fashion, and the great races at Longchamp were among the highlights of the season. This was a fairly recent development, an aspect of the general enthusiasm for the ways of English society that had been a feature of French taste since the 1830s.

Degas's interest in the races, which as we have seen was first aroused when he visited the Valpinçons' estate in Normandy, was purely as a subject for painting. There is no evidence that he rode himself nor, as Ronald Pickvance tells us, that any of his pictures describe actual races, particular horses, or real racing colors. The world of the turf that he presents is, in its details, largely his own invention.

There are two periods when the horse race was an important subject: first during the 1860s and then for a while during the early 1880s. During the first period, which follows from the *Scène de Steeple-Chase*, Degas was mainly interested in horse racing as a social spectacle. *Le Défilé*, also known as *Chevaux de Course (Devant les Tribunes)*, and *Le Faux Départ* are both pictures that re-create the atmosphere of the race course with the horses seen against the background of the crowd. The *Aux Courses en Province* gives a wonderful impression of the racegoer's day under open skies: mounted spectators dotted over the plain, and in the far distance a race in progress. There is a Brueghel-like displacement of focus: the landau in the middle distance contains a tiny portrait of the Valpinçons' newborn son in the lap of his nurse, shaded by a parasol and attended to by his mother.

The social occasion of the races provides the context for several studies of individual figures: Manet dressed at his most elegant, lounging at the rail; the mysterious woman behind the binoculars. There are also many studies of riders in the saddle. These range from swift sketchbook notes surely made directly to highly worked drawings in pencil or a variety of other mediums, such as gouache and oil paint on paper, which were almost certainly done in the studio—where, it is said, Degas once had a dummy horse complete with harness on which to pose his models.

These are among his most beautiful drawings. He discovers exactly how riders sit, how their legs mold themselves to the horse's girth, how they look downward from under the long peaks of their caps or, relaxed, turn back to look behind them, the free hand resting on the horse's rump. Degas looks with peculiar intensity at the way the reins are held, or the way the feet rest in the stirrups and at the exact inclination of the rider's body.

Observations of this kind were essential to the expression of movement. The horse's movement could be seen more clearly through the rider's action than it could be directly drawn. The movement of a horse is like the movement of a wave in that it

Thoroughbred

You hear the violence of his approach,
His strong, harsh breathing. With the dawn
The training starts, the groom is rigorous:
Scattering dew, the fine colt gallops on.

Like daylight drawn out of the eastern sky,
The power of the blood allows the steed
—So young and so inured to discipline—
The right to lord it over lesser breeds.

Casual and discreet, ambling it would seem,
He enters his stable—the oats are there.
He is ready. Now he belongs to the race,

And for the manipulations of a bet
He must begin—a dark horse on the field!
Nervously naked in his silken gown.

EDGAR DEGAS

Aux Courses (At the Races). c. 1876–77

Jockey. 1866–68

Jockey. 1866–68

cannot be seen in a single aspect. Indeed, until the invention of the camera it is not clear quite what the conception of a "stopped" movement could have meant. So in Degas's drawings of horsemen, it is the way the rider leans or handles the reins that embodies the horse's action: a jockey leans forward, half-lifted on his stirrups, urging his mount onward; a bowler-hatted groom puts his weight back on the reins, pulling his horse up; another sits relaxed on a standing horse.

Degas had been learning ways of drawing horses ever since he had been copying from the antique. Among the sources that have been cited as providing models are Uccello, Gozzoli, Van Dyck, and Géricault. During the sixties Degas was friendly with the sculptor Cuvelier, who specialized in animals, particularly horses. Degas also respected Meissonier's mastery of horses and copied from his military paintings on several occasions. Perhaps the most important source for his patterns were the English sporting prints by Herring and Alken and others that had become fashionable in Paris at about the same time as horse racing itself. Géricault and Delacroix had collected them. Degas knew them well, and his father probably owned examples, one of which, Herring's *Steeple Chase Cracks*, appears hanging on the wall behind the man in Degas's dramatic painting called *Bouderie.*

The horse in the foreground of *Le Faux Départ* could have been copied from the Herring print. It is in an identical position, although reversed. This position, with all four legs outstretched, was the strongest graphic convention that existed for a horse at full gallop. It can be seen in an even more conventionalized form in the distance of

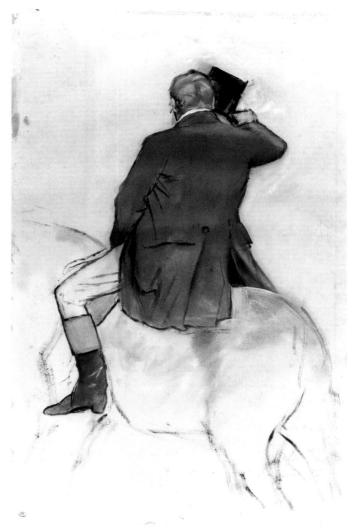

Aux Courses en Province, where racing horses, at full stretch, seem to fly over the turf like birds.

During the eighties Degas made models of horses in three dimensions, a subject that had also occupied him in the sixties. From the evidence of the sculptures that survive it seems clear that he had become interested in Eadweard Muybridge's photographs of horses in movement. Muybridge's experiments—in which, by galloping a horse in front of a row of cameras, he was able to get pictures of each phase of its action—were first published in France in 1878. Muybridge himself gave a presentation in Paris that many artists attended.

The most interesting finding of the Muybridge photographs was that at no point in its gallop did a horse take the position that the English sporting prints had used, with all four legs outstretched. Its movements were far more complicated, less graceful, and also less speedy-looking.

Degas was well aware that the expression of movement involved more than the description of a single position. The galloping horse in the foreground of *Le Faux Départ*, all four legs extended and not touching the ground, is in its direct way a faster-moving image than the horse in the Philadelphia Museum of Art's pastel *Le Jockey*, surely copied from a Muybridge frame. Degas's attraction to the Muybridge photographs must have been inspired partly by this paradox and partly by the novel challenge that it offered him. The data that came out of these pictures—the curiously graceless lines of the horses' legs, so unlike what one "sees" of a galloping horse—

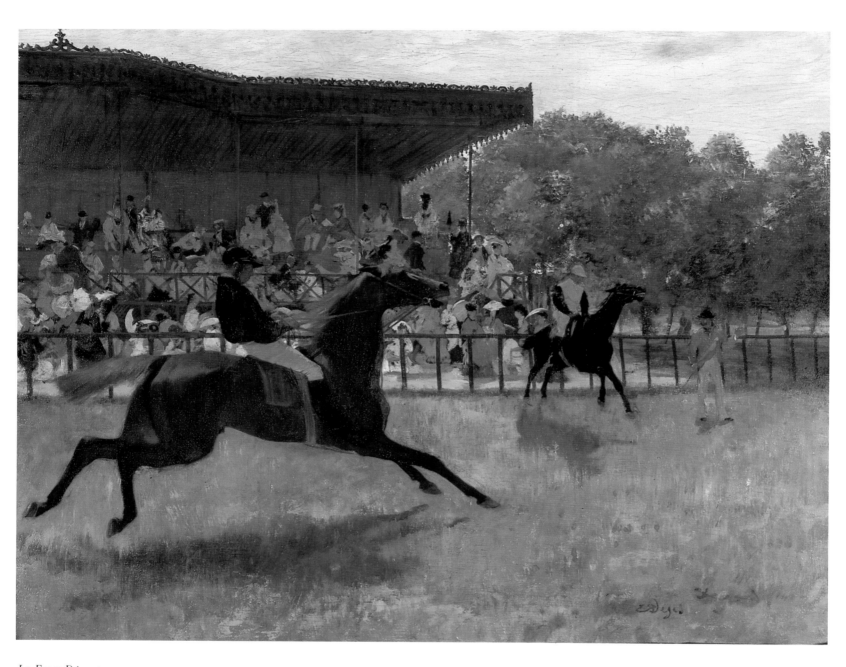

Le Faux Départ
(False Start). 1869–71

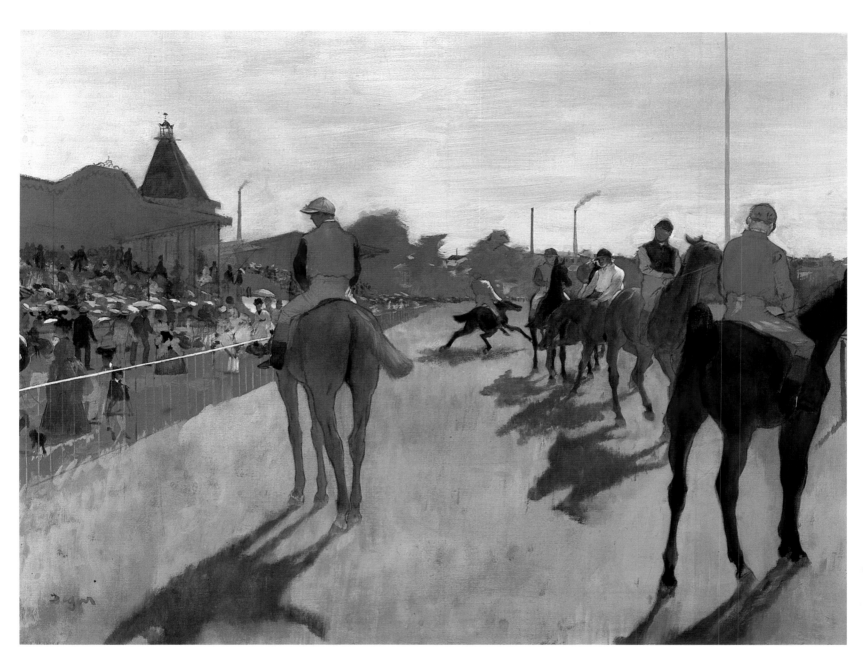

Le Défilé, also known as
Chevaux de Courses, Devant les Tribunes
(The Procession, *also known as*
Race Horses Before the Grandstand). c. 1866–68

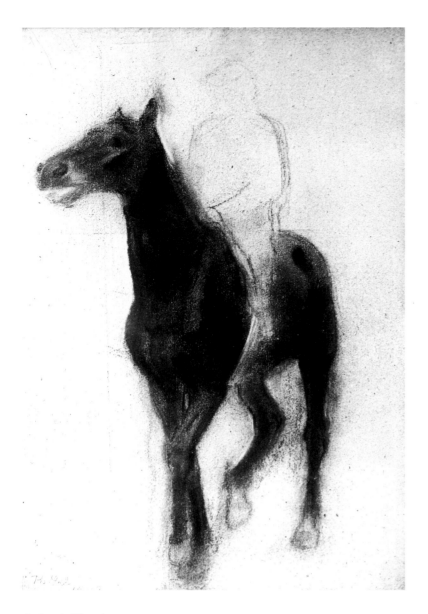

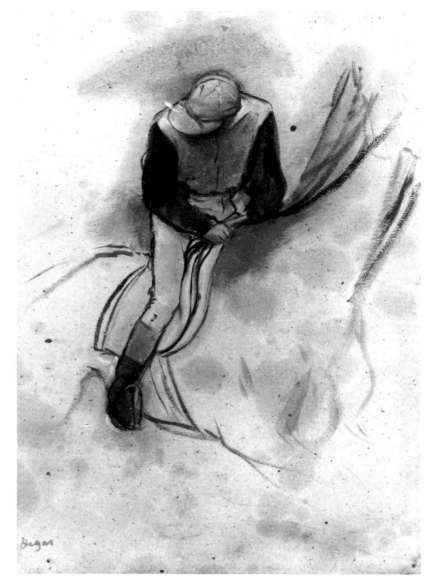

Jockey à Cheval
(Jockey on Horseback). c. 1866–68

Jockey. 1866–68

offered a puzzle not unlike the puzzle of occlusion. Just as the awkward and almost invisible cutting of whole forms by overlapping in perspective had become, in his hands, the material for a completely new mode of articulation, so the gaucheries of horse-movement revealed by Muybridge's lenses became material for highly original articulations of movement in the pastels and paintings of the eighties.

In both the dancer pictures and the horse-race pictures of the eighties, all traces of narrative were fast disappearing. The decorative element dominated. The pictures turn upon their linear development, the way the horses' legs and the silhouetted riders move across the picture space, dividing it into intervals, inscribing lines across it, and drawing out of the background of grass and sky shapes that cannot be named but only scanned rhythmically.

In the two versions of *Avant la Course*, the same group of horses enters from the left and moves toward the right. In the version at the Clark Institute we are closer to them; the frame cuts the nearest horse. Both pictures are essays in movement. The horses are represented in movement, and become the agents of pictorial movement. There is a continual interplay between the descriptive and the geometric.

The horses' heads are the front or point of their forward movement. They are like arrows, indicating direction, attention, thrust. This arrow-like function is augmented by repetition: we look from the head in profile that enters on the left to the two other

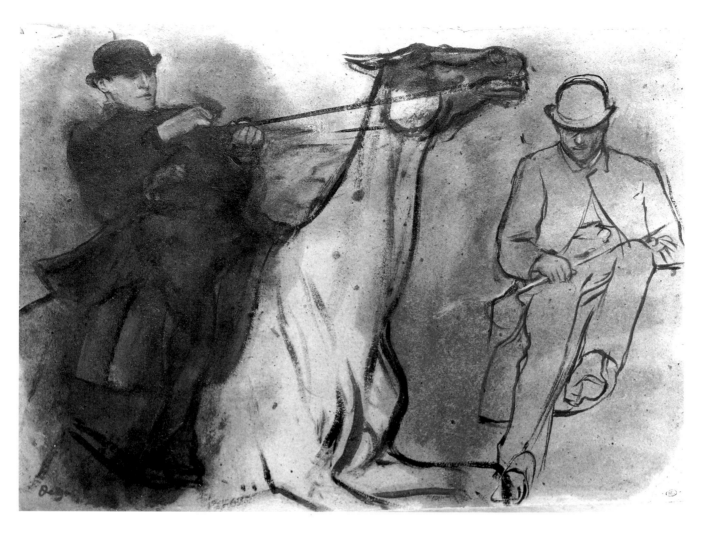

Deux Etudes de Cavalier
(Two Studies of a Groom). c. 1875–77

heads in profile, one dark and lifted, cut out against the white breeches of the jockey beyond it, the other dropped, craning forward to the corner of the picture. The pointing of the heads is speeded by the long, tight reins that clarify with straight lines. On the right-hand side of the picture there are corridors of open grass that run to the horizon. The horses are seen in a rough diagonal, nearest on the left, farthest on the right. The impulse toward the open horizon is speeded by the heads, then checked and turned by the stationary rider on the extreme right. This movement is further modulated by the horses' legs and the movements of the riders. The jockey who is entering on the left is bolt upright and facing somewhat toward us; the jockey in yellow and red leans forward, adding his movement to the dipping head of his mount; the jockey in pink behind him, half-occluded, turns back into the picture, starting the move toward the horizon. But his white breeches join with those of the rider in front of him, making the top of an arch whose base is among the horses' legs below. Here we are caught up among shapes cut out of the grass by the horses' legs, a row of irregular roughly four-sided shapes that dance across the picture as though they had a life of their own, until they reach the last horse of the group, the open corridor to the horizon, and the stationary horse with its red-vested rider. Even this stop is dynamic: the horse inclines its head slightly into the picture, meeting the movement toward it with its look. Its rider stares to the right, out of the picture, promising further

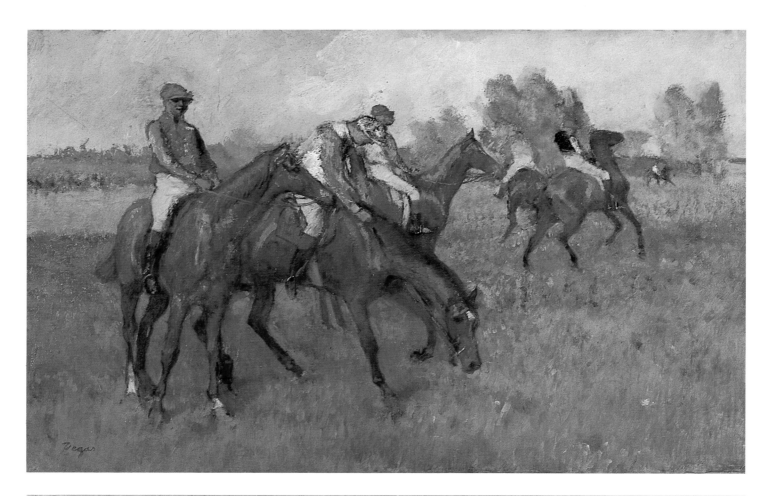

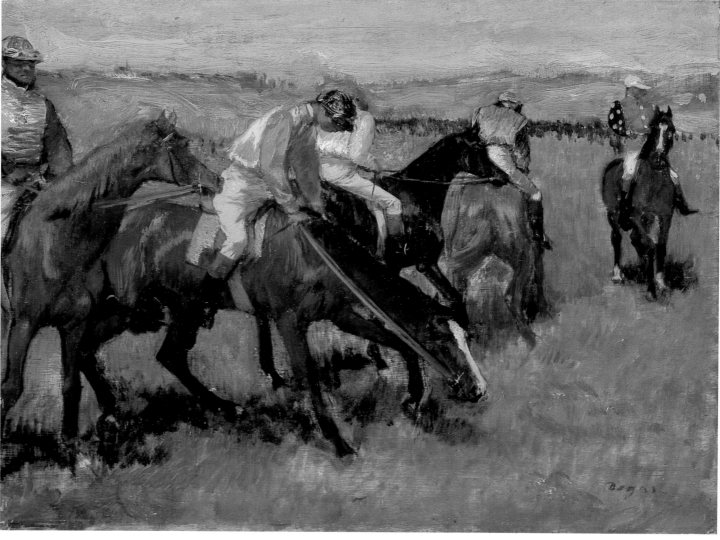

Avant la Course (Before the Race). 1882

Avant la Course (Before the Race). 1882

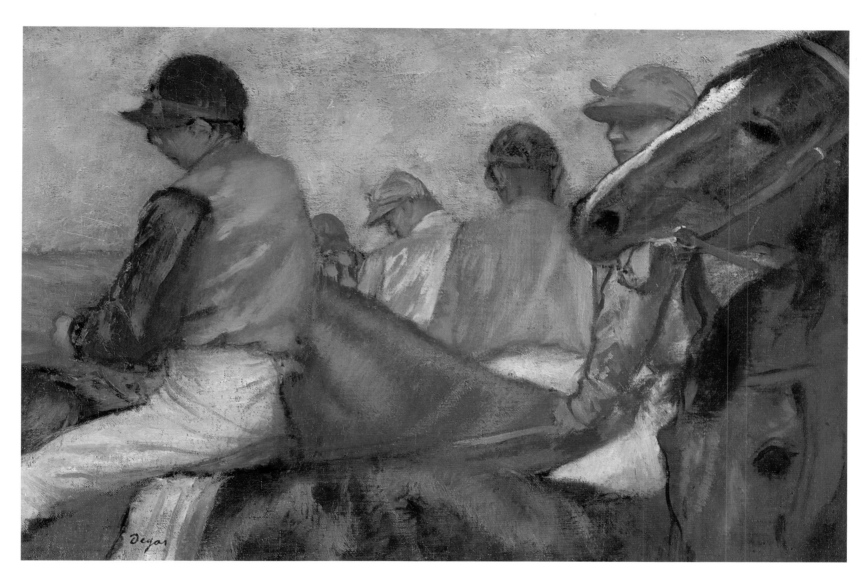

Georges Jeanniot, the young painter who became a particular friend of Degas, gave the following account of Degas at work on a racecourse scene:

I rang his bell in the Rue Fontaine with a certain excitement. He came himself, wearing a soft hat and a long housepainter's smock. He was working on a picture of racehorses. "Provincial jockeys," he told me.

I was struck by the accurate, lively look he had managed to give the scene. The jockey in the foreground was seen in profile, looking to the right, his silks painted with pure white and a few gray shadows. . . .

The postures of the riders galloping or trotting their horses were astonishingly accurate. Not that literal truth which too many artists invoke, but a particularly severe truth which can select and eliminate. The drawing of the bay or chestnut horses was overpowering in the richness of its form and the power of its contours. As for the reflections . . . just what was necessary to preserve the severe harmony of the whole. The horses were leaving the scales and making a preparatory turn before lining up for the start. The bearing of the fine, elongated heads with their flaring nostrils was as accurate as the splendid movements thoroughbreds make, champing at their bits. The background, already painted in, represented the paddock; in the background, a wood under a silvery-gray sky.

I watched Degas at work. He mixed his colors, wiped the brush with a rag, dipped the tip of his brush into the paint-saucer, hesitated. . . . Finally he made up his mind, and with a light, swift scumble he set a yellow shadow on the monochrome ground. Then, turning around toward me: "That's what's called a glaze."

Deux Têtes d'un Gentleman-Rider (de Broutelles),
also known as
Portrait de M. de Broutelles, en Gentleman-Rider
(Portrait of M. de Broutelles as a Gentleman Rider).
c. 1878–80

Jockeys, also known as *Jockey—Deux Etudes*
(Two Amateur Jockeys). c. 1878–80

movement. The whole picture is like a tightly constructed machine, each part fitting into its place, engaging with its neighbor, leading the eye forward in exact beats.

Most of the racing pictures are constructed as if the viewer were on the same level as the riders, mounted. From this position the horses' legs are seen at their greatest extension against the grass. The high viewpoint allows Degas to set up the long corner-to-corner diagonals that start the movement going. He does the same with the floors of the rehearsal rooms, giving himself the clearest field against which to draw the dancers' limbs.

On the other hand, *Jockeys* is composed as if we were standing on the ground, very close to the horses. Our field of vision is filled with huge fragments. The tossing and jostling of crowded animals is reconstructed in a series of alignments that opens like a fan pivoting on the bottom left corner.

When Degas came back to the racecourse in the early eighties, it was not to renew his interest in the subject as a social event. There are no more spectators or grandstands or bolting horses. Horses and riders have become the objects of aesthetic contemplation only, like dancers. And indeed there is a comparison to be made: both dancers and thoroughbreds were specialized beings whose training and breeding put them outside workaday life. The *rats* were significant only as dancers, and their whole physique spoke of their specialization; the same with the horses, good for nothing but speed. Both were the creatures of an aesthetic attitude—if the phrase may be expanded to include social display, seeing and being seen, gambling and the forms of connoisseurship that go with it.

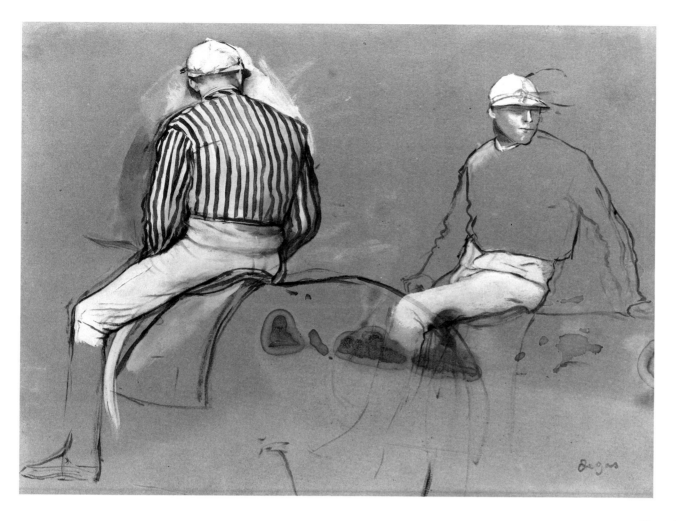

Deux Jockeys (Two Jockeys). c. 1866–68

Trois Jockeys (Three Jockeys). c. 1866–68

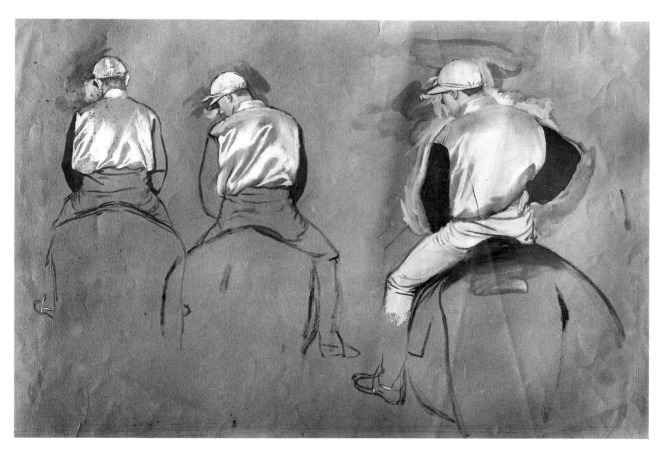

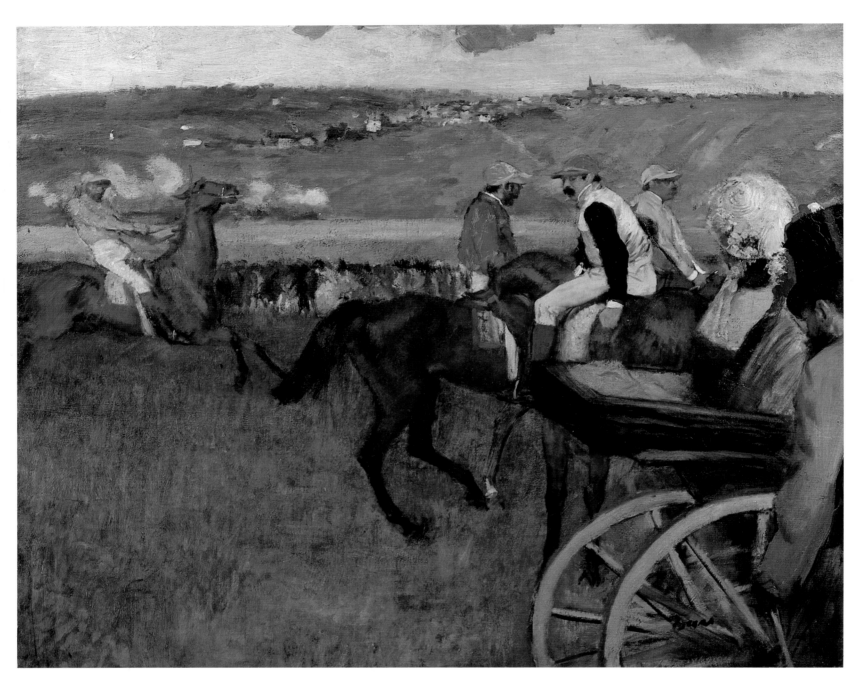

Le Champ de Courses, Jockeys Amateurs
(Racecourse, Amateur Jockeys).
Begun 1876, completed 1887

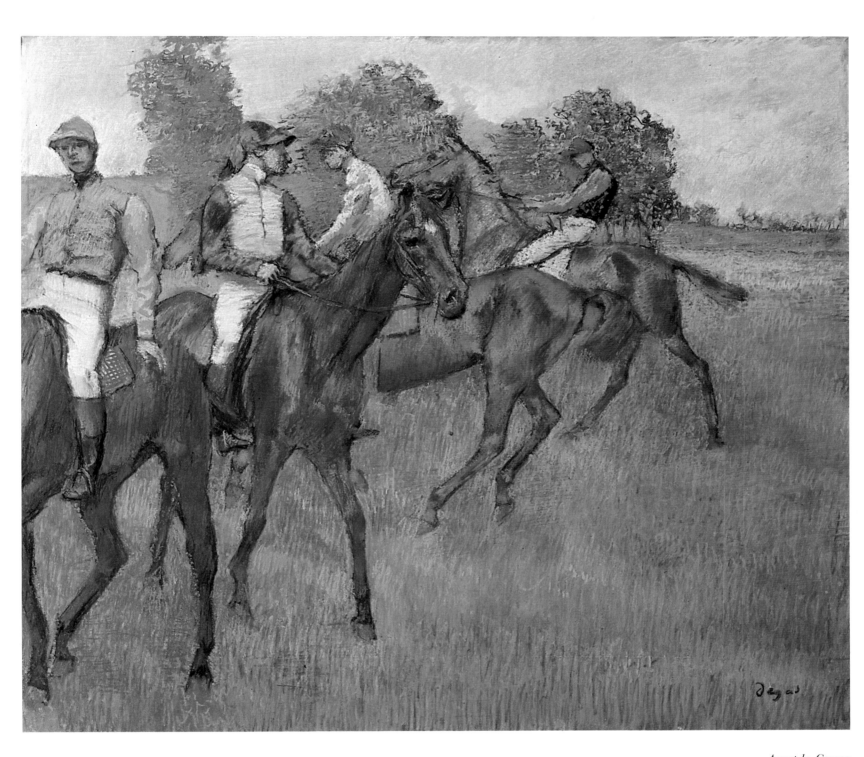

Avant la Course
(Race Horses). c. 1884

The painting dealer Ambroise Vollard recorded the following conversation in his book devoted to Degas:

*"Monsieur Degas, on my way through the Boulevard de Clichy, I happened to look up, and there, on the end of
a hook, I caught sight of a horse that was being drawn up on a rope into a painter's studio. . . ."*
 Degas took down from a shelf a small wooden horse:
 *"When I come home from the racetrack, these are my models; how could you make real horses turn in the
light the way you want?"*

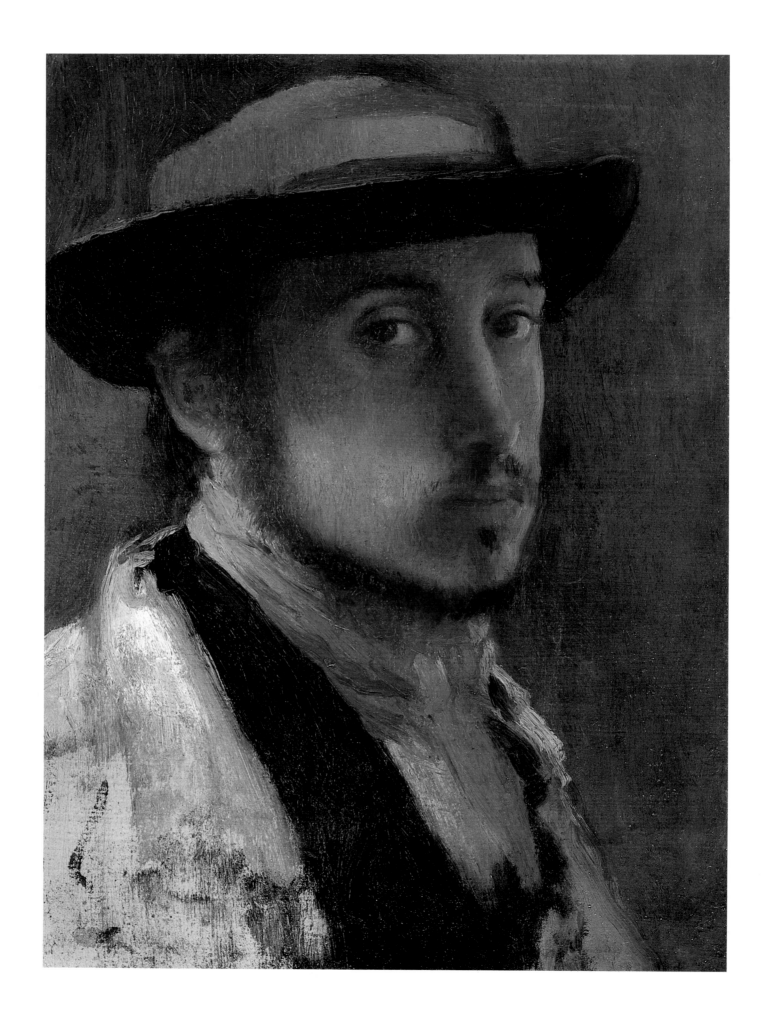

Calm your mind and follow . . . that path which lies open before you, which you yourself have laid open. It is yours and yours alone. Work peacefully in this fashion, I tell you, and you can be sure you will achieve great things. You have a splendid career ahead of you, do not be discouraged, and do not torment yourself. . . . You speak of the boredom you suffer in doing portraits; you must overcome this later on, for portraiture will be one of the finest jewels in your crown.

AUGUSTE DE GAS in a letter to his son, November 11, 1858

Auguste De Gas's son became the greatest portrait painter of the nineteenth century—not, however, as a professional: on the few occasions when he accepted a commission, things went badly. It was rather that the task of portrait painting exactly suited his needs, at any rate during the first half of his career.

The masterpiece of his youth was the group portrait *La Famille Bellelli.* It has a conviction that he could not bring to the historical compositions that he was working on at the same time. The purpose of the painting, however complex, was clear. When Degas was drawing his sitters, they were really there, in the present, challenging his powers of observation and the particular quality of objectivity that was an essential ingredient in his temperament. At the same time, the search for likeness was a timeless undertaking that put him immediately in the company of Hans Holbein, Agnolo Bronzino, and Van Dyck.

From the outset Degas's approach to portraiture was ambitious. He saw that the genre was ramified. A portrait was both a likeness and a social statement. The particular and the general supported and authenticated each other. He also saw that in his time the relationship between the individual and the type was more fluid, more problematic than it had been; and that the problem of modern portraiture was coextensive with all the problems that faced the modern painter, the dissolution of hierarchies, the Death of the Gods. All this can be asserted in the light of his achievement—pictures like *Lorenzo Pagans et Auguste De Gas,* or the portrait of *Diego Martelli,* or the *Place de la Concorde*—pictures that redefine the nature of portraiture and bring to it concepts of composition and expressive definition that are carried over from the unfulfilled demands he made on history painting. He invented a new kind of picture. The invention would have been inconceivable except in the hands of a painter whose ambitions for subject matter were matched by the acuity and pointedness of his observation.

During his time in Rome Degas made several studies from the model of the kind known as *têtes d'expression.* This was a traditional exercise by which students practiced drawing heads whose features were supposed to register stock emotions— rage, fear, despair, and so on. These studies would begin from pattern books,

Portrait de l'Artiste,
also known as
Degas au Chapeau Mou
(Self-Portrait). 1857

87

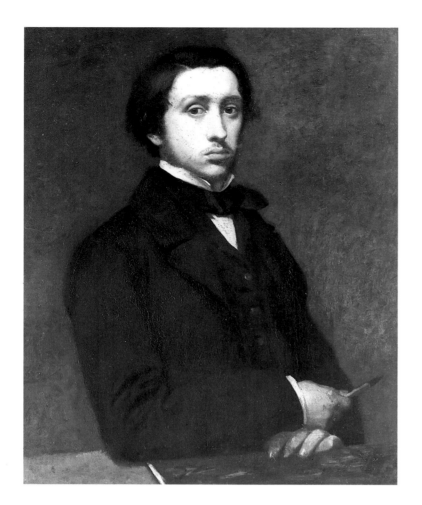

Portrait de l'Artiste,
also known as *Degas au Porte-Fusain*
(Portrait of the Artist). Spring 1855

René de Gas à l'Encrier
(Portrait of René de Gas). 1855

sometimes from casts, only later progressing to the model. When he made the four drawings Degas must have been thinking of his model as a type—a curly-haired, aquiline Roman—and of his expressions as typical; but interest in the head itself continually breaks through. Degas carves out the planes of the skull, sets the eyes in their deep sockets, roots the nose. Every interval changes from view to view, but Degas's grasp of the underlying ratios of skull to features is so firm that the model's presence is constant—alert and bright-eyed or agape in a conventional expression of piety.

A student practiced the *tête d'expression* in preparation for historical figure composition. Command of facial expression was one link in the chain of signs that extended from the grand compositional architecture of the picture to the smallest nuance of gesture and, in theory, bound form and content into one tightly packed bundle. All through the sixties Degas must have asked himself what the *realist* equivalent would or could be to this all-inclusive correspondence of "form" and "content" that the great tradition was founded upon.

It was a question that had as much bearing upon life as upon art. What was the connection between how a person looked and who he was? In the old days there had been nothing problematic about it: trades and classes carried their signs like a livery. Heroes made heroic gestures in heroic halls; funny peasants threw up in dark kitchens. Now, for Degas, bourgeois, whose brothers spelled their name with the particle, the question was of compelling importance. Answers were as elusive as the word "appearance" itself. Was likeness the effect of appearing or the condition of appearing? Clearly a portrait was both a face and a frame, a description and a presentation.

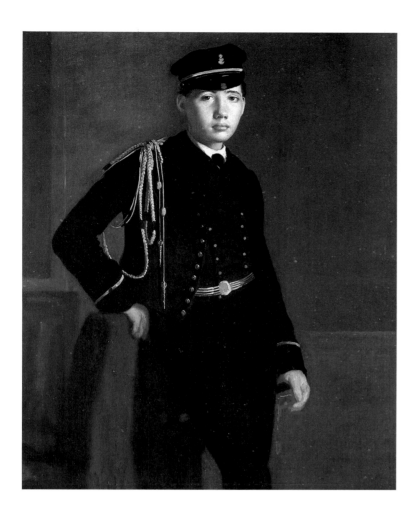

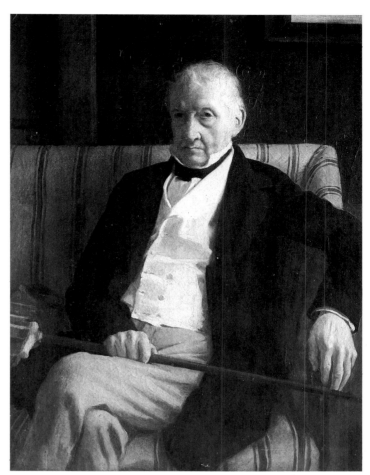

In his first portraits, which are of members of his family, Degas supported his
sitters' faces in the traditional way, by placing them in generic roles. He paints René
as the Schoolboy, in blouse and white collar, surrounded by the attributes of his
studies—ink pot, dictionary, papers, and a glimpse of the outside world through a
window. Achille, the Cadet, strikes a nonchalant pose, one hand on the hilt of his
sword. One of his self-portraits shows Degas as the Painter, crayon in hand, in the
Mannerist tradition. When he painted his Neapolitan grandfather, he relied upon the
great papal portraits to frame the likeness of the old man. Pose and features augment
each other. The deep-set eyes with their look of dry amusement, the thin, turned-
down mouth, his masterful stillness in the corner of the settee, the dark cane across
his knee like a baton of authority: these are beautifully observed particulars laid
down on a pictorial model that goes back to the sixteenth century.

La Famille Bellelli too is based on ambitious models. It is a dynastic portrait. Degas
painted it in Paris, having made studies from his sitters during two visits to Florence.
The family is grouped in two units—on the left the imposing pyramid of Aunt Laura
and the girls, and on the right the solitary Bellelli, seen from behind, who turns
toward his wife with a somewhat impatient gesture. She stares remotely over his head.
In the gap between them—a gap reinforced by the interior architecture—there hangs
on the wall a drawing of Laura's recently dead father, Degas's grandfather. Laura is
pregnant.

Detective work by Jean Sutherland Boggs has shown that the picture can be read as
an account of a relationship. Laura nursed memories of an earlier love for a man
whom her father had considered unsuitable; the marriage to Baron Bellelli had been
an arranged one. There is evidence in family letters that Bellelli and his wife were not

*Degas's family watched his emergence as a
painter with benign though not uncritical
interest. His father volunteered the following
advice in a letter of January 1859:*

*You know that you have little or no fortune, that you
must make painting your career, your livelihood, but
if instead of being a painter you remain an
ideologue, you will have spoiled everything. I implore
you, Edgar, to get your head out of the clouds—
don't suppose that if you fail to set up a career for
yourself in the world, without a persistent and
painful effort, you can then set aside reason itself
and not consider the things of this world as they are
in reality. All unconsidered actions, all resolutions
made frivolously and without careful attention, are
so many stones rolling into the abyss, until the
entire structure collapses. . . . If the artist must have
enthusiasm for art, he must also carefully organize
his behavior, or remain a nothing for the rest of his
days.*

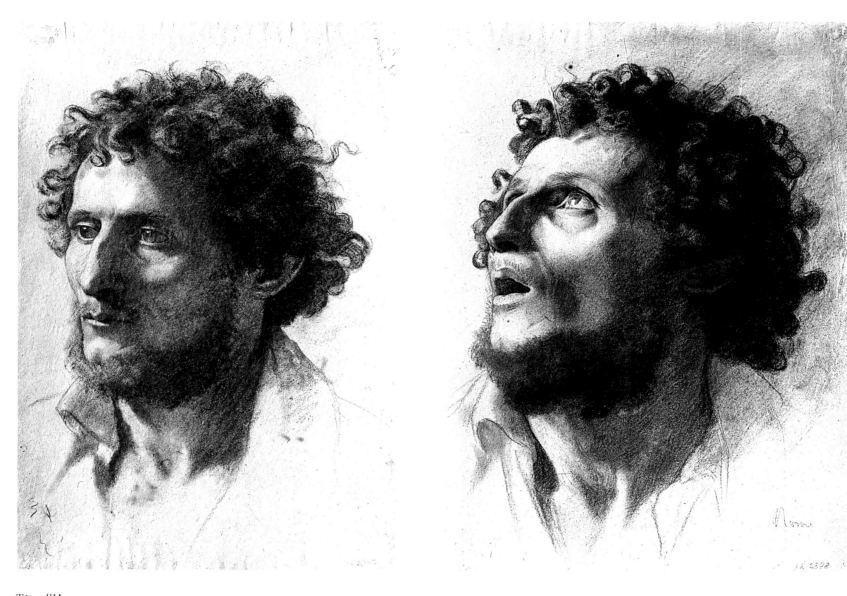

Tête d'Homme
(Head of a Man). c. 1858

Tête d'Homme
(Head of a Man). c. 1858

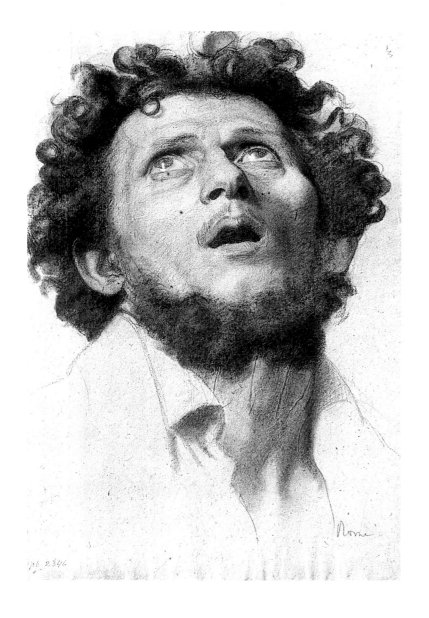

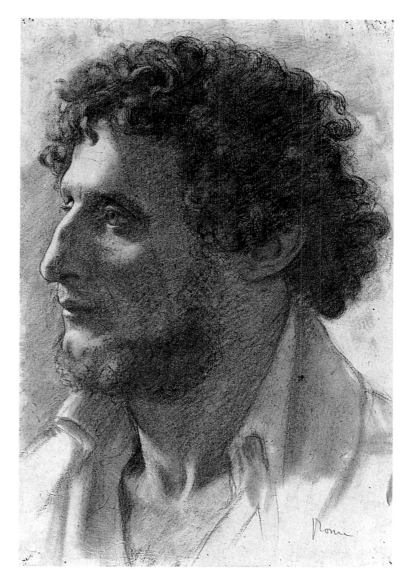

Tête d'Homme
(Head of a Man). c. 1858

Tête d'Homme
(Italian Head). c. 1856

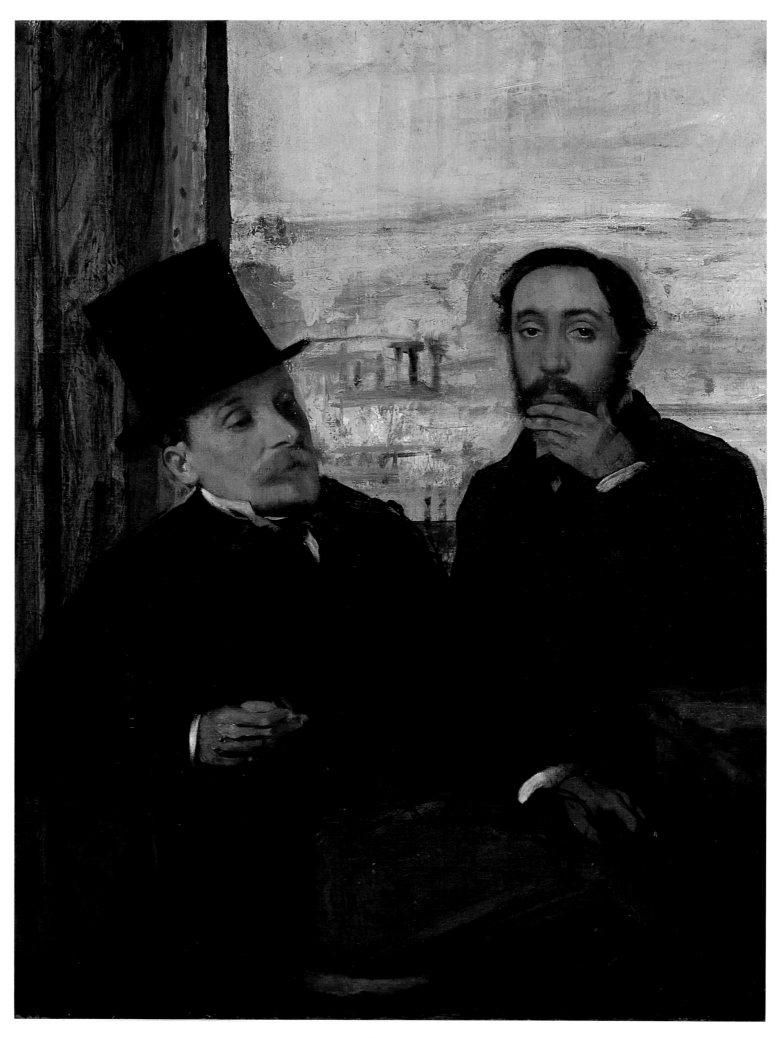

Portrait de l'Artiste avec Evariste de Valernes
(Portrait of the Artist with Evariste de Valernes). c. 1865

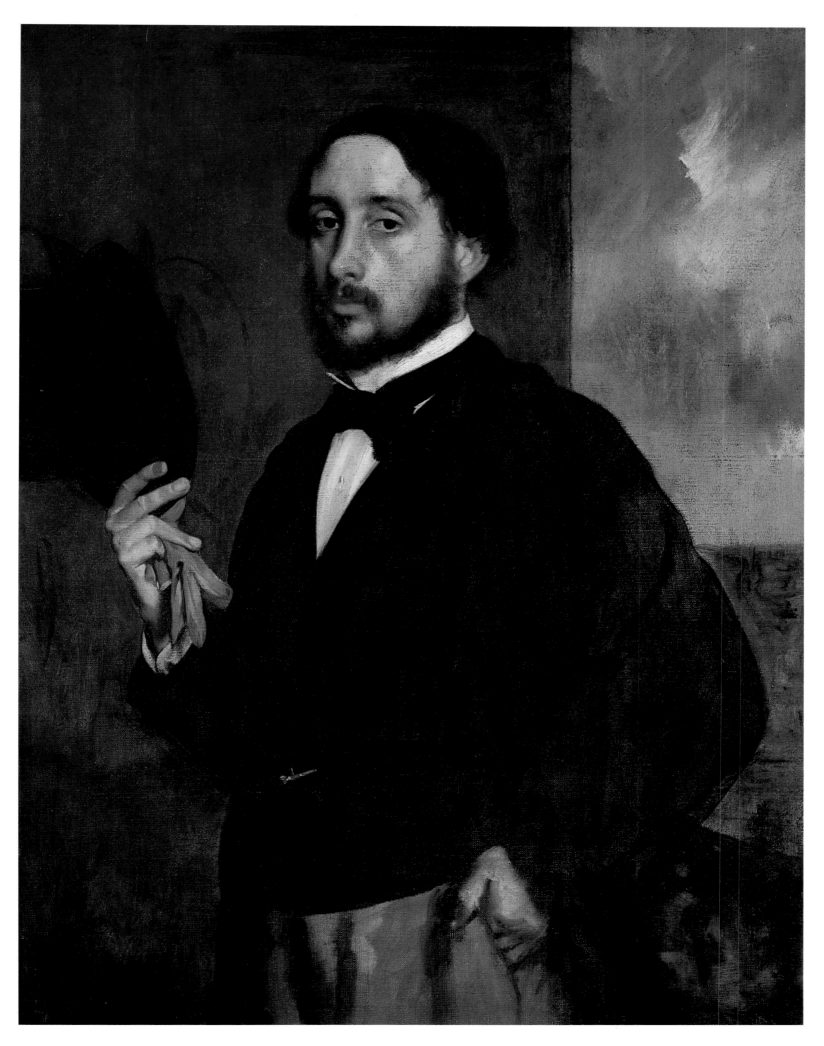

Portrait de l'Artiste, also known as *Degas Saluant*
(Self-Portrait). c. 1863

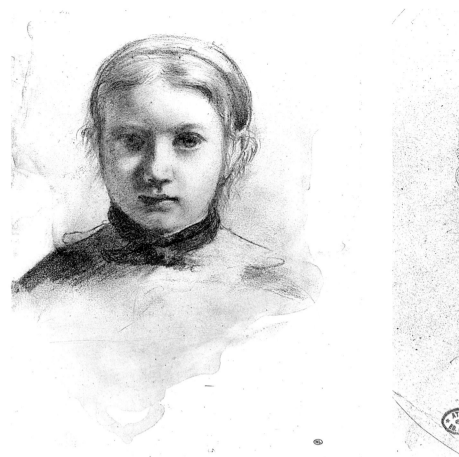

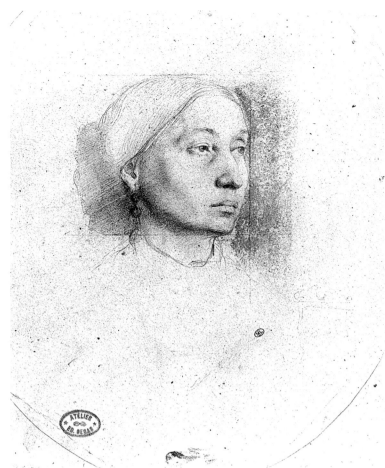

Giovanna Bellelli, étude pour *La Famille Bellelli*
(Giovanna Bellelli, *study for* The Bellelli Family).
1858–59

Laure Bellelli, étude pour *La Famille Bellelli*
(Laura Bellelli, *study for* The Bellelli Family).
1858–59

PAGES 92 AND 93:
*Evariste de Valernes was a painter whom Degas
most likely had first met in the Louvre in 1855.
In spite of the difference of age between them,
they became fast friends and continued so well
after Degas had become celebrated and Valernes
had retired into provincial obscurity. They both
loved Rome, and in this commemoration of their
friendship Degas pretends to be on a balcony
overlooking the Forum. His gesture conveys a
private perplexity that is at odds with the
brooding insolence of his gaze. It seems to draw
attention to everything that is strange about the
picture—the indeterminate distance between the
two heads and the extreme contrast in their
presentation: Degas stares us down; Valernes is
relaxed, dreamy, oblique. It is as though Degas is
formulating the riddle of appearance and identity
in front of our eyes.*

*In Degas Saluant the painter makes a decisive
statement about how we are to see him: aloof,
ironic, proud, yet without a trace of vanity.
This was the last self-portrait that he did.*

on good terms. The situation is set out here as if on a stage: the dead author of the marriage presiding; Laura's remote suffering, in mourning both for her own past and for her father; the baron's bad-tempered disengagement; the two girls, one cleaving to her mother, the other reaching out toward her father. Every aspect of the scene contributes: the straightened space of the apartment, narrowed on Bellelli's side by the armchair that squeezes him into a corner; a hint of another room opening behind the back of the black-clad woman, whose serene, monumental pyramid stands in contrast to his secular aspect, cut off from her world by the straight edges of the fireplace and writing table.

What does a person's appearance signify? The question, spoken or implied, is a constant motif in the literature of the nineteenth century. Observation is equated with intelligence. The greatest observers, from Honoré de Balzac's diabolical Vautrin to Arthur Conan Doyle's Sherlock Holmes, connoisseurs of signs, were masters of both impersonation and disguise. When Degas moved into realist circles, among his closest friends was the novelist and critic Edmond Duranty. Duranty published a long article on physiognomy in 1867. His famous "La Nouvelle Peinture" of 1876, the definitive application of realist literary theory to painting, is filled with implied references to Degas, connections that would have been recognized within their circle. The two must have exchanged ideas endlessly. Duranty's prescription for the modern painter's approach to likeness reads like an introduction to Degas's portraiture—or to the methods of Sherlock Holmes:

What we want is the special note of the modern individual, in his clothes, amid his social habits, at home or in the street. The datum becomes singularly intense; it is the joining

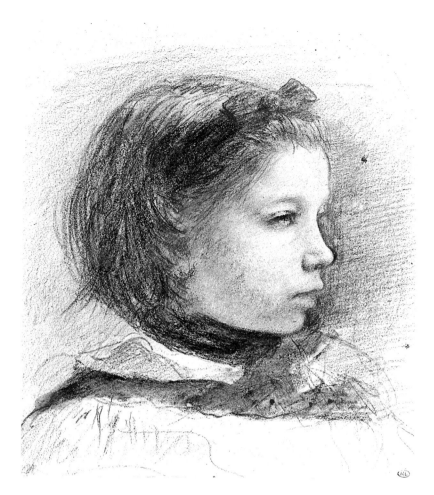

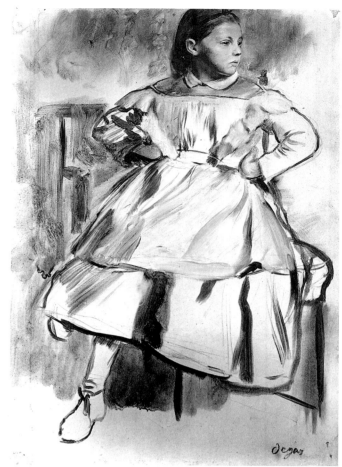

together of a torch and a pencil, it is the study of moral reflections on physiognomies and on garments, the observation of a man's intimacy with his apartment, of the special feature his profession gives to his appearance, the gestures it obliges him to make, the aspects under which he develops and best accentuates himself.

In a back, we want a temperament to be revealed, and an age, a social standing; in a pair of hands, we must express a magistrate or a shopkeeper; in a gesture, a whole series of emotions. Physiognomy will tell us for sure that here is a well-behaved man, dry and meticulous, and that this other one is offhandedness and disorderliness itself. Posture will tell us that this person is going to a business meeting, and that this other one is returning from a love tryst.

The indispensable means for this kind of observation, Duranty says, is drawing. "Hence the series of new ideas has been formed above all in the brain of a draughtsman, one of our own . . . a man of the rarest talent and the rarest spirit." Degas.

In one of his studio notebooks, among many instructions to himself, Degas had written: "Make the *tête d'expression* (academic style) a study of modern feeling— Lavater, but a more relative Lavater, somehow—with occasional symbolic accessories." Even in an art based upon the present, with all its contingencies and accidents, nothing must be left unexamined or vague. Duranty claims that a person

In November 1858, while he was making the studies for his ambitious group portrait La Famille Bellelli, *Degas wrote to Moreau:*

I have two little cousins to eat up. The elder is really a little beauty; the little one has a devilish wit and an angelic kindness. I'm doing them in their black dresses and little white aprons, which become them wonderfully. All kinds of backgrounds run through my head. I want a certain natural grace with a nobility I can't quite characterize. Van Dyck is a wonderful artist, Giorgione too, Botticelli too, Mantegna too, Rembrandt too, Carpaccio too. See if this adds up to anything, if you can.

never appears against neutral backgrounds, vague and empty. But around and behind him are furniture, mantelpieces, hangings, a wall that expresses his fortune, his class, his profession: he will be at his piano, or examining his cotton sample in his office, or waiting in the wings for his moment to make his entrance, or ironing at the trestle-table . . . or avoiding carriages as

he crosses the street, or glancing at his watch as he hurries across the square. His rest will not be a pause, nor a meaningless pose registered by the photographer's lens—this rest will be in *life*, just like his actions.

It was part of his sitter's life that Degas painted in the picture called *L'Amateur d'Estampes*. The man, whose name we do not know, is in his element, and the picture is as much about collecting as it is about the collector. Degas knows the pose exactly, the familiar way this man holds the portfolio between his knees and dangles the print as if considering whether to throw it back in the portfolio or to set it aside. Certainly he is not presenting himself for his portrait. He looks up as if interrupted. His mind is focused on what he has been looking at. The picture is about a passion and a way of life.

Of the mutilated portrait of Manet listening to his wife play the piano, George Moore wrote: "Those who knew Manet well cannot look without pain upon this picture; it is something more than a likeness, it is as if you saw the man's ghost." And to the rest of us too there is something astonishing about the *wholeness* of Degas's representation of his impossible friend. No one else could have seen as he did how the man existed in the pose; how Manet had ungracefully, carelessly, elegantly thrown himself back onto the sofa, one leg up, one leg down, a hand deep in his pocket (a man who sits down without taking his hand out of his pocket), the other hand in his beard—none of this could have been invented, but neither could it have been seen and remembered except by someone to whom every nuance of behavior was expressive and the important material for likeness. To be able to see like this signals not just visual curiosity but wit and an extraordinary independence of mind.

Degas's first move into the world of the Opera—the world that was to claim more of his energy than any other—was by the route of portraiture. A few years after *L'Orchestre de l'Opéra* he had penetrated to the rehearsal rooms, and the first results were paintings of dancing classes in which the key figure is the dancing master. Degas clearly revered Jules Perrot, who in his prime had partnered the legendary Taglioni, and in the various pictures he made of him at work he shows him as a figure of the utmost authority. Perrot is firmly placed in his world, standing on the dance floor as if he owned it, his legs spread somewhat, his hands clasped on the heavy tapered stick that at times will thump out the beat or affirm his words. In these crowded compositions where a whole gamut of movement and gesture, from the formal movements of the dance to the unconscious movements of the resting dancers, is laid out and categorized, Perrot stands alone at the psychological center.

The element of comparison on which much of the characterization of Perrot turns was a powerful resource that Degas loved to develop in his pictures of two people together. The features of the subjects of *Henri Degas et Sa Nièce Lucie Degas* enhance each other through their strong resemblance. In the great double portrait of *Lorenzo Pagans et Auguste De Gas* much turns on the comparison between the upright singer and the frail, bent-over, old man absorbed in listening. We move back and forth between the two. The presence, the quality of each man is augmented by the other. And in that movement between them we become aware of another polarity: between the painting as an addition to a long sequence of concert pictures, images of the making and taking in of music, and the painting as a topical account of two distinctive individuals shown in the bright light of their uniqueness.

Another more radical example of Degas's use of comparison as a mode of characterization is in the extensive sequence of images that he derived from drawings

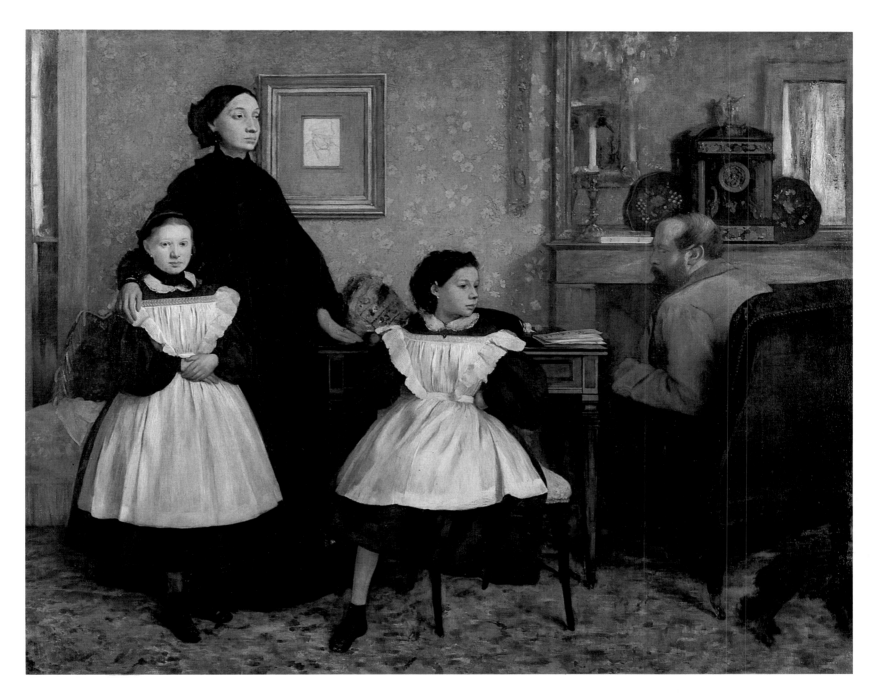

Portrait de Famille,
also known as *La Famille Bellelli*
(Family Portrait,
also known as The Bellelli Family).
1858–67

Baron Bellelli was a political exile in Florence when Degas made his studies for the painting. By the time the picture was finished Bellelli was able to return home to Naples, and it was there that it was sent. Some years later Degas, on a visit to his Italian relatives, discovered that the painting had been damaged. He took it back with him to Paris, where it was found after his death.

97

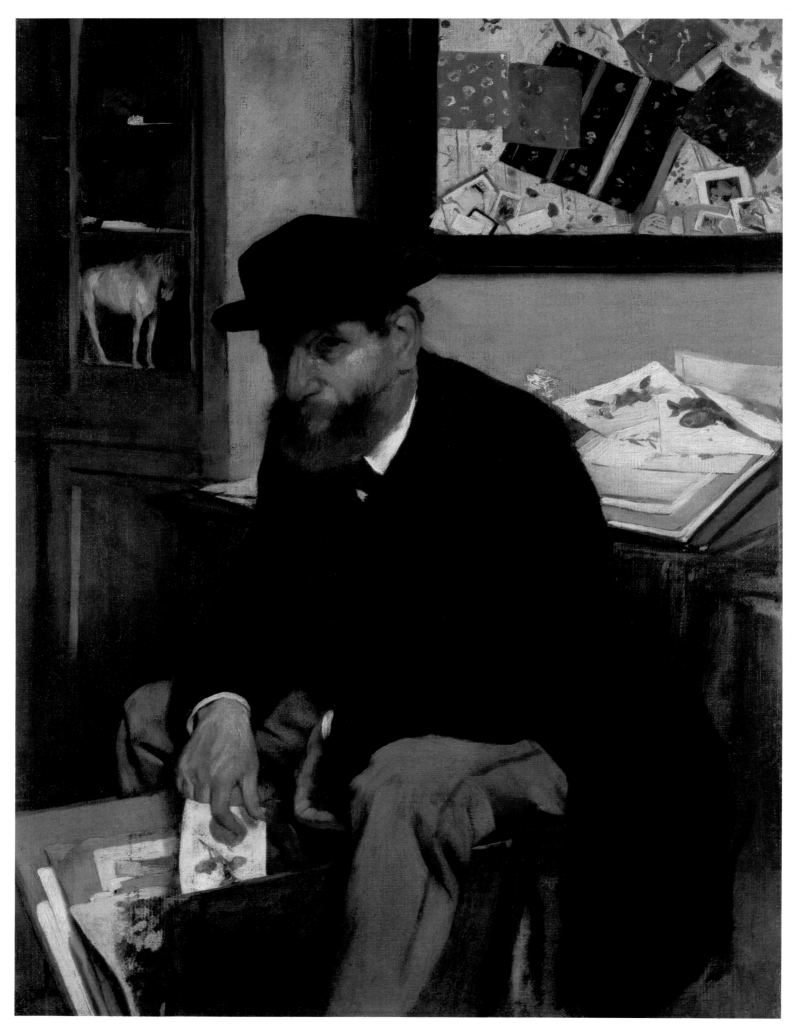

L'Amateur d'Estampes
(The Collector of Prints). 1866

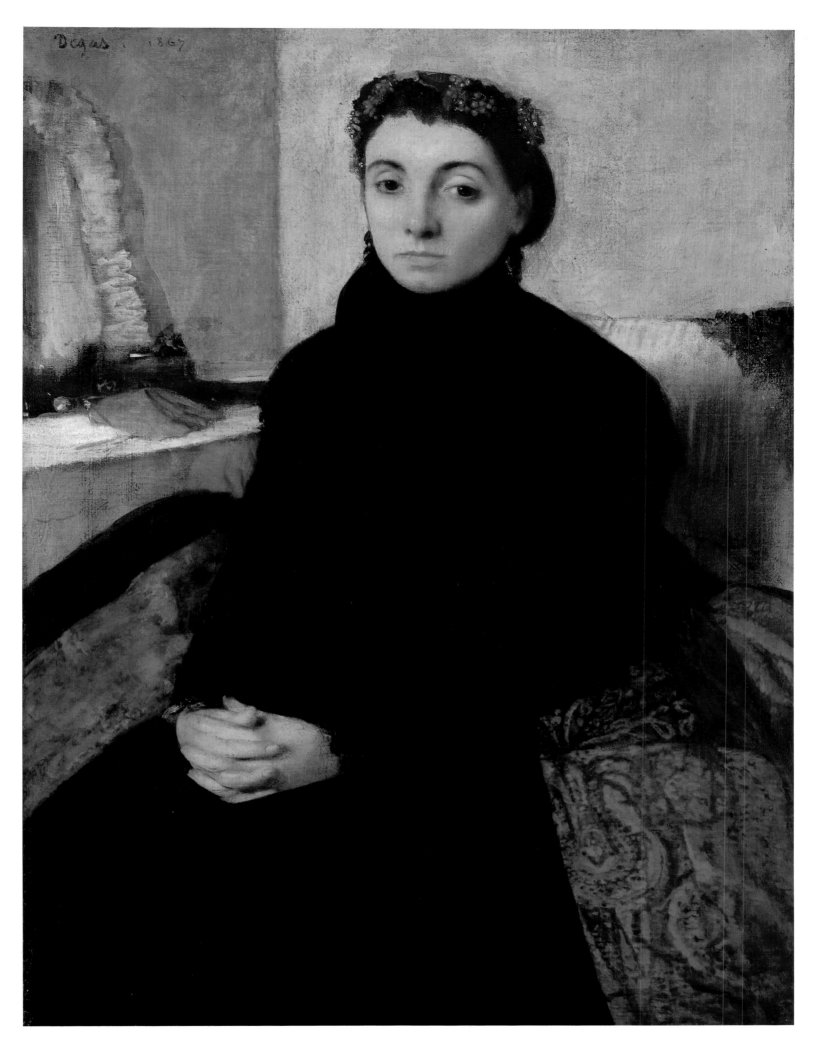

Madame Gaujelin. 1867

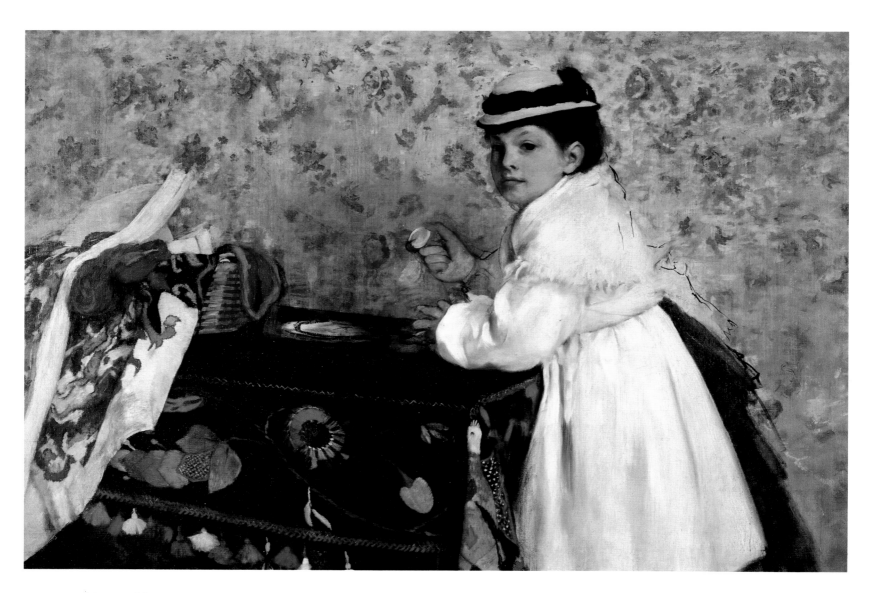

Hortense Valpinçon. 1871

There are conflicting views about the origins of La Femme aux Chrysanthèmes. One view is that it was a still life of flowers into which Degas later inserted a portrait. Proponents of this view point to the double signature and to the evidence of repainting of flowers and table around the figure. Others contend that it was intended as a portrait from the first, one of the earliest of the genre portraits in which Degas surrounded his sitters with the attributes of their normal lives. The sitter here may be Mme. Valpinçon, wife of the painter's old schoolfriend whose country estate Degas often visited.

It was at the Valpinçons' estate in 1871, while enjoying the country after the rigors of the siege of Paris, that he painted the portrait of their daughter Hortense seen above. Thirteen years later, shortly before her marriage, Hortense was to sit for him again, this time for a half-length bust in clay which fell to pieces when Degas tried to cast it.

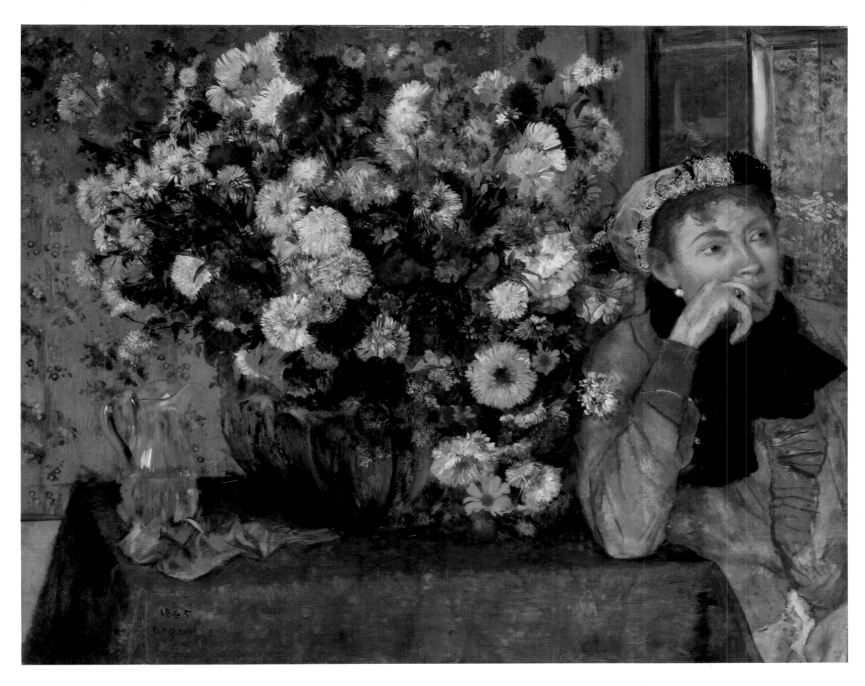

Femme Accoudée près d'un Vase de Fleurs,
also known as *La Femme aux Chrysanthèmes*
(A Woman with Chrysanthemums). 1865

PAGE 102:

*Degas and Henri Rouart were old schoolmates who were thrown together
during the siege of Paris and remained intimate until Rouart's death in
1912. The quality of Degas's feelings for Rouart is suggested by this
letter he wrote him in 1897:*

*Terribly sorry, my good friend, to find you were here and left. Your note said
you would come to see me, but I never dreamed it would be in the afternoon!
There is no task, no labor, nor any sacrifice I would not make for the pleasure
of seeing you, believe me, my old friend.*

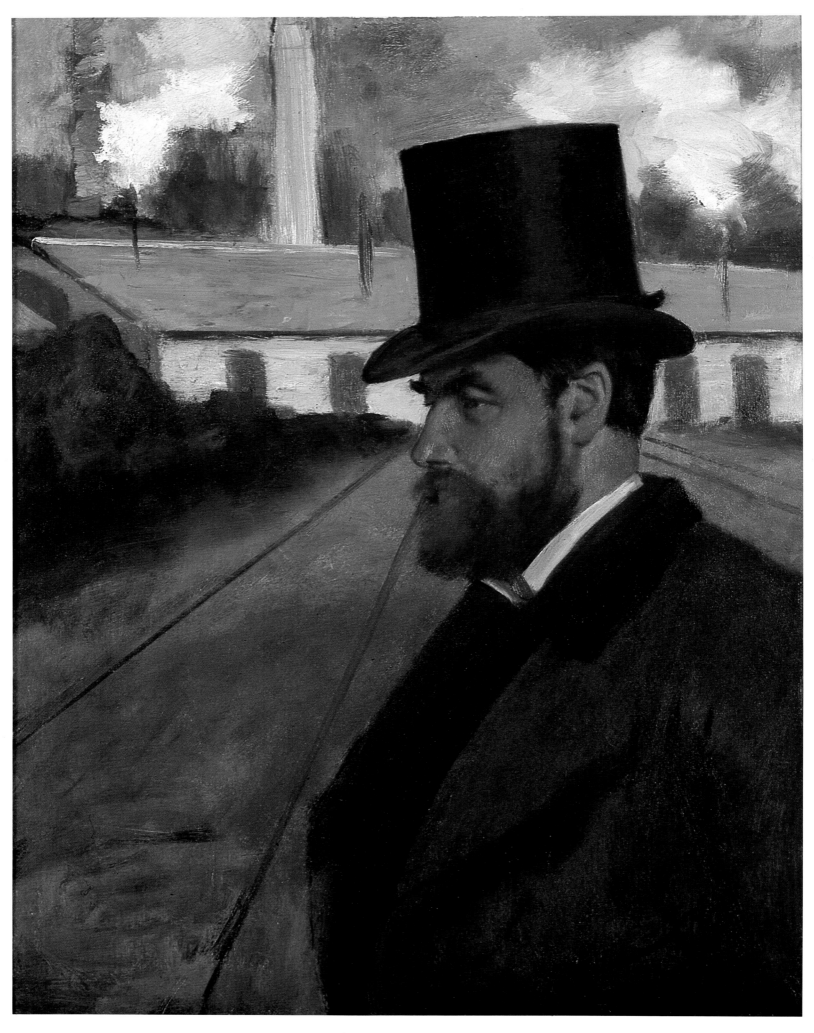

Portrait de Monsieur H. R. . . . ,
also known as *Henri Rouart Devant Son Usine*
(Henri Rouart). c. 1875

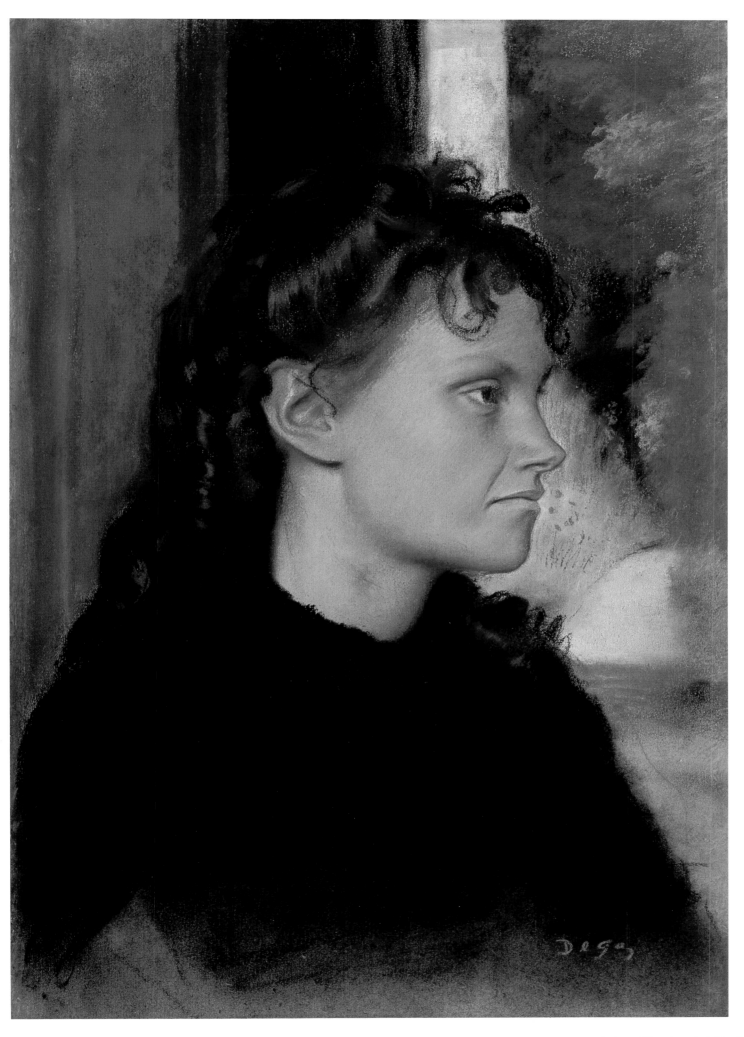

Madame Théodore Gobillard (Née Yves Morisot)
(Portrait of Yves Gobillard-Morisot). 1869

PAGE 103:

The eldest sister of Berthe Morisot sat for this portrait in May 1869. Degas was friendly with the whole family. Mme. Morisot wrote to her second daughter, Edma, "Did you know that M. Degas has become quite wild about Yves's head?" A month later she wrote:

M. Degas has taken up her every moment. This eccentric arrived Tuesday; this time he took a big sheet and began working on the head in pastel; it seemed to me that he was doing a very pretty thing, and drawing wonderfully; he asked me for an hour or two in the day; yesterday he came for lunch and spent the whole day. He seemed pleased with what he was doing, and sorry to be separated from it.

Henri Degas et Sa Nièce Lucie Degas
(Uncle and Niece [Henri Degas and His Niece Lucie Degas]). 1876

Monsieur et Madame Edouard Manet
(Mr. and Mrs. Edouard Manet). c. 1868–69

In its original state this painting included Mme. Manet, who was seated at the piano. Degas gave the double portrait to Manet in exchange for a still life of some plums. Manet decided to cut the portrait of his wife out of the picture. When Degas discovered this he reclaimed the canvas, returning Manet's still life with a curt note. Ambroise Vollard reminded Degas of the affair years later:

Vollard: But afterward you made it up with Manet.
Degas: How could you stay on bad terms with Manet? Only he had already sold the Plums. *You can't imagine how pretty that little canvas was. . . .*
Vollard: Manet could just as well have cut a Delacroix in two, or an Ingres?
Degas: Yes, a Delacroix or an Ingres — he would have been quite capable of that, the beast! But if he had done that, I don't think I would have seen him again.

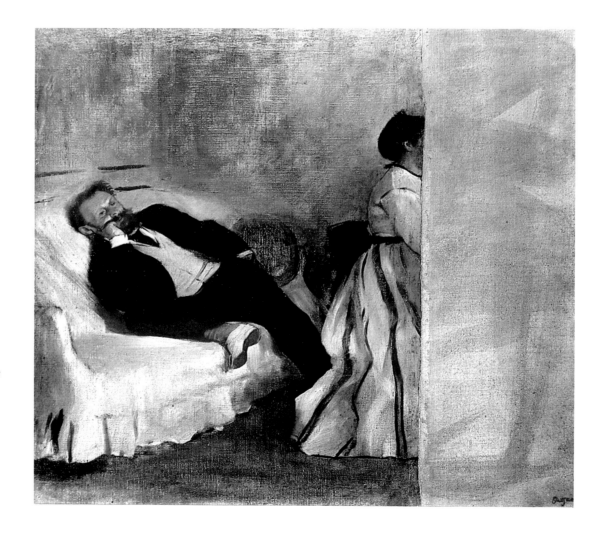

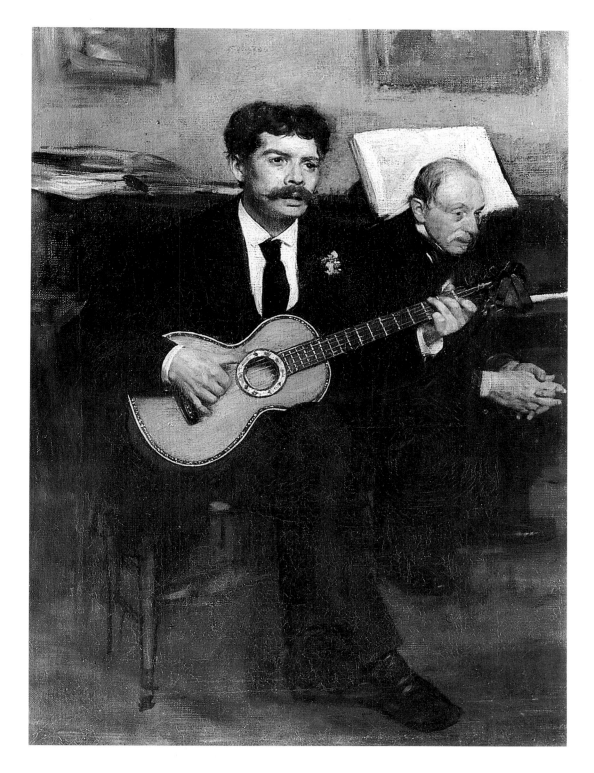

Lorenzo Pagans et Auguste De Gas
(Lorenzo Pagans and Auguste De Gas).
c. 1871–72

Degas had an exceptional regard for this double-portrait, and he kept it close to him for much of his life. Paul Poujaud wrote:

My memories which go back forty years are very precise. I had had lunch alone with Degas. After our coffee, he laid his hand on my shoulder, smiling and confident, and beckoned me to follow him. He led me into his room and showed me the precious picture over his little iron bed. "You knew Pagans? This is his portrait, and my father's." Then he left me alone. That was his way of showing me his work. Out of a sort of proud modesty, he did not accompany the scrutiny. . . . After a few minutes he came back into the room and without saying a word—and without a word from me—looked into my eyes. That was enough for him. He was always grateful for my silent admiration. I'm sure he didn't show me the Pagans as a memory of his father—whom I hadn't known, and of whom he had never spoken to me— but as one of his finished works which he preferred to the others. I haven't the slightest doubt about that.

PAGES 106 AND 107:
Both pictures are portraits, and also very specific scenes of city life. The painter's subjects are described with precision as individuals, but individuals caught in their public parts, defined by their surroundings. Even the representation of the uniform clothes is nuanced. Ludovic Halévy and Albert Boulanger-Cavé, men-about-town chatting backstage, stand at a certain distance from each other, nonchalant yet aware of their style in a way that Ernest May, the financier on the steps of the Bourse, absorbed in the exchange of information, is not. Every detail of the two pictures supports and informs every other detail.

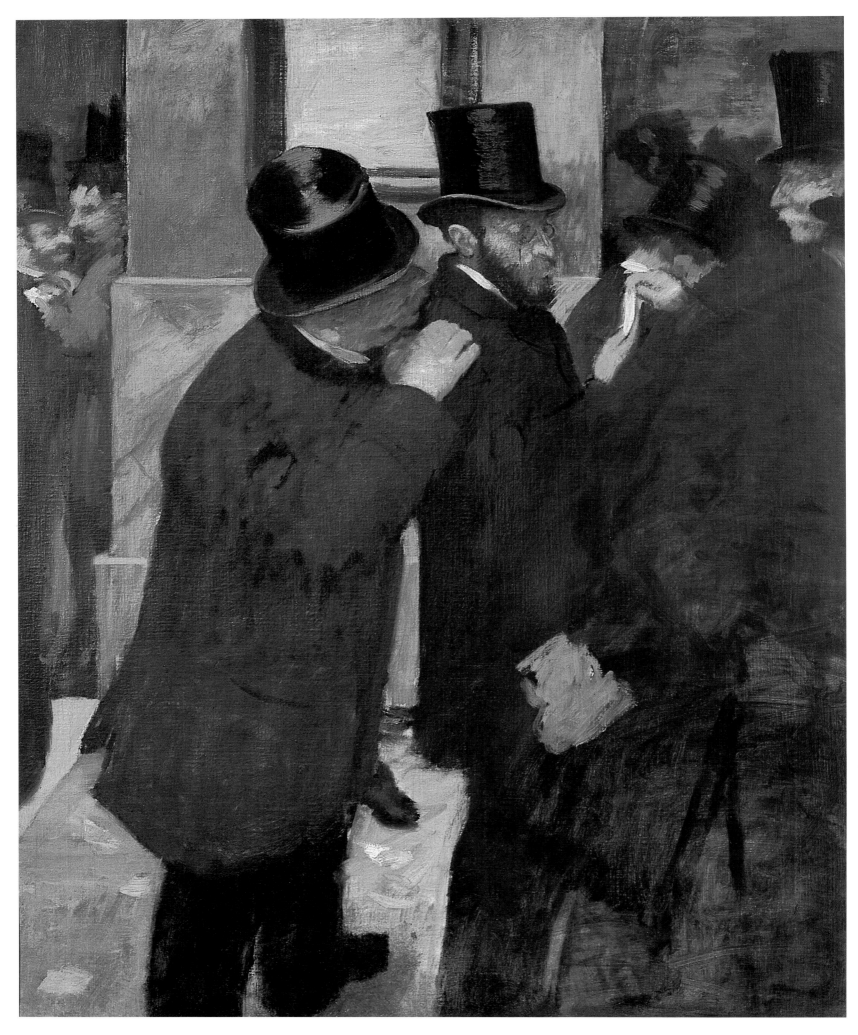

Portraits, à la Bourse
(Portraits, at the Stock Exchange). c. 1878–79

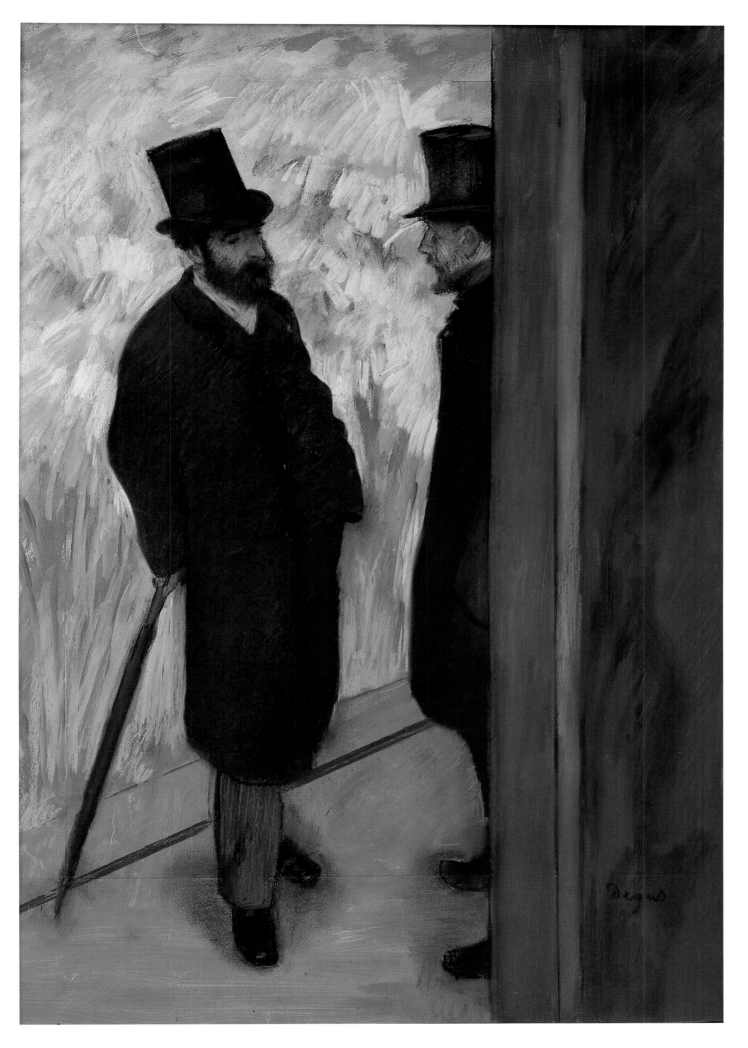

Portrait d'Amis, sur la Scène
(Portrait of Friends, on the Stage). 1879

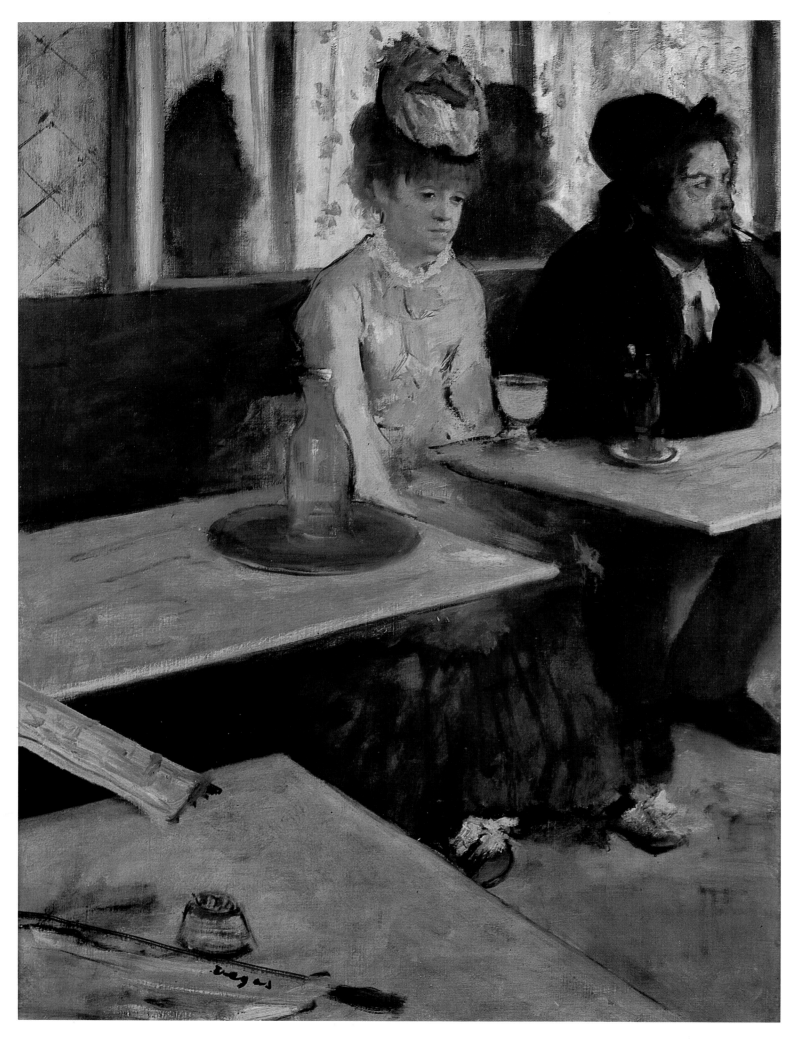

Dans un Café, also known as *L'Absinthe*

(In a Café, *also known as* The Absinthe Drinker).

1875–76

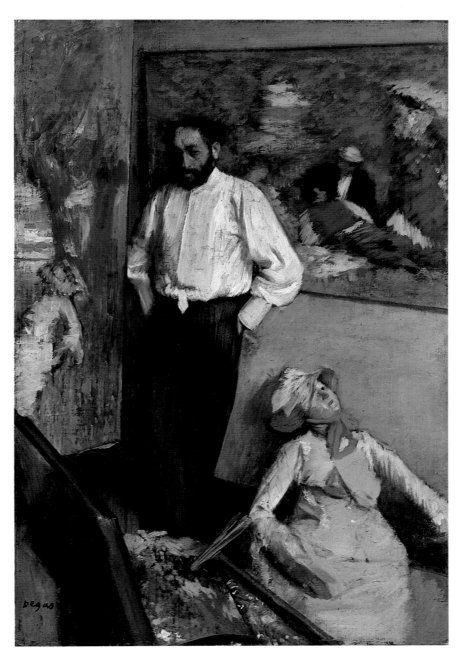

Portrait d'un Peintre dans Son Atelier,
also known as *L'Homme et le Pantin*
(Portrait of a Painter in His Studio). 1878

In 1893 Dans un Café, *which had recently been bought by the Scottish
collector Arthur Kay, was shown at an exhibition at the Grafton Galleries
in London. It had been given a spurious and melodramatic title:*
L'Absinthe. *The picture caused an uproar in the London press. Philistine
opinion pretended to be outraged by its "repulsive subject" of "two rather
sodden people drinking in a cafe." It was ardently defended by admirers
of Degas, one of whom was the painter Walter Sickert.*

*Degas once asked Sickert what his chances would be at the Royal
Academy. They would certainly show you the door, Sickert told him. "I
thought so," said Degas. "They don't admit cynicism in art."*

109

Madame Dietz-Monin. 1877–79

This portrait, which Degas had undertaken for a fee, was the occasion for misunderstanding with the sitter. It was Mme. Dietz-Monin who chose to be shown in fancy dress, but she evidently resisted the painter's characterization, saying that the picture made her look drunk. Among the papers found in Degas's studio after his death was the following draft of a letter:

Let us drop the portrait, if you please. I was so amazed by your letter proposing that I reduce it to a boa and a hat, that I shall not even answer you. I thought that Auguste or M. Groult, to whom I had mentioned your latest idea and my utter disinclination to go along with it, would have let you know. . . . Need I say that I regret having begun something in my own way, only to see it entirely transformed into something in yours? It would hardly be polite to do so, but still . . . I could scarcely say anything more about the matter, dear Madame, without making it quite clear that I am still very much hurt. Aside from my unfortunate art, please accept all my compliments.

Degas is perhaps the only artist ever to have made a laughing face whose expression does not stiffen and die as one looks at it. Mme. Dietz-Monin's expression, gay and sad at the same time as she waves goodbye to an unseen friend after a ball, does not congeal into a grimace but returns full of life with each viewing of what must be one of the most haunting images of a laughing person ever made.

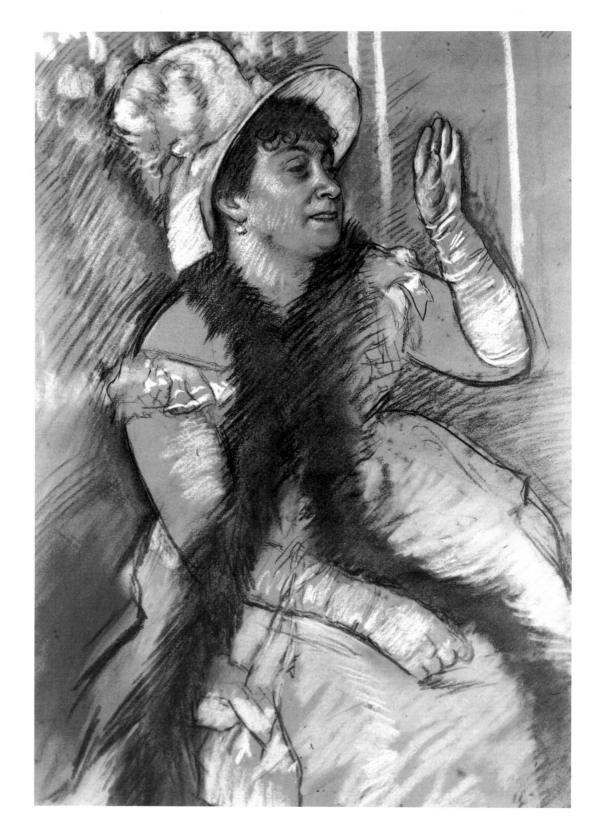

of Mary Cassatt and her sister Lydia at the Louvre. The drawing of Mary in her elegant hat and tailored jacket, leaning stylishly on her tightly rolled umbrella, contrasts with that of her seated sister, who makes a dumpy shape, a soft "S" beside Mary's virile arrow. There are pastels of each figure alone, and a pastel of the two together in the picture gallery of the Louvre. They appear again, traced from a pencil drawing, reversed, in an etching-aquatint in which they are looking at an Etruscan sarcophagus. Reversed again and now overlapped, they reappear in the tall, narrow etching-aquatint called *Au Louvre: La Peinture (Mary Cassatt)*, a print that Degas took through no fewer than twenty states.

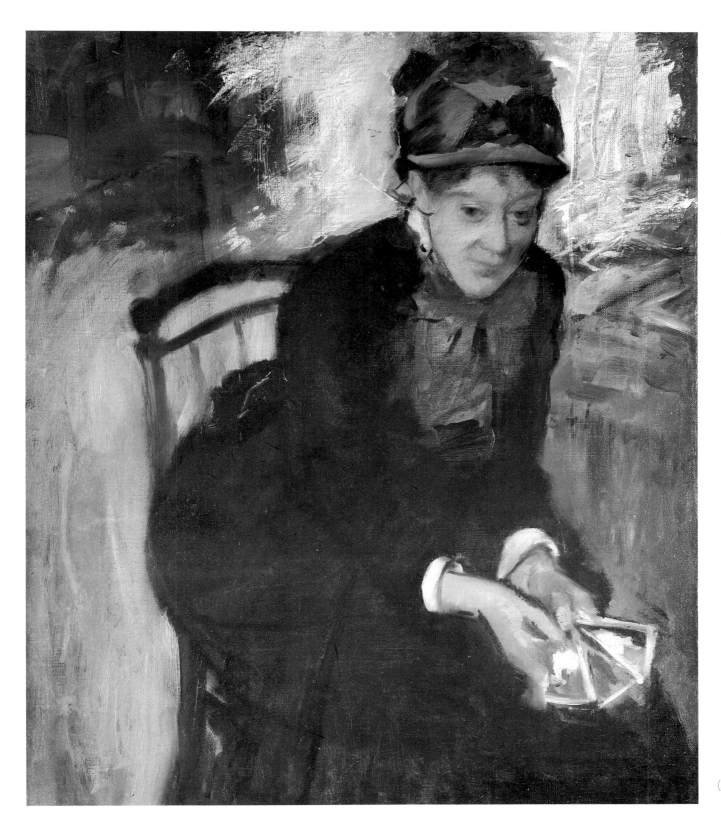

Miss Cassatt Assise,
Tenant des Cartes
(Portrait of Mary Cassatt).
c. 1884

By the time Degas had taken the drawings through all these places they must have seemed to him freestanding, like figurines that he could pick up and put down at will. In each version, the figures make the same shapes. They have become definitive. The two women are bound into their shapes. Degas can switch their orientation, move them nearer or farther apart, adjust their clothes, change the room in which they are seen, give them different things to look at, but their identities remain the same.

Mary is completely at home in the museum. She is absorbed in what she is looking at, so much so that she is unconsciously performing a balancing act of great beauty, propping her weight daringly on the tip of her slender umbrella. Concentration and

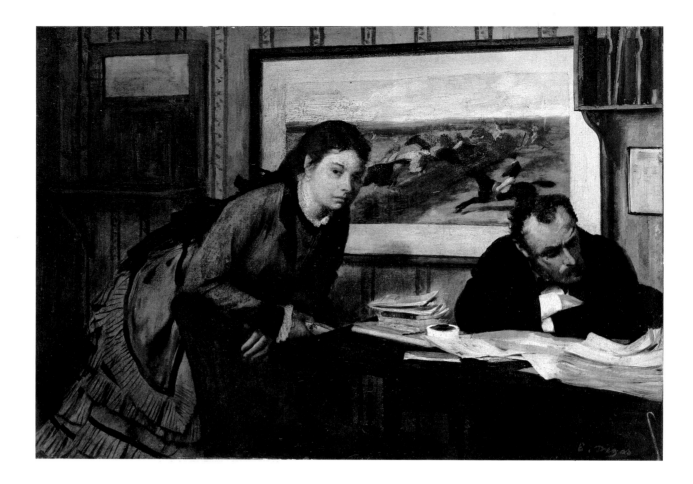

intelligence, it seems, are given to us both by the way she is depicted—the nature of her pose—and by the hard geometry of the shape she makes: the straight-edged, lean triangle whose apex is in her head. In contrast, Lydia is unsure. She is a pupil in the museum. She looks up from her catalogue, obedient to her reading or to a word from her sister. Her shape is tentative. She peeps over her book. Even the way her hands hold it seems unsure compared to the firm grasp of Mary's left hand and the relaxation of her right, hanging on her hip.

The shapes of Mary and Lydia could be moved from place to place, fulfilling their parts in different situations. The complement of this process was to give different parts to the same shapes, as if to experiment in casting. Mary Cassatt was again the principal in a series of pictures that Degas made in the early 1880s of milliners' shops. In these pictures, customers who try on and choose the beautiful hats are set beside the milliners who make the hats and serve. These are complex statements about class and fashion, about work and leisure, and perhaps, indirectly, reflections about art and its public.

In the pastel *Chez la Modiste*, also known as *Femme Essayant un Chapeau chez Sa Modiste*, the customer stands in front of a tall mirror taking in the effect. One gloved hand is raised to adjust the hat; the other is stretched forward in a gesture of formal courtesy as though playing hostess to her own reflection. Light from the mirror floods her face with a silvery gleam. The shop girl, bearing more hats, is half-hidden behind the mirror. When this picture was first shown at the Eighth Independent exhibition it was accompanied by another pastel, *Petites Modistes*, which shows two milliners at work trimming hats. The graceful, assured self-appraisal of the customer was contrasted with the unself-conscious craftwork of the two working girls. It is never in question whether Degas is thinking of a figure as an equal or an inferior, as an

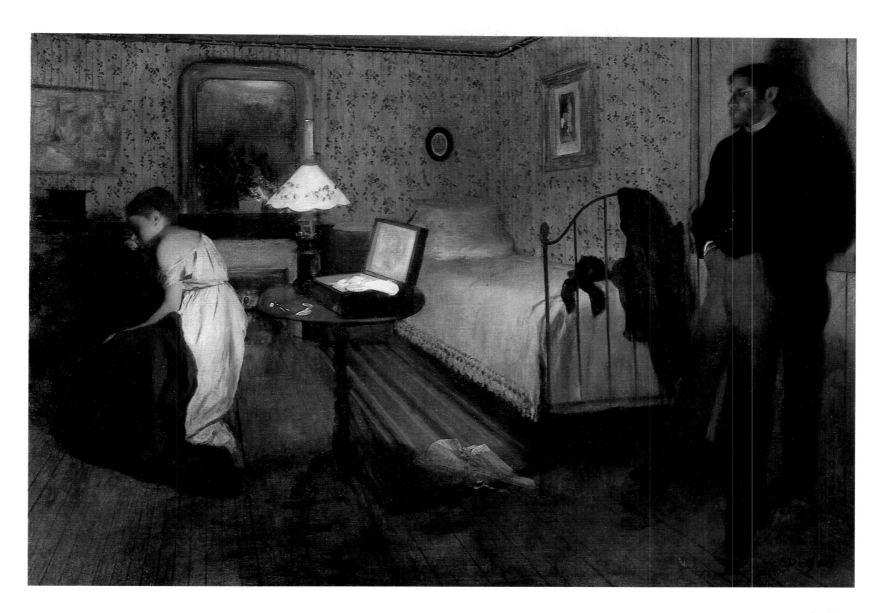

Intérieur,
also known as *Le Viol*
(Interior). 1868–69

For many years the subject of this picture, the most theatrical of all Degas's compositions of modern life, was a mystery. It now seems certain that Degas had in mind the following passage from Thérèse Raquin, *a novel by Emile Zola that had appeared in 1867:*

Laurent carefully closed the door behind him and remained there a moment, leaning against it, staring into the room with an anxious, confused expression.

A bright fire was burning in the grate, casting golden patches that danced over the ceiling and the walls. The room was thus illuminated by a brilliant, vacillating glow which dimmed the lamp set on a table. Madame Raquin had tried to arrange the room attractively, all white and scented, as though to serve as a nest for young lovers; the old shopkeeper had chosen to add to the bed a few bits of lace and to fill the vases on the mantel with big bouquets of roses. A gentle warmth lingered in the air, with soft odors. The air was still, laden with a sort of voluptuous torpor. Amid the tremulous silence, the fire in the hearth produced a series of tiny dry explosions. It was a kind of happy desert, a forgotten corner, closed to all outside disturbance, one of those nooks designed and prepared for the senses and the needs of passion's mystery.

Thérèse was sitting in a low chair, to the right of the fireplace. Chin in hand, she was staring fixedly at the dancing flames, and did not turn her head when Laurent entered the room. Wearing a lace-edged petticoat and bed-jacket, she looked particularly pale in the bright firelight. Her jacket had slipped from one shoulder which showed pink through the locks of her black hair.

Laurent took a few steps, not speaking. He removed his jacket and vest. In shirtsleeves, he glanced again at Thérèse, who had not stirred. He seemed to hesitate. Then he noticed the pink shoulder, and bent down to press his trembling lips against that bit of bare skin. The young woman pulled her shoulder away, turning around abruptly. She stared at Laurent with a gaze so strangely mingling repugnance and dread that he stepped back, troubled and uneasy, as if overcome by terror and disgust himself.

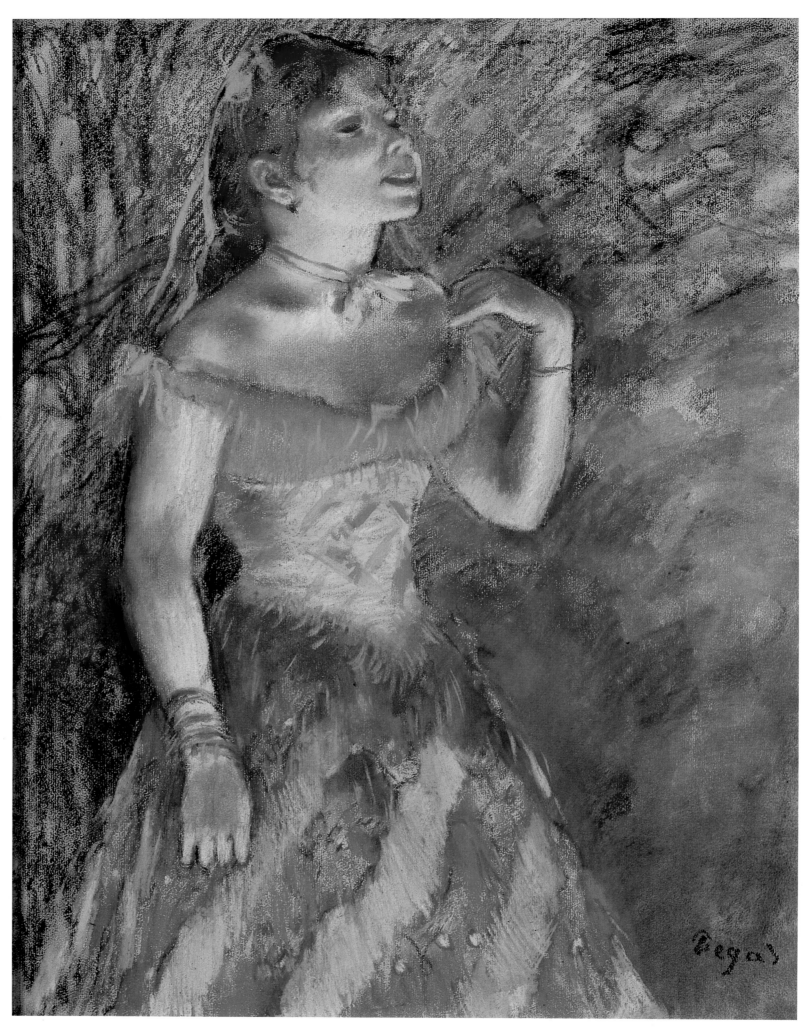

La Chanteuse de Café-Concert,
also known as *La Chanteuse Verte*
(The Singer in Green). c. 1884

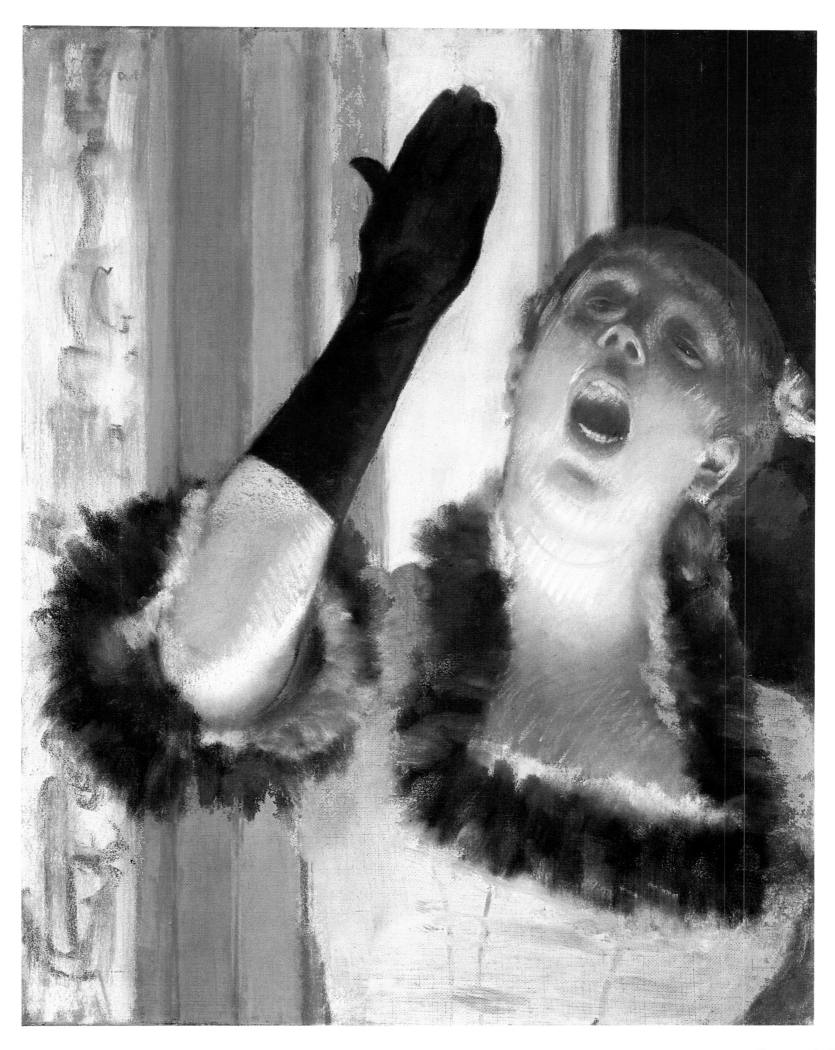

Chanteuse de Café
(Singer with a Glove). c. 1878

Chanteuse de Café-Concert
(*Café-Concert* Singer). c. 1884

Deux Etudes de Chanteuses de Café-Concert
(Singer at the *Café-Concert:* Two Studies).
1878–80

OPPOSITE:

The most celebrated of the chanteuses of the café-concerts was Thérésa, described here by Louis Veuillot in Les Odeurs de Paris:

I found her nowhere near so hideous as I had been led to believe. The young woman was rather tall, well set up, with no charm but her fame, which is of the first order. She has, I believe, a certain amount of hair; her mouth seems to run around her entire face; for lips, two puffy negroid strips; shark's teeth. One woman beside me called her "a fine brown fellow". . . .

She can sing. And the singing is indescribable, as is the song. One must be a Parisian to understand the allure; a refined Frenchman to relish its profound and perfect nonsense. This inheres in no language, no art, no truth. It is something picked up in the gutter, and one must find in the gutter the product which savors of the gutter. . . .

She acts her song as much as she sings it. She acts with her eyes, her arms, her shoulders, her hips, boldly enough. Nothing charming about it; she strives rather to cancel out anything that would smack of feminine grace; but this is perhaps the tasty thing, the supreme flavor of the stew. . . .

A Parisian through and through, she never weeps, she whimpers; she never laughs, she leers; she never jokes, she teases; she never dances, she cavorts; she never loves, she lusts.

individual friend or as a public type. In preparing for *Chez la Modiste* (The Art Institute of Chicago) Degas made two drawings of a woman who holds up a hat and turns it appraisingly. The pose, the gesture is the same in both, but in one drawing she is a customer and in the other a milliner. Despite the identical pose the different signals bound into each drawing are unmistakable: the refined, slender lines of the customer, the broad drawing of the milliner, the customer's head elegantly cut by the curving brim of her hat, the working girl bareheaded, her hair pulled back. In the painting she ends up working with pins in her mouth.

Classical art takes for granted that outward appearances mirror the inner person, that a person "is" what he or she looks like. It was a correspondence that the old order endorsed. When signs of rank and occupation were firm, the double function of portraiture—the simultaneous representation of likeness and station—locked. The grounds for this agreement had been shifting for half a century when Degas began to paint. The teasing mobility of the city, Balzac's passion, was accelerated by Haussmann's demolitions. Populations were on the move, figuratively and literally. "All this affects me as though I were a traveler in my spiritual homeland," the Goncourts wrote in their journal in 1860. "I am a stranger to what is coming and to what is here. . . . It is silly to come into a world in time of change, the soul feels as uncomfortable as a man who moves into a new house before the plaster is dry."

It is tempting to see reflections of a similar insecurity in Degas's preternaturally acute observations of other people. What is a face? What does it stand for? The crucial picture in his move into modern life—*Mlle. E. F., à propos du Ballet de la Source*—he had called a portrait: a portrait of an actress in a part, Mlle. Fiocre, the part so completely absorbing the person that she could be taken for an Oriental princess.

At what point did Degas first entertain the idea of his sitters as actors? Certainly the Bellelli family group can be thought of as a tableau, sharing in the grand

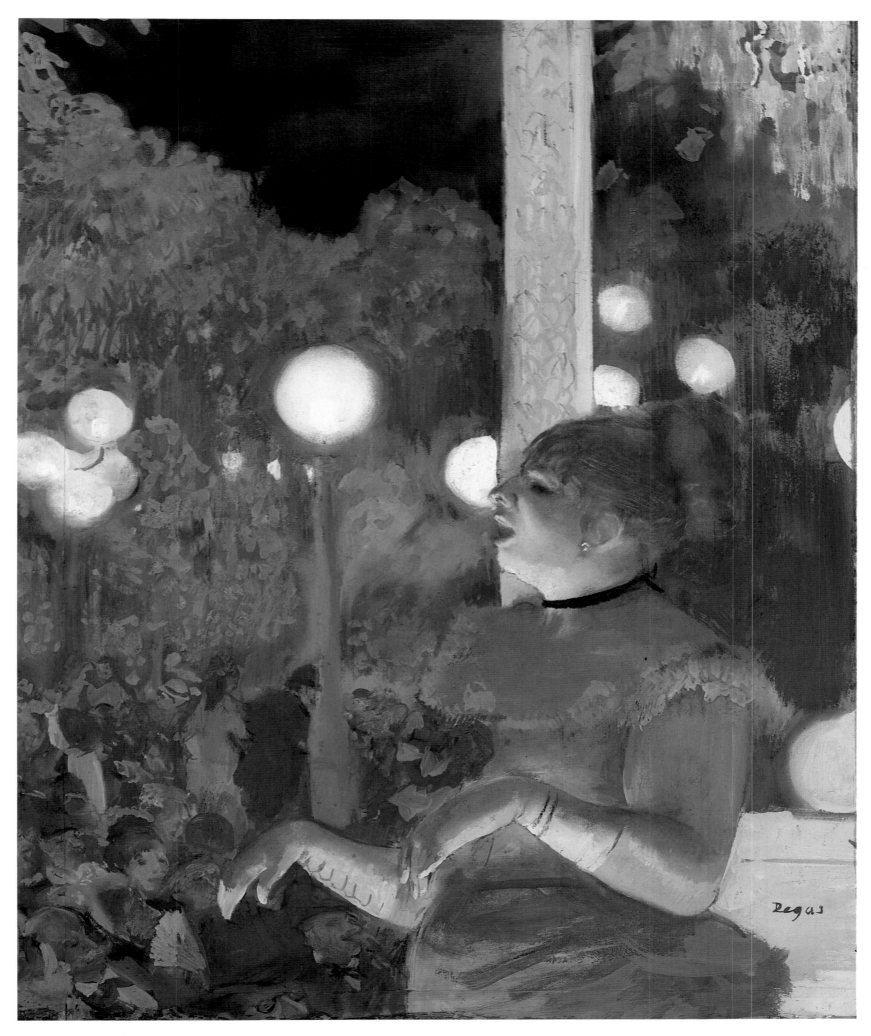

Au Café-Concert: La Chanson du Chien
(At the *Café-Concert:* The Song of the Dog).
c. 1876–77

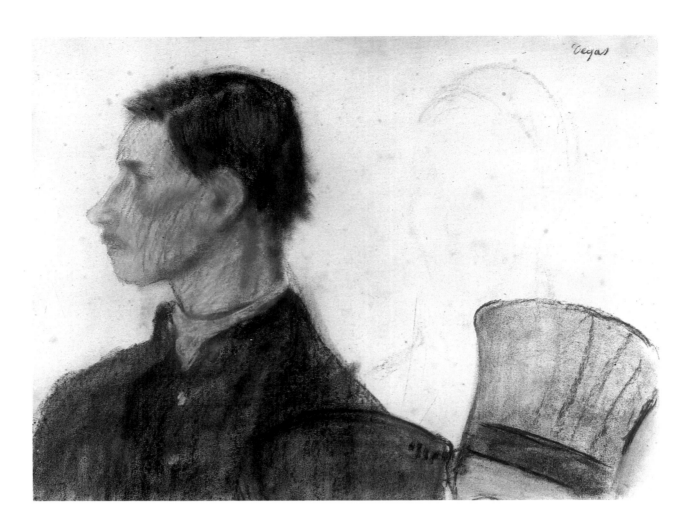

Physionomie de Criminel
(Physiognomy of a Criminal).
1881

metaphor of the picture as a stage. Real members of his family are drawn into a dramatic fiction that in turn illuminates their appearance.

There were occasions when Degas used his friends in pictorial charades. The painter Henri Michel-Lévy and an unknown woman are used like actors in the dramatic painting called *Intérieur.* We see a small, wallpapered room lit by a single lamp standing on a table in the center. Upstage right, Michel-Lévy leans against the door, hands in pockets, legs splayed, his morose features lit from below by lamplight. At the opposite side of the picture, the woman, in a long, white shift, sits with her back to him in a pose of dejected estrangement.

There are various signs of her occupation of the room: her day clothes over the end of the narrow single bed; an undergarment on the floor; her sewing box opened on the table, its interior rosy in the lamplight. The same light throws the man's shadow onto the door behind him; it expands his dark presence and looms over his head, a gigantic double.

It is a disturbing picture, filled with threat and a sense of incipient violence. What has happened between them? What is going to happen? Unknown events hang broodingly in the air. The intimate promise of the room is strained against steep perspective. Friendly lamplight turns bad, making the man's features into a mask and his shadow into a monster. The two people are thrust apart by it, not drawn together. Black : white; standing : crouching; dressed : undressed; straight : curved; facing in : facing out—every feature that can be named in each of them finds its opposite in the other. This is intimacy of a terrible kind.

It is like a reenactment of the Bellelli picture in the accents of melodrama and of other occasions when Degas had pushed men and women out to the edges, women to

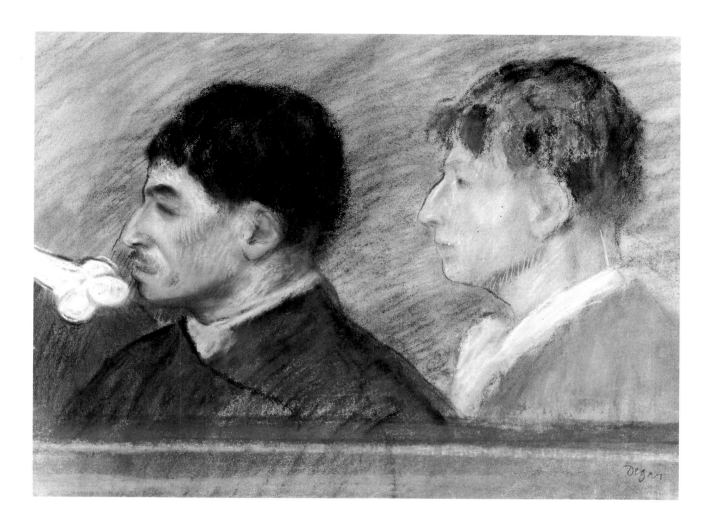

Physionomie de Criminel
(Physiognomy of a Criminal).
1881

the left, men to the right, the gap between them crossed by taunts or murderous aim: the *Petites Filles Spartiates*, the *Malheurs*, or *Bouderie*, a scene in a modern office where Duranty and Ellen Andrée scowl and pout, playing out who knows what charade Degas had set for them.

The persistence of this scheme has often been noticed and interpreted as an expression of Degas's misogyny and sexual anxiety. But we do not need to know that he was a bachelor to see how he has harnessed one of the most fundamental currents of picture-reading, by which we scan pictures from left to right, and has charged it with sexual consequence.

It has been assumed for a long time that there was some connection between *Intérieur* and the realist literature of the sixties. Duranty's novels have been searched for passages that correspond. Recently Theodore Reff has shown that a passage from Zola's *Thérèse Raquin* provides a nearly exact text. The two characters had been lovers. A year earlier they had murdered the woman's husband. Now they have themselves married. This is their wedding night. They discover that their guilt has incapacitated them. This moment is the beginning of the end for them.

Degas painted Michel-Lévy again, some ten years later. *Portrait d'un Peintre dans Son Atelier* has none of the staginess of *Intérieur*—Michel-Lévy is being no one but himself and we see him in full light—but it is an even more disturbing picture. The painter is in his shirt-sleeves, hands thrust deep into his pockets, leaning against the wall in a pose similar to the one he had taken in *Intérieur*. He is hemmed in by canvases behind him and by his paintbox and palette on a table between him and the viewer. Slumped at his feet, her head tilted back, is a studio dummy in a long pink dress and wearing a summery bonnet tied under her chin with ribbons. It is the same

La Lorgneuse,
also known as *Femme Regardant avec des Jumelles*
(Woman Looking Through Field Glasses).
c. 1865?

Femme Regardant avec des Jumelles,
also known as *Femme à la Lorgnette*
(Woman with Opera Glasses). c. 1866

She appears first in a quick note in pencil at the side of a drawing of a top-hatted Manet at the races, as though Degas had seen this woman staring through binoculars in his direction and quickly recorded the pose. Later a model whom we know only by her first name, Lyda, posed for at least four major drawings in which Degas explored the pose in different dresses and hats and with tiny adjustments of the hands and arms supporting the binoculars. Degas tried unsuccessfully to fit her in to the foreground of a composition of the races; but she is far too potent to play a subsidiary role. By her direct stare, her symmetrical frontality, the severe pyramid of her dress, and the menacing concealment of her face, she becomes one of his most aggressive images. His preoccupation with looking and with all that looking could mean is for once stated in a way that is not oblique, but unnervingly direct. The power of looking and the power of concealment are linked in a single image.

costume that the woman is wearing in the picture on the easel, a large *Déjeuner sur l'Herbe.* The dummy's eyes are as vacant as his are watchful. There is a daft tilt to her head as though she is watching birds, or as if her neck had been broken. The contrast between the two figures—between his dark, cornered stillness and the illusory animation of the lay figure—is extreme. Michel-Lévy is cast in his own person and in his own milieu, but there is an atmosphere of extreme tension in the picture, even of violence barely suppressed, as though the painting had become in some sense a self-portrait and a private reflection on the painter's lot.

Sitters as actors, pictures as scenes, the viewer as audience: whether Degas was exploring modern subject matter along the lines of figure composition or portraiture, the metaphor of the picture as theater held. The dramatic contract implicit in a classical tableau places the onlooker on a central axis. Something like this contract governs the portrait only with certain potent features of its own. The face is the psychological center of a portrait. How could it be otherwise? There is an attraction, therefore, between the face and the perceptual center of the canvas. Furthermore the face itself is directional. The pull toward the center is also a pull toward the frontal symmetry of the face, a pull that we experience at a primitive level in our own viewing. We *face* the canvas, looking to its center as to a power, as to an enthronement. Centrality persuades. What we see is how they are; it is how we take them to be. But is it the sitter himself that we see or the part that he is playing? The question reflects on us as well as "them"—that mythical entity of artist-sitter. It is a matter of credulity as well as credibility.

Degas began to ask the same questions of portraiture that he was asking of figure

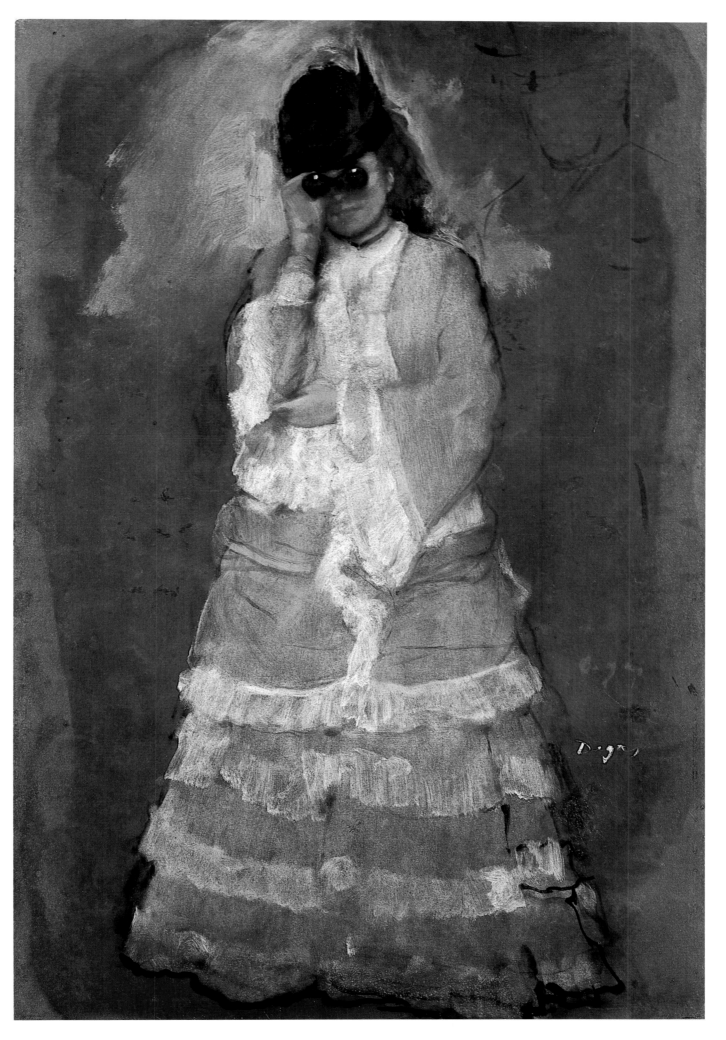

Femme Regardant avec des Jumelles,
also known as *Femme à la Lorgnette*
(Woman with Opera Glasses). c. 1875–76

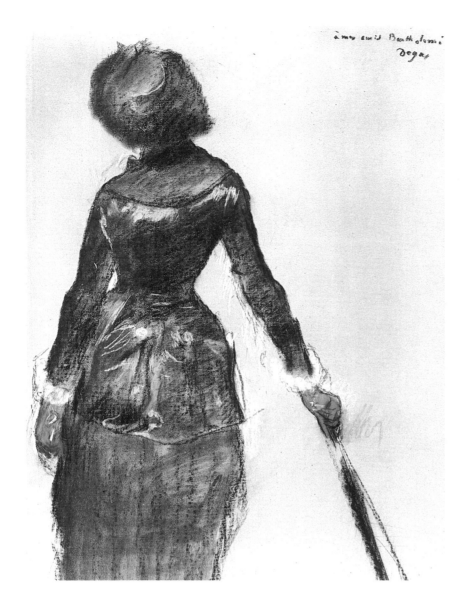

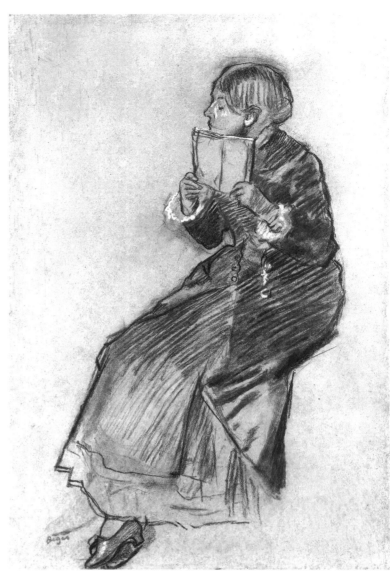

Miss Cassatt au Louvre
(Mary Cassatt at the Louvre). 1880

Femme Assise, Tenant un Livre à la Main
(Seated Woman, Holding a Book in Her Hands).
1879

painting. He addressed this issue in an early and important picture traditionally called *La Femme aux Chrysanthèmes*. A magnificent bouquet of late summer flowers occupies much of the canvas. Over to the right, almost in its shadow, staring pensively out of the frame, is a portrait of a woman. She sits as if unaware of our presence, lost in her thoughts. It is the flowers that stare back at us, offering a vigorous center to our attention. The two—flowers and woman—are painted quite differently, the flowers robustly brushed in a warm and varied palette, the woman painted thinly and delicately in cool tones.

An astonishing counterexample to the obliqueness of *La Femme aux Chrysanthèmes* is an image that he repeated several times in various mediums of an unknown woman who faces him directly and stares straight back at him—through binoculars. Her silhouette is an incisive symmetrical pyramid crowned by her dark bonnet. She supports the arm holding the binoculars with her other hand. The binoculars conceal her face like a metallic domino. Although the two circles of the binocular lenses seem to fix us, rooting us to the spot, there is awkwardness in our position in front of them. She is at the races. If she is watching the horses, we have interrupted her view. If she has playfully turned her binoculars onto us, she can see more of us than we can of her. In either case, we are in the wrong place.

Degas's concern for viewpoint—which amounted to an obsession—embraced the viewer and the viewed. The aspect that his sitters present is crucial to the meaning of

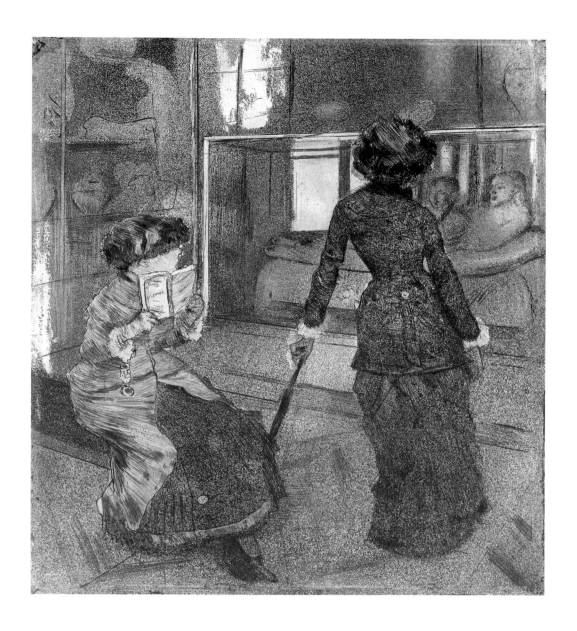

the picture: backs, shoulders, ears, even the focus of their eyes. One feature of the double portrait of his father listening to Pagans that brings music so poignantly into the picture is the distant focus of the men's eyes. It is as though we can see them following the sound. Another example of song linked to focus is the *Chanteuse de Café*. She sings forcefully, outrageously, but not, although we are right in front of her, to us. We are too close to her. Her projection goes beyond us. Her upthrust hand in its black glove gestures to an audience behind our back. And we can see clearly the paradoxical inwardness of performance: concentrated, she seems to be looking into herself as well as projecting beyond us.

In both *L'Absinthe* and *Portrait d'une Peintre dans son Atelier*, Degas comes at his subjects obliquely, trapping them within lozenge-shaped spaces, a table between us and them. He does the same in his portrait of Duranty, where the table, littered with papers, is like a parapet behind which the writer crouches, backed by bookshelves in steep perspective. The table does not act as a foreground so much as a screen, something like a theater flat on its side. We do not enter the picture by it but look over it into the reserved space of the subject whose being we watch without engagement. The geometry of these paintings relates to a trapezoid or lozenge as though the canvas itself had been turned aside from its own frontal symmetry, twisted within its own walls, away from the centralized frontality that it—and the stage—normally assert.

Mary Cassatt au Louvre: La Galerie de Peinture
(Mary Cassatt at the Louvre). 1885

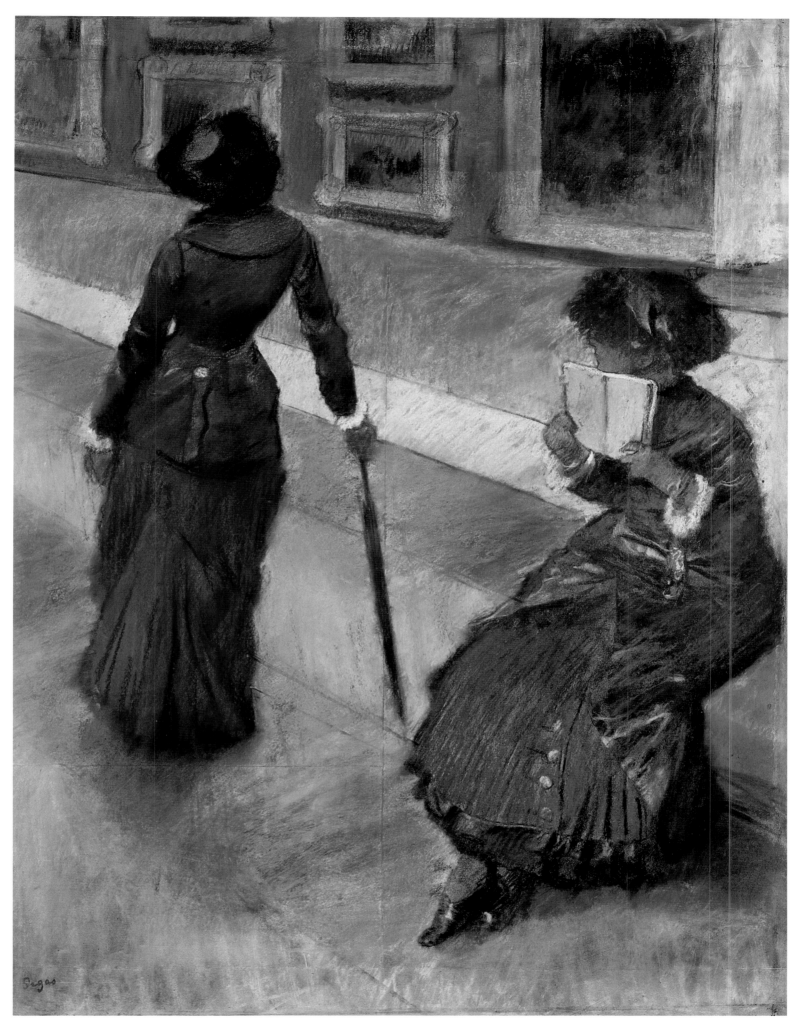

Au Louvre, also known as
Au Musée du Louvre (Miss Cassatt)
(At the Louvre). c. 1879

Unusual viewpoints promised qualities of distance, that is to say, unusual controls of likeness. Sometime in 1879, that extraordinary year in his life, Degas had jotted into a notebook some thoughts about viewpoint: "Studio projects—set up tiers around the room to get used to drawing from below and above things." And on another page: "No one has ever yet done the monuments or the houses from below, foreshortened, the way you see them as you pass in the streets." Above this note is a tiny sketch of the Pantheon from street level.

Oddities of viewpoint, foreshortening carried to an extreme degree, now fascinated Degas. They represented the utmost challenge to his powers of observation and abstraction. And in their violent deviation from the "natural" aspect, they paralleled his deviation from "natural" placement by which the center of the picture corresponds to the center of interest.

There was a painting that Degas made at this time of a circus performer whose act was to be hoisted into the dome of the Cirque Fernando by her teeth. Degas drew her from below, and there are notes in the sketchbook he used that map the seating arrangements of the circus. In the same book are studies for the *Portrait de M. Diego Martelli*—a picture in which the foreshortening is so abrupt that we have to imagine Degas standing on a chair or a stepladder to make his drawings.

Just as in the theater, the view from the box reveals the stage not as a picture, but as an open arena, a field for movement, so too Degas's stepladder view here displaces the picture-like view of Martelli's face and opens the whole canvas to likeness. A vigorous endomorph in his shirt-sleeves, his belly and chubby knees are as much Degas's subject as the intelligent Latin head. Martelli has turned his chair away from his worktable to pose. Everything in the picture is active in the portrait. The writer's round bulk is set off against the straight edges of the papers on the table, in the middle of which a shiny round ink pot condenses his presence.

Martelli is contained within the canvas, his feet tucked up under him. His slippers and the edge of the chair point from the bottom left corner to a center, the point where the corner of the chair crosses the bottom edge of the sofa. This center is progressively displaced by the edge of the table, then by the sharp edges of the papers, then by the straight edge of Martelli's shoulder, then by the junction of the floor and the wall, a series of arms that spread and sweep like a windmill. The centers of these arms move in a curve that answers the curve of Martelli's torso. Their spiraling sweeps up the curve of the sofa back, which is itself carried forward into Martelli's far side, his chest, his belly, and into the creases of his amply packed trousers.

Every form, every shape, every movement here returns us to the sitter, working not just as a sign, an accumulated attribute of his personality and *métier*, but as a factor in a dynamic event that is charged with his likeness. By looking down on him and by throwing him out from the center, Degas discovers for Martelli a larger role. His presence spreads.

Composition had now taken on a novel meaning. It is the geometry of what we see there, happening in the picture, and the geometry of how we see it. It is both choreography and perspective. Composition reveals this double meaning with any urgency only in the context of an art that gives value to looking and makes the experience of audiencehood part of its content. These were issues that all of Degas's generation were wrestling with in their own way. Only he had the analytical intelligence to see the implications of them so clearly, or the temperamental need to do so; for to make that division involves a peculiar degree of distance, a willed splitting of experience, a deliberate backing away from the oneness of perception.

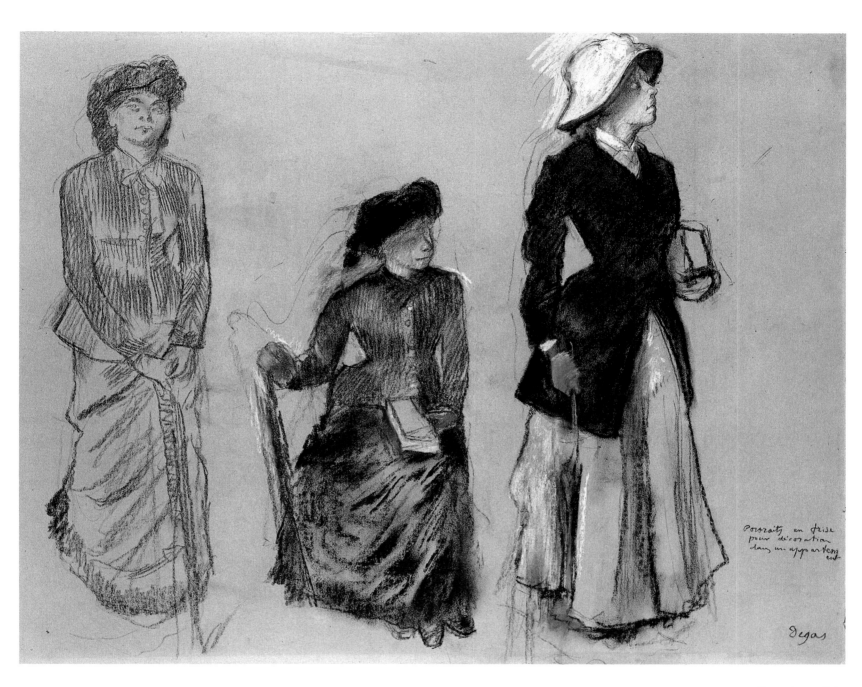

Portraits en Frise
(Portraits in a Frieze). 1879

According to Vollard, Degas harbored an ambition to paint mural decorations. The opportunity to do so never arose, nor was he commissioned to paint domestic decorations as were Monet, Renoir, and many other of his contemporaries. However, this pastel is evidence that Degas thought about the possibilities.

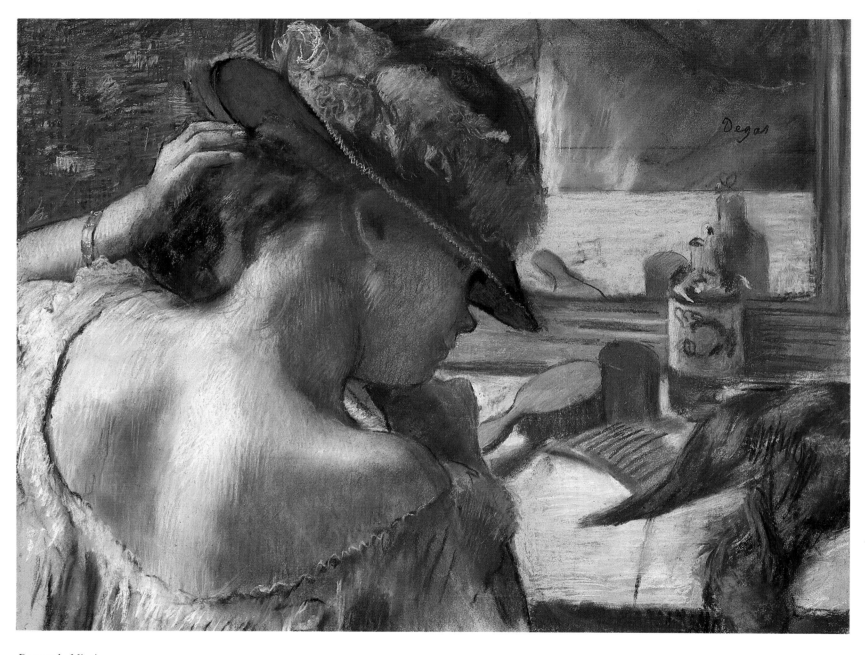

Devant le Miroir
(Before the Mirror). c. 1885–86

In a notebook that he was using during the years 1868–72, Degas made
an entry that seems to anticipate the subject of these pastels:

Devise a treatise on ornament for women or by women, according to their way
of observing, of combining, of feeling their toilette and everything. Every day
they compare a thousand visible things with each other—much more than men.

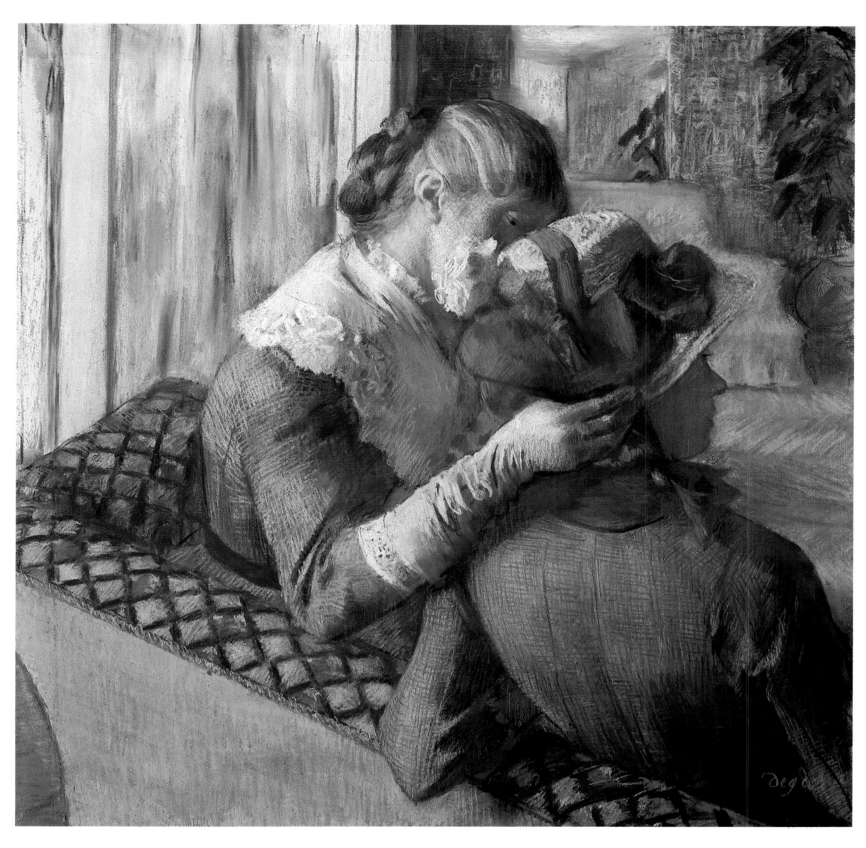

Chez la Modiste
(At the Milliner's). c. 1882–84

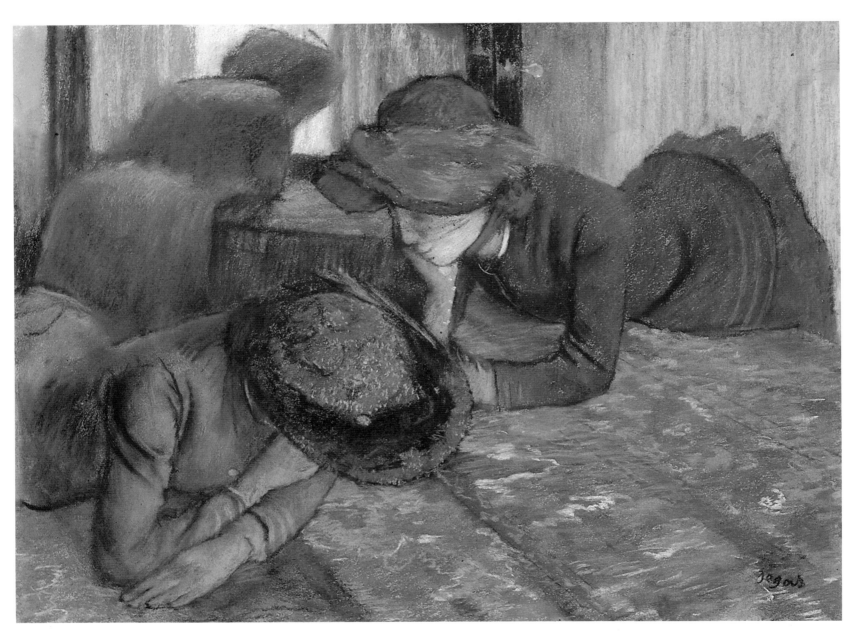

La Conversation chez la Modiste
(Conversation at the Milliner's). c. 1882

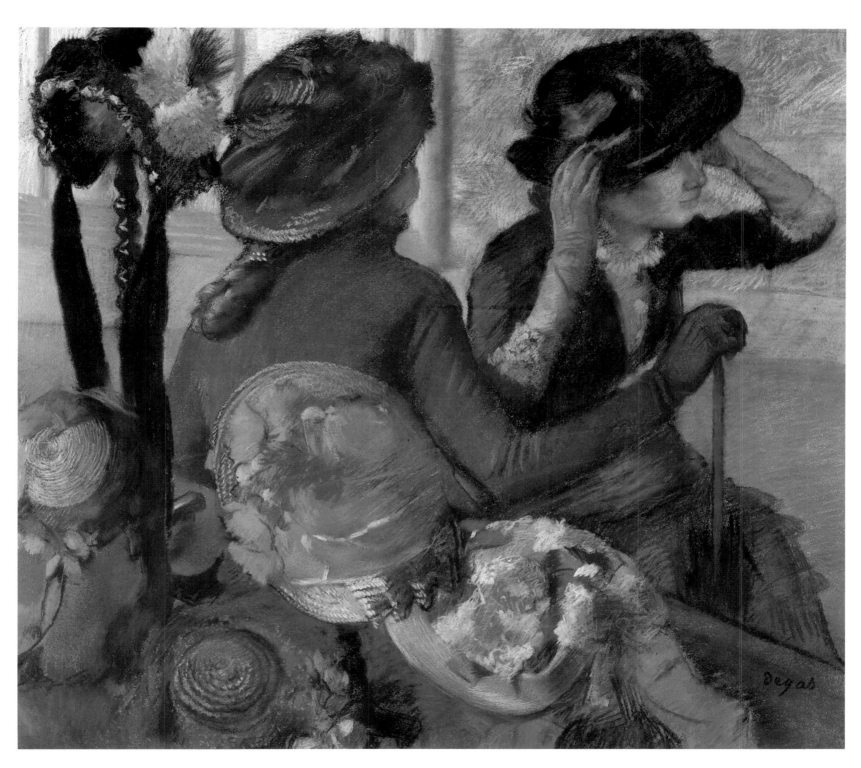

Chez la Modiste
(At the Milliner's). 1882

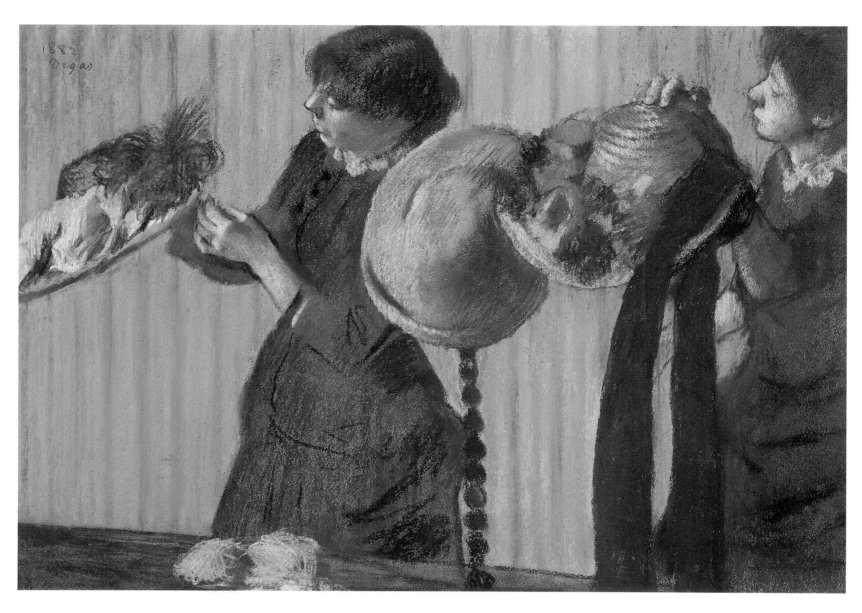

Petites Modistes,
also known as
L'Atelier de la Modiste
(Milliners). 1882

Pastel offered Degas possibilities that were beyond the reach of oil paint as he understood it. He used pastel in a way that exploited it as line and as color, making directly on the surface of the paper juxtapositions that allowed for the vivid play of simultaneous contrasts. Jeanniot remembered a particular pastel:

One woman is shown in profile trying on a hat, reflected full face in the mirror—an indefinable shade, its matte surface vaguely reminding you of certain frescoes, or fragments of them, in the Louvre. How can I say what it was like? It was so deliciously unexpected, so personal, and all in that exquisite combination of colors he liked to devise. "How you must have enjoyed finding that harmony," I remarked.

"Yes, I remembered a certain Oriental rug I saw in the Place Clichy: You must use your memory; but you know, that blue there, actually it is a cold green. . . ." As he said this, his face assumed that victorious expression I saw there only when he had achieved one of those enthralling successes which occasionally illuminate an artist's life.

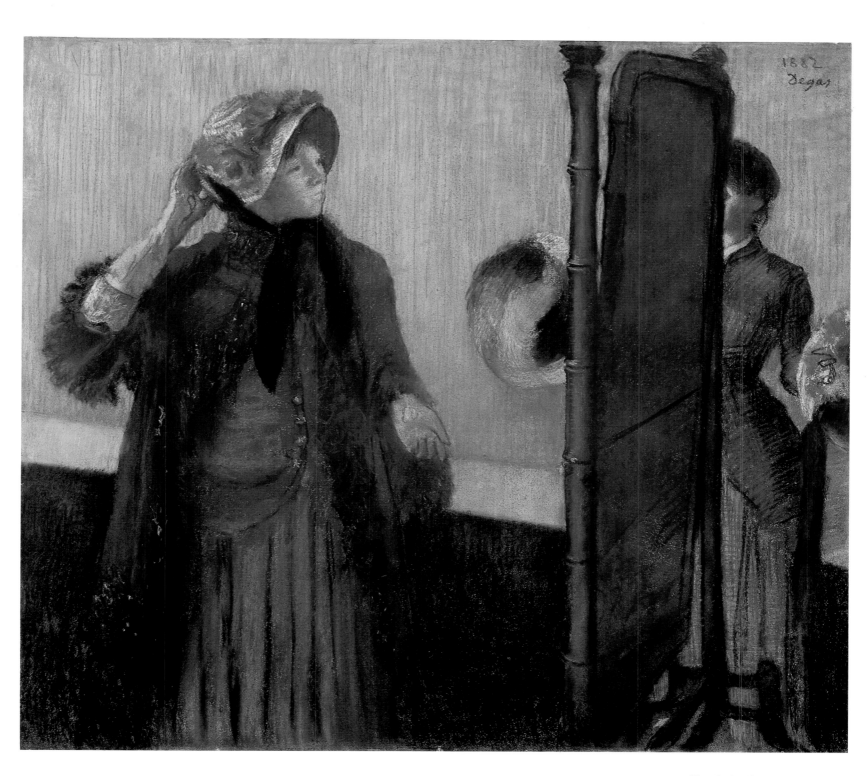

Chez la Modiste, also known as
Femme Essayant un Chapeau chez Sa Modiste
(At the Milliner's). 1882

133

Chez la Modiste,
also known as
Modiste Garnissant un Chapeau
(At the Milliner's). c. 1882–84

Femme Tenant un Chapeau,
also known as
Modiste Garnissant un Chapeau
(Woman Holding a Hat).
c. 1882–84

Modiste
(The Milliner). c. 1882

Such a splitting can become the lonely man's substitute for company. It holds a promise of control, but at the price of distance. In a mysterious way Degas's incomparable power over likeness and his originality as a composer stem from the same sources. His oblique views from the wings, his evacuation of the pictorial center, his asides glancing off his models feather-light yet pondered, his *coulisses*: all work toward likeness, a distanced command of his dancers, his friends, the world around him, beloved lay figures.

Degas was completely revising the meaning of pictorial composition. By drawing attention to the viewer's experience of looking—which is the first consequence of his decentering and cutting, his emphasis on unusual viewpoints—he is defining the sitter in a way that portrait painting had never known before. He is asserting the openness of the modern city and the nature of its encounters, where what is known of other human beings is what we make of them within the field of our own experience, and not what is laid down for us by their status and their self-presentation.

The extreme example of this splitting open of the contract that all previous portraits had insisted upon is the picture called *Place de la Concorde*, now lost and believed to have been destroyed in World War II. There is some irony in the fact that this of all pictures should be known only through photographs, for it has been discussed again and again in relation to photography. In fact the kind of hand-held snapshot that it evokes to our eyes did not exist when it was painted. Looking at reproductions of it we face a double task—to imagine it as a painting, and to imagine what it must have looked like in a world where the snapshot did not exist.

The following account was given by Marcel Guerin, editor of the Lettres de Degas:

Mme. Straus reports that Degas—who had come to enjoy it—often accompanied her to her fittings at the dressmaker's. When she was astonished, one day, at the pleasure he was taking, and asked him what so entertained him about these fittings, Degas replied, "It's the red hands of the little girl holding the pins."

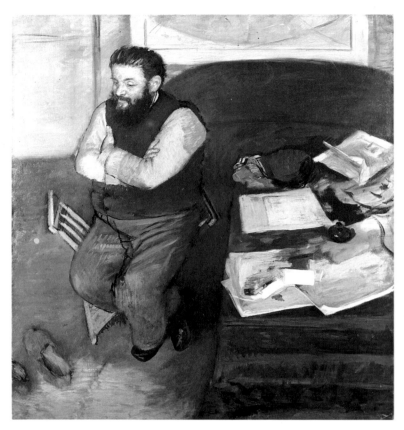

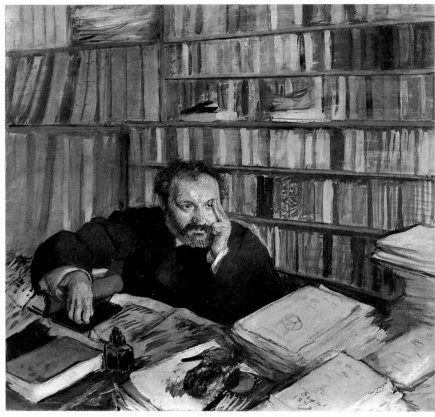

Portrait de M. Diego Martelli,
also known as *Diego Martelli*
(Portrait of Diego Martelli). 1879

Portrait de M. Duranty,
also known as *Duranty*
(Duranty). 1879

Among the realist writers with whom Degas became friendly during the 1860s, it was Edmond Duranty who most clearly shared his view of modern subject matter. As early as 1856 Duranty had written:

Why not treat man the way the landscape-painters treat the houses and the trees and the grass? I recently began looking about me, and I saw not only many colors and lines which are no stranger than those of the past, but I also saw life, a society, actions, professions, physiognomies, various milieus. . . . Individual types struck me as more than once appropriate to their professions. This society seemed to me to be expressed by differences in clothing—people wearing smocks and aprons have ideas, feelings, and faces different from those of the men who wear frock-coats. Finally, all is disposed as if the world had been created exclusively for the delight of the painters.

Of Duranty's portrait the novelist and art critic Joris-Karl Huysmans wrote:

Here is Monsieur Duranty, among his prints and his books, sitting at his desk, and his nervous tapering fingers, his sharp mocking eyes, his acute searching expression, his wry smile of an English humorist, his dry little laugh into his pipestem, all pass before me again at the sight of this canvas where the character of this curious analyst of our society is so skillfully rendered.

Diego Martelli was a Florentine writer and art critic who became a supporter of the French Impressionists. Degas made two portraits of him during Martelli's visit to Paris in 1878–79. Years later, when Martelli tried to acquire one of the pictures from Degas, the painter refused on the grounds that "Duranty didn't approve of the foreshortening of the legs." Duranty had been dead for fourteen years.

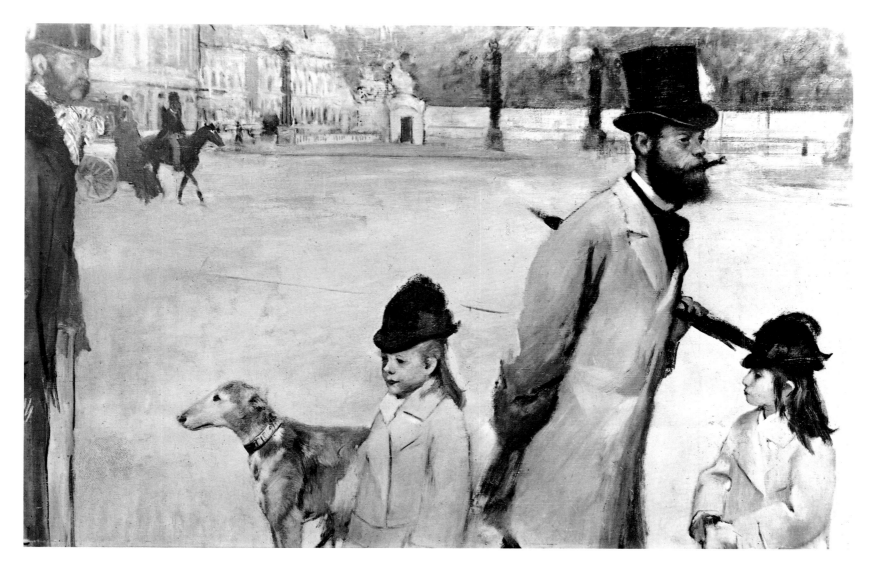

Place de la Concorde. c. 1875

The democratic eye of the camera has so transformed our expectations of images that the shock of *Place de la Concorde* has gone forever. The wonder remains that the camera in its time should have come to occupy so exactly the perceptual world of this picture.

We are out in the open spaces of the Place de la Concorde looking toward the corner of the Rue de Rivoli and the Tuileries. The buildings are described in a narrow frieze along the top of the canvas. Nearly four-fifths of the picture area is given to the empty surface of the Place. Across this emptiness there pass in a series of parts, Degas's friend Lepic, his two daughters, and his greyhound. All are cut off by the bottom of the canvas. If these had been individual, centered portraits at three-quarter length, this cut would have been invisible, but here, in a public space, it renders them fragmentary and fleeting. Lepic walks to the right, hands behind back, tightly rolled umbrella under his arm at one angle, the cigar between his teeth at another. It is a rather splendid progress. He is sure of himself, glossy in the sunshine of early summer. But he is not presenting himself. His demeanor is not central but contingent. We watch his stroll, and he is almost out of our view. Even so, it is our view of him that dominates, not his. Nor is his progress augmented by the girls, who have turned back as if to follow the dog, which points its fine nose toward a tall gentleman, sliced lengthwise by the left edge of the canvas, who watches Lepic's retreating back.

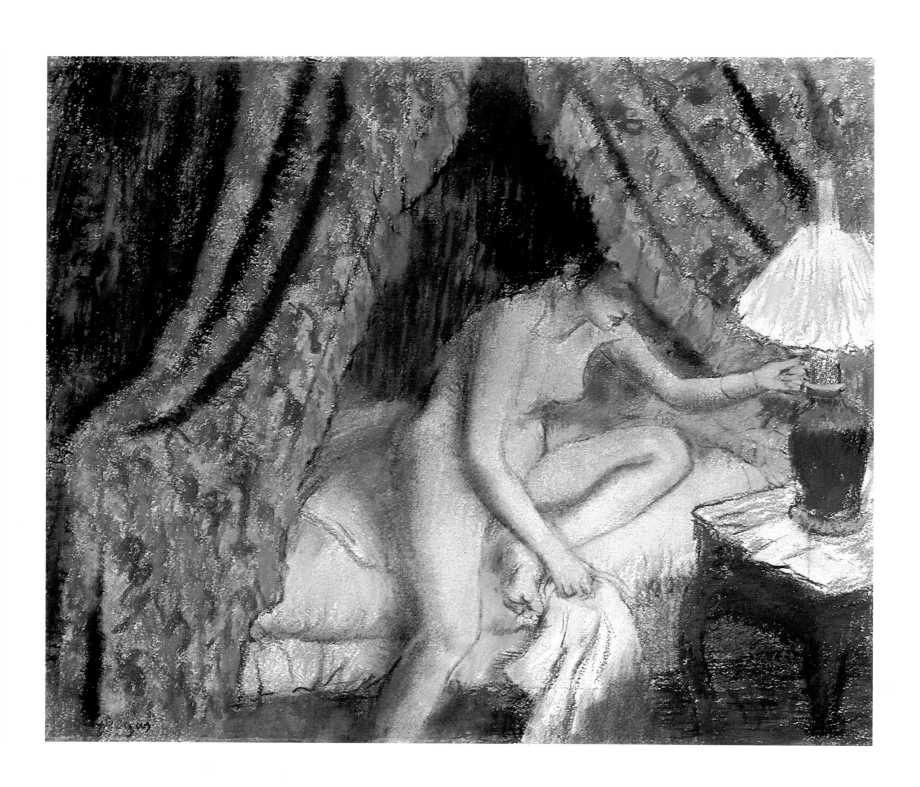

Pantomime

Degas had the good nature and the high spirits that attend a sense of great power exercised in the proper channel, and therefore profoundly satisfied. The sensation that seemed to me to be perpetual with him was comparable to the irrepressible laugh of a boxer who gets in blow after blow exactly as he intended.

WALTER SICKERT, *The Burlington Magazine*

Degas's zest for the human comedy in conjunction with his ability as a draughtsman-caricaturist make him the greatest illustrator between Goya and Picasso. There is narrative in almost everything he does, either explicit or implied. The telling takes place on many levels. At one extreme it is precisely represented, as in *Intérieur* or *Place de la Concorde*, where the onlooker is drawn into something like a pictorial charade; at the other extreme the "story" unfolds namelessly through our reading of the forms of the picture. These two extremes act upon each other.

For twenty years, from the Bellelli's apartment to the *modiste*'s shop, the descriptive and the overtly psychological are in the ascendancy. From the eighties, pictorial structures become the story. The bathers turn their faces away. The story, the befores and afters, are buried within the forms, not laid out in clues that we can put a name to. Portraits interest him less. The dance pictures are about the dance, less about life backstage.

The change represents a gradual withdrawal from the public arena, a retreat into the studio, and the abandonment of, or perhaps simply a loss of interest in, narratives of modern life. No doubt there were external, biographical reasons for this; but there were also reasons internal to the working experience. Work is not a passive reflection of intention: work reveals, opens new channels of feeling. Artists follow their work as well as lead it. The experience of new techniques, printmaking and sculpture, contributed massively to Degas's later work.

Le Coucher
(Retiring). c. 1883

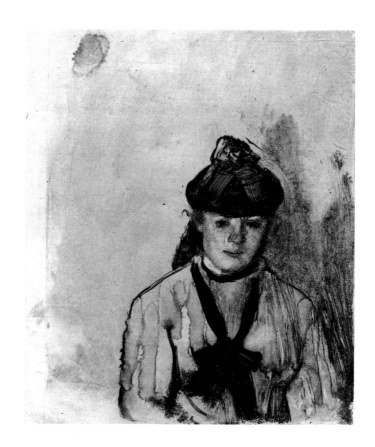

Ellen Andrée, also known as *Buste de Jeune Femme*
(Portrait of Ellen Andrée
[formerly Portrait of a Woman]). c. 1876

OPPOSITE:
Les Deux Amateurs
(The Two Connoisseurs). c. 1878

Dans l'Omnibus,
also known as *Omnibus de Voyage*
(In the Streetcar). c. 1877–78

Both brought him to a consideration of sequence in a new key—printmaking because of its focus on repetition and the sequence of states internal to each print, and sculpture because of its inescapable address to movement in three dimensions. Experimentation released new subjects. Above all this was true of the technique of monotype, which proved extraordinarily fertile for Degas, redefining drawing and in the end suggesting new attitudes to pictorial form.

Degas's first experience in printmaking was in his early twenties before the Italian journey. He was shown how to etch by his father's friend Prince Grégoire Soutzo. The first etchings are of imaginary landscapes inspired by illustrations for an English translation of *The Iliad*. In Rome, during the winter of 1857, he became close to the painter-printmaker Joseph Tourny, who continued his education. Degas copied Rembrandt, and the self-portrait etching *Edgar Degas, par Lui-Même* is the reward of these studies. Back in Paris, he made occasional etchings for several years, notably three portraits of Manet around 1866–68, and then appears to have dropped it, taking it up again only in the middle of the following decade.

For about four years, from 1876 to 1880, printmaking obsessed him. "Degas . . . is no longer a friend, is no longer a man, is no longer an artist!" Marcellin Desboutin, himself a printmaker, wrote in a letter to Mme. de Nittis in July 1876, "he's a *plate* of zinc or copper blackened with printer's ink, and this plate and this man are laminated by his press, in the gears of which he has vanished altogether!"

In 1876 Degas had been shown the technique of monotype by Ludovic Lepic, and his first monotype—an image of the *maître de ballet* Jules Perrot—was signed by both artists. For at least the next decade monotype was a favorite technique. It was rapid and direct, the ink being applied directly to the plate without biting or cutting, and it allowed for the utmost flexibility and improvisation. The image could be manipulated by addition or subtraction, by being painted on or wiped off. Printed, it gave an immediate and suggestive sense of light. As a technique for graphic improvisation it had no equal.

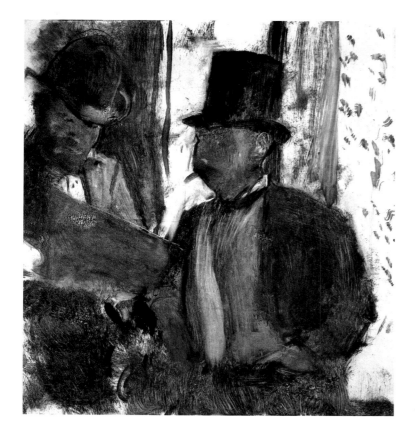
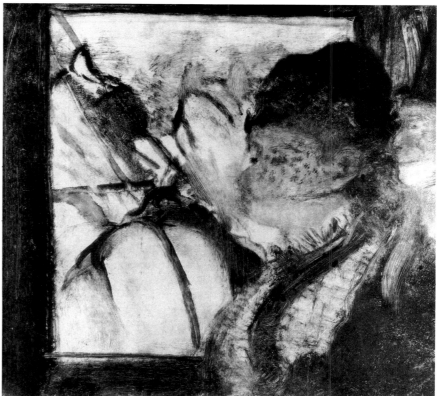

Monotype is the least indirect form of printmaking. The plate is left smooth and untouched. Ink rests on the surface of the plate and is pressed off onto the paper directly. Only one strong print results. Degas would often put the first print aside and would make a second, a ghost of the first, and work into it with oil or pastel. The print acted like a toned ground in which the presence of his subject was already embedded. In the *Café-Concert* at the Corcoran Gallery of Art, for example, the monotype base can be read throughout the picture and Degas's pastel can be seen cutting into and elaborating the dark undertone.

Degas made monotypes of all his current subjects—the ballet, the café, laundresses—and of subjects from the street that do not appear anywhere else in his work. In style they range from the delicate, controlled portrait *Ellen Andrée* (The Art Institute of Chicago) to images in which he joins in a crazy game with the ink, dabbing it with his fingers or pushing it about with a brush or rag, conjuring faces and figures out of the darkness like luminous phantoms.

The portrait head in Chicago of a young woman in a hat is like an exquisite brush drawing carried off with extraordinary clarity. The head is lit as if from a lamp slightly to our left. Light falls full on her face. Shadow fills the right corner of the page. Her tam-o'-shanter and the big bow hanging round her neck are a rich velvety black. There is a particular luminosity about the image that goes beyond this description of the direction of the light, a glow that is as much present in the shadows as in the lights. Its source is the interaction of ink and paper. The paper gives back some of its luminosity through the ink, reminding us of the quality of light in a watercolor, here bound into a powerful tonal framework.

Degas's manipulation of the ink is visible in every nuance of the light, in the diluted but firmly drawn stripes of the dress or the dabbled roundness of her head, into which one can read his fingertips and the point of a rag. As he lifts the ink from the plate he is uncovering light. One senses his plastic involvement and the identification of light and copper.

Nowhere does Degas's wit as an illustrator join more dazzlingly with his skill at improvisation than in his image of a rather flashily dressed woman and her goofy companion on a bus. Their presences seem to grow spontaneously out of the manipulation of the ink. The ability to read life into the material in this way is akin to the gift of impersonation. Paul Valéry tells the following story about Degas the impersonator:

He described to me, one day, an observation he had made on top of his streetcar the night before. . . . He said that a woman got in and sat down not far from him, so that he noticed the care that she took to be seated comfortably, so that her clothes would be properly arranged. She ran her hands down her dress, smoothed it out, settled herself and sank back into her seat so as to fit more securely into its curving back; she pulled on her gloves more tightly, buttoned them carefully, ran her tongue over her lips which she nibbled a moment, shifted within her dress as if to be certain she was at ease in the layers of warm linen. . . .

The streetcar shook and started up. The lady, properly installed in her seat, remained a good fifty seconds in this perfection of her entire being. But then, at the end of this interval, which must have seemed an eternity to her, Degas (who had mimed to perfection what I am so laboriously describing) realized that she was dissatisfied: she straightened up, turned her neck back and forth within her collar, flared her nostrils slightly, pursed her lips, and then resumed her rectifications of posture and appurtenance. . . . A whole quite personal labor, followed by a new apparently stable state of equilibrium, though one lasting only for a moment.

Degas, for his part, resumed his pantomime for me. He was enchanted.

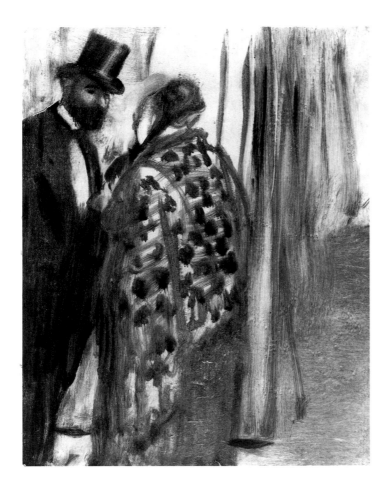
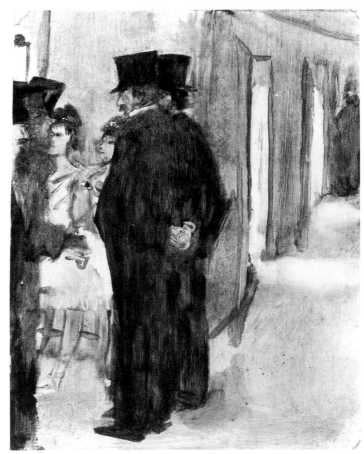

Conversation (Ludovic Halévy et Mme. Cardinal)
(Conversation [Ludovic Halévy and Mme. Cardinal]).
1876–77

*Pauline et Virginie Cardinal Bavardant
avec des Admirateurs*
(Illustration for "La Famille Cardinal").
1876–77

*Several Degas monotypes illustrate precise
episodes from three of Ludovic Halévy's stories.
The following passage is from Halévy's "Madame
Cardinal," written in 1870:*

*A stout lady, carelessly dressed, an old plaid shawl
around her shoulders, and huge silver spectacles on
her nose, stood motionless, leaning against a flat in
the wings of the Opera, and from there, as though
in a trance, fastened her squinting and brimming
eyes on the stage. . . .*
*I went up to the stout lady and touched her
lightly, from behind, on the shoulder: "Good
evening, Madame Cardinal," I said. . . . "How are
you?"*
*"Fair, fair," she answered, "not too bad, thank
you."*

The monotype process exposes his improvisations, his readings and revisions, giving impetus to his incomparable power as an illustrator. It was a magical device that he had under his hand, giving back life and light with each move he made.

A monotype called *Les Deux Amateurs*, which is taken to represent Paul Lafond, the curator of the municipal museum at Pau, the first public collection to own a work by Degas, and the collector Alphonse Cherfils, is an example of the brilliant way in which Degas exploits the qualities of the medium in the service of illustration.

Two men are examining a drawing. They have moved over to the window for a better view. Daylight streams in over their shoulders. The man in the bowler, who holds the drawing, is the expert. He is tilting the drawing to the light, his head bent over it eagerly. His top-hatted companion is taking it calmly, cigarette in mouth, hands in pockets.

Each element in this scene comes over simultaneously as an event in the ink and its interplay with the paper; the thick, black, precisely expressive shape of the top-hatted man grows out of formlessly brushed ink, his silhouette defined by fierce wiping that cuts the light of the window around his nose and shoulder and the sharp edge of the topper. His ear is drawn with a scraped mark that releases a line of light. His nose is drawn with a touch of ink added, a slow, pondered, epigrammatic accent. The drawing that the bowler-hatted man is holding is a thinly washed plane, its edge defined by a scratched line. The eager face above it is in shadow but filled with a reflected glow from the white surface of the picture that we cannot see but only imagine. His attention, the intensity of his stare, is given back by this reflected light.

Degas's friend Ludovic Halévy, librettist and playwright, had published a collection

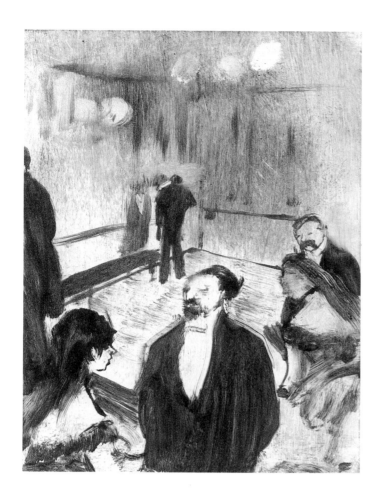
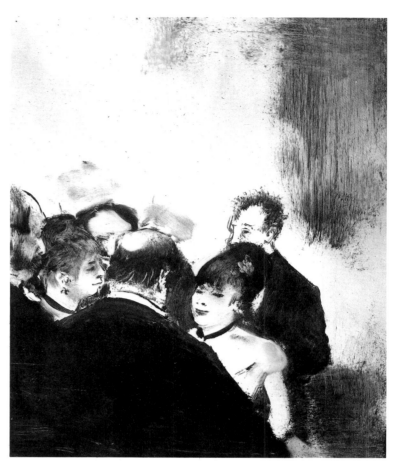

of stories about backstage life at the Opera, "Mme. et M. Cardinal" which appeared in 1872. The stories, which dealt in an ironic and worldly tone with the adventures of two young dancers caught between mercenary parents and predatory admirers, were a popular success. Degas formed the idea of making illustrations for them. They were in monotype, to be reproduced in heliogravure. Halévy is said to have found them too unspecific, but an edition entitled *La Famille Cardinal* was published in 1938 using the Degas illustrations.

They are lighthearted and witty. Halévy, elegant and saturnine, appears in several illustrations exactly as he does in the pastel of him backstage chatting with Albert Boulanger-Cavé. In *Conversation (Ludovic Halévy et Madame Cardinal)* he is facing Mme. Cardinal, a round, dumpy figure. The two personalities are given in the language of shapes: Halévy's tall black form completed by his shining top hat, the mother oval-shouldered, wrapped in a long shawl, the strings of her bonnet hanging down. These broad characteristics are minutely particularized: the top hat juts forward at an exact angle, alert and worldly; her person is fully revealed even though her face is turned away and all we can see of it is a single soft curve beyond which a tiny but precise hint of pince-nez protrudes. A dumpy hand is raised as she speaks. His hands are not to be seen: we imagine them outside the picture, behind his back.

The whole image springs from Degas's manipulation of the ink, as if he were breathing life into it, reading its potential, fanning it in the way that it wants to go, toward a moment of recognition, a spark that catches. In *Pauline et Virginie Cardinal Bavardant avec des Admirateurs* there are, at the left, four top-hatted gentlemen in a semicircle around the two dancers, who are backed against the wall, fluttering with

Halévy's "Les Petites Cardinal," 1875, followed:

We were in the wings . . . there were wonderful old wings in the Opera, with all those dim little corners and those smoky little lamps. We had picked up the two little Cardinal girls in one of these wings, and we were asking for the pleasure of their company the next evening—for dinner at the Café Anglais. They were dying to come, the two little Cardinal girls, but Maman would never let them, never, never. . . . You don't know Maman! . . . And suddenly there she was, right there in the wings, this formidable mother.

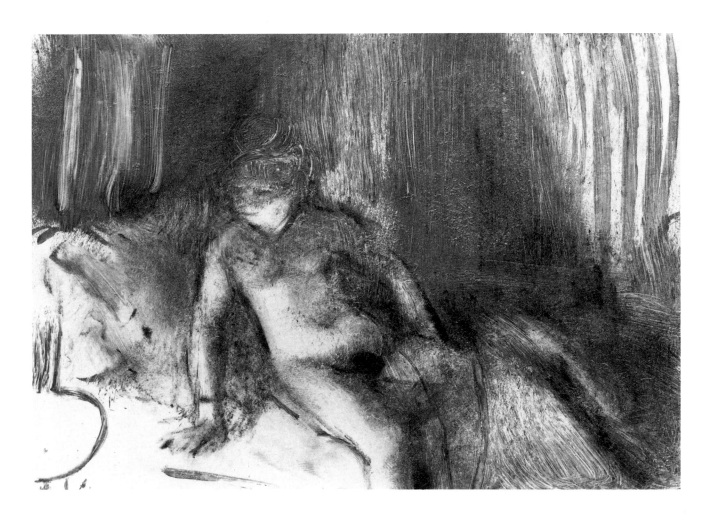

Attente, formerly *Le Coucher*
(Waiting). c. 1879

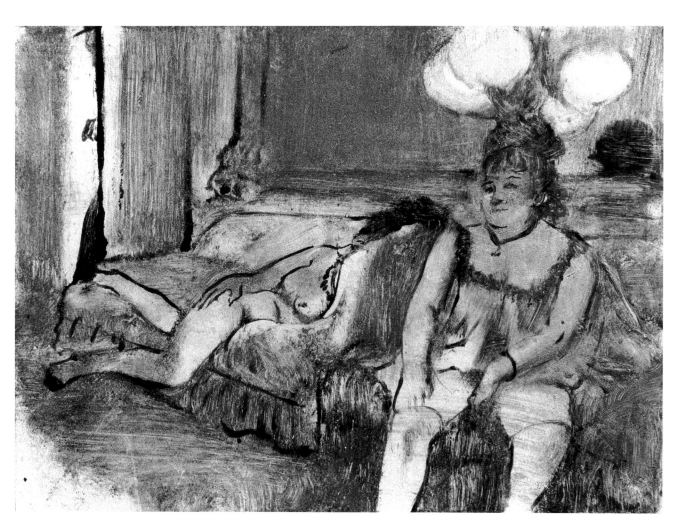

Repos
(Rest). 1876–77

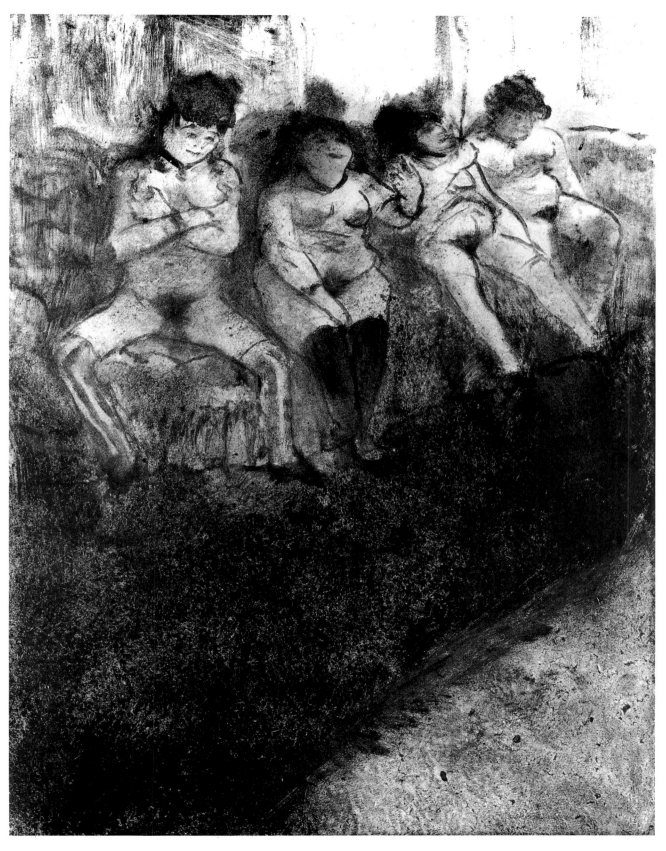

L'Attente, Seconde Version
(Waiting, Second Version). 1876–77

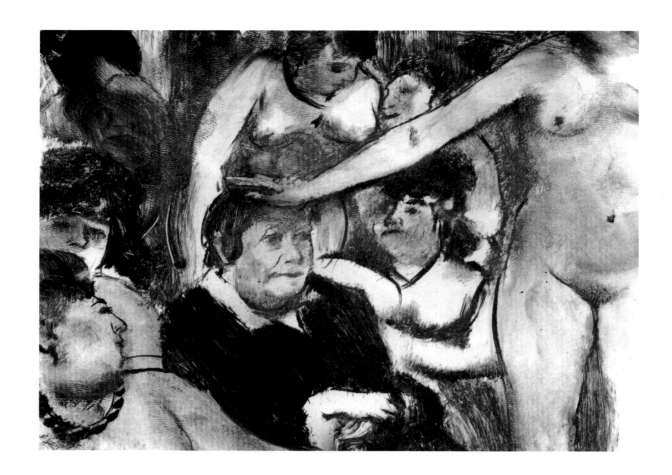

La Fête de la Patronne (Petite)
(Saint's Day of the Madame,
small version). 1876–77

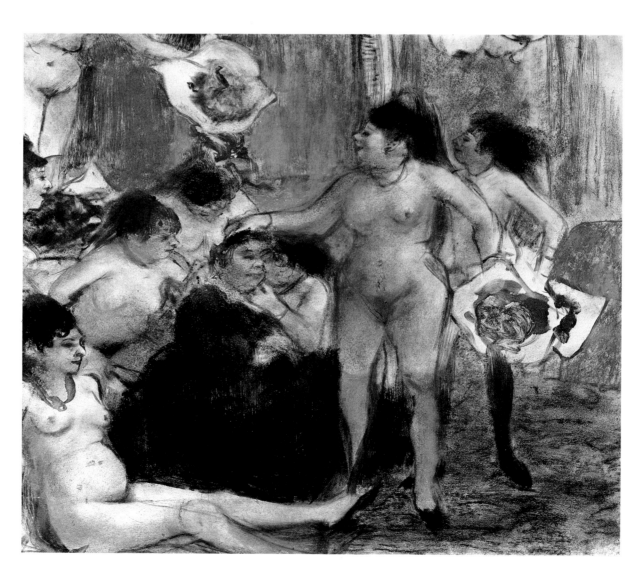

La Fête de la Patronne
(Saint's Day of the Madame). 1876–77

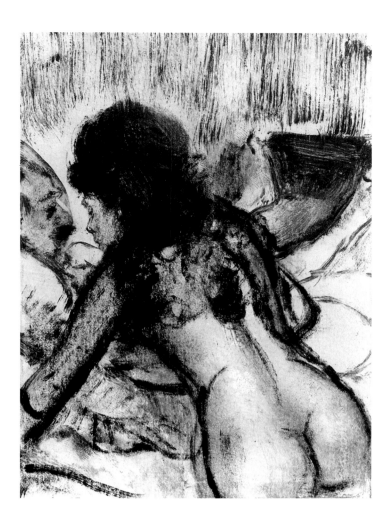

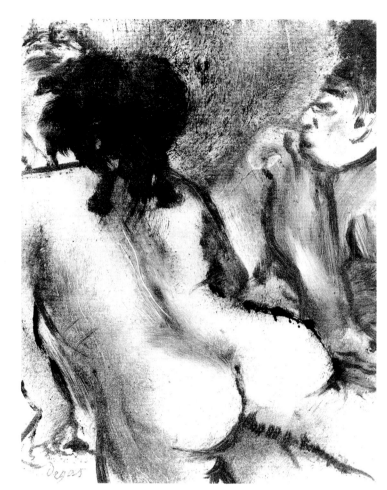

Conversation. 1876–77

L'Entremetteuse
(The Procuress). 1876–77

delight at an invitation to dinner. To the right a corridor runs back into the distance and at the end is a little black oval blob. It is Mme. Cardinal approaching. She will put a stop to the fun. This blob, featureless and without arms or legs, is as precisely and exactly the mother as the detailed figures in the foreground are themselves. Degas's ellipsis is like a stammerer's wit: the joke discharges itself in the slight hesitation, the pause given to our recognition.

For Degas, Ingrist draughtsman for whom line was the mind and conscience of art, who disclaimed spontaneity and improvisation, the practice of monotype must have been a kind of transgression. Here he is not drawing with lines but with wiped edges, not thinking of divisions but of the whole plate, in which nuances of light and dark, background and foreground are in continuous play. The graphic act is unbridled by the medium: unbridled imagery results.

There must be a connection between his experience of the monotype technique and the emergence of louche subjects, the brothel scenes with their parsnip-shaped whores and their ludicrous, adoring, or bashful clients, and with the appearance of a genuinely erotic imagery beyond laughter in which forms and rhythms of terror and desire weave their way secretly in the darkness. The imagery emerges out of the ink— out of Degas's willingness to project into it, to allow its life and physiognomy, to acknowledge it as a kind of black magic, the medium of fantasy.

The whores in *Attente, Seconde Version* are a gang of clowns, formidable and funny, rocking the sofa with their laughter, showing their parts like hairy traps. Laughter breaks taboos: a more terrible excitement is allowed to rise. In *Attente* the woman is waiting alone on the edge of her bed. She is lit from below by the bedside lamp. Her

In nineteenth-century Paris the maison de tolerance *was a legally recognized public place of amusement where respectable husbands found relaxation and school boys were initiated. The life of the inmates was a popular subject among realist writers at the time that Degas was making his monotypes. On two occasions he considered illustrating stories—Edmond de Goncourt's* La Fille Elisa *and Guy de Maupassant's* La Maison Tellier*—but the series of about fifty monotypes he did make do not relate to a text. They tell his own story, set in a brothel of his imagination.*

Talking about the way Degas treated this subject, Renoir told Vollard, "When you paint a brothel . . . it's always hideously depressing. Only Degas can give that kind of subject an atmosphere of delight and at the same time the quality of an Egyptian bas-relief. That . . . chaste quality which makes his work so elevated—it intensifies when he deals with whores."

right side is flooded by light. Her shadow looms enormously on the wall behind her. The angle of the light throws her brow and the shelf under her eyes into shadow. Her eyes are slits. She turns her head alertly like a cat listening. The heavy hair is raised like a coil on her head, twisted out of the ink with the bristles of a stiff brush that raises fine white lines in a coil. Out of the corner of one's eye, in the half-light, the hair becomes a horned headdress, demonic, a horned cat's head.

Degas explores these forbidden terrors, but then pulls back from them. A print called *Femme Nue dans Sa Baignoire* is one of a small group of nudes that are violently and crudely wiped out of a thick black ground; they are the most extreme of his images, almost bestial. His subject's hand has the form of a paw. Her weighty shoulders and simian head seem to be modeled out of the tarry substance that she is sunk into. A pastel made from the second printing *Femme dans Son Bain Se Lavant la Jambe* puts her in a more reasonable light. Human proportions return. Her head is delicately poised on a neck, not a lump of muscle. The slant of her features is reversed. A welcoming towel lies across the chair. Daylight skims in from the window, putting refreshing greenish lights on the surface of the bath water. The black monoprint is like an ambivalent dream.

Any artist will experience different relationships with the medium. At some times and in some working moods it will be obedient to intention; at others it will assert a life of its own. A painting that is planned, whose ideas develop through stages, is likely to demand a subservient *matière*. A painting that is open to improvisation, emergencies, sudden revelations, will relate to its medium as to a living organism. This is one way of describing the great alternative fantasies of art and the connections between art and the experience of being in the world. Schools have been founded on this difference. Probably with the greatest, matters proceed in polyphony, division and fusion ebbing and flooding like the tides.

Degas's first affinities were with an academic tradition in which the medium, whether pencil or oil paint, was inevitably subservient to the idea. It is difficult to imagine Ingres willingly changing his mind because of the paint. But in the forbidden world of Delacroix there was to be found an invitation to a different relationship. In spite of Degas's polemical disclaimers there is spontaneity and a vividly particularized transaction with the medium in almost everything that he did: it is the equivalent of wit.

An extreme was reached with the "landscapes" that he made out of oil paint monotype and pastel. They astonished his friends, and Degas had fun with his explanations. He called them dreams, acknowledging the element of projection in their making. He did not have to be in the country to make them, he told Ambroise Vollard teasingly: "From time to time, when I travel, I stick my nose out the train door." The eye, looking and dreaming both, was the agent of metamorphosis, the medium its magic. "Without even leaving home, couldn't you do all the landscapes in the world with a vegetable soup and three old brushes stuck into it?" One landscape, a cliff that corresponds exactly in its topographical outlines to the motifs that Monet had painted on the Normandy coast in 1882, was drawn over the naked figure of a woman. Her limbs and breasts become the rolling mounds and hollows of the cliff top. Halévy tells of Degas coming to lunch with a piece of granite in his hand that he had picked up on the street. He was enraptured by it, by the line of one of its edges, and held it up to the light. He saw a shoulder in the rock, and in the shoulder he saw a cliff: "And I know what the sailors call it, the Cap de la Belle Epaule."

Femme Nue dans Sa Baignoire,
also known as *Femme au Bain*
(Female Nude in Her Bathtub). c. 1879–83

Femme dans Son Bain Se Lavant la Jambe
(Woman in Her Bath Washing Her Leg). 1883–84

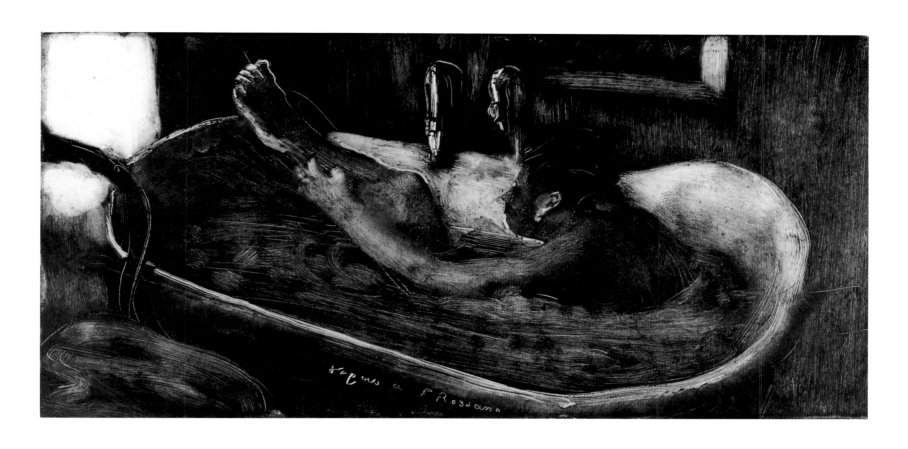

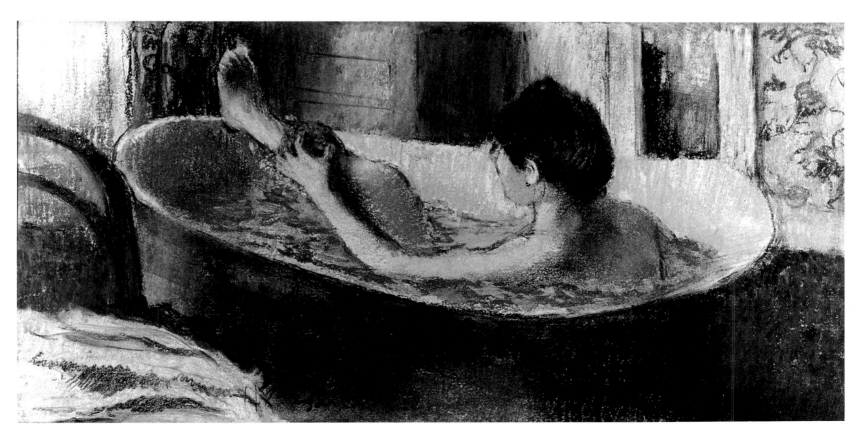

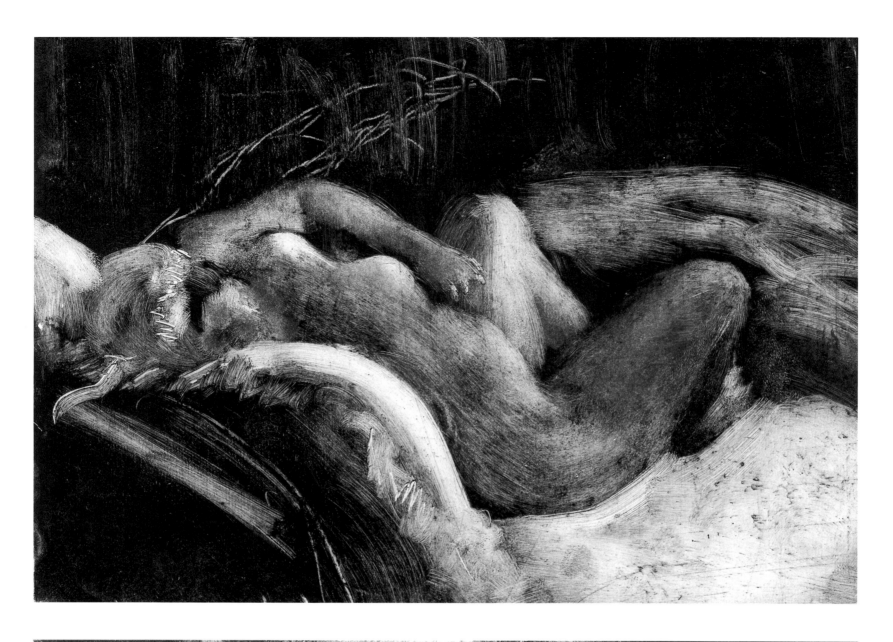

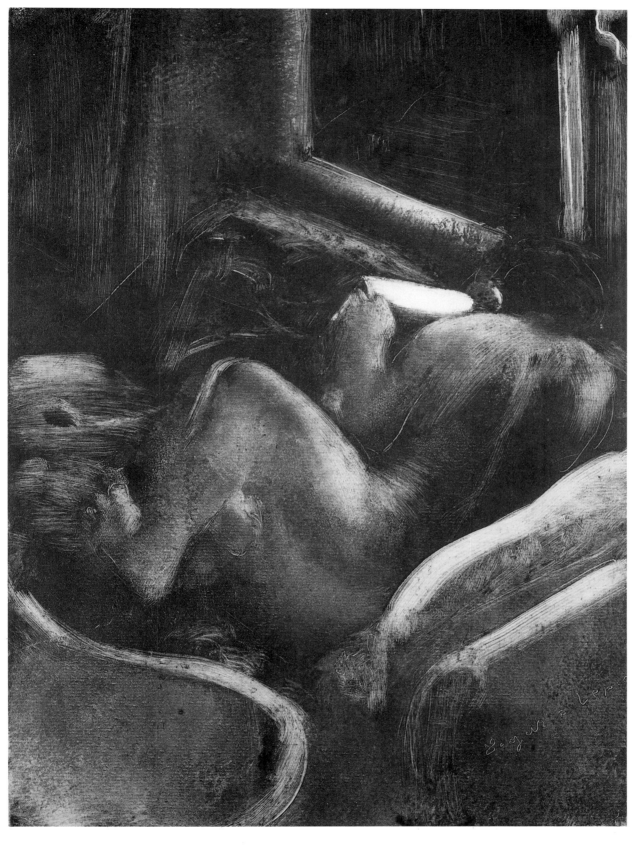

Liseuse (Reader). c. 1879–85

Evidently these prints of bathers wiped out of a dense black ground had a special importance for Degas. Four of them were dedicated to friends while he was making them; he scratched the dedication into the wet ink. The inscriptions were to Philippe Burty, a critic and a great connoisseur of prints, the painter Michel-Lévy, a ceramicist called Rossana, and Vicomte Lepic, who had first initiated Degas into the technique of monotype. Although the images appear crude at first sight, the ink can be seen to be manipulated with the utmost finesse and there is meaning in every nuance, from the direction and speed of the wiping, to the way the edges are found.

In these dark monotypes Degas brings the forms of his naked subject close up to the viewer, condensing the space beyond. They anticipate the structure of his late pastels in which deep perspectives give way entirely to a shallow relief space.

OPPOSITE:
Femme Nue Allongée,
also known as *Le Sommeil*
(Sleep). c. 1879–85

Femme Nue Etendue sur un Canapé
(Female Nude Reclining on Her Bed).
c. 1879–85

151

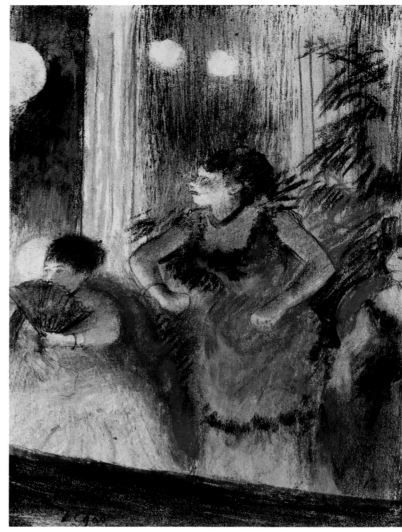

La Chanteuse de Café-Concert
(The *Café-Concert* Singer). c. 1876–77

Mlle. Bécat aux Ambassadeurs,
also known as *Divette de Café-Concert*
(Mlle. Bécat at the Café des Ambassadeurs).
c. 1877–78

Two contemporary accounts of the café-concerts, the first by Paulus describing the singer Emélie Bécat, and the second by Anatole France:

During the summer of 1875, a delightful young woman made her debut at Les Ambassadeurs, inaugurating the epileptic *genre: this was Bécat. . . . She seemed to have quicksilver in her veins, running, leaping, twisting this way and that with teasing, appealing gestures which were always telling. With this, eyes and a smile that promised everything, a delicate, rounded waist and exquisite legs shamelessly revealed by her short gown. She would sing "Le Turbot et la Crevette"; nothing could have been sillier. . . . There was no need to understand anything more than this: that the singer was enchanting and that the audience devoured her!*

At a distance, the Ambassadeurs, the Horloge, and the Alcazar seem to be enchanted palaces. Those glistening garlands formed of opal globes, those fiery gates of a fairyland architecture, those great trees to which the brilliance of gaslight gives the precious lustre of emerald and which seem steeped in a magical atmosphere; those brilliant gowns, those naked arms and shoulders, glimpsed through clumps of shrubbery in a Moorish salon—this is the Pavilion of Armida in the cool of the night. What delight for uncultivated minds! What refreshment for body and soul! What voluptuous treats for a lawyer's clerk or a ministry functionary! I would be the first to be seduced, the author of these very lines, if there were not two things missing, two essential things: silence and mystery.

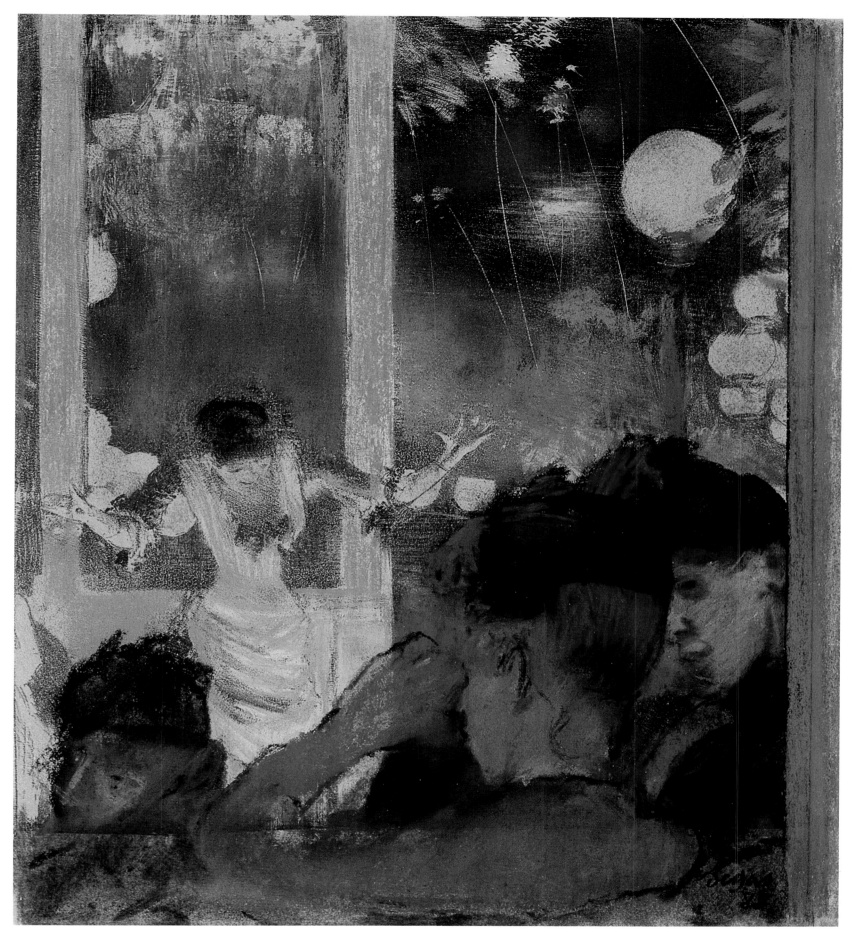

Mlle. Bécat aux Ambassadeurs,
also known as *Aux Ambassadeurs: Mlle. Bécat*
(Mlle. Bécat at the Café des Ambassadeurs). 1877–85

153

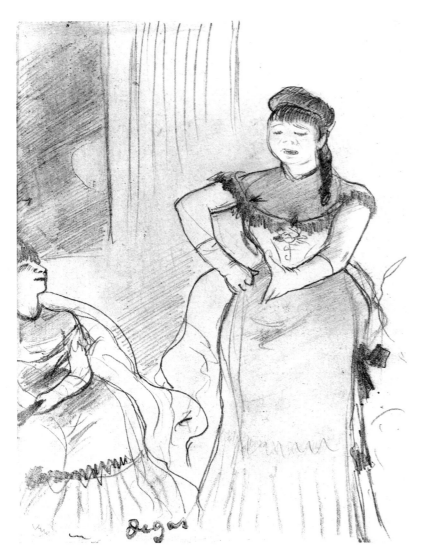

Chanteuses de Café-Concert
(*Café-Concert* Singers). 1877–78

Chanteuses de Café-Concert
(*Café-Concert* Singers). 1877–78

OPPOSITE:
Les Blanchisseuses, also known as
Le Repassage Les Blanchisseuses
(The Laundresses). 1879–80

Les Blanchisseuses, also known as
Le Repassage Les Blanchisseuses
(The Laundresses). 1879–85

Degas reworked his drawings in several ways. Reversing them by tracing or transfer was a favorite method that allowed him to see them afresh. The illustrations of the café-concert singers are on a single sheet of paper thin enough for the drawing on the recto to be seen and traced on the verso. Degas plays variations on the image, suppressing the seated figure on one side and bringing out the shadow on the wall and developing a subtle effect of light on the singer's face. Particularly interesting is the change in the singer's action that results from her different orientation in the two drawings. In one, the stretched hand seems to oppose our reading of the space of the drawing, which flows from left to right. In the other, the stretched hand seems to follow the direction of our reading in a swelling, long-drawn movement. It is as though we hear two different songs. In each case the rest of the drawing complies with this impression—the first bare and harsh, the second softer and more nuanced.

Another favorite way of reworking was to take a print and work over it with pastel or paint. Invariably this led to a transformation of scale and a shift of subject. Here the etching of the laundry, made with some sort of wire brush as well as with orthodox etching tools, becomes larger and clearer as it is reshaped by pastel. The steamy atmosphere clears, and a sharper light breaks over the figure in the foreground, who loses her features but gains in mass. Everything else seems to become larger: the ironing table projects toward the door and the laundresses bend more weightily across it. Through the door the approaching woman has turned into a blinkered horse.

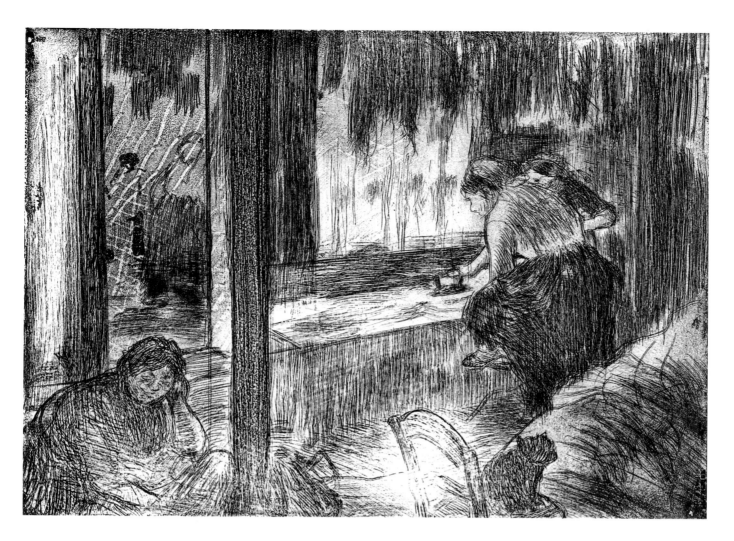

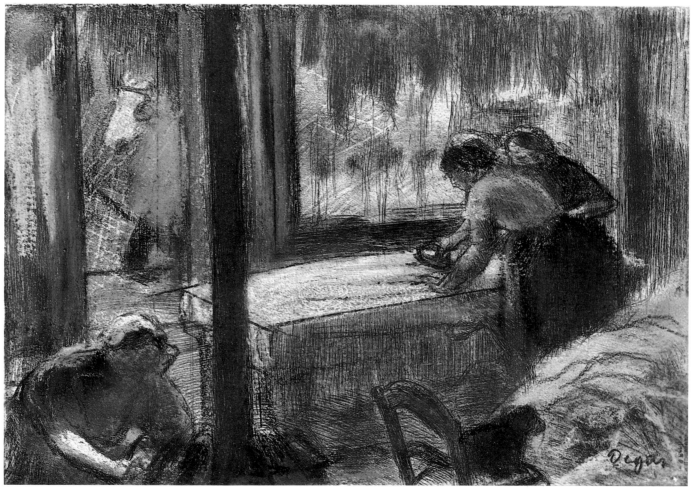

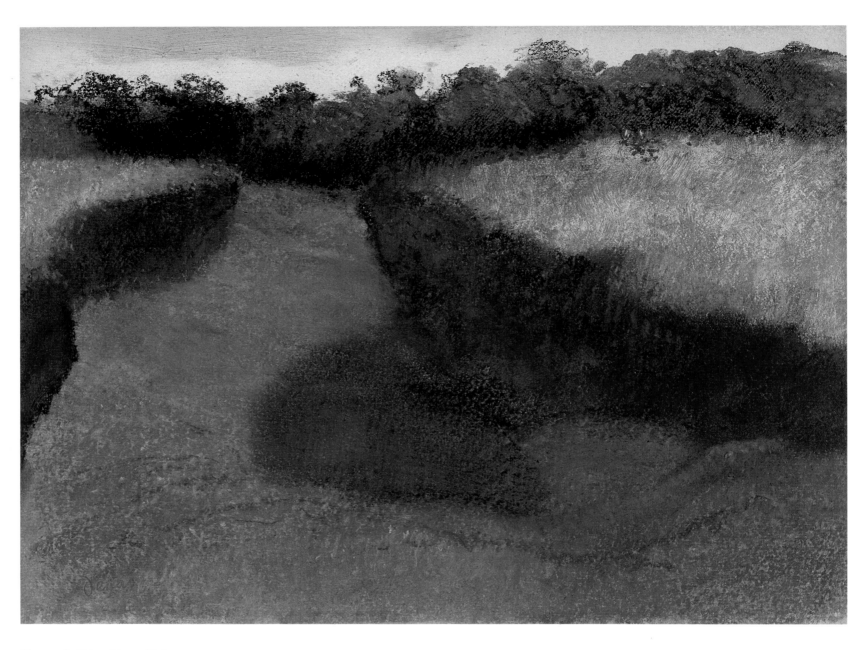

Champ de Blé et Ligne d'Arbres
(Wheatfield and Row of Trees). 1890–92

Daniel Halévy remembers that autumn when Degas "became a landscape-painter":

The notion came to him one summer, during those long train rides he would take trying to rest his troublesome eyes. Sitting in the corner of a car and always looking, looking as hard as he could—could he stop looking? the whole business of his life was in the plunder of his gaze—he had glimpsed, divined, perceived valleys, trees, rocks, plains, and once back in our Montmartre, brooding over all that had diverted him, he took up pastels and paper and worked in secret. . . . One day he announced: "I've finished eighty landscapes!" Everyone exclaimed: "Eighty landscapes?" "Yes, fantasies, dreams. . . ." "A landscape," someone said, repeating Amiel's remark, "a landscape is a mood, a state of mind. . . ." Degas didn't like that formulation at all, he suspected it of being literary, and he stubbornly remarked: "Well, no, a landscape is a state of the eyes."

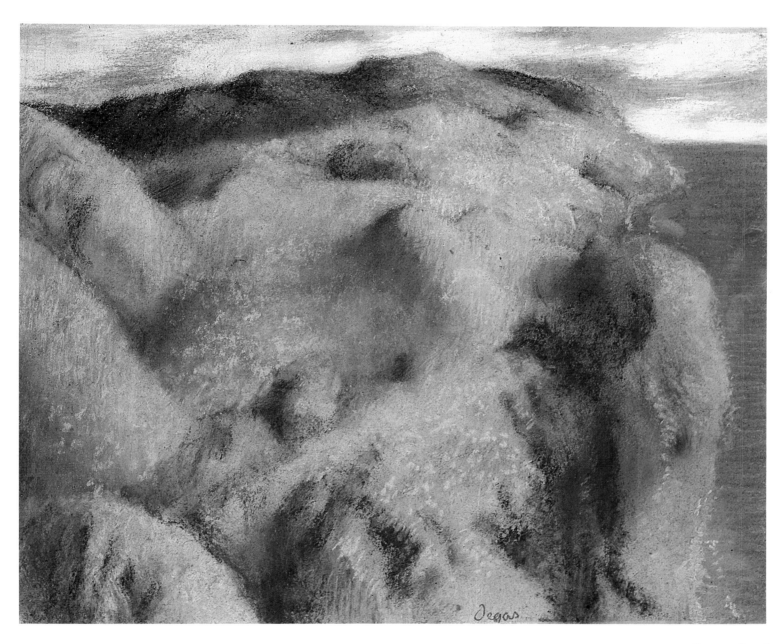

Paysage (Landscape). c. 1892

The following story, told by Halévy, is relevant to this pastel, in which Degas is playing with analogies of human and landscape form:

The highways department of the city of Paris began repaving the Rue de Douai. The edges of the sidewalks were marked by some fine granite stones, cut lengthways. To match these stones the workmen would pound them to pieces right there in the street, and there were fragments lying all over the ground. These pieces were what interested Degas. He picked them up, studying the shapeliest ones; some he found magnificent. One day, when he came to lunch, he walked in proudly, a lump of granite under his arm. He showed it to us: the break had produced a sort of curve that he couldn't stop caressing, admiring, holding it to the light to admire it the more: "What a line," he kept saying, "as fine as a shoulder! I'll make a cliff out of it, seen from out at sea. . . . A cape, and I know what the sailors call it, the Cap de la Belle Epaule."

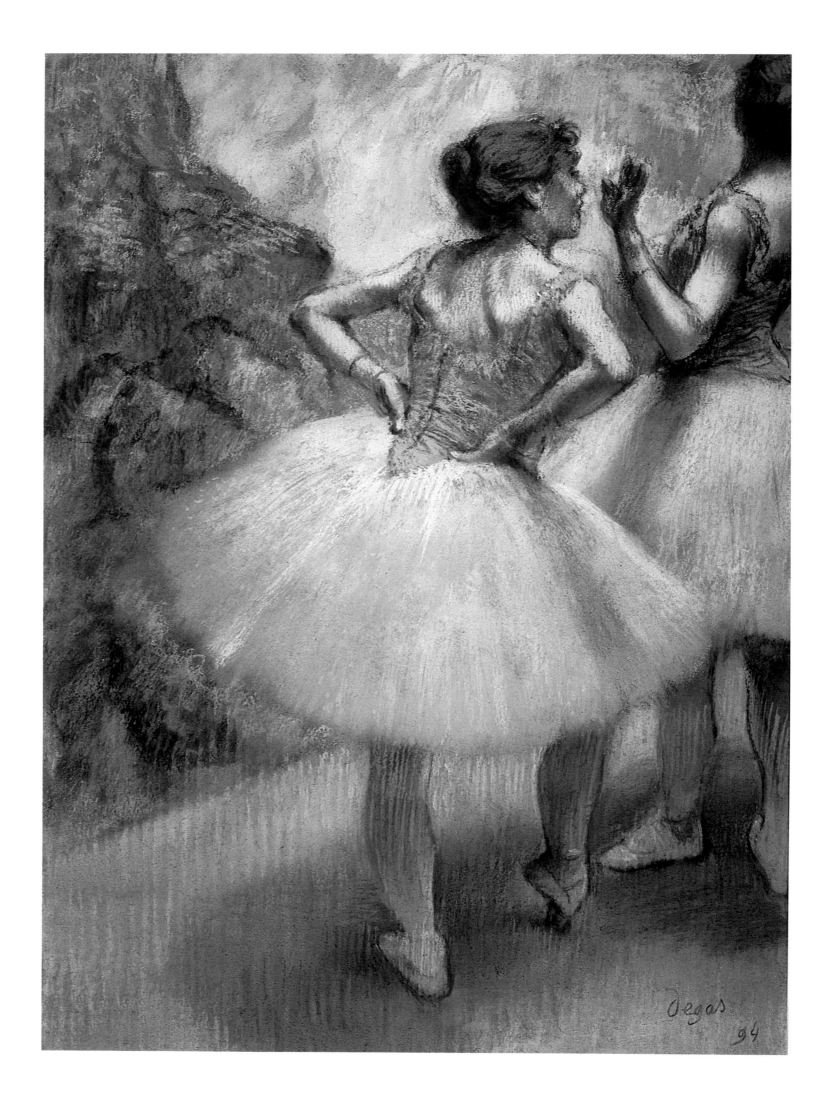

His models are . . . very particular products of contemporary civilization, of its luxury, of its power, of its poverty and above all its physiological collapse. No longer the dancer, Muse or Grace of the classical artist, of Mantegna for example, of robust, healthy, complete contours who dances slowly as she eats, as she drinks, as she sings, for the pleasure of it, letting her limbs assume, quite freely, postures suggested to her by her natural grace and her need for movement. His is the dancer by will, by ambition, by penury—and by her need for repose. Above all, his is the dancer by training.

ROBERT DE LA SIZERANNE, *Revue des Deux Mondes*

Degas's attachment to the ballet as a subject lasted all his working life. It was by far the most important of all his subjects, and half his mature work relates to it. From *La Source* to the last dancers there are around fifteen hundred drawings, paintings, pastels, and sculptures. They reflect the changing character of his art, moving from scenes of theatergoing and life backstage as seen through the eyes of a sophisticated *flâneur* to strenuous studies of dancers practicing, resting, and performing, to the last pictures, in which Degas seems to be inventing his own dance, choreographing the forms of the picture to purely decorative ends.

When, at the time of the *Petites Filles Spartiates*, Degas made his swerve away from the ideal toward the particulars of modern life, it cannot have been without questions. Was he condemning himself to description only? Where among the top hats and frock coats was the language of the body, the grand rhetoric of gesture and athletic pose to be discovered?

I have argued earlier that for Degas the theater was more than a subject for naturalistic description but, because of its metaphoric relationship to pictures, it offered an opportunity for thinking about pictures in new ways. Here I am extending the point to the dancers themselves. They were his allies, the inhabitants of a figure art that was emptied of useless cargo of sentiments and ideas.

The dance was supremely and self-evidently an art of the body. It was also chaste, artificial, the upshot of rigorous preparation and practice. Repetition took place in the dance studio tirelessly. It was not improvised but practiced in the most extreme sense, to the point of pain and deformation. When a dancer returned to a position again and again she was like a model taking up a pose; but also like a painter, making a drawing, repeating it, tracing it, learning it by heart. And when she performed, her performance was effortless in its appearance, filled with an abstract joy. "Nothing in art must look like an accident, not even movement."

Although this achievement, her performance, involved a total control of her body in space, it had a front and a back, just like a picture. The positions, for all their spatial extension, were orientated to a frontal axis. The positions were named for their

Danseuses, Rose et Vert (Pink and Green). 1894

159

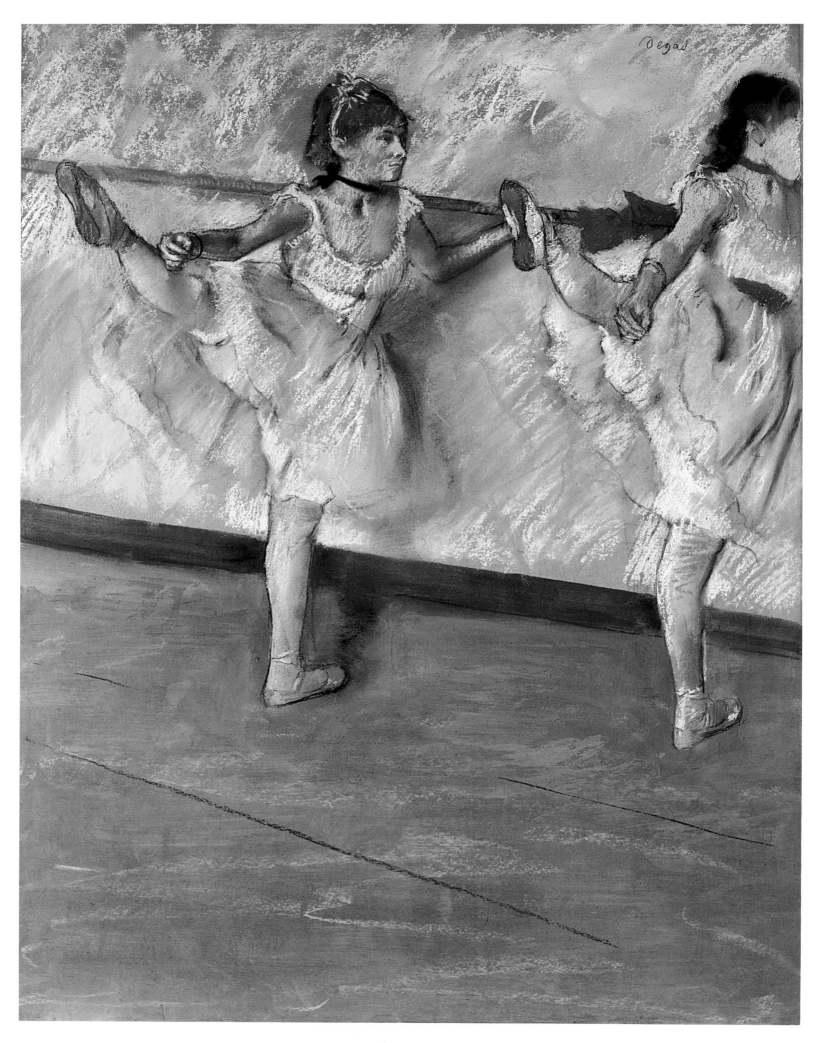

Danseuses à la Barre
(Dancers at the Barre). c. 1877–79

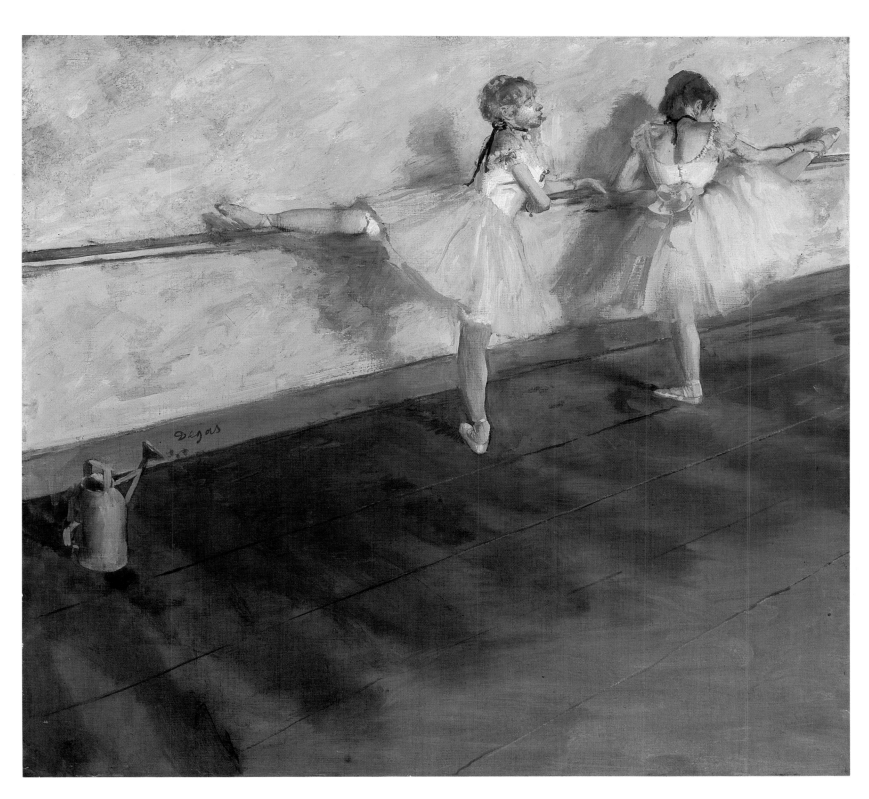

Danseuses à la Barre
(Dancers Practicing at the Barre). 1876–77

The following passage is from J.-K. Huysmans's 1883 review of "L'Exposition des Indépendants" that appeared in L'Art Moderne:

The rest-period is over, the music grinds up again, the torture of the limbs begins all over, and in these pictures where the figures are often cut by the frame, as in certain Japanese images, the exercises accelerate, the legs are raised in cadence, the hands grip the barre running around the walls of the room, while the toe-slippers frantically thump the floor and the lips automatically smile. The illusion becomes so complete when the eye fastens upon these dancers that all of them come alive and gasp for breath, the cries of the dancing-mistress seem to fill the air, piercing the shrill chatter of the room: "Heels out, hips in, chests up, now bend!" and at this last command the great développé *occurs, the leg raised high, raising with it the blur of skirts, then comes to rest, tense, on the highest barre.*

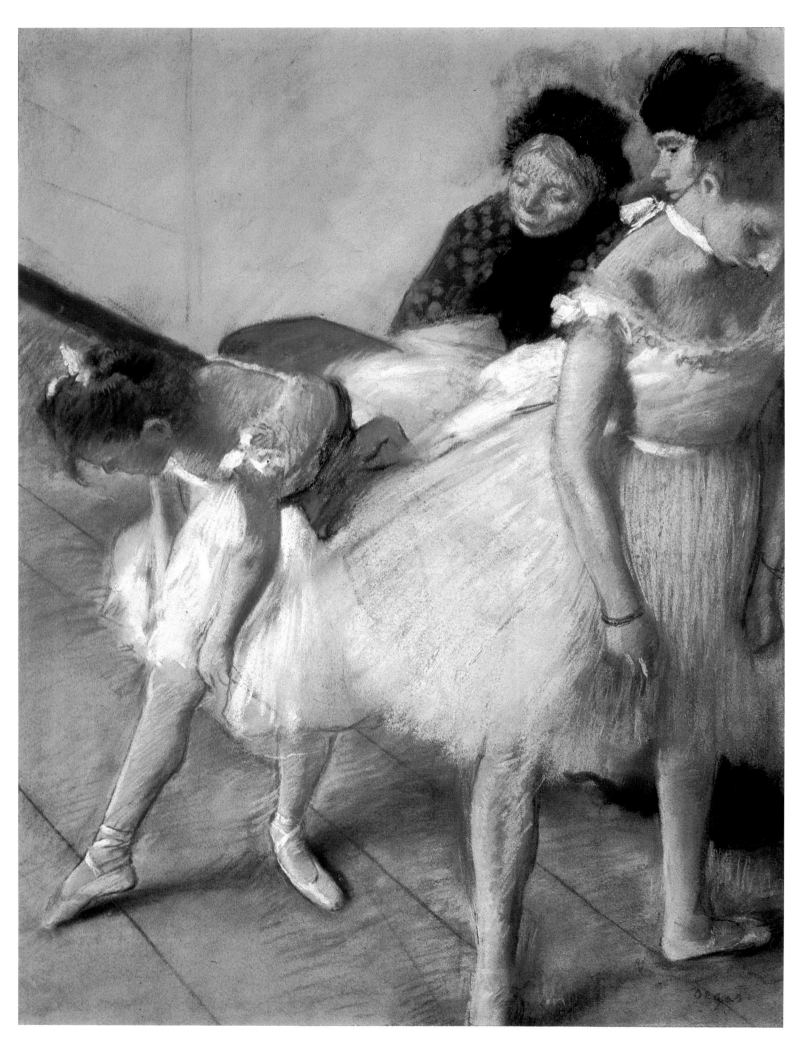

Examen de Danse,
also known as *Danseuses à Leur Toilette*
(The Dance Examination). c. 1879

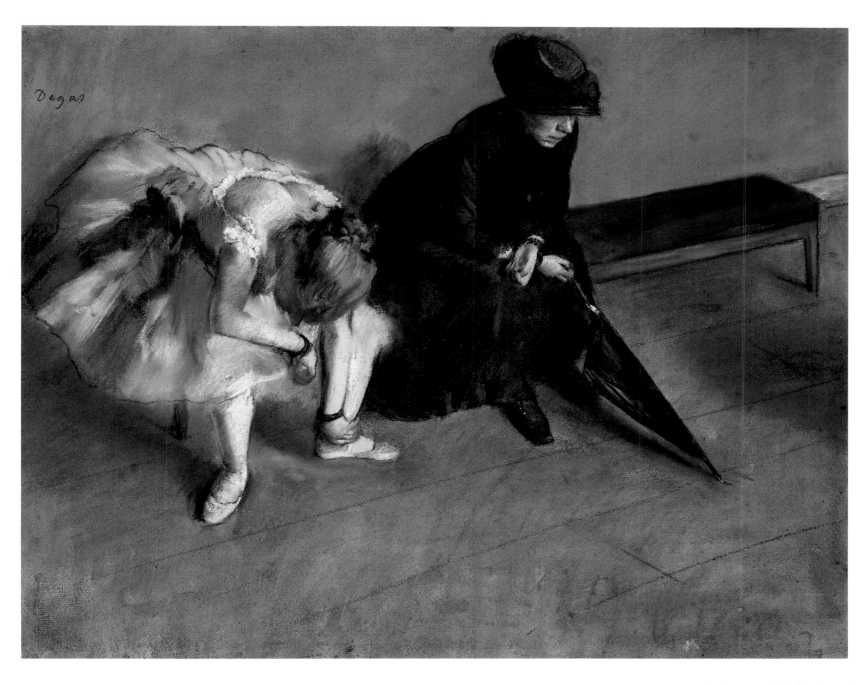

Degas was particularly fascinated by the frontiers between the ballet and the world that surrounded it, between the dance and ordinary life, represented by the audience, backstage admirers, or the mothers and elder sisters who helped the dancers dress or kept them company. He liked to dwell on the specialized and artificial character of the dancers' bodies and poses, seen, as here, against women in street-clothes. All this was consistent with his ideas about a modern naturalistic art that illustrated a social context.

 J.-K. Huysmans's response to Examen de Danse *was published in* L'Art Moderne:

What truth! what life! how all these figures stand free in the atmosphere, how the light bathes every detail of the scene, how the expression of these countenances, the boredom of a laborious mechanical labor, the watchful gaze of the mother whose hopes are raised as her daughter's body drudges away; the indifference of the others to fatigues they know only too well, are emphasized, are recorded with an analytical perspicacity which is at once cruel and subtle!

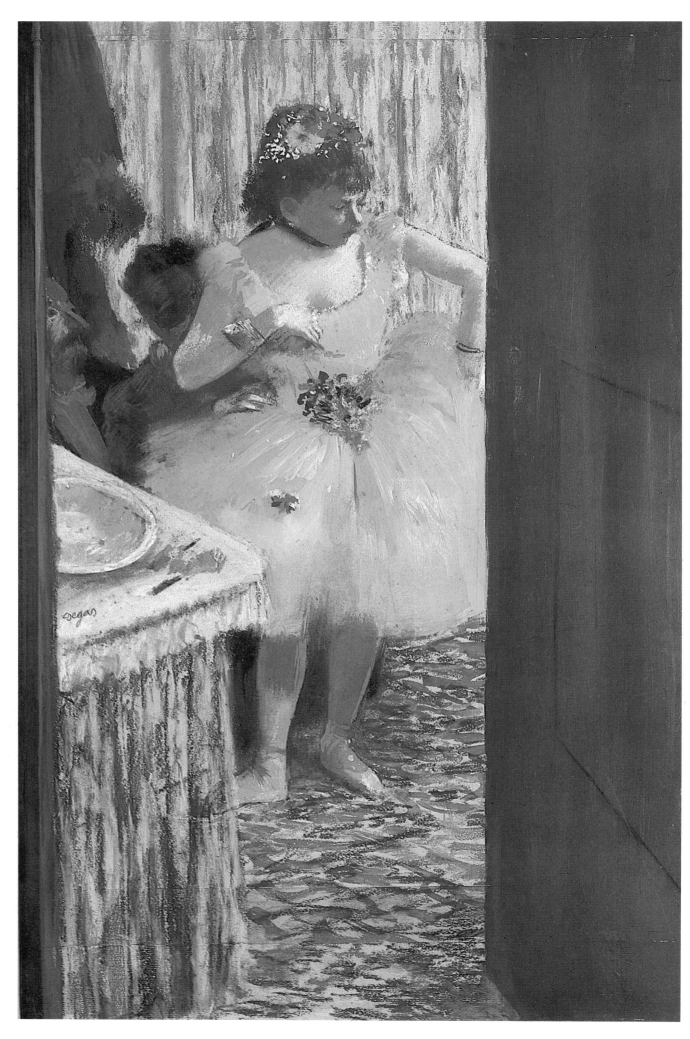

Danseuse dans Sa Loge, also known as *Loge de Danseuse*
(Ballet Dancer in Her Dressing Room). 1878–79

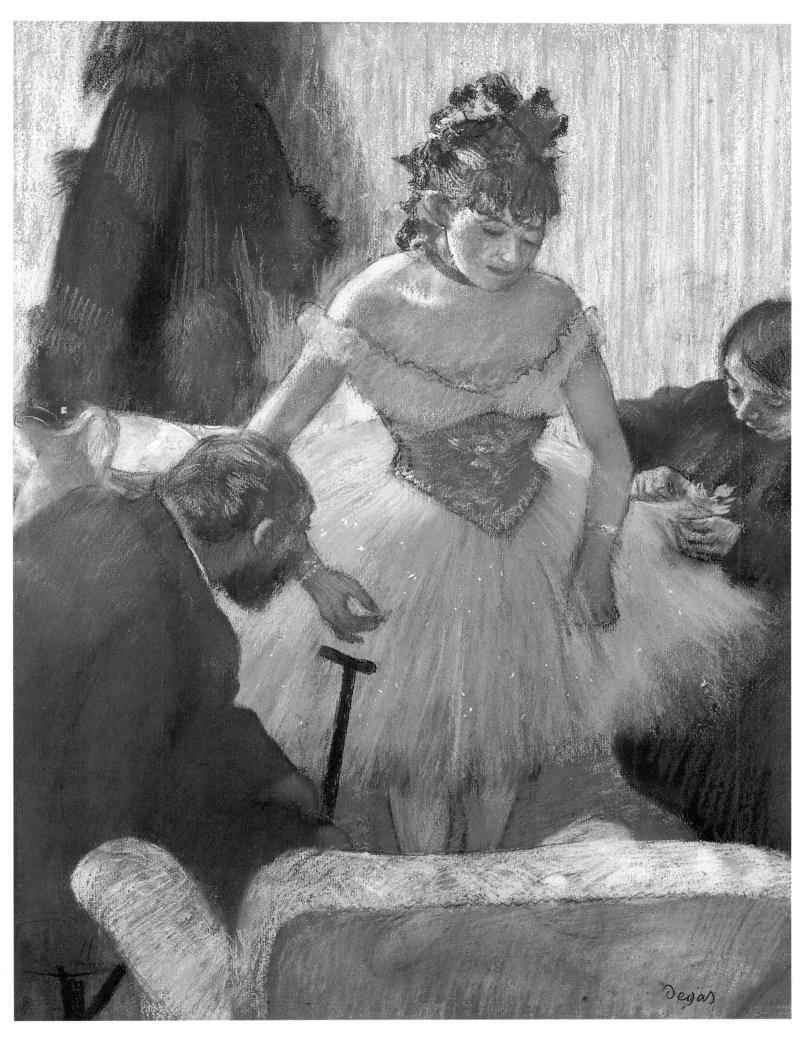

Avant l'Entrée en Scène
(Before the Entrance on Stage). c. 1880

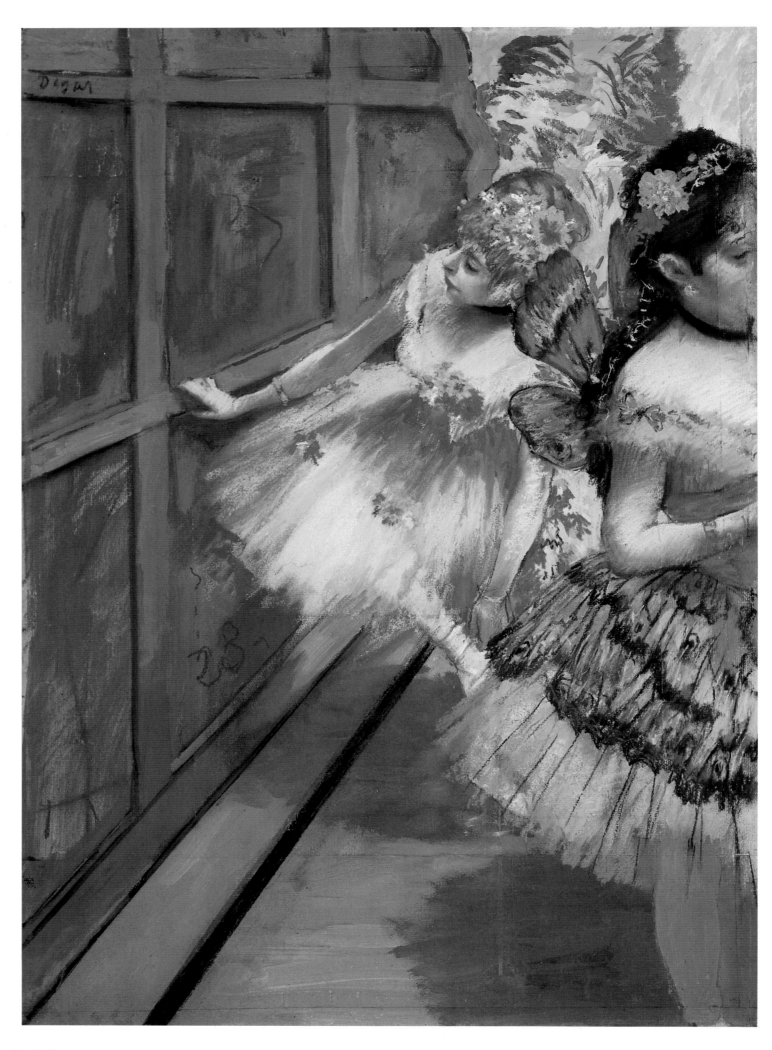

Danseuses Derrière le Portant
(Dancers in the Wings). c. 1878–80

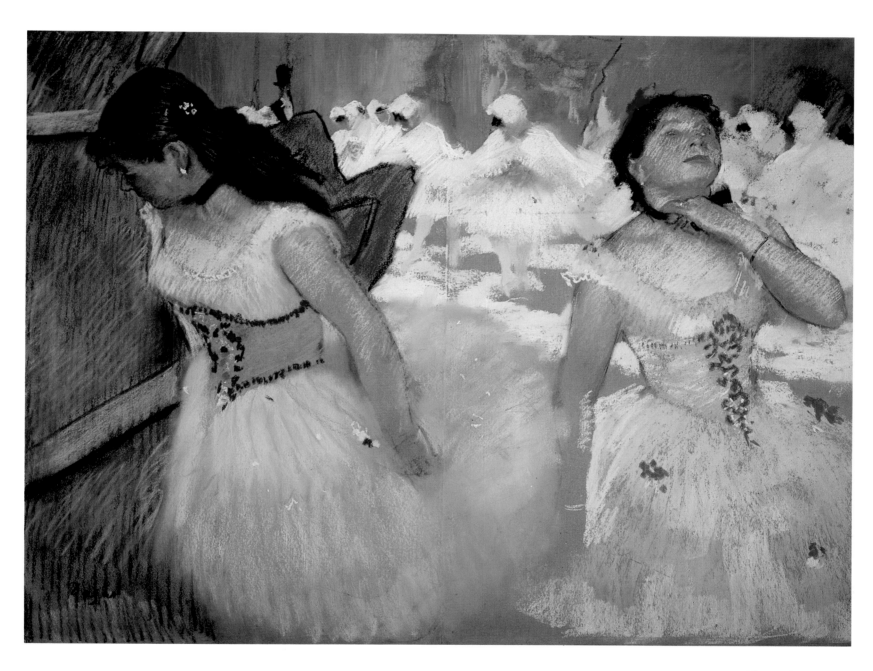

The journalist François Thiébault-Sisson published this account of seeing Degas at work:

The rehearsal was in full sway: entrechats and pirouettes followed one after the other with rigorous regularity; in a laborious tension of all these young and supple bodies, and the spectacle was so curious to a young novice like myself that I was utterly absorbed in silent contemplation from which I would not have emerged for a long while if my companion had not suddenly nudged me.

"You see that thin fellow over there, the one with the cylindrical head and a beard, sitting in the corner on a chair with a drawing-pad on his knees? That's the painter Degas. . . ."

Degas comes here in the morning. He watches all the exercises in which the movements are analyzed, he establishes by successive features the various gradations, half-tempos and all the subtleties. When evening comes, at the performances, when he observes an attitude or a gesture, his memories of the morning recur and guide him in his notations, and nothing in the most complicated steps escapes him. . . . He has an amazing visual memory.

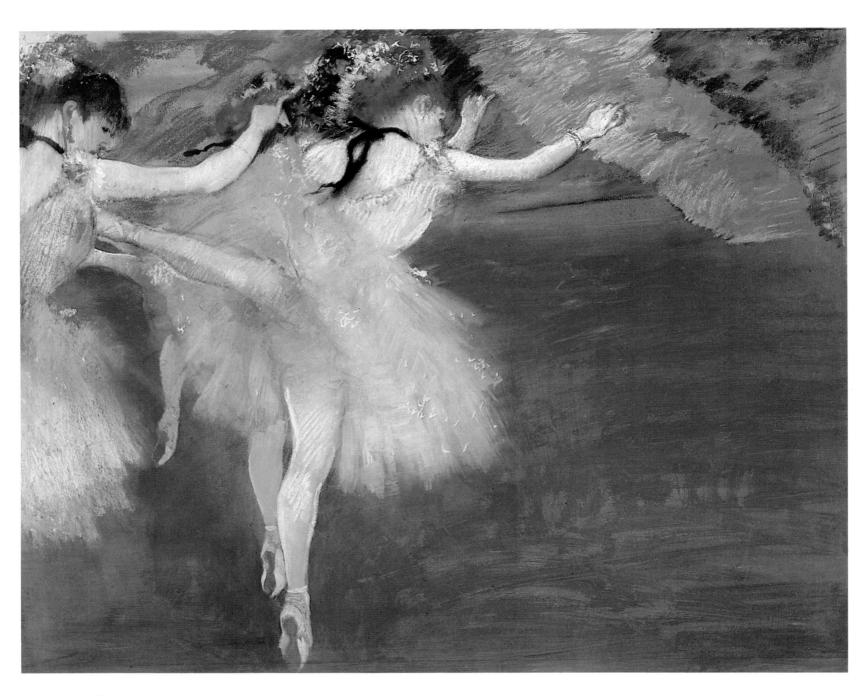

Danseuses en Blanc
(Ballet Girls in White). c. 1878

In his Degas Danse Dessin *Paul Valéry described moments of arrested movement in ballets,*

during which the grouping of the ensemble offers a picture, stilled but not permanent, a system of living bodies stopped short in their attitudes, affording a singular emphasis to the impression of flux. The dancers are transfixed in poses quite remote from those that the human physique can maintain by its own strength . . . while thinking of something else. Consequently there is this wonderful impression: that in the Universe of the Dance, rest has no place; immobility is a thing compelled, constrained, a state of passage and almost of violence, while the leaps, the counted steps, the poses on point, the entrechats or the dizzying turns are quite natural ways of being and of doing.

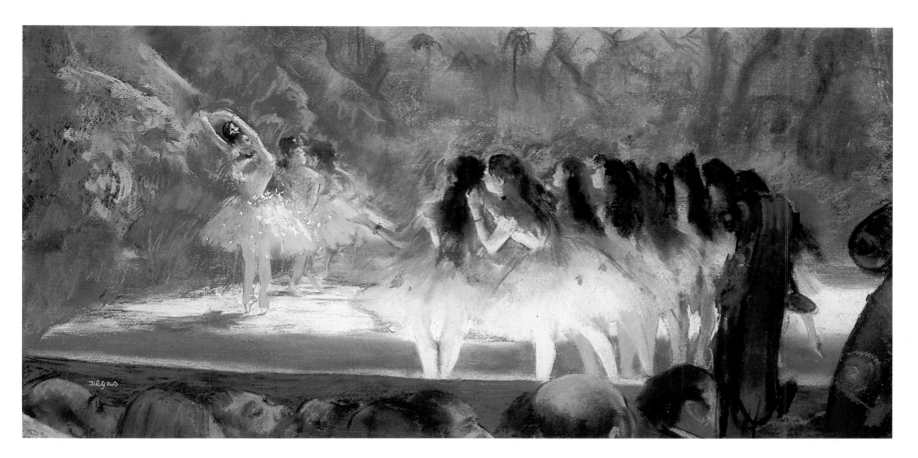

Ballet à l'Opéra
(Ballet at the Paris Opera). 1877

This pastel, drawn over a monotype print, is a successor to the series of
images that Degas had started as early as 1870, in which events on stage
are seen beyond the orchestra in the pit. The necks of the bass violins and
the tops of the musicians' heads come between us and the dancers, putting
the fictional world of the stage at a distance, but at the same time
enfolding us in the experience of theater-going.

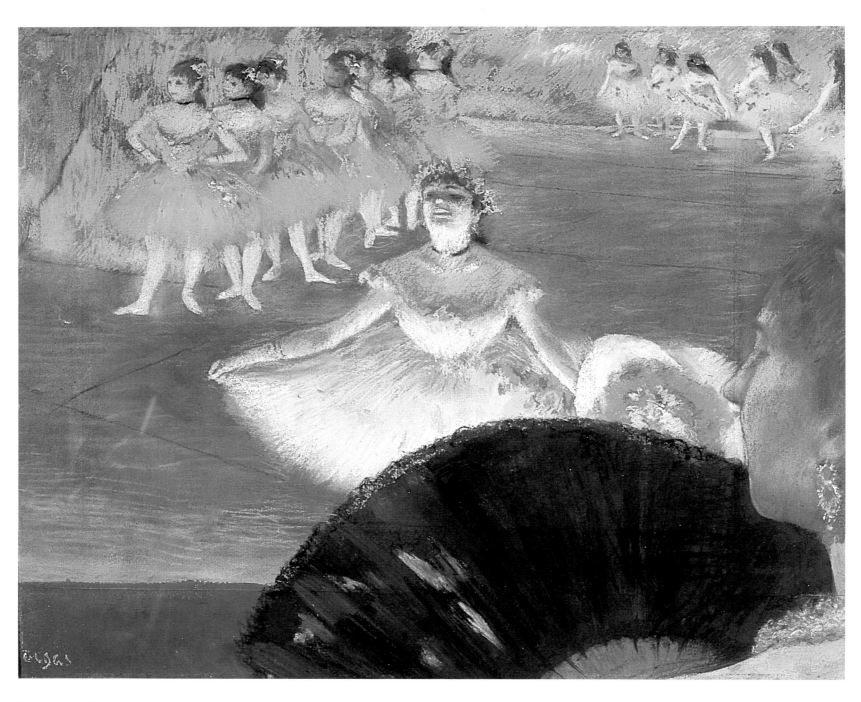

Danseuse au Bouquet
(Dancer with Bouquet). c. 1877–78

Degas was preoccupied by viewpoint. His experiments with unusual angles of vision gave him new compositions and new subjects: the onlooker's awareness of his own sightlines becomes central to the content of the picture. In both Danseuse au Bouquet *and* Au Théâtre *Degas addresses the complex occasion of theater-going, which included seeing and being seen, the spectacle of the stage and the occasion of being in the audience.*

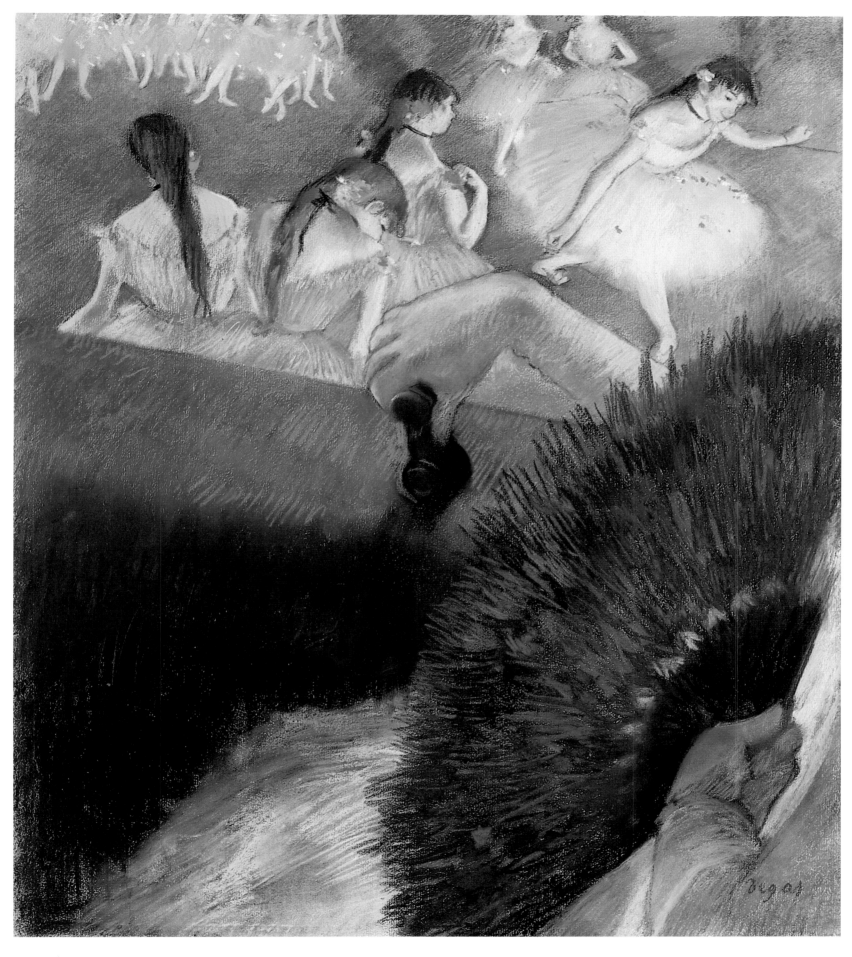

Au Théâtre
(At the Theater). c. 1880

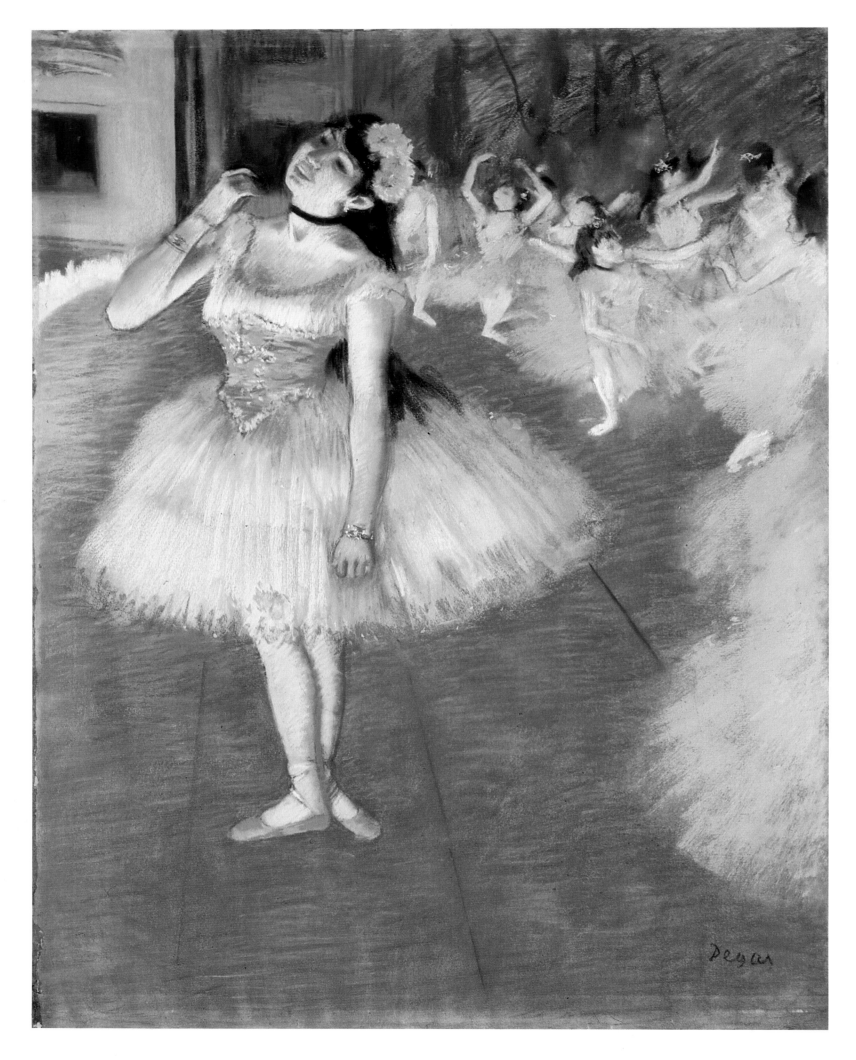

L'Etoile (The Star). 1879–81

Etude de Loge au Théâtre, also known as *La Loge*
(Study of a Box at the Theater). 1880

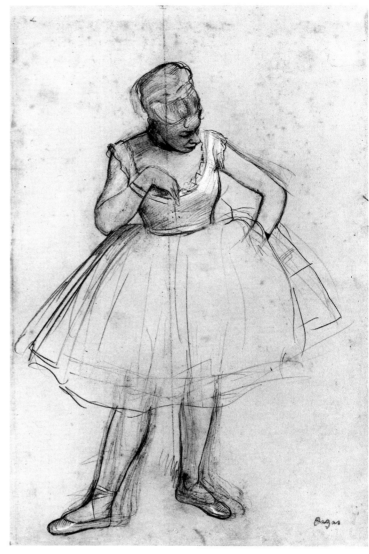

Danseuse (Vue de Face)
(A Ballet Dancer in Position Facing
Three-Quarters Front). c. 1872

Danseuse
(Ballet Dancer Adjusting Her Costume).
c. 1873

In his review of the Fifth Independent Exhibition of 1880 J.-K. Huysmans wrote of the Etude de Loge
au Théâtre:

Here, I must point out a pastel of an empty theater-box adjoining the stage, with the cherry-red of a half-raised screen and the purplish depths of the wallpaper background; a woman's profile leans down from the balcony above. The tone of her cheeks warmed by the heat of the theater, of the blood rising into cheekbones whose coloring, still-glowing at the ears, fades at the temples, is of a singular exactitude in the burst of light that falls upon them.

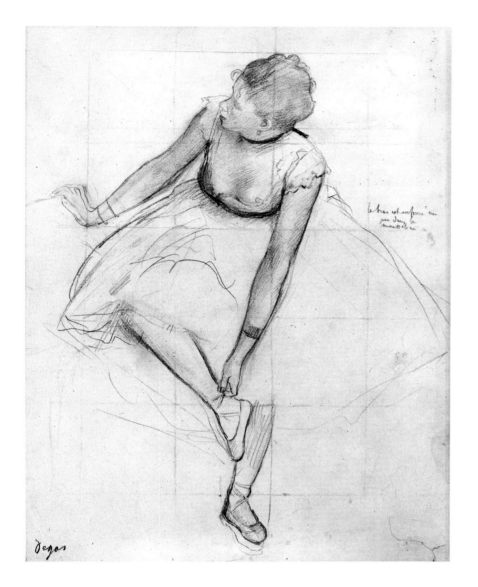

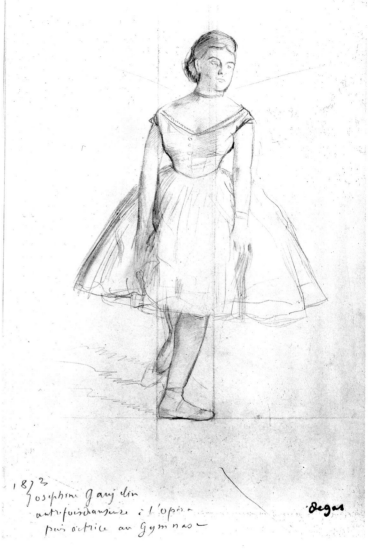

Danseuse Rajustant Son Chausson
(Dancer Adjusting Slipper). 1873

Danseuse
(Portrait of Josephine Gaujelin). 1873

Each of these four drawings was used more than once for figures that appear in Degas's paintings. They are early members of the cast that he was to assemble over the years, the backbone of his pictures of the dance. Here the draughtsman is at his sharpest pitch. He observes soberly, without the slightest flourish but with an even pressure of attention that misses nothing. He draws with a wonderfully restrained grace, dry, crisp, economical. He focuses steadily on questions of direction and proportion, the geometrical underpinning to every shape. He never generalizes.

The crucial observation is always the à plomb, *the vertical alignment of the head and the load-bearing foot. Often Degas will rule a vertical line upward from the heel of the foot, or from the toe, and sometimes from heel and toe so that the whole figure is seen against the length of the foot. It is characteristic of his mind that these firmly and openly stated lines were seen as part of the drawing and their information was accepted alongside the information given by the freehand lines. The same is true of constructions of another kind, the grid that Degas ruled in the traditional way over drawings he wanted to transfer to canvas. Other artists would treat this grid as extraneous to the drawing, ruling it in a neutral way across its surface. With Degas it invariably becomes part of the drawing, and he will use it as a form of measurement, deriving the size of its squares from the length of the head, which then becomes a module for the whole drawing.*

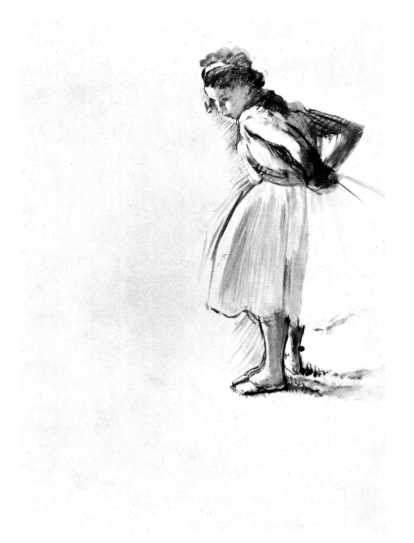

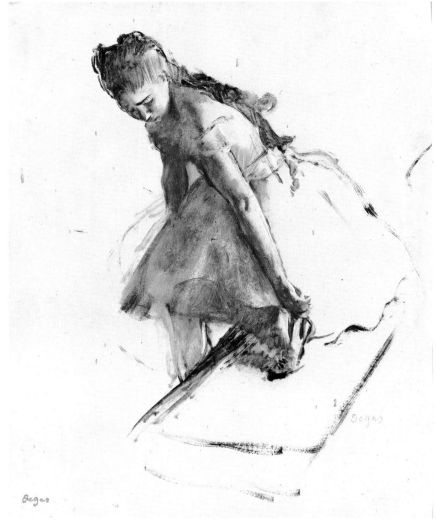

orientation to the audience: *l'arabesque croisée, l'arabesque ouverte,* and so on. The dancer's profile was as directional in its address to the audience as was the stage and the proscenium arch itself.

This frontality too could be explored obliquely not merely by drawing the performance from the wings but by juxtaposing dancing poses and not-dancing poses, an arabesque with a yawn.

The dancer could be seen as an incarnation of drawing. Line was the governing element of her achievement, the right and wrong of what she was doing. Line was given by her limbs, her arms and legs, the centering of her body, her *à plomb.* To draw a dancer's body was to reenact through her limbs the terms of figure drawing itself, both as description and as expression. How often in his drawings of dancers the line of an arm or a leg will soar out from the body, cutting out a shape that has no meaning that can be translated but presents itself simply as a measured claim upon space?

Degas's approach to the dance itself was indirect. The Opera was a bounded world that extended from the banality of routine to the ideal of the performance. At one end, the street and mama in her black bonnet and umbrella, at the other the perfect arabesque incandescent in the footlights. Between were the corridors and corners of backstage, the predatory *abonnés,* the traffic in sexual favors, and the rehearsal rooms.

To begin with, when his interest in social illustration was in the ascendant, the

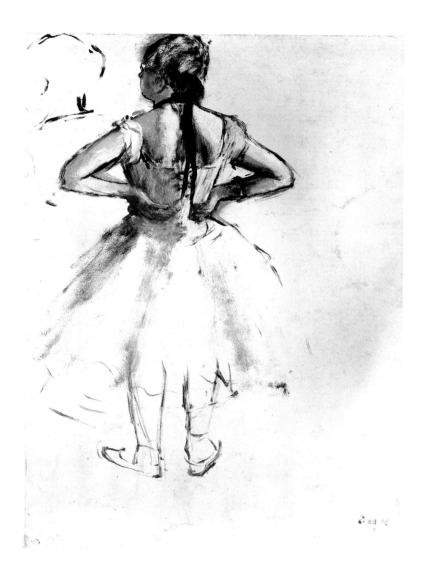

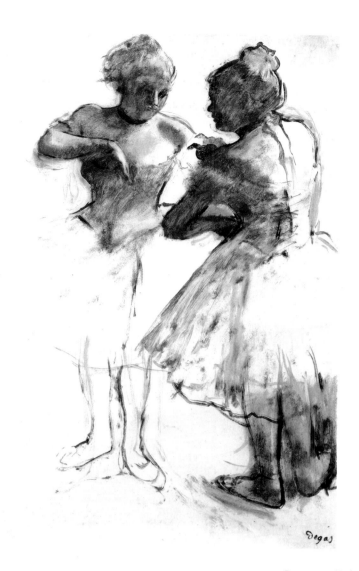

Danseuse Debout, de Dos
(Standing Dancer, from Behind). c. 1873

Deux Danseuses
(Two Dancers). 1873

pictures that Degas made were reconstructions of this microcosm. The rehearsal room is the context for his portraits of the admired ballet masters Mérante and Perrot. Each of the rehearsal pictures gives an opportunity to juxtapose categories of movement from the unconscious informal gestures of dancers resting to the controlled effortful movements of the ones who are working. Between the two extremes are the practical movements of the mothers who tie bows, the violinist who accompanies, or the teacher. *La Répétition de Danse* in the Burrell Collection and *La Répétition sur la Scène* at The Metropolitan Museum of Art are compendia of movements from the natural to the artificial, from the animal to the aesthetic, with work somewhere in between.

A kind of narrative could be constructed from a survey of all his ballet pictures. He follows the dancer from preparation to rehearsal and from rehearsal to the wings where she readies herself for performance. The performance implicates the audience and the view from the house. The curtain rises. The orchestra is silhouetted against the stage lights. The star makes her dazzling bow. We look down upon her from a box. In one pastel, *Etude de Loge au Théâtre*, we see the house from her viewpoint.

In none of these images do we see a male dancer. The men that we see in the ambience of the dancers are observers, whether active like the teachers or passive like the dress-suited admirers who hang around the wings or lounge on chairs to watch rehearsals. One comic pastel, *Avant l'Entrée en Scène*, carries the theme of male looking to such an extreme that it seems to be on the brink of action. The dancer's bald-headed admirer has risen from his armchair and crouches to stare with such

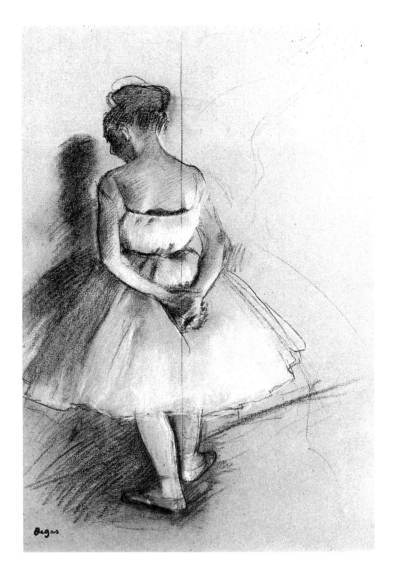

Danseuse Debout les Mains Derrière le Dos,
also known as
Danseuse, les Mains Croisées Derrière le Dos
(Standing Dancer, Hands Clasped Behind
Her Back). 1874

Danseuse Vue de Dos
(Dancer Seen from Behind). c. 1876

abandoned intensity at the triangle of her bodice, surrogate pubis, that we expect him to tumble onto the floor, explode, shower her with louis d'or. But usually admiration is more contained.

Degas made his own world out of the ballet, a circumstance that he admits in a letter to his influential friend, the banker Albert Hecht: "Can you *possibly* get me a pass for the Opera on the day of the ballet auditions, which I am told is a Thursday. I've painted so many of these auditions without actually having seen one that I'm rather ashamed of myself." Only rarely did he depict actual performances. The pictures are built up from drawings of poses that were studied for their own sakes. It is the opposite way of working from how he had prepared the *Petites Filles Spartiates,* where his studies from the model followed his plans for the picture, already sketched.

A group of three drawings all of the same model were made at some time during the early seventies. *Danseuse (Vue de Face)* appears to be the basis of the dancer in the fourth position in the center of all three versions of *Répétition d'un Ballet sur la Scène.* She reappears as the key figure face to face with M. Perrot in *La Classe de Danse* a few years later. The drawing of her adjusting her bodice (*Danseuse*) was probably used for a dancer who makes the same gesture, half-hidden behind other dancers, in the Musée d'Orsay version of *Répétition d'un Ballet* and reappears behind

Danseuse (Deux Etudes)
(Dancer [Two Studies]). c. 1874

M. Perrot in *La Classe de Danse.* The dancer on her points in the three *Répétition d'un Ballet*s again appears in an oil painting in the collection of the Courtauld Institute, *Deux Danseuses en Scène*, and again, reversed, when Degas made his first monotype, under Lepic's tutelage. The drawing of the *Danseuse Rajustant Son Chausson* was once in the very foreground of *La Classe de Danse* and can be seen clearly in X rays of the picture published by the Louvre. She was replaced in this picture by the standing dancer with a fan but reappears in several other contexts, for example in the Norton Simon Museum *Danseuses Derrière le Portant*, which was made at least five years after the drawings.

It would be a mistake always to expect a literal connection between a particular drawing and the appearance of the same pose in a picture. Degas's methods were indirect and various. What must be imagined is a continual effort to learn a pose and to master its configuration. His target is the bare geometry of a pose, its directions, its grip of the floor, its *à plomb.* His passion, Valéry says so accurately, was to "remind us that the whole mechanical system of a living being can *grimace* like a face."

Repetition, in which a pose was studied again and again and individual drawings, copied or traced or reversed by running them through the press, became an habitual discipline, analogous to a musician's practice, or a dancer's. It was not aimed toward a

Georges Jeanniot recounts the story of a visit paid to Degas in his studio:

At that moment, someone knocked. "Come in!" he exclaimed. A young woman appeared, pretty, rather nicely dressed, with dimples in her cheeks.
"There's a pretty one . . . a real find—and a wonderful back. Show Monsieur your back— Monsieur is a painter." The moment I was a painter, the girl quite offhandedly showed me her back. Degas made her turn around under the lamp so that I might admire the beauty of that radiant flesh and the fragile grace of that young back. I then learned that she was one of the ballet apprentices at the Opera and had posed for his pastels.

Danseuse Assise
(Dancer Adjusting Her Stocking). c. 1880

Danseuse Rajustant Son Maillot
(Dancer Adjusting Her Tights). c. 1880

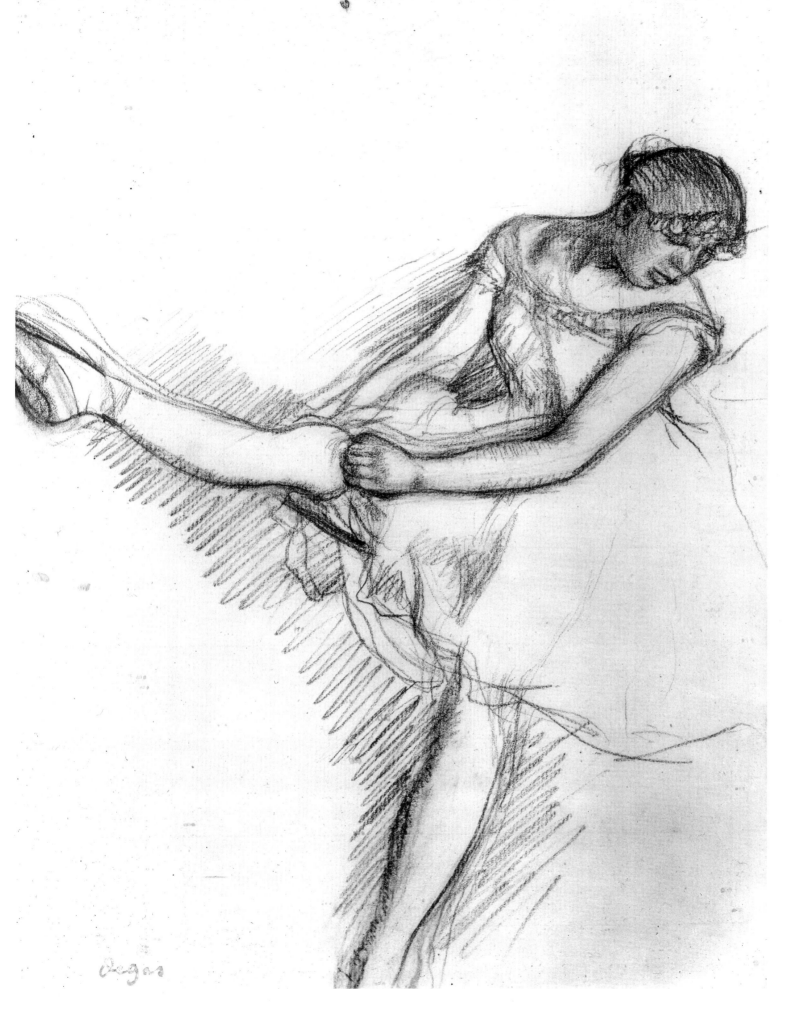

Etude de Danseuse
(Study of a Dancer). c. 1880

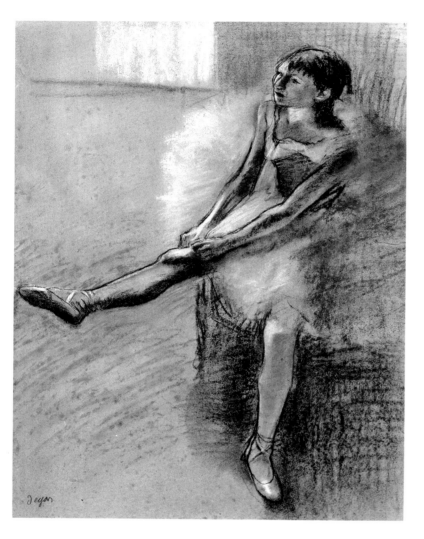
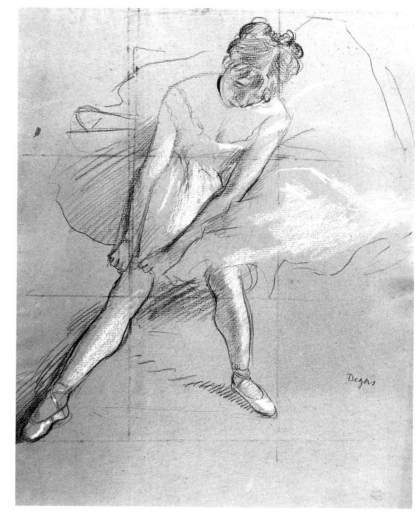

Danseuse Tirant Son Maillot
(Dancer Pulling up Her Tights). c. 1886

Danseuse Assise, Rajustant Son Maillot
(Seated Dancer, Adjusting Her Tights). c. 1878–79

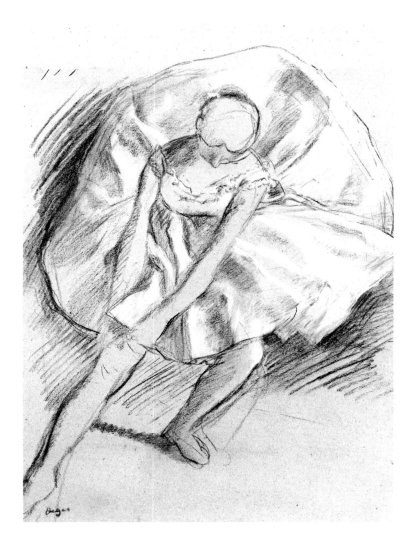

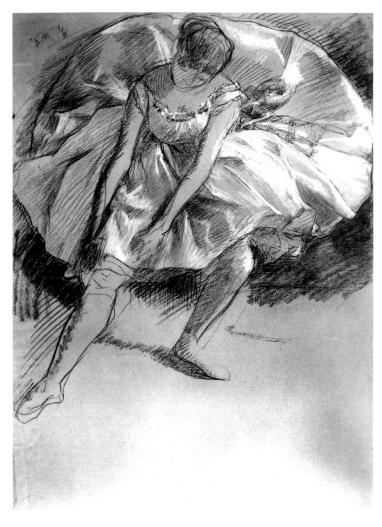

Danseuse Rajustant Son Maillot
(Dancer Adjusting Her Tights). c. 1878–79

Danseuse Assise
(Seated Dancer). c. 1878–79

"The ballet dancer," art critic Jules Claretie *wrote in the* Gazette des
Beaux-Arts,

*deserved a special painter, in love with the white gauze of her skirts, with the
silk of her tights, with the pink touch of her satin slippers, their soles powdered
with resin. There is one artist of exceptional talent whose exacting eye has
captured on canvas or translated into pastel or watercolor—and even, on
occasion, sculpted—the seductive* bizarreries *of such a world. It is Monsieur
Degas, who deals with the subject as a master, and knows precisely how a
ribbon is tied on a dancer's skirt, the wrinkle of the tights over the instep, the
tension the silk gives to ankle tendons.*

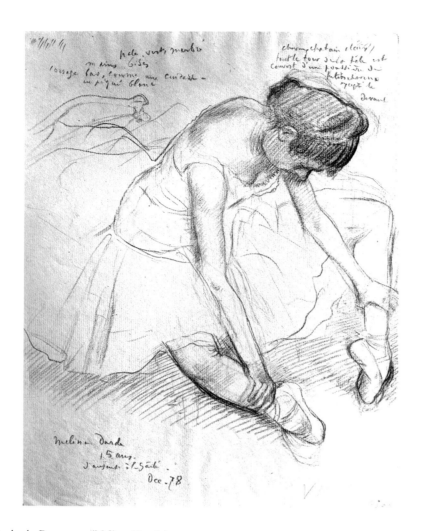

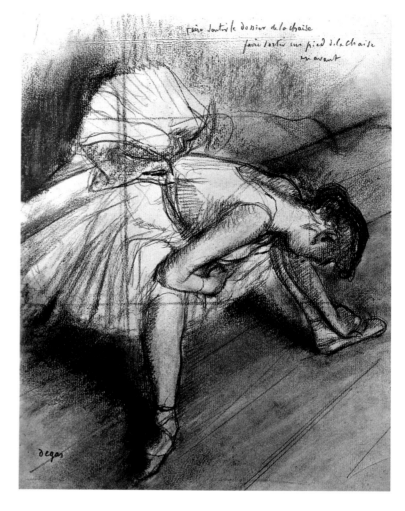

Etude de Danseuse (Melina Darde)
(Study of a Dancer [Melina Darde]).
December 1878

Danseuse Ajustant Son Soulier
(Dancer Adjusting Her Shoe). c. 1885

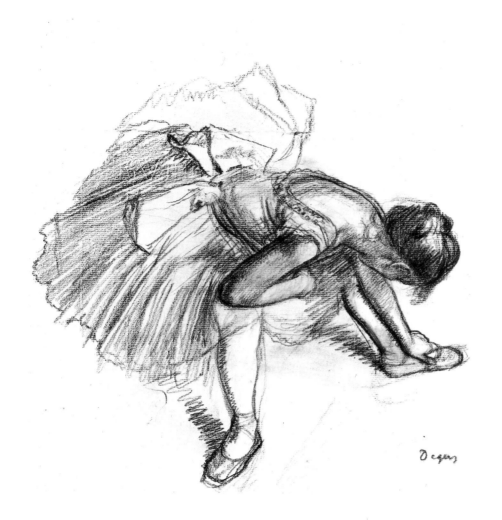

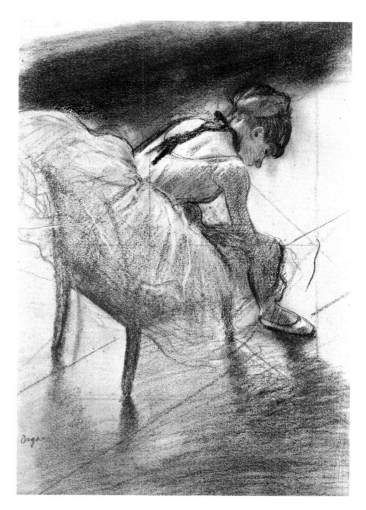

Danseuse Rajustant Son Chausson
(Dancer Adjusting Her Slipper). 1885–87

Danseuse Rajustant Son Soulier
(Dancer Fixing Her Shoe). c. 1885

Shifting viewpoints opened endless variations on whatever theme Degas addressed. He instructed himself in a notebook entry:

Perform simple operations such as drawing a stationary profile while moving oneself, higher or lower, the same for an entire figure, a piece of furniture, a whole room. Make a series of arm or leg movements in the dance which would not move, oneself turning around them—Finally study from every perspective a figure or an object, no matter what. Use a mirror for this—without moving from your place. Only the place would be raised or lowered, you would circle round it.

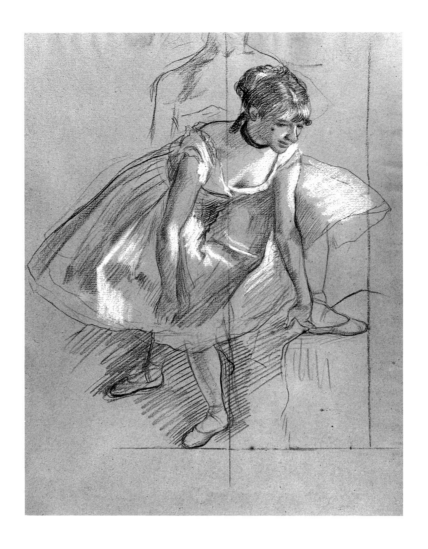

Danseuse Rajustant Son Chausson
(Dancer Adjusting Her Slipper). c. 1878–79

Georges Jeanniot describes his first meeting with Degas. It was at the house of Lepic. A dancer had been posing for them. Degas arrived in excellent spirits: he "knew that he was going to be seeing some dancers." Jeanniot goes on:

Degas looked at our drawings. He showed us how to see a dancer's foot. He discussed the special shape of the satin shoes held on by silk cords which lace up the ankles, using terms that revealed long study. Suddenly he snatched up a piece of charcoal and in the margin of my sheet drew the structure of the model's foot with a few strong black lines; then with his finger he added a few shadows and half-tones: the foot was alive, perfectly modeled, its form released from banality by its deliberate and yet spontaneous treatment.

definitive solution but was almost an end in itself. One of its consequences, perhaps not anticipated, must have been to bring the poses into his mind and hand with the wholeness and vividness of objects.

It was out of these "things" that the pictures were made. The drawings were the units, to be placed, measured, overlapped, spread apart, given whatever role his fancy determined in the *mise-en-scène*. Their arrangement, their spacing, was a separate operation in the making of the picture, distinct from drawing the figures. The figures become like pawns to be moved on a board, and we are always aware of their placement. Compositional sketches are rare. Usually the figures are drawn alone, to become members of a cast that Degas employed over the years. The obvious comparison—it was made in his own time—is with that other painter obsessed with the analogy between stage and picture, Antoine Watteau.

In the majority of Degas's paintings of ballet subjects, the dancers are set in deep and complex perspectives. The shape of the canvas is crucial and determines the quality of the space. For many years Degas sometimes worked on long, narrow canvases, somewhat over double-square. He used this friezelike shape for some of the racehorse pictures and also for scenes of dancers, for example, *Danseuses au Foyer* at The Metropolitan Museum of Art. Another composition, of which there were many versions, shows a corner of the rehearsal room with a wall and a bench in front of it with dancers resting, and in the distance a view of the practice barre with a row of dancers working at it. There is an extreme contrast of scale between the two groups that seems to stretch the empty floor between them. The horizon in all these pictures corresponds almost exactly with the top edge of the canvas, tilting the floor upward

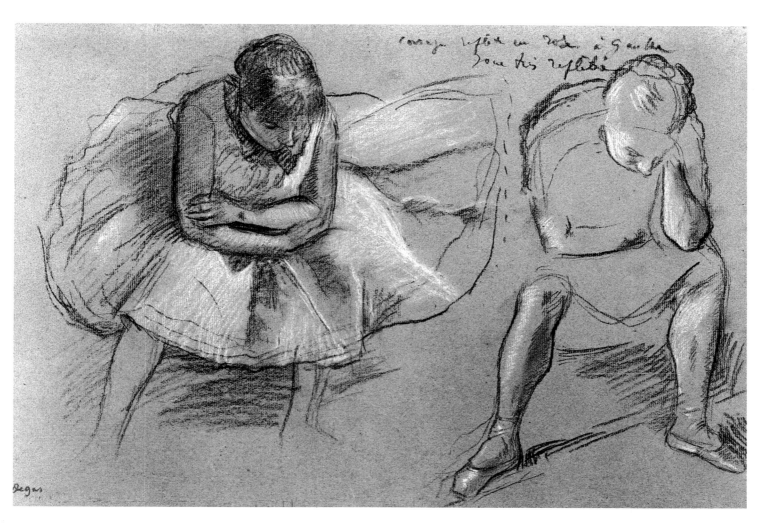

Deux Danseuses au Repos
(Two Dancers at Rest). c. 1878–79

and giving an insistently downward-looking, enclosed feeling in spite of the bare and empty floor and its deep recession.

The figures at the barre repeat the formal movements he had been studying for a dozen years. Each figure is firm and whole like a little figurine that he can rotate in his mind's eye and arrange at will. The larger figures in the foreground are resting, and their poses are more complex. In *La Leçon de Danse* the standing dancer with a fan is reminiscent of the figure in the foreground of *La Classe de Danse*, except that she raises her left hand to her head. She is in the same pose in *La Salle de Danse* but rotated somewhat less than 180 degrees. To the extreme right of this picture is a dancer who leans forward, her head lower than her knee, a hand clasping her left foot. We look down on her head and the bare expanse of her shoulder and upper back framed by the halo of her skirt.

This seated figure, knees spread, with the arms stretched toward the feet, particularly fascinated Degas, who drew it many times. It represented the extreme opposite to the weightlessness and grace of the dancer in action. It is earth-bound; the head hangs, evoking the Baudelairean image of the white bird grounded. This aspect of the pose gave rise to pastels such as *Danseuses au Foyer*, in which we are brought close to the dancer's exhaustion. In *L'Attente* the same pose is drawn into a narrative and expresses boredom as the dancer sits waiting beside her mother in black street clothes.

The pose shows the figure of the dancer in a highly unfigure-like aspect. Each drawing that he made of it reminds us of his quest for unusual viewpoints, his passion for the oblique. It is as though in discovering the dancer at rest like this, unawares, he

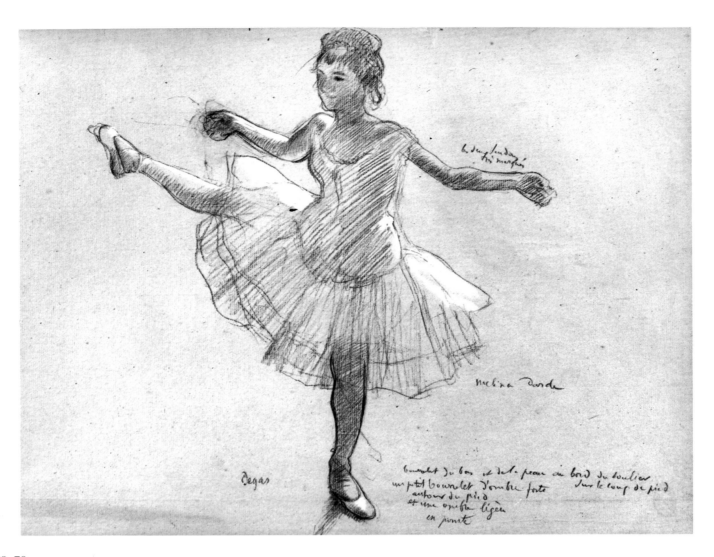

Danseuse (Dancer). c. 1878–79

is able to claim a tighter grip on her, discovering her physical presence piece by piece in an unfamiliar order, the drawing aestheticized by being somehow out of step with familiar figuration. In the great pastel on gray paper *Danseuse Ajustant Son Soulier* the structure is more like a flower than a figure. The skirt radiates its petals outward from the waist of her bodice, which we are looking down upon and see in section. Her torso emerges from the same point, coming toward us in steep foreshortening, the head lower than the waist. The hard, naked back, tightly modeled in hatching of gold and olive, orange and white, the spine clearly ridged, is embedded like a warm stone in the midst of the radiating folds of the skirt; and, by a paradoxical inversion, it declares her vulnerability.

In the same notebook in which he had told himself to practice drawing people and monuments from unfamiliar points of view, Degas described another, closely related project: to draw the same thing systematically, from different angles. "Perform simple operations such as drawing a stationary profile while moving oneself. . . ." There are several sheets that exemplify this intention particularly clearly. They are of a young dancer who stands with her feet in the fourth position, her weight on her left leg and with both arms behind her back, her fingers laced. In three of these sheets there are three views of her, a central one, evidently drawn first, and one on either side drawn from positions roughly ninety degrees to left and right. These drawings are of a dancer called Marie van Goethem. It is she who was represented in the sculpture *Petite Danseuse de Quatorze Ans* that Degas exhibited in 1881. The wax corresponds

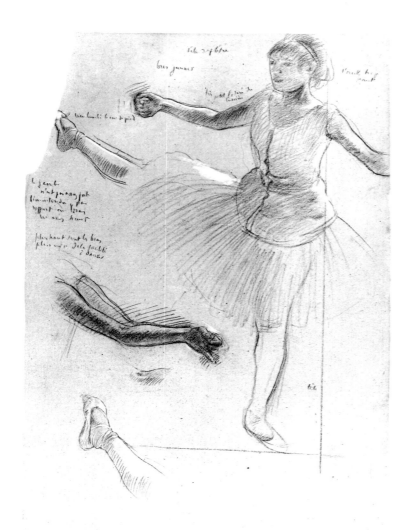

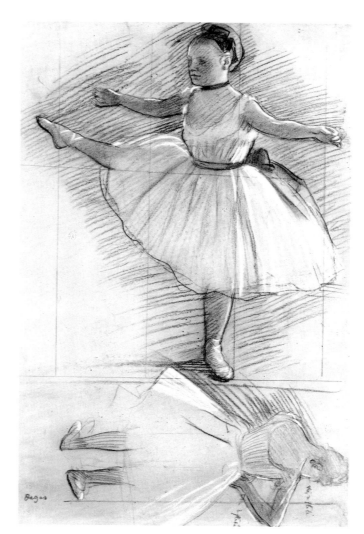

Danseuse, also known as
Danseuse Faisant des Exercises de Jambes
(Dancer). c. 1878–79

Etudes de Danseuse
(Studies of a Dancer). c. 1878–79

closely to the drawings and these have generally been taken to be preparatory studies for it. Recently George Shackelford has argued convincingly that they represent a pictorial idea pursued for its own sake and only later transformed into sculpture. This particular instance stands for a more general—if more vague—point to be made about Degas at this midpoint in his working life. Sculpture was on the way to becoming as important to him as painting. But the new activity was not a breaking away from what he had been doing, a change of direction, but rather an acknowledgment of much that had been implicit in his work up to now and a critique of much else that was beginning to appear irrelevant. Sculpture is the midwife to his later work in two dimensions, his greatest achievement.

The connection between pictures and sculpture runs deep in Degas's work, through the conduit of his drawing. Sculpture is implicit whenever he repeats or reverses a figure. It is implicit in his arrangement of drawings as closed units within the field of the picture. It is implicit on an ideal level in the tradition of drawing to which he was heir. Based on linear division and shading and on a conception of relief, Florentine drawing inevitably aspires toward an ideal of sculptural form on a flat plane.

Degas's twenty-year effort to extend the great tradition of drawing into a modern, naturalistic context had brought him to a crossroads. However he enriched his naturalism with psychological observation and sociological reference, these features were ancillary to the main task. Drawing itself was the center: the rest was peripheral, a line of defense against triviality. But in the end this defense proved to be an illusion. Majesty escaped him. "Drawing must not be confused with *mise en place*,"

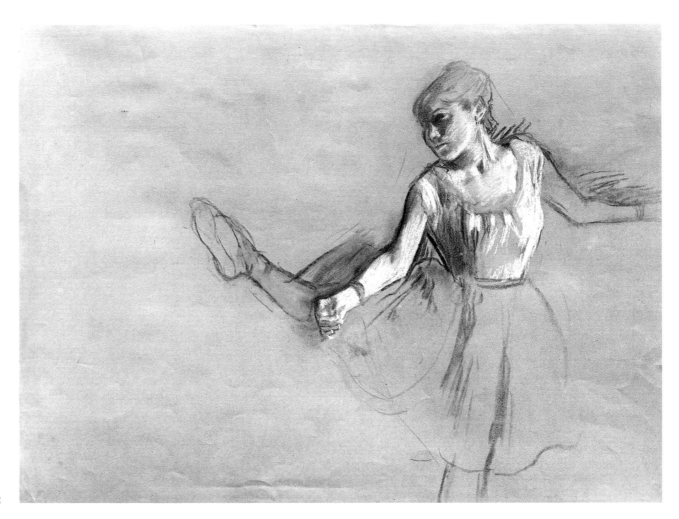

Etude de Danseuse
(Study of a Dancer). c. 1880–82

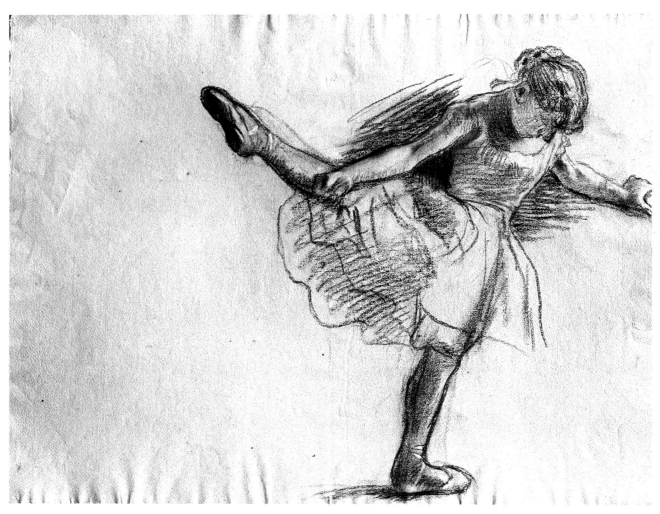

Danseuse,
also known as *Danseuse Debout*
(Dancer). c. 1878–79

190

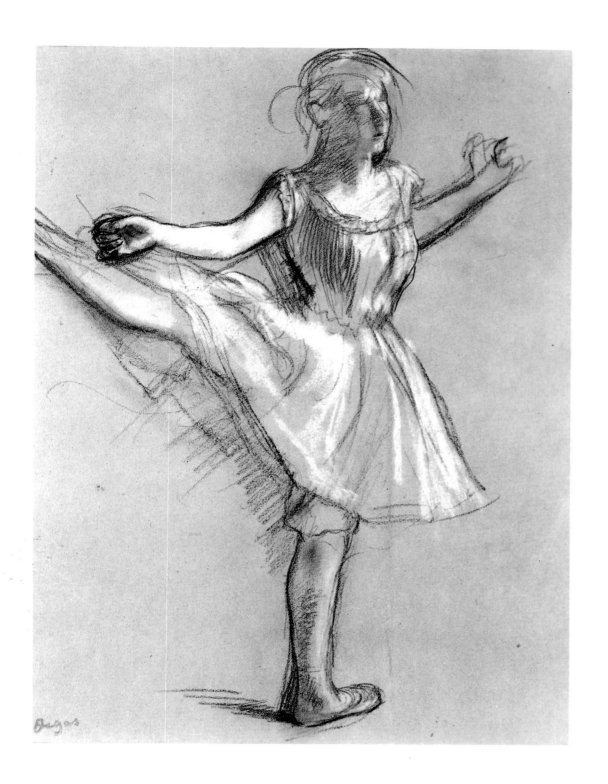

Grande Battement à la Seconde,
also known as *Danseuse Debout*
(Grande Battement, Second Position).
c. 1880–82

Work, specifically drawing, had become for him a
passion, a discipline, the object of a mystique and
an ethic which were quite self-sufficient, a sovereign
preoccupation which did away with everything else,
an occasion for precise and perpetual problems
which released him from all other curiosities. He
was—wanted to be—a specialist in a genre which
can be raised to a kind of universality.

PAUL VALÉRY, 1938

191

he said, which I take to be an acknowledgment that drawing and the arranging of drawings to make a picture are two different things.

Did he ever ask himself whether these two different things were compatible? There is no knowing. But I imagine him at the time when sculpture was claiming its place in his work, continually brooding on this question, driven back to it again and again both by his own experience of monotype—those underworld adventures that had opened up currents of feeling that had somehow to be acknowledged—and by the external challenge of his Impressionist colleagues. For there were intimations of a new kind of pictorial unity in the work of Monet, Pissarro, and Cézanne that Degas could not possibly be unaffected by, however scornful the front he maintained against the *plein-airist* example.

He had, of course, been drawing from sculpture all his life. There is even some evidence that as a student he had considered sculpture his calling. In Rome he had been friendly with Henri Chapu at the Villa Medici. Later he had become close to Joseph Cuvelier, the brilliant animal sculptor whose death in the Franco-Prussian War affected Degas deeply. He knew and admired Jules Dalou, the realist sculptor who had taken refuge in London after the Commune. Various events during the seventies may have directed his thoughts toward sculpture. Antoine-Louis Barye, whom Degas greatly admired, died in 1875 and was commemorated by a large retrospective exhibition. In 1878 Durand-Ruel mounted an exhibition of Daumier that included his hitherto-unknown sculpture. And in Degas's private life, his loss of family, his father's death must have increased his own sense of mortality. Sculpture, after all, is the medium of memorials.

But, typically, it became in his hands the medium of postponed decisions. His technique was improvised: "You do the best you can with whatever you have, whatever that is, if you're as unbalanced as I am," he wrote to his sculptor friend Bartholomé, ruefully admitting his technical inadequacies. A model who worked for him remembered his envy of Bartholomé, who had everything he did cast: "How I wish I could call in someone to make a cast. But I'm still not finished with my sculpture; I keep having one disaster after another." On the other hand, he told Vollard, "It's taking too much responsibility to leave something in bronze—that's a substance for eternity."

Only three of his sculptures were cast in his lifetime and those only in plaster. The *Petite Danseuse de Quatorze Ans* was the only sculpture he ever exhibited. His prodigious activity as a sculptor was largely secret, a kind of obsessive writing on water, done for the sake of doing. When Vollard visited the studio one day Degas told him exultantly that the dancer he had been working on for a long time was nearly right: "This time I've got her. One or two more little sessions and Hébrard [the founder] can come." The next day the dancer was once again a ball of wax. In answer to Vollard's amazement: "I know you, Vollard, you're thinking what it was worth, but not even a hatful of diamonds could have matched my delight in demolishing the thing for the pleasure of starting all over again."

Degas's sculpture reflects the subjects that he had treated in his pictures: horses, portraits, dancers, bathers. There are thirty-eight pieces of the dance remaining. They are by far the most important of his sculptures. In them sculpture and the dance come together, irradiating each other with their qualities. Here the themes of gravity and its denial, of movement and silhouette, the interactions of viewer and viewed, the unfolding dream of total physical possession experienced through seeing, are brought to a pitch of realization that transforms the possibilities of sculpture. He reaches out

As if an indolent nature in those days,
Confident of beauty, would rest—would sleep
Too heavily, if not for a certain grace
Rousing her with a happy, panting voice.

And then, keeping an irresistible time
With the movement of her speaking hands,
And the interweaving of passionate feet
Forcing her to leap before her with delight.

Begin, you darlings, without the futile help
Of Beauty—leap despite your common face,
Leap, soar! you priestesses of grace,

For in you the Dance is embodied now,
Heroic and remote. From you we learn,
Queens are made of distance and dyed flesh.

EDGAR DEGAS

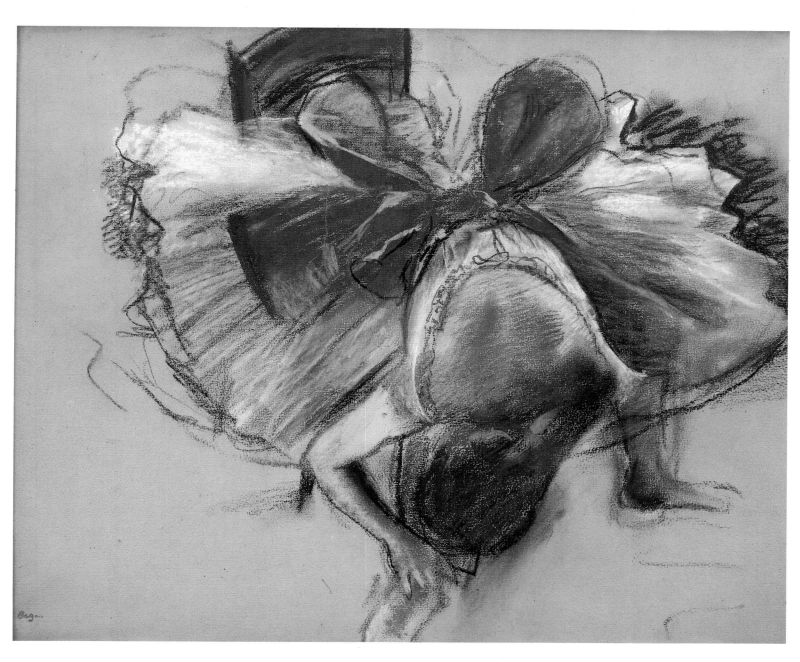

Danseuse Rajustant Son Chausson,
also known as
Danseuse Assise, Rajustant Sa Chaussure
⟨Dancer Adjusting Her Slipper⟩. c. 1882–85

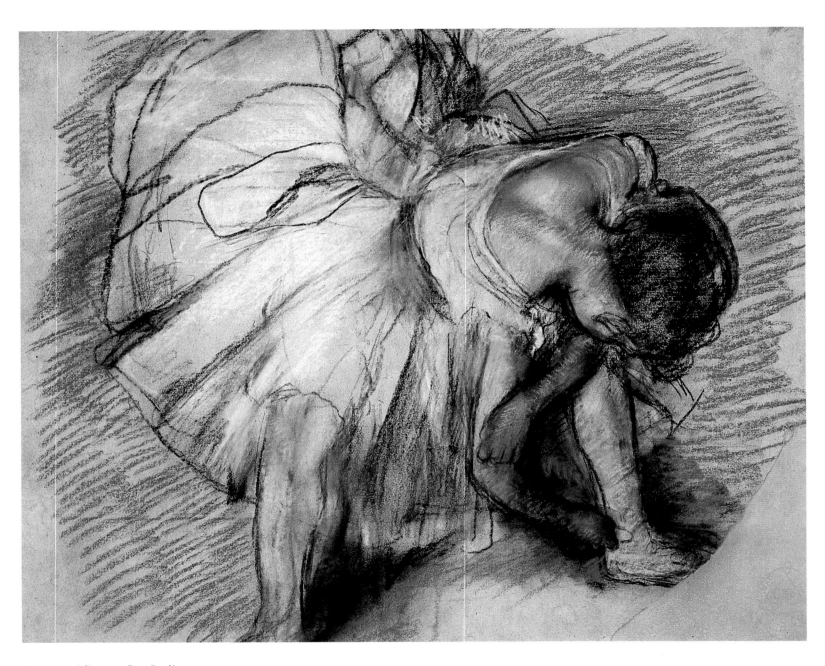

Danseuse Adjustant Son Soulier
also known as *Danseuse Ajustant Son Chausson*
(Dancer Adjusting Her Shoe). c. 1880

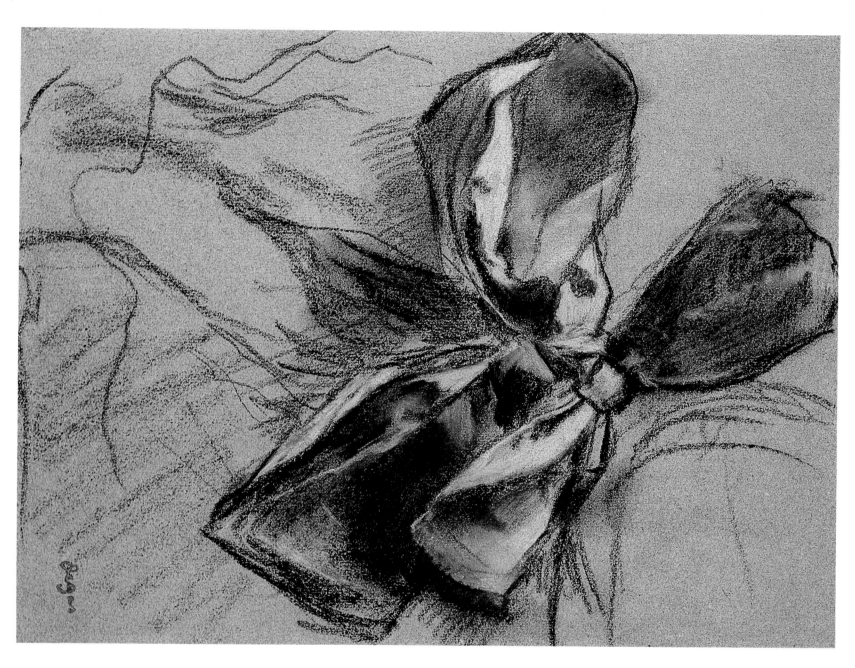

Etude d'un Noeud de Ceinture,
also known as *Noeud de Rubans*
(Study of a Bow). c. 1882–85

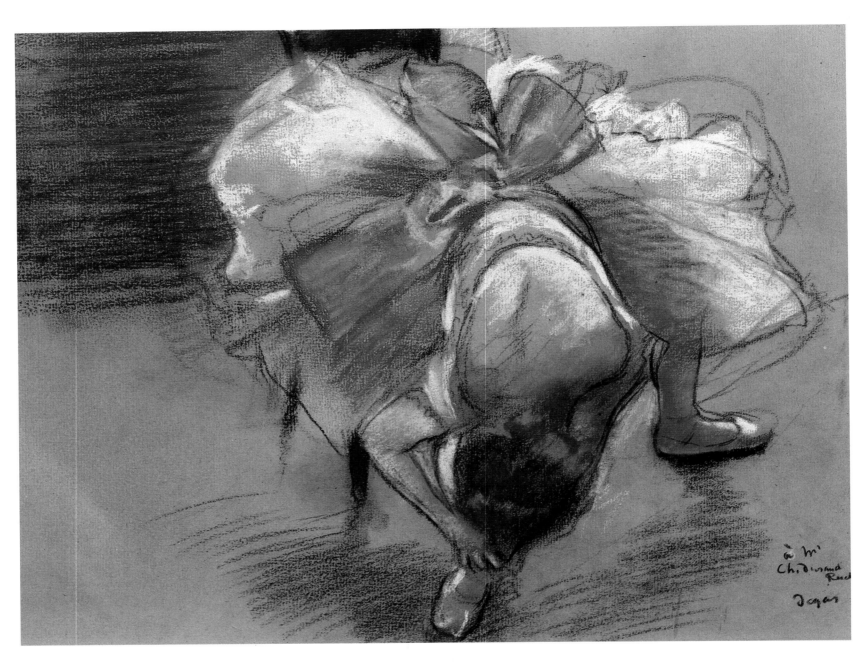

Danseuse Assise Rattachant Son Chausson
(Seated Dancer Tying Her Slipper). c. 1882–85

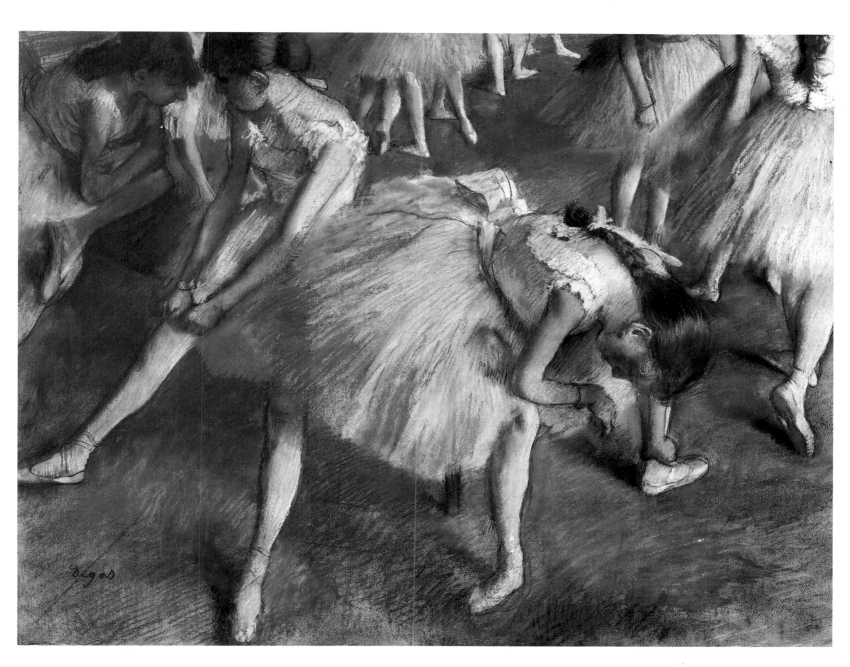

Danseuses au Foyer
(Dancers in the Green Room). 1879–80

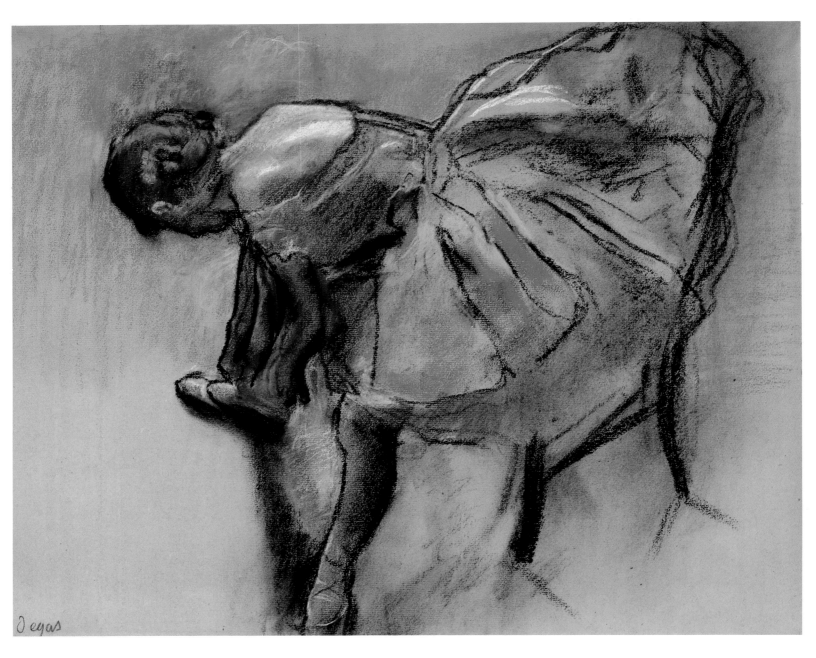

Danseuse Attachant Son Chausson
(Seated Dancer Tying Her Slipper) c. 1880

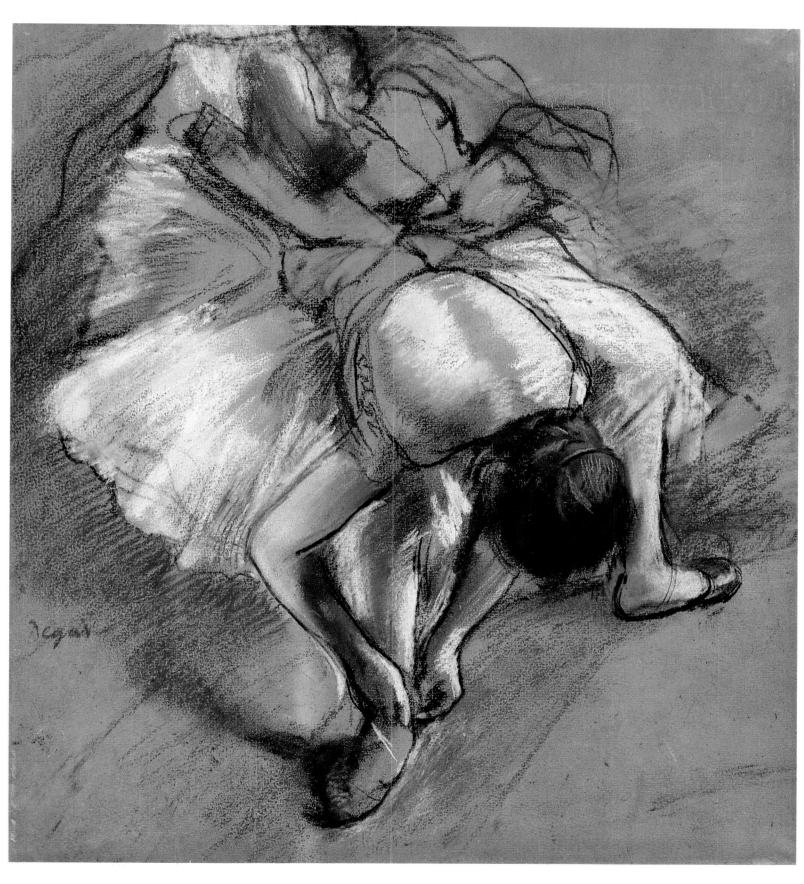

Danseuse Attachant Son Chausson
(Dancer Adjusting Her Slipper). c. 1880–85

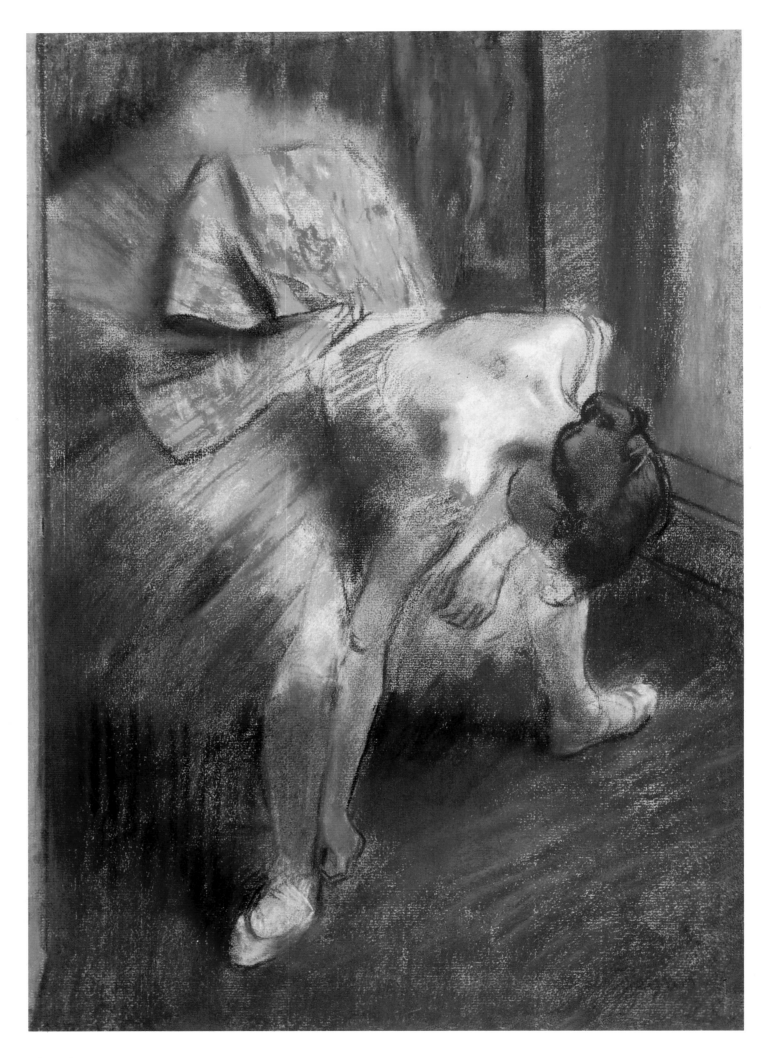

Danseuse au Tutu Vert
(Dancer in Green Tutu). c. 1880–85

beyond the dancer to give body to that supreme organization of movement that we think of as dancing; though whether we recognize that organization in the sculptural piece or in our own corporeal sensations as we look at it, I do not know.

The *Petite Danseuse de Quatorze Ans* stands apart and alone. Here, definitively and for one time only, Degas presents the dancer herself. She is the epitome of her caste, representative of all those laboring children, half dedicated, tired guttersnipes, half austere angels beyond the reach of gravity, that he had studied and drawn in an icy coil of paternal rigor and curiosity and desire.

The figure is about two-thirds life-size. It is made out of wax over an armature mostly of wire. The figure is dressed in a real bodice of yellowish silk, buttoned on. The skirt is of tulle and gauze. She wears real dance slippers. Her hair is horse hair and falls in a long pigtail tied in a bow with a ribbon of pink satin. Both her hair and her legs and feet have been covered with a thin layer of wax, bringing them close to the surface modeling of the head.

She is standing as only a dancer could stand. Her body is like an undrawn bow, and one is aware of its special formation from head to toe: the outward turn of her right foot that brings it parallel to her shoulders; the extreme *contrapposto* from the pelvis down that is not carried through into the upper body but is straightened by muscular control. The long, narrow arms are stretched rigidly behind her back, the fingers locked together in a supremely self-conscious gesture that pulls her shoulders back and lifts her chin.

She has a unique presence. Every encounter with her is a shock. She entertains a thousand contradictions: frail and tough, child-professional, chaste and sexy, mortal and timeless, she epitomizes that quality that so moved Degas in all the resting dancers who, released for the moment from the selfless discipline of their work, were able to reenter their bodies as themselves, but only conditionally, as tenants, so to speak, of premises that no longer completely belonged to them.

On her first appearance critics invoked the Madonnas in Spanish churches dressed like dolls in real gowns and decked with jewelry. But there is nothing doll-like in the little dancer's presence. Her limbs are developed to a fine-drawn, wiry surface, her stance is active and supremely aware. The conjunction of the actual clothes and the modeled wax brings us to dark regions, close to those brittle, pointed fingers of mummies wrapped in rags or to those photographs of the Danish bog people that haunt us with their revelations of *drawing* embedded in the mud.

Her chin is tilted up, her eyes nearly closed. From certain views there is a look of complete inwardness, as if she had closed her eyes in order to see more clearly what she is picturing to herself. From other views one reads sensuality, the surrender of orgasm. Several of the first critics, carried along by the conventions of the day, pretended to be shocked by her face, calling it ugly, depraved, Cro-Magnon, and so on. They saw the tilt of her head as provocative. One may as well see it as a gesture of withdrawal, a kind of recoil from her situation and the painfully trained body that locks her into it. All the same, the violence of those first responses rings a bell. It matches something we experience again and again, the intolerable shock of that head on that body, one with it, yet not one with it, the same but different. The head challenges one's reading of the body and disjoints one's longing; perceptions of personhood and thingness become hopelessly entangled.

I look to her head as to her center: but the dancer's center is in her torso, not her head. That mere point at the apex of the long leggy triangle is an appendage, and we expect it to be mute, a smiling mask. Here this strange, uplifted, closed, unforgettable

All that the fine word pantomime *implies*
And all that ballet's *agile, lying tongue*
Says to those who grasp the mystery
Of bodies moving, eloquent and still;

Who see—who must *see in the fleeting girl*
—Incessant, painted, harlequin, severe—
Vanish all trace of their transitory soul,
Flashing faster than the finest strophe;

—All, even the crayon's careful grace:
A dancer has All, though weary as Atalanta;
Serene the tradition, sealed to the profane.

Beneath fake boughs, your infinite art observes:
Uncertain of a step, I think of you,
And you come—you come, tormenting an old faun.

EDGAR DEGAS

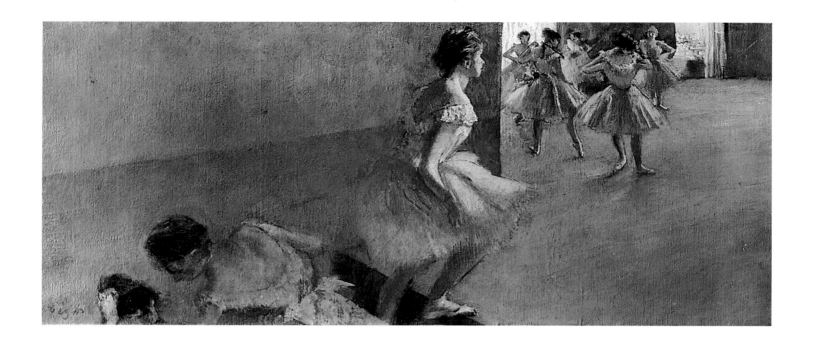

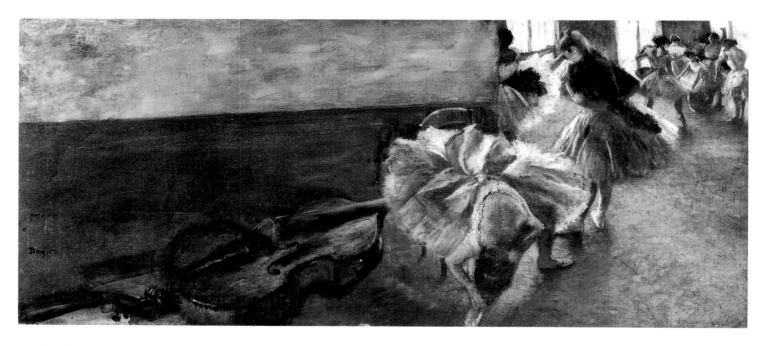

Danseuses Montant un Escalier
(Dancers Climbing a Flight of Stairs). 1885–90

Danseuses au Foyer,
also known as *La Contrebasse*
(Dancers in the Rehearsal Room,
with a Double Bass). c. 1882–85

OPPOSITE:
La Leçon de Danse
(The Dancing Lesson). c. 1880

Le Foyer de la Danse,
also known as *Dans une Salle de Répétition*
(Before the Ballet). 1890–92

La Salle de Danse
(Ballet Rehearsal). c. 1885–90

The long, narrow, friezelike format of these pictures, which Degas
returned to over a period of years, suggests that he was thinking of them
as items in a possible scheme of decoration. It is known that like most
artists of his generation, Degas was interested in making paintings that
could be incorporated in the decoration of a room. The pastel Portraits en
Frise *is the best-known instance of his rumination on the subject—
rumination that was self-motivated, as there does not appear to have been
an actual location in view; nor was there one for the series of dance
rehearsal pictures to which these examples belong. Many of his later
pictures of race horses were also on frieze-shaped canvases, more than
twice as long as they were high, and it is conceivable that he was
thinking about panels of dancers and of horses in the same decorative
scheme.*

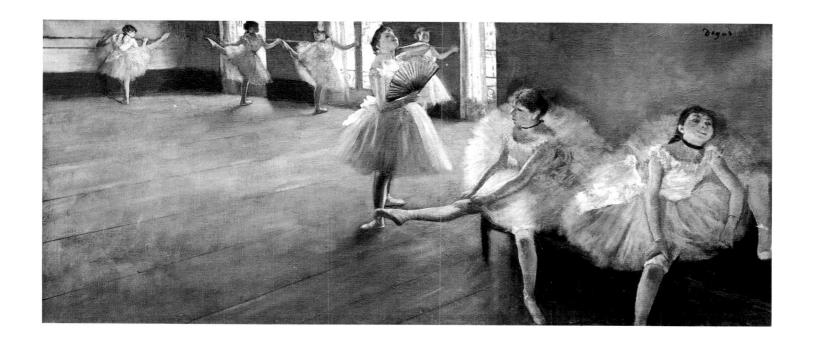

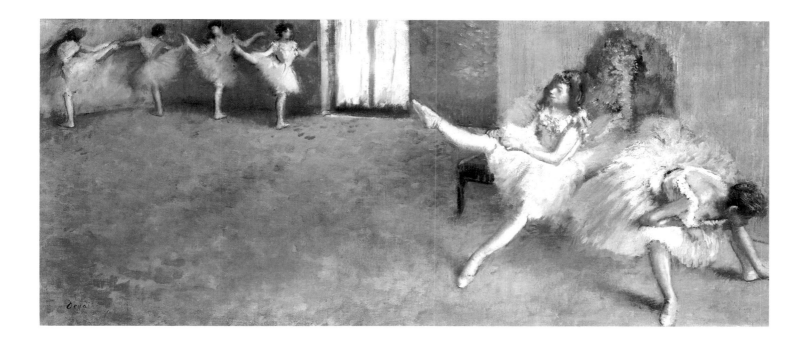

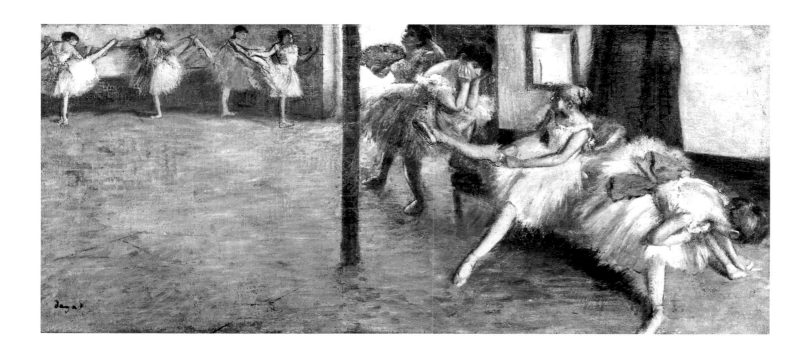

face, crowning the pose yet drawn apart from the body as if disowning it, affects us as if we were watching her die.

On the flat surface of canvas or paper, balance is a feature of the picture as well as what is pictured. An outstretched limb is as much a part of the picture as it is of the body to which it is attached. Time after time it had suited Degas's wit to fragment and to dismember bodies, appealing to viewpoint, playing off the action of the figures against the geometry of the canvas. In the pastel *Un Coin de la Scène Pendant le Ballet* we are absorbed into a world of pale arms that weave across the slanting space, shaping invisible forms. They are powerfully lit in the footlights. We are so embroiled in the event, so close to it, that we can see nothing whole. Accidents of occlusion are invented to cement together new unities that have no meaning outside the picture and answer to nothing we can name. From the center outward to the left top corner, the arms of four different dancers fan and sweep as if impelled by a single impulse, supporting the disembodied head of the dancer in blue, whose identity, like her companions', has dissolved into a new organism. In the bottom right corner a forearm and a hand glide into the picture, palm downward, fingers curled, the little finger extended. It is shaping the space below it, as if finding an invisible object—the corner of the picture.

But working in three dimensions, the problem of backgrounds shelved, Degas was able to give himself over completely to the figure, an unqualified wholeness. The piece must balance in real space.

The subject is stripped bare: it is the dance that is being constructed, and its parts are not dancing masters and stage flats and perky faces but gravity, weight, energy, body-sense—and movement, which is both real and represented.

Degas's obsessive repetitions, by which he drew a pose again and again, tracing it, reversing it, moving it around, meet a particular fulfillment in the sculpture. Now repetition is extended through 360 degrees; the meaning of a pose is not in any single form or any single viewpoint but in the unfolding, the transition from plane to plane, from compression to extension, from aspect to aspect: the onlooker's memory becomes truly and inseparably part of the form.

With *Danse Espagnole*, for example, movement is both presented in her pose and discovered as we move around her. Just as our real movement imputes ideated movement to her, so, symmetrically, the real interactions of mass and their unfolding in space impute ideations of weight and balance to our own bodies. The ebb and flow of these sensations, back and forth, is organized by the representation itself, the effigy of the dancer.

She strikes her pose. If we approach her from the left and look at her most clean-cut profiled aspect, her weight is firmly supported on her left leg. The far leg, much elongated, just brushes the ground in a long, slanting gesture. Her arms, one in a horizontal plane, one in a vertical plane, encircle her torso and head like open hoops. We are drawn toward her front, to face the astonishing *contrapposto*, the pelvis thrust upward by the weight-bearing leg, the whole torso twisted away from the vertical of that leg, curving away from it and then back in the turn of the head and the curve of the raised arm that encircles it. By the time we have moved to where we see the head in profile, the weight-bearing leg is lost to view behind the long slant of the right leg. Its angle joins with the direction of the torso, and she is seen tipping, spinning toward us. But now her left arm, the one that curves in a horizontal plane, is seen to be encircling a space, a column of air that stands like an invisible guardian of her

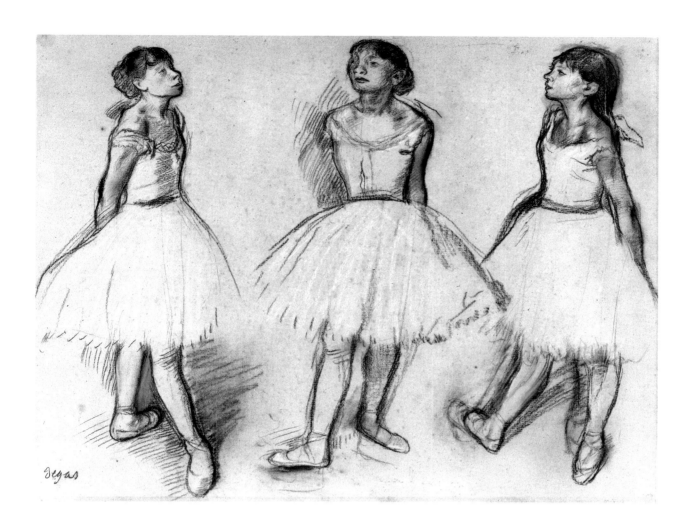

Trois Etudes d'une Danseuse
en Quatrième Position
(Three Studies of a Dancer
in Fourth Position). 1879–80

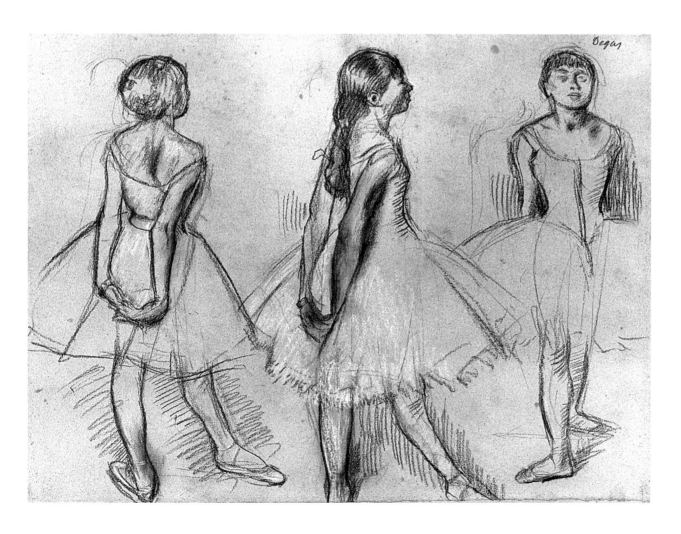

Etudes de Danseuse
(Three Studies of a Dancer).
1879–80

205

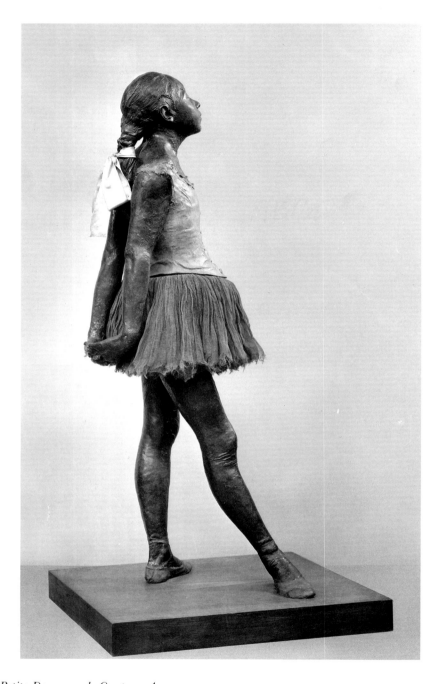

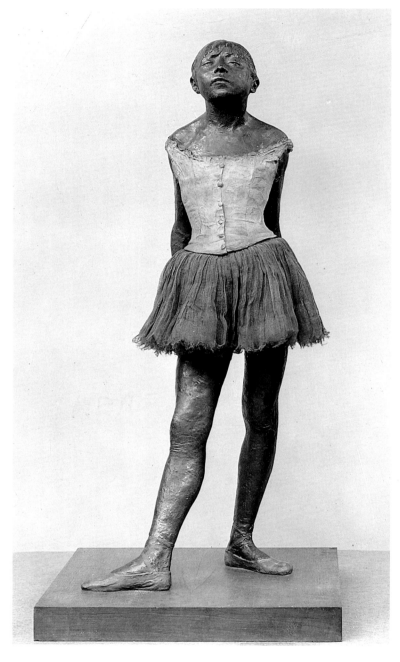

Petite Danseuse de Quatorze Ans
(The Little Dancer of Fourteen Years
[*versions in bronze and wax*]). 1879–81

The Petite Danseuse de Quatorze Ans, *the only sculpture Degas showed during his lifetime, was among the most discussed of all the works in the Sixth Independent Exhibition. Following are excerpts from reviews by J.-K. Huysmans and Nina de Villars:*

The terrible reality of this statuette evidently produces uneasiness in the spectators; all their notions about sculpture, about those cold inanimate whitenesses, about those memorable stereotypes reproduced for centuries, are here overturned. The fact is that with his first attempt Monsieur Degas has revolutionized the traditions of sculpture as he has long since shaken the conventions of painting.

Adopting the method of the old Spanish masters, Monsieur Degas has immediately made it his own, entirely individual and entirely modern, by the originality of his talent. Like certain madonnas painted and dressed in real gowns, like the Christ in the Cathedral of Burgos whose hair is real hair, whose crown of thorns is made of real thorns, whose drapery of real fabric, Monsieur Degas's dancer has real skirts, real ribbons, a real singlet, and real hair. The painted head, slightly tilted back, chin up, mouth half-open in her sickly and grey-brown

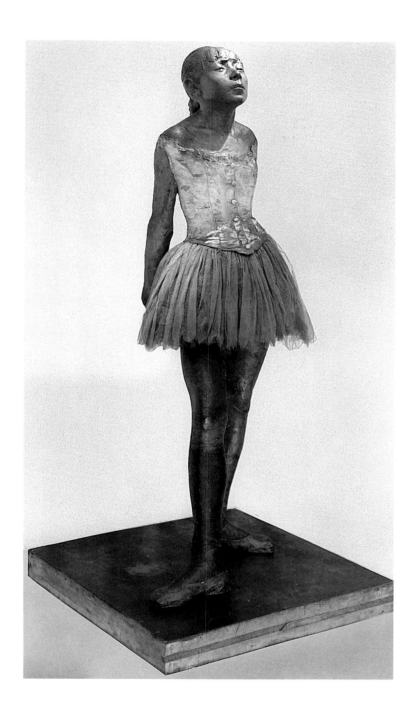

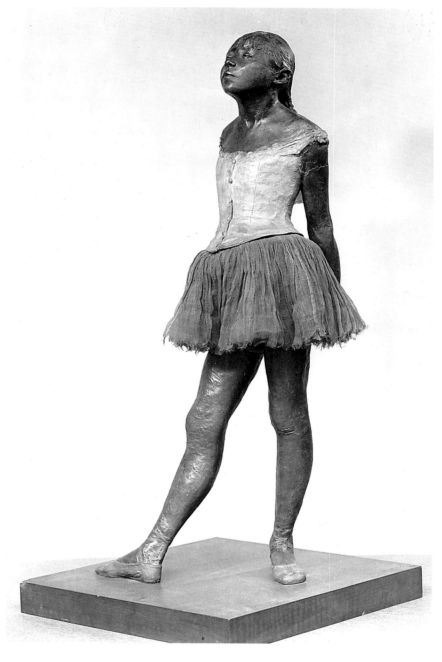

face lined and faded before its time, hands clasped behind her back, flat chest crammed into a white wax-clogged singlet, legs set for the struggle, fine thighs which exercise has made nervous and sinewy, surmounted like a flag by gauzy skirts, neck stiff, circled by a leek-green ribbon, hair (real hair) falling over one shoulder and caught up in a chignon with another ribbon of the same color—such is this dancer who comes alive as we look at her and seems about to step down from her pedestal.

It takes a good deal of suffering to arrive at the aerial lightness of the sylphide and the butterfly; such is the sad reality of the profession; the grubby face is contracted by effort. The child is ugly, but certain exquisite delicacies about the chin, the eyelids, the ankles, herald future splendors. In the presence of this statuette, I have experienced some of the most violent artistic impressions of my life: I have long dreamed of such a thing. Seeing in village churches those virgins and saints in polychromed wood, covered with ornaments and fabrics and jewels, I would think: why has it not occurred to some great artist to apply these naïve and charming methods to a modern and powerful work? And here I find my notion realized down to the last detail.

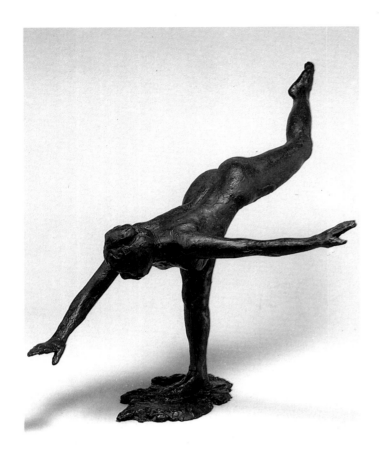

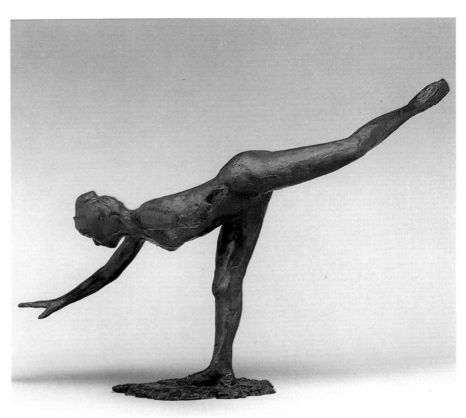

Grande Arabesque Troisième Temps
(Grande Arabesque, Third Time [*two views*])
c. 1882–95

play, reinforcing the leg, guaranteeing her return to stability. From behind she seems to hang against that space, to swing back from her invisible column recklessly, her right hand triumphantly raised. And as we move farther to complete the circle, the firm vertical of the left leg is restored.

We experience her balancing objectively as it is given to us in the bronze and subjectively in our movement around it. This flow back and forth between her movement and our movement is at its richest in pieces where the dancer is poised on one leg. Of these there are seven *Arabesque*s remaining, three *Fourth Position*s, two of a dancer pulling on a stocking, and an extraordinary set of six variations of a dancer who holds the sole of her right foot in her right hand.

The *Arabesque*s are planar. The pose is addressed to an audience. It has a front, which we face precisely at the point where we see the pose from tip to toe at its greatest extension. This is both a matter of perspective and of imagery, for it is at this point that the arabesque most unmistakably reveals its face. It is the correct view perceptually and psychologically. The line of the torso and outstretched arm swoops down, the solid length of the thigh and leg balanced by the torso and head. The gesture of the arm asserts the direction of the whole body like an arrow. The supporting leg, thrust backward by the dipping swoop forward, is strongly rooted in the ground. It is a form of immense strength and dynamism, and miraculously stable.

But as we move away from the "correct" view, losing its unified expression in foreshortening, it is as though we can watch her actively sustaining her balance. The arabesque is still there—her balance—but no longer visible. From an oblique angle

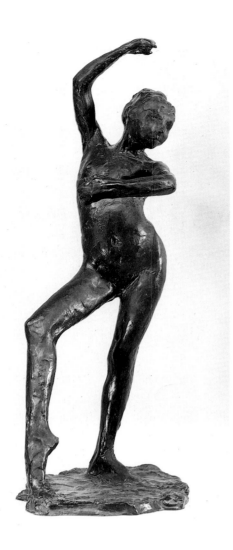
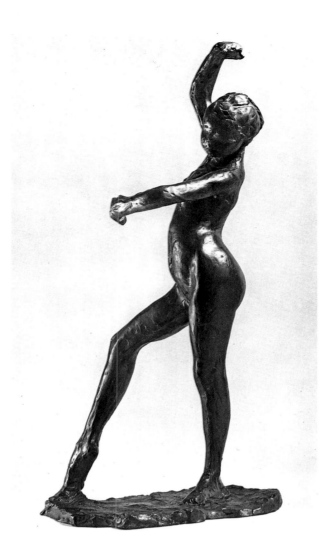

Danse Espagnole
(Spanish Dance [*two views*]). c. 1882–95

from behind her outstretched leg it is as though we see her outreaching herself, nearly falling. The changing weight and proportions are like a flux of efforts and achievements, now diving, now scooting forward, now precariously held, now in fluid exchange, hanging on the brink, to be rescued only in the planar view to left or right, the complete arabesque.

With the figures who stand on one leg not in a dance position but to pull on a stocking or to look at a foot, there is no single definitive view of the pose but a succession of views, none of which is self-contained. With the six versions of the dancer holding her foot, the main force of the pose is generated by the challenge to gravity of the full curving weight of the leg pulled back. In two versions the supporting leg is straight, the knee locked. She leans forward, her outstretched arm straight, balancing like a stork. In other, more complex versions, the knee is bent as if she has to hop to balance.

We discover extreme changes: in one piece, the lower back seen from behind is deeply hollowed and thin, but as we move around, what seems to be the same form flows and swells, revealing a luxurious convexity that is unimaginable from an earlier point of view.

The form is alive. The figures never turn into little self-contained figurines. We are always involved in Degas's drawing, his "way of seeing form." Distortion does not attach to the figure but to Degas's realization of it. The resilience of the figure and its dance with gravity is played over to us in a succession of planar alignments that fan out from its center and engage our viewing. A simple instance of this is in a version

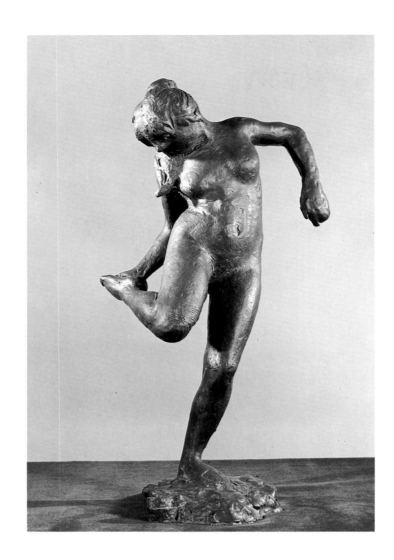

Danseuse Regardant la Plante de Son Pied Droit
(Dancer Looking at the Sole of Her Right Foot
[*two views*]). c. 1882–95

Pauline, one of Degas's models, offered this
account of posing for the artist in 1910; her
story was recounted by Alice Michel:

"All right, let's take that pose again. . . ."
The session continued in silence until Pauline,
tired of her gymnastics on one leg, asked for a rest.
While she was standing near the stove, she tried to
recall the tune of the minuet. Unable to do so, she
said, "Monsieur Degas, would you teach me that
pretty tune you were singing just now?"
"Of course, my girl. I'll sing it for you." He stood
in front of Pauline, and while singing the minuet
made little bows and steps which the girl returned,
laughing, delighted by the comical aspect they
presented: she, stark naked, with only a pair of
mules on her feet, and he, the white-haired old man,
in his long sculptor's smock.
Degas seemed quite happy. Once the minuet was
over, he grasped the model's hands and made her
turn around while he hummed an old French
folksong.

of *Danseuse Regardant la Plante de Son Pied Droit* where the balancing arm is stretched out straight in front of her, parallel to the left foot, making a plane that although literally invisible is as real as if we could touch it. When we arrive at a point where the outstretched arm is pointing straight toward us, we discover that from this point of view the supporting leg is cut into planes with hard arrises. We are on a knife's edge. The slightest move to left or right will break that alignment and send us off toward her uplifted thigh, the pull on her foot, the clockwise search for balance. But meanwhile this alignment of arm and foot and leg holds us: it is one station in front of the piece, one view, but instead of imposing a kind of picture on the pose as the arabesque does elsewhere, it draws a spatial connection between our place and hers, and between our stillness and potential movement and her stillness and imagined movement. We are joined with her in her act of balance. Moments like this, so elating to experience but so tedious to reconstruct in words, appear among the dancers again and again.

"Drawing is not form, it's the way you see form." Degas's marvelous aphorism was surely made in the light of his experience of sculpture. Form came to life there in an ever-changing sequence of planes rather than in a final state. It was discovered in movement and was not to be split off from its surrounding space. His sculpture questioned the fixed divisions of classical drawing, although it was from classical drawing that it sprang.

At the same time, no painter who ever made sculpture could return to the canvas

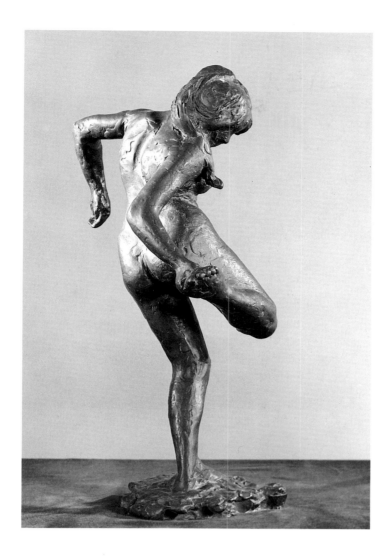

without a vastly amplified sense of its flatness and the power contained there. When we read of the old Degas praising the flatness of pictures we know that it is the sculptor speaking.

In the last twenty years of his working life Degas lost interest in the ballet as a subject for illustration. Some of the old images of backstage or of dancers taking their bows keep coming, but the point now lies with something beyond narrative. All is now a kind of dance.

He loses interest too in virtuoso arrangements in deep space and in play with extreme contrasts of scale. Increasingly form dominates space. The dancers press toward us. The picture grows in a different way. Instead of placing his figures in a constructed space that is tied to the shape of the support, he now prefers to allow the picture to change shape with the development of his thinking. Working on paper, he can add or subtract at will. Pictures will grow outward from single drawings—often tracings from other drawings—and strip after strip of paper will be added as new figures and new constellations accrue.

Obviously these changes in his work cannot be dissociated from the additive procedures of sculpture nor from his use of pastel, which had now nearly supplanted oil paint. With pastel, drawing and coloring at the same time, he works openly across the whole picture surface, stringing a mesh of color hatchings that he often uses to emphasize the flat surface as if to reinforce its resistance to his rifling of the solid form. Typically, these hatchings will cross a form at right angles to its direction, deliberately cutting against its flow.

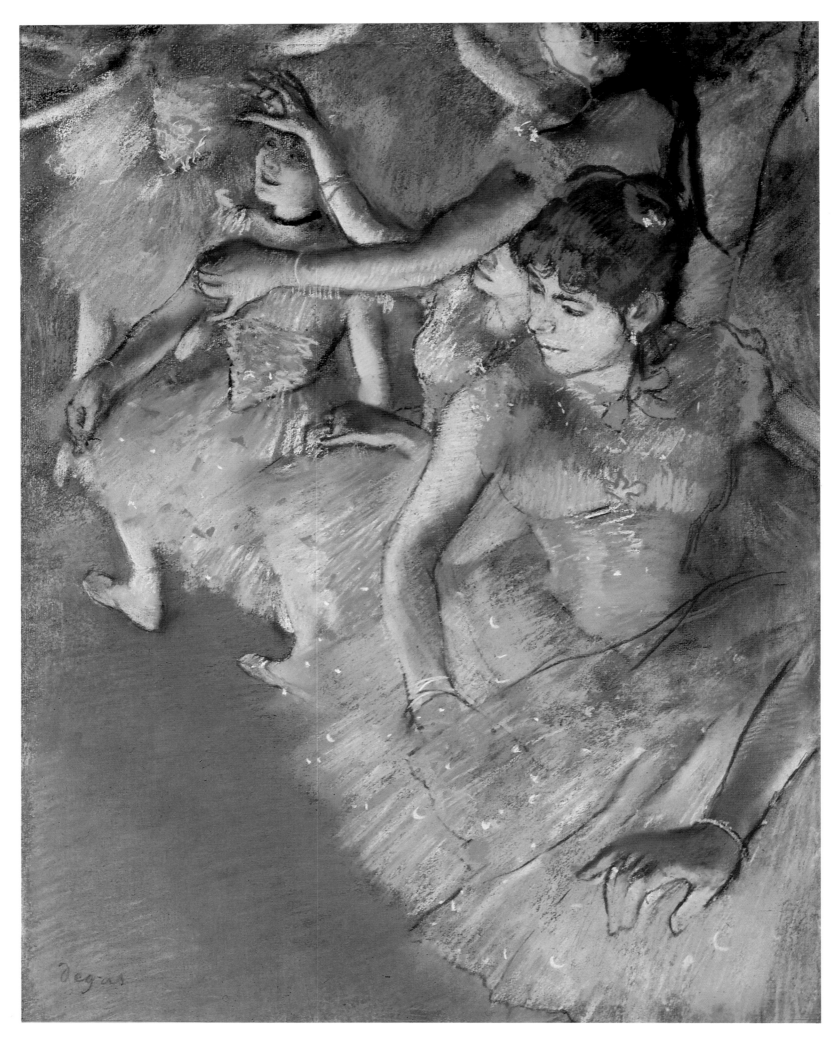

Un Coin de la Scène Pendant le Ballet, also known as *Danseuses en Scène*
(Ballet Dancers on the Stage). 1883

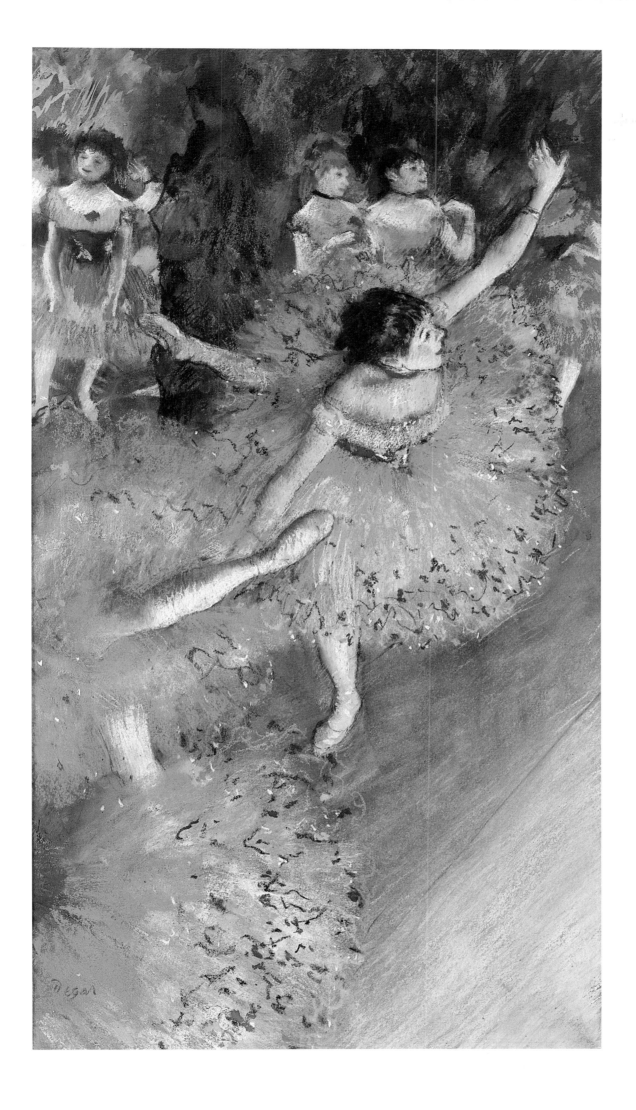

Danseuses Basculant, also known as
Danseuse Verte (Green Dancer). c. 1880

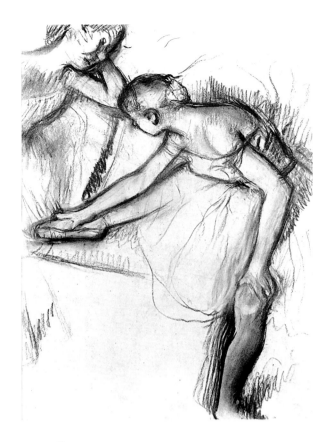

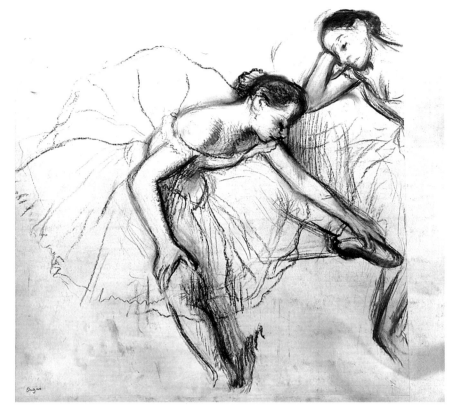

Deux Danseuses au Repos
(Two Dancers at Rest). c. 1896

Deux Danseuses au Repos
(Two Dancers at Rest). c. 1896

Among the themes that absorbed him now was the old one of the dancers who prepare to perform and who adjust their dresses. In the past these movements of preparation had been used to characterize a moment. The Art Institute of Chicago's *Danseuses dans les Coulisses* (*Preparation for the Class*), for example, puts us in the frame of mind of an onlooker who notices this little ritual out of the corner of his eye and is charmed by it. But in the later versions the gestures and positions of the preparing dancers are not fleeting sidelights but central.

In the two pastels called *Danseuses*, one in The Toledo Museum of Art, the other in a private collection, and in many drawings and tracings associated with them, the figures are cut just below the waist. The dancers' heads and shoulders and arms dominate the picture space. We are very close to them, as if among them. Faces are hardly differentiated. It is the arms that matter above all.

Degas draws with them, specially charged lines that cross and recross the picture space making shapes as clear-cut and responsive to adjustment as capital letters: diamonds, Vs, Xs, Ws, Zs. The scale of the arms is such that they are clearly proportionate to the picture. In the private collection *Danseuses*, for example, the arms of the nearest dancer can be apprehended immediately in their relation to the width of the picture. We can visualize how the arms would move and how their movement would fit the picture. Her right arm is bent at the elbow at a right angle. It is like a displacement of the bottom corner of the picture. We can imagine it swinging down to fit that corner. Her shoulder, the pivot of that movement, has become part of the anatomy of the picture. In the same way, the figure behind her, who repeats the pose as if in a mirror, holds her right arm at an exact horizontal that cuts the picture in half. In this way the divisions of the picture reinforce the symmetry of her pose.

The arms are lines—and the lines are arms. Although Degas's drawing is much broader than before, a feature partly connected with his repeated tracing, the quality of the form is as precise as it had ever been. There are no more bracelets or finely

214

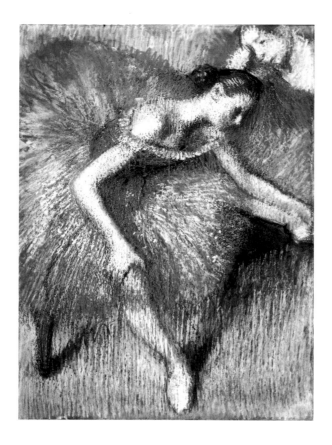

defined fingertips to specify the form. But the structure is hard and firm. We can follow every change in the articulation of arm and shoulder, or in the transition from upper arm to forearm. The hard points of wrist or elbow are exactly placed. The powerful, flat pattern of the picture is threaded through with bones and their spare mantle of flesh, considered in three dimensions. This sense of anatomy—to be expected of any painter as learned as Degas—is more than knowledge. It is heightened, cathected, the expression of a special order of feeling. Simply to follow along its length the implied section of any single arm in one of these late pastels is immediately to taste the quality of Degas's mind as a painter, the flavor of his awareness, his sense of being in the world, his eros.

Arms had a special claim on him, as though they carried a higher voltage than any other part. It had always been so, from the aggressive jabbing of the Spartan girl to the mocking, fluttering, white-gloved arm of the singer at the Ambassadeurs or to the "thin and divine arms" of the opera star Rose Caron, whom he adored. "How long she can hold them out in the air," he wrote ecstatically to Ludovic Halévy after seeing her in the late summer of 1885, "without any apparent strain . . . and then—so gently!—bring them down."

The arms of the dancers seem almost autonomous. Because we do not see the arms' balancing relationship to the legs, their movements are unbounded by gravity. And because they are more clearly particularized than the dancers' faces, we see them unbounded by expression. They have a life of their own, infinitely more weighty than their trivial task of tweaking a strap or leaning.

It is an aggressive part they play in their narrow boniness, cutting the picture into sections, making hard, geometrical shapes that shoot abruptly across the picture; but it is also a receptive part. They nurse and entwine. The fantasy of their independent life is exactly ambivalent: just as they are simultaneously hard and comforting, so they project freedom and encirclement, flying and drowning.

Degas had been drawing similar poses of dancers resting, knees spread, for many years. When he had first used them they had been incidents in compositions that illustrated aspects of the dancer's life. Here, in these late versions, the high viewpoint, the spread skirt, and the limbs extended without reference to gravity combine to make configurations that are purely aesthetic. The dancer fills the page not with figure-like form but with an open trapezoid drawn with her limbs, a displaced version of the rectangle upon which she is drawn. Her bent elbow wants to drive back into the top left corner of the page, which it would fill, as though the whole framework of her limbs could pivot on the head of her weary companion whose neck and elbow fill the top right corner like a bracket. The skirt of tulle radiates out from the foreshortened torso in every direction, filling the spaces framed by the limbs. But again, its outside shape is barely defined. It is less than skirtlike. We become absorbed in its texture and its radiating directions as it absorbs the floor through the agency of Degas's long pastel strokes.

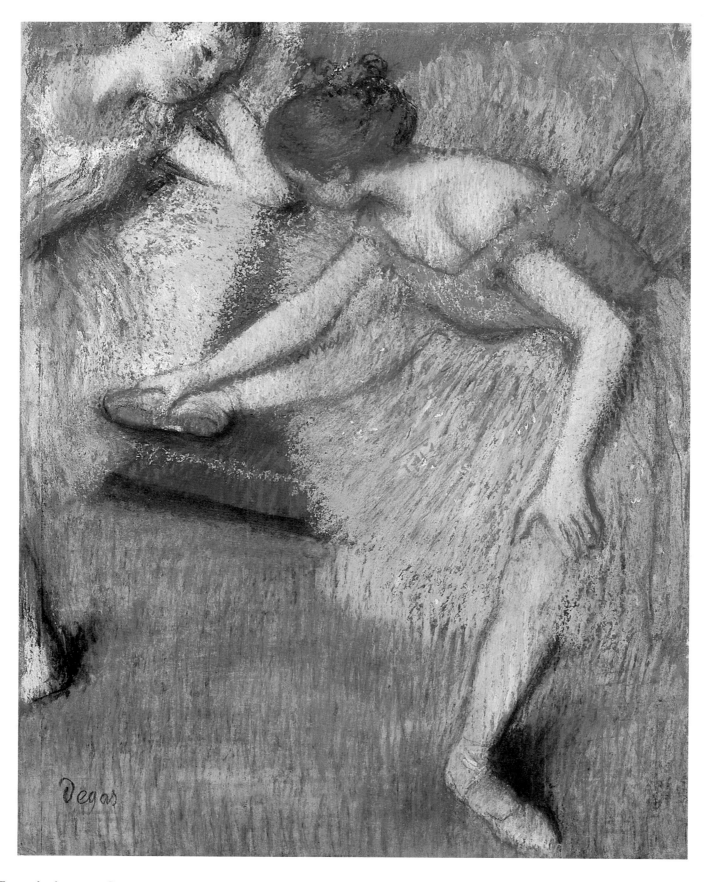

Danseuses au Foyer, also known as *Danseuses*
(Dancers in the Green Room). c. 1896

216

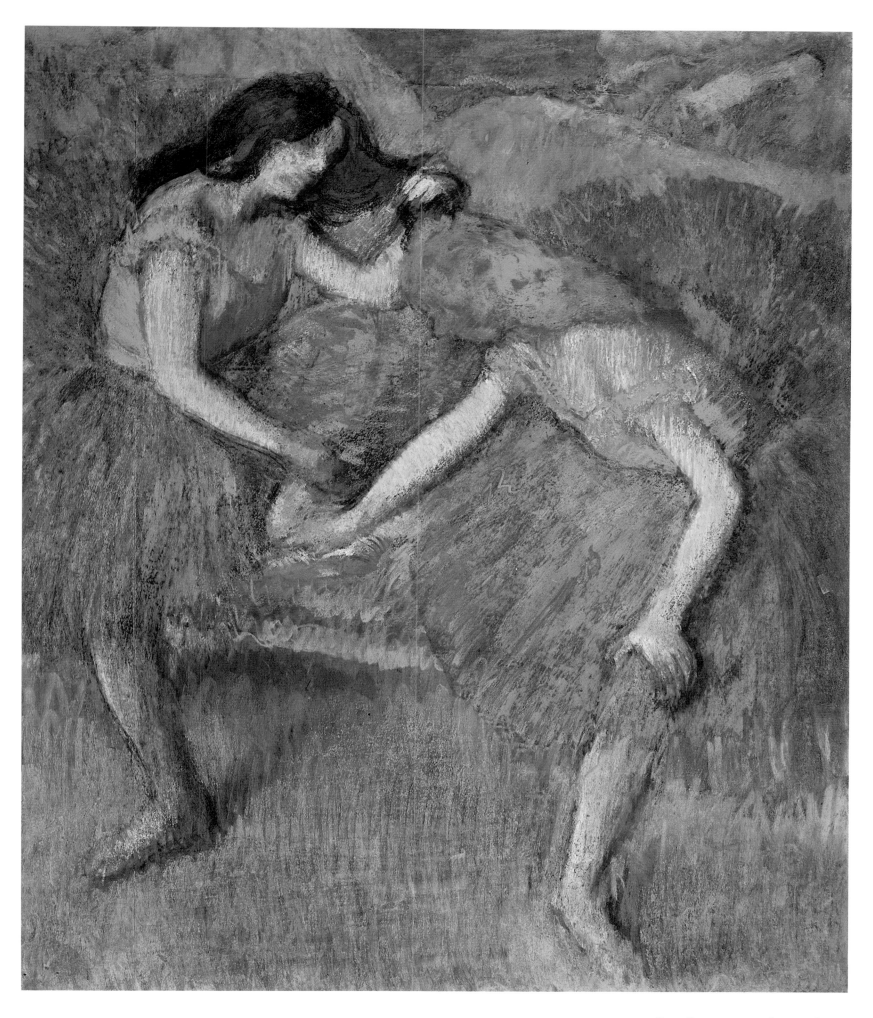

Deux Danseuses aux Corsages Jaunes
(Two Dancers with Yellow Bodices). c. 1902

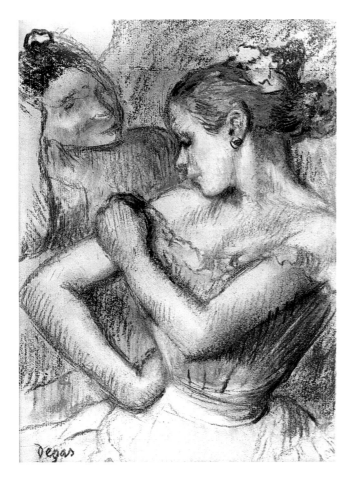

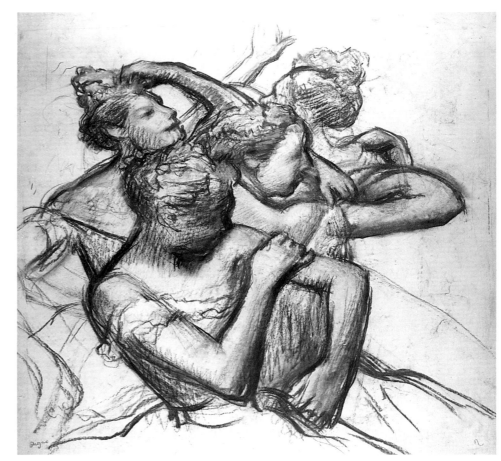

Danseuse (Dancer). c. 1895–1900

Quatre Danseuses à Mi-Corps
(Four Dancers, Half-Length Studies). c. 1899

In the Toledo *Danseuses* nothing calls from outside the picture except the understanding that these are dancers. The distinction between working and resting, between formality and informality, so important in the earlier pictures of the ballet, has long since collapsed; just as distinctions between what is drawn and not drawn, form and not form, foreground and background have dissolved into a continuum articulated only by the lilting geometry of the cranked arms.

The nearest dancer makes a trapezoid in perspective with her lifted arms, her right forearm echoed by the figure beyond her, her head turning back against the drive into the depth of the picture. Her bare shoulders and that magical passage of skin drawn tight over the lifted scapula are raked with vertical strokes that bring them flat onto the picture surface. The shape of the back, framed in the semicircle of the red bodice, rhymes with the bare chest of the dancer on the left, who leans with her arm out straight. That straight, gleaming arm closes the corner of the picture and commandingly gathers up into a single organization all those sections of "background"—skirts, scenery—that now are not secondary at all but parts of the body of the picture.

His response to the human body—central to his work ever since the beginning— has crossed its old boundaries. The dancers, no longer spied out at a distance, no longer observed in representative attitudes, have become the substance of the picture itself. Their movements are the movements of the picture. The draughtsman, the man who "loved drawing very much," had found immediate access to the music of painting, a music that no longer needed a libretto in manners, in categories of dress or gesture, in witticisms of viewpoint, in order to be heard. Now the body is its own music, the picture its own body.

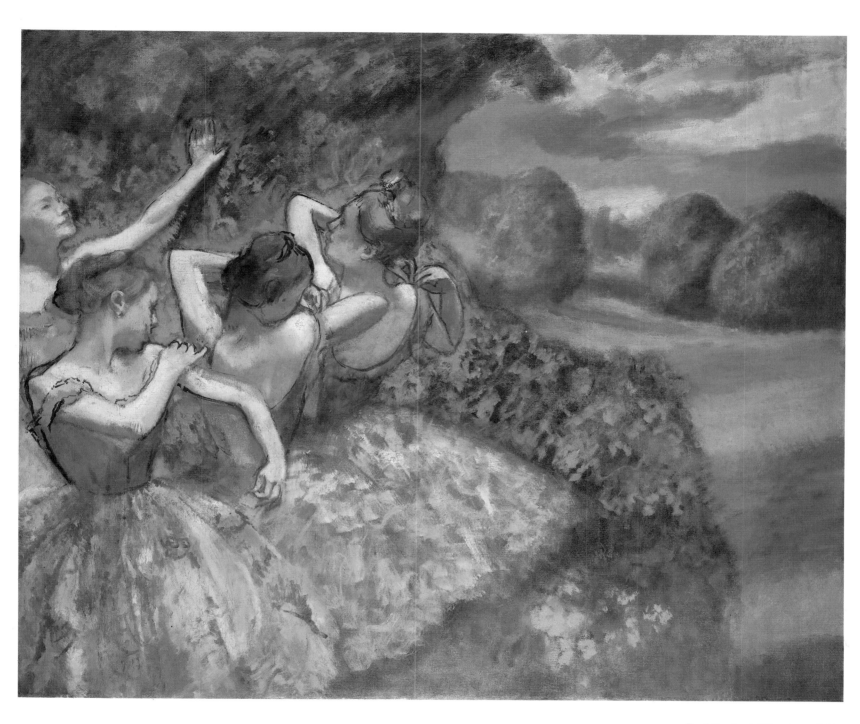

En Attendant l'Entrée en Scène,
also known as *Quatre Danseuses*
(Four Dancers). c. 1896–1898

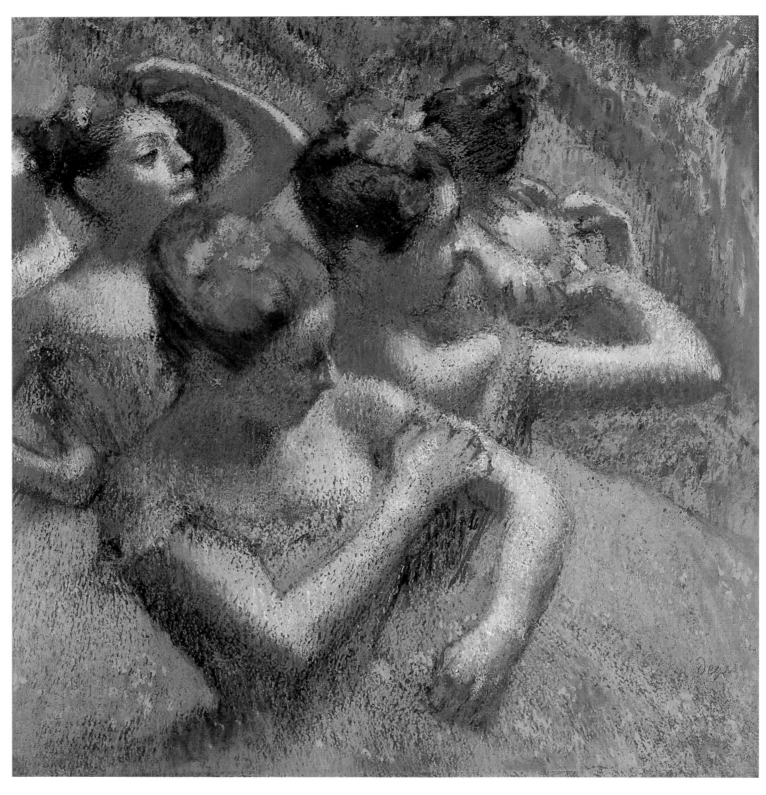

Danseuses (Dancers). 1899

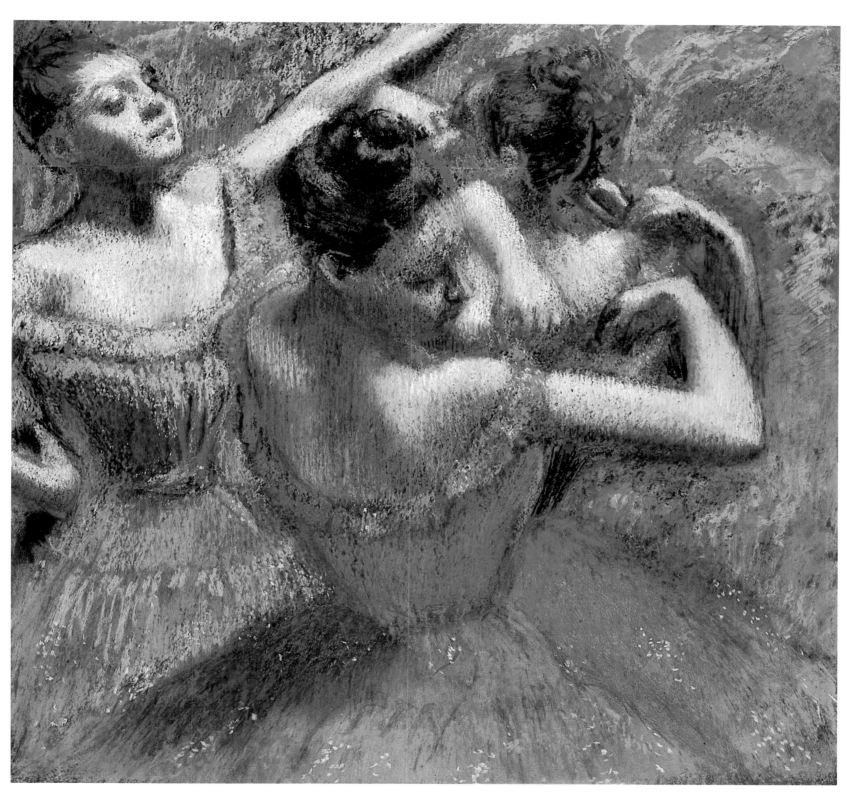

Danseuses (The Dancers). c. 1899

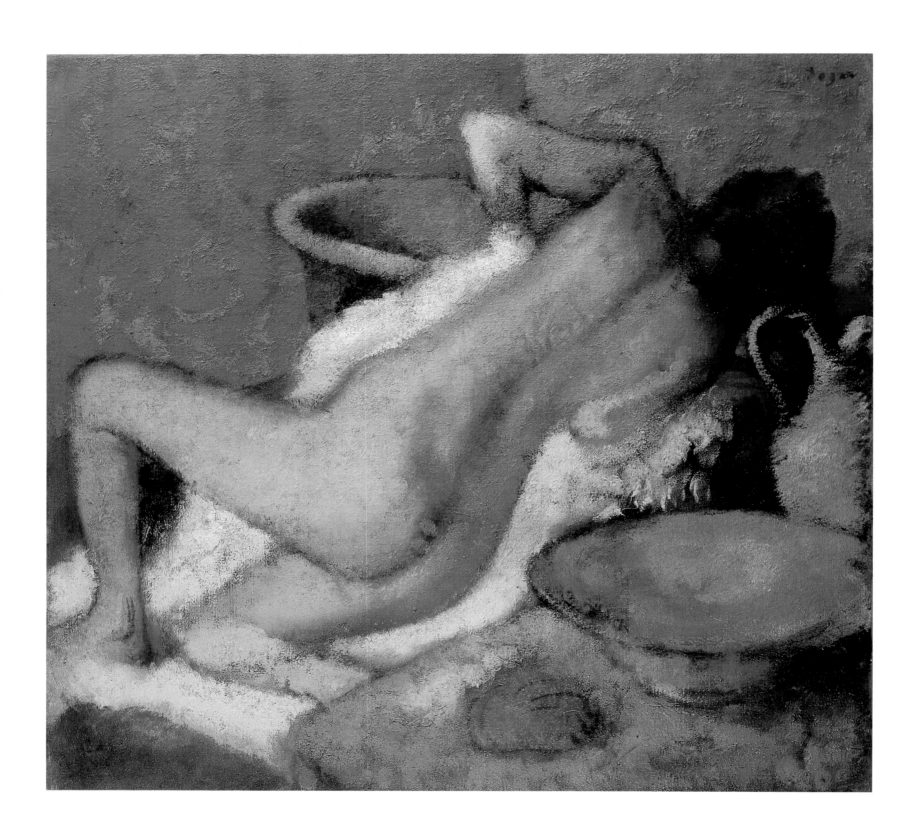

He came and went as usual between the model and his statuette in order to follow with his thumb some detail of the naked body which he then modeled in the clay. A sign of good humor, he hummed in Italian some tune from Don Giovanni, and [the model] Pauline listened with pleasure to his sweet and expressive voice. He knew a great number of Italian operas by heart, and some days he spent the morning singing all kinds of tunes, whose texts he would translate for Pauline, exclaiming, "delicious, no?"

But this morning work soon absorbed him altogether. . . . He spoke of a green and tender princess, devoured by love and fleas, who wandered among the ruins of art; then of a tiger, embellished by a bandage, that pissed against the ramparts of art; of a red, voluptuous serpent, fond of groceries and art, that devoured her own children; and so on. This all ended with: "Ah, art, you bitch!"

ALICE MICHEL, *Mercure de France*

At the Eighth Independent Exhibition of 1886 Degas showed two pictures from his *modistes* series, one with a customer grandly trying on a hat and the other of two milliners at work. He also showed a group of pastels that he described in the catalogue as being of women "bathing, sponging, drying, combing, and being combed." The women were mostly alone, or occasionally with a maid, undressed, their backs to the spectator or with their faces turned away. The milliner pictures showed a familiar side to Degas's art, and the critics had no hesitation in responding to his narrative of contrasting social types. The bathers presented them with an altogether different problem.

It takes an effort of imagination to grasp what these pictures of bathers can have looked like when they first appeared. The camera has made us so familiar with images of people who do not know that they are being watched that many of the disturbing overtones of Degas's pastels have vanished. The course of painting has moved away from the mode of mutual presentation that was still looked for a hundred years ago in almost any picture of a single figure. Degas's bathers went behind the public aspect of women as it was habitually maintained in social behavior or art. His bathers did not project a style of femininity, nor was his treatment of them tinted by sentimentality or idealization or prurience. Compared with Courbet's notorious *Les Baigneuses*, which had so enraged the emperor thirty years earlier, or with Renoir's luxurious nudes, his treatment was dry. What was the point? The critics filled the vacuum by descanting on Degas's cynicism.

"This is . . . woman regarded as female," Gustave Geffroy wrote in *La Justice*, "expressed only in her animality, as if these were superior illustrations to a treatise of natural history." Degas was "eager to reveal lines that no one has sought to establish, or even to see," Geffroy says accurately, drawing attention to the fact that since these

According to a reminiscence by Georges Jeanniot:

Degas was very concerned with the accuracy of movements and postures. He studied them endlessly. I have seen him work with a model, trying to make her assume the gestures of a woman drying herself, tilted over the high back of a chair covered with a bath towel. This is a complicated movement. You see the two shoulderblades from behind; but the right shoulder, squeezed by the weight of the body, assumes an unexpected outline that suggests a kind of acrobatic gesture, a violent effort.

Etude de Nu
(Nude Study). 1896

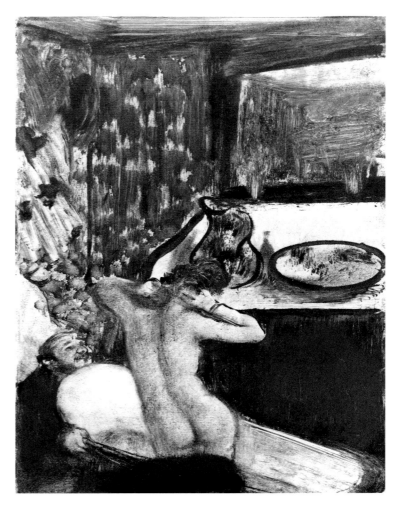

Femme Debout dans une Baignoire
(Standing Woman in a Bathtub). 1876–77

Admiration. 1876–77

mundane positions had never appeared before in pictures, they were invisible in life. As if unconsciously to prove his own point he and other critics fell back on disgraceful comparisons to frogs and monkeys, drawing on current slang terms for women.

Other critics went further, projecting a novelistic interpretation: the women were whores and their bathing and combing was a necessary aspect of their working routine. "Degas lays bare for us, with an artist's fine and forceful shamelessness, the puffy, pasty flesh of the modern prostitute. In louche boudoirs of registered brothels, where certain ladies take the social and utilitarian role of great sewers of love. . . ."

Nor was this line unreasonable, for the first bathers that Degas had drawn had in fact been denizens of his imaginary brothels. There are several monotypes and a small etching that describe the women bathing and washing, often with comic overtones. A much-quoted remark of Degas's to the effect that if he had been painting these subjects two hundred years earlier they would have been of Susannah and the Elders is an indication of his attitude to the narrative aspects of the subject and its overtones of voyeurism. If the images are taken as dramatic fictions, we have to picture ourselves at the keyhole, watching but unseen. For twenty years, the observer's viewpoint had been a major component in his composition, and even earlier, in Italy, he had considered a story of voyeurism as an historical subject. This was the story of *La Femme de Candaules*, which he would have known both in its original form in Herodotus and as it had been recently retold by Moreau's friend Théophile Gautier. King Candaules was so proud of his wife's beauty that he secretly arranged to show her off to a friend. Just as she is retiring to bed, the queen realizes that she is being watched. In revenge for the insult she arranges for her husband's murder. Degas made

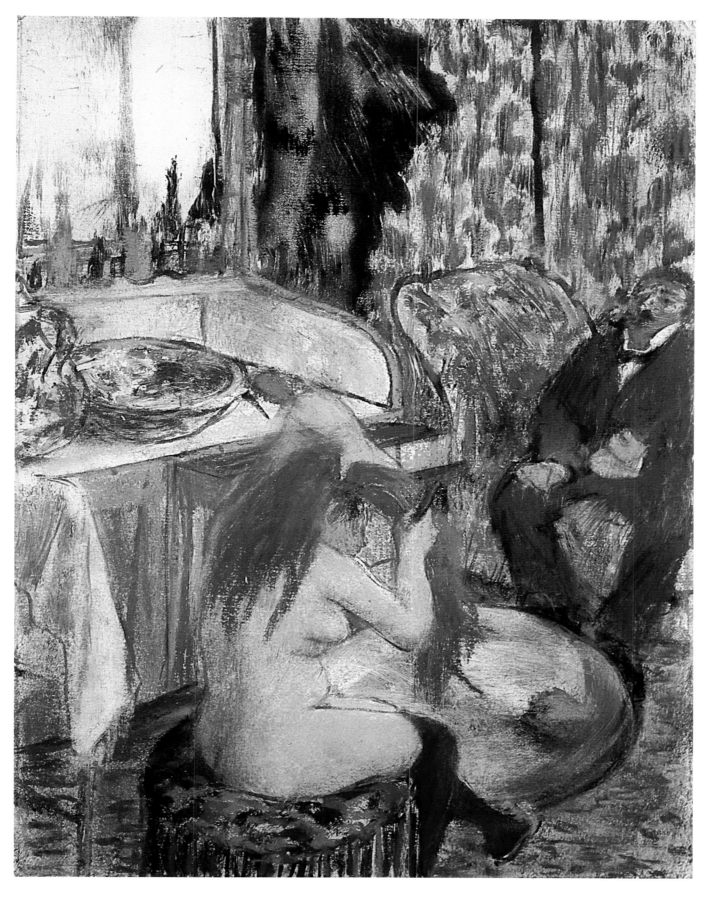

Femme Nue Se Coiffant
(Nude Woman Combing Her Hair). c. 1876–77

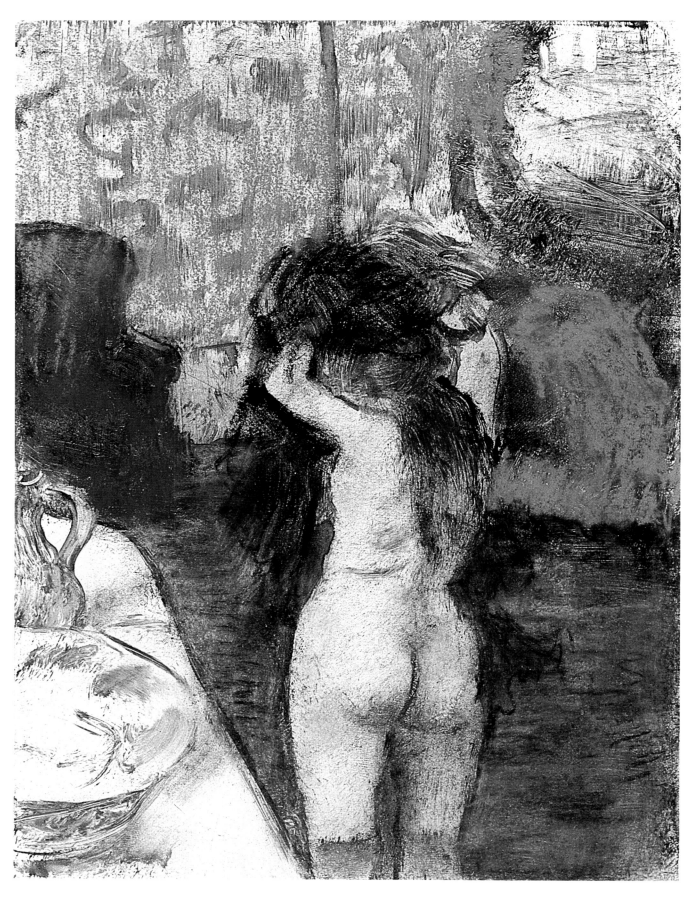

La Sortie du Bain
(Leaving the Bath). 1876–77

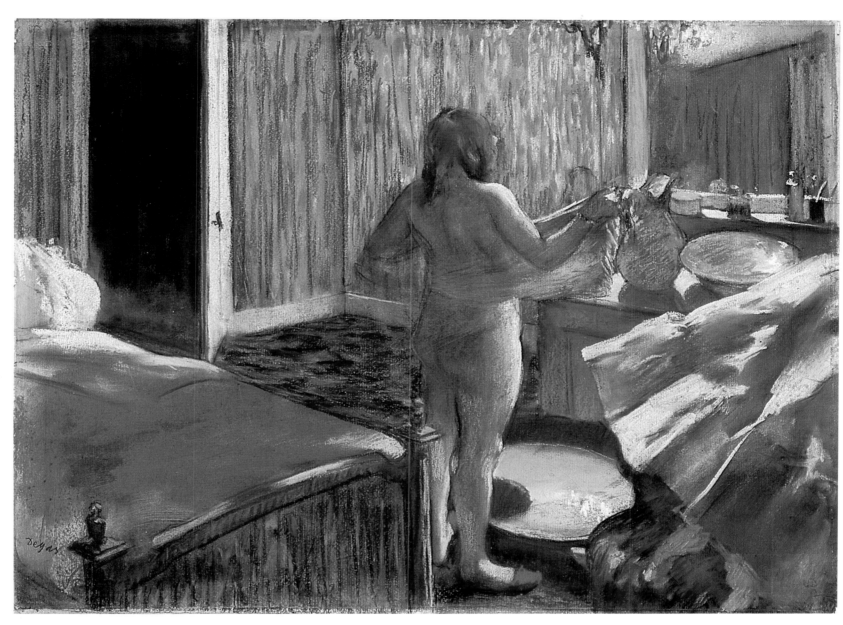

Femme à Sa Toilette
(Woman at Her Toilette). c. 1876–77

*André Fontainas published a review of an exhibition at the Galerie
Durand-Ruel in July 1898, from which the following is taken:*

*Here woman is built around her skeleton, and her flesh weighs her down, her
face has lines of fatigue and her breasts do not always rise as they should. She
has gestures and postures which do not suitably accompany a music of insipid
minuets. Indeed she walks with a marked clumsiness, heavily, and her
movements, which give off gusts of a soft and tawny odor, scarcely correspond
to the rhythms of our conventional popular songs. The stupidity of living and
the material preoccupation of ordinary cares overcome her, though she seeks
to belie them by a studied appearance of more idyllic charm; all these women,
as Degas presents them, are magnificent, burdened, always the center of
unfailing desires.*

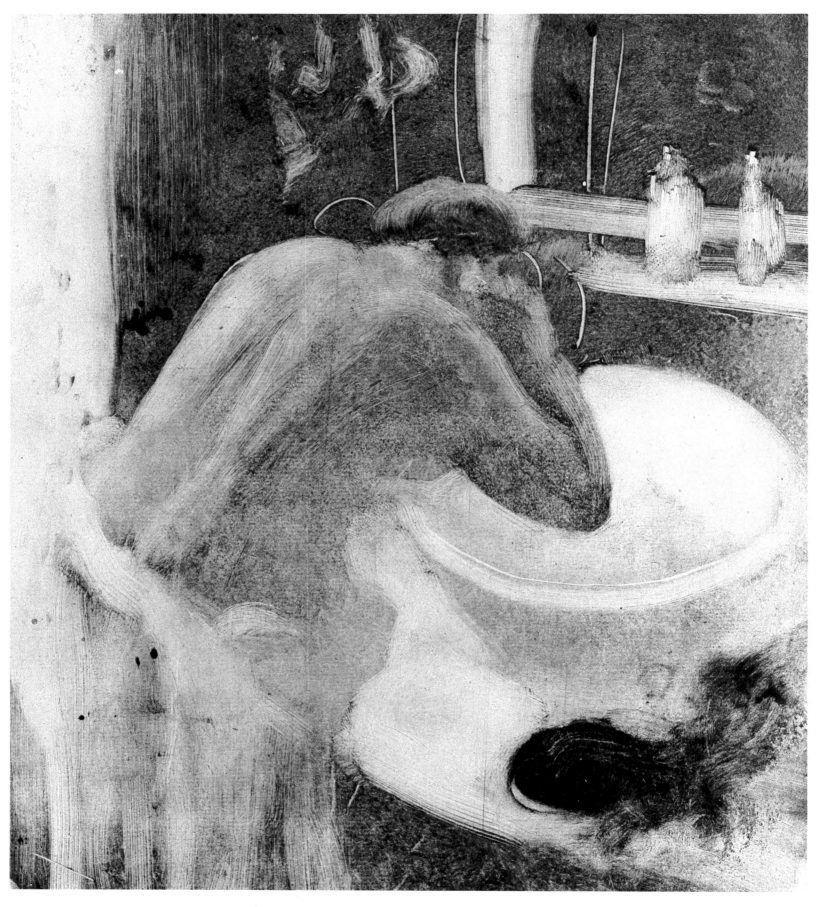

La Toilette (La Cuvette)
(The Washbasin). c. 1879–85

228

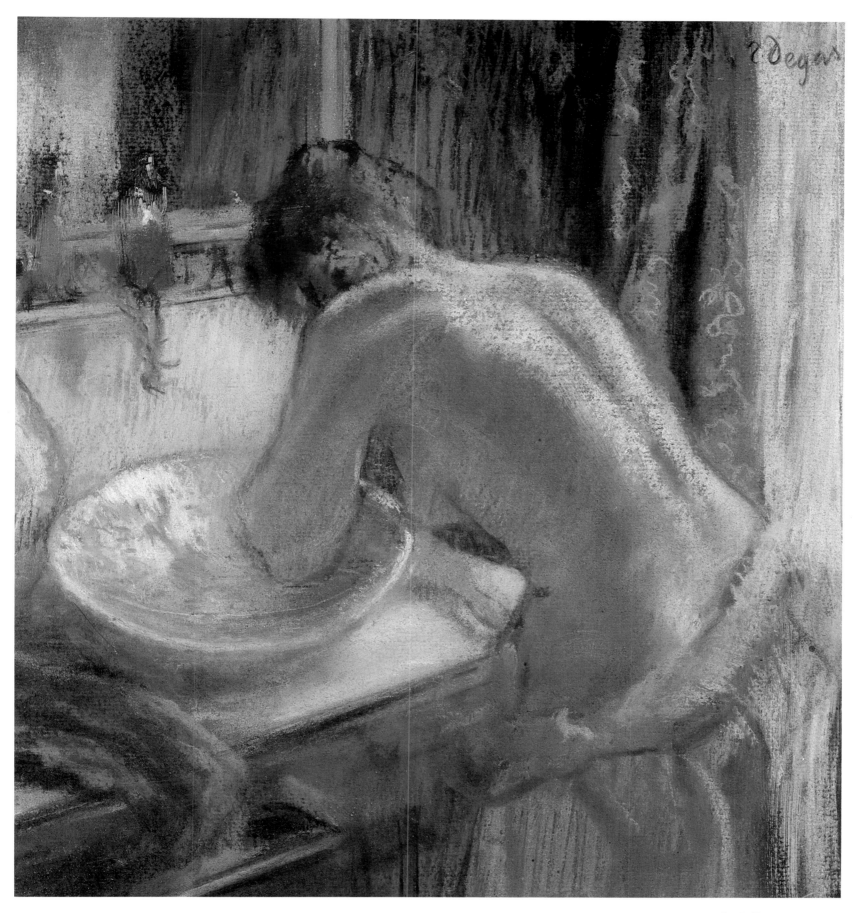

La Toilette. c. 1884–86

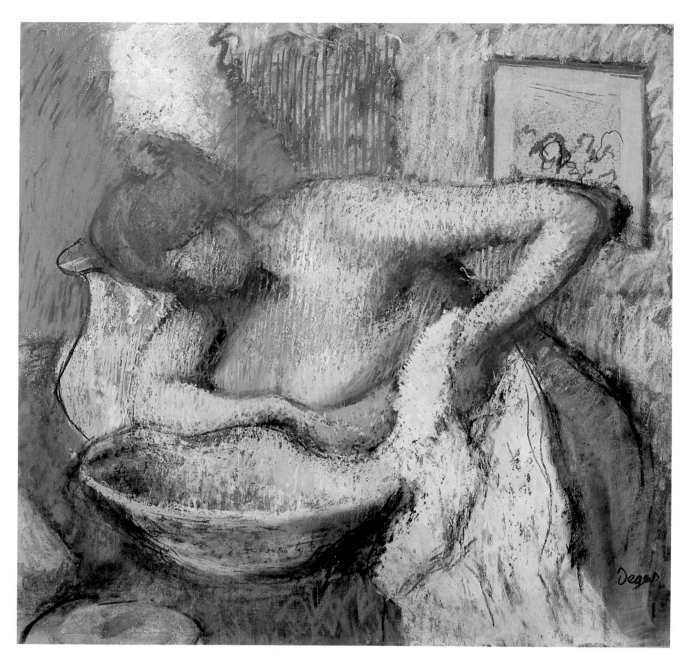

La Toilette. c. 1897

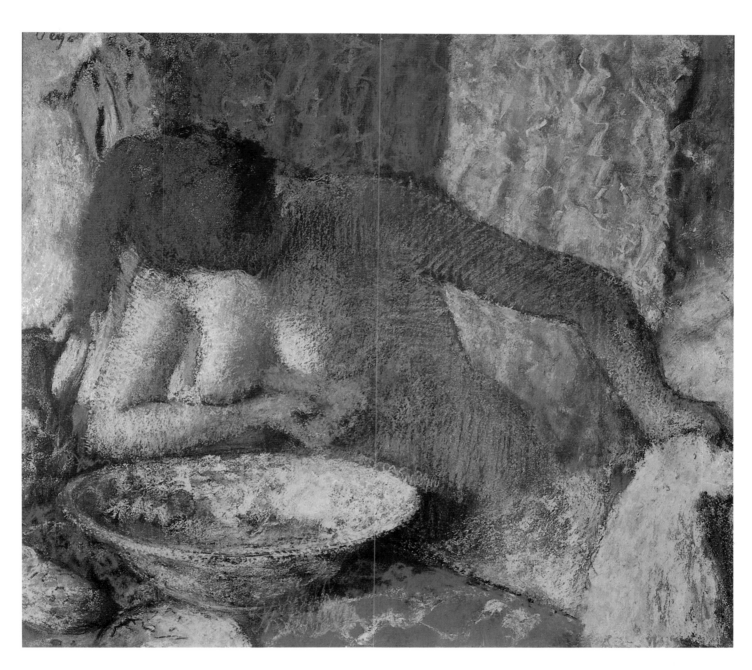

Femme à Sa Toilette (Woman at Her Toilette). c. 1897

J.-K. Huysmans discussed the bathers as a group:

What we may see in these works is the unforgettable veracity of these types, captured with a deep-seated and ample draughtsmanship, with a lucid and controlled passion, as though with a cold fever; what is to be seen is the ardent and subtle coloring, the mysterious and opulent tone of these scenes; the supreme beauty of this flesh tinted pink or blue by water, illuminated by windows hung with gauze in dim rooms in which can be made out, in the daylight creeping in from the courtyard, walls covered with toile de Jouy, sinks and basins, flagons and combs, boxwood brushes, kettles of rosy copper!

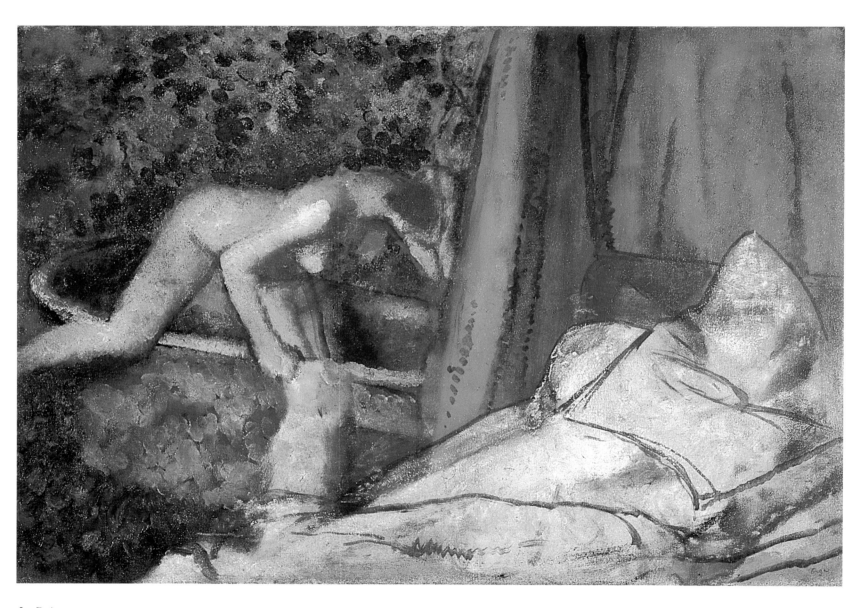

Le Bain
(The Bath). c. 1895

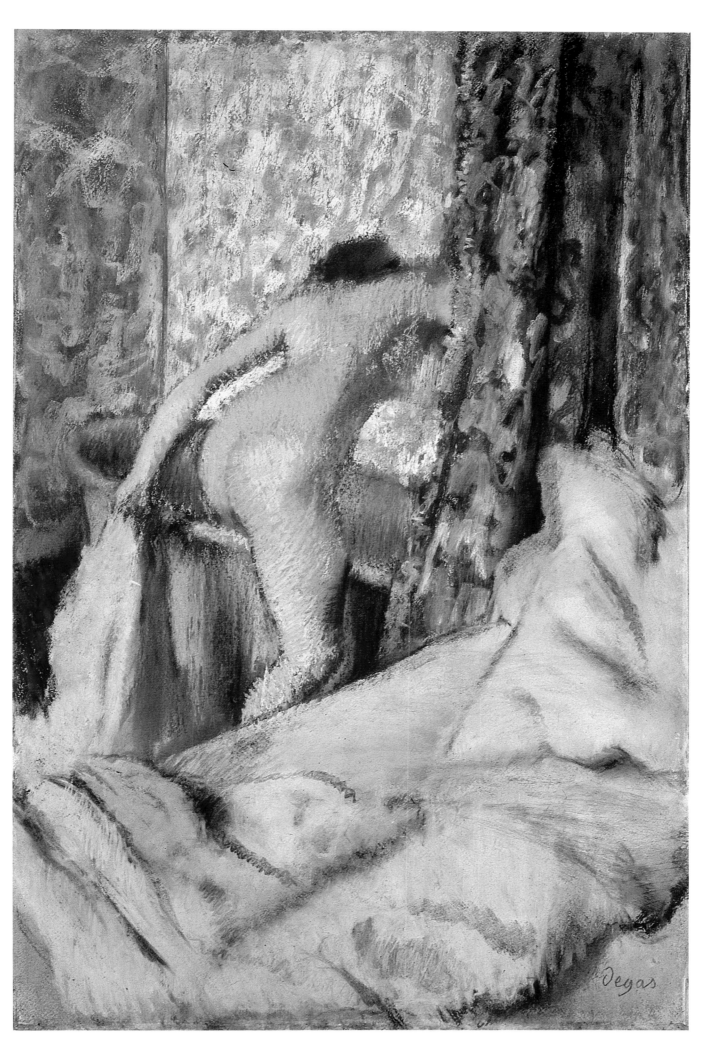

Le Bain Matinal
(The Morning Bath). c. 1895

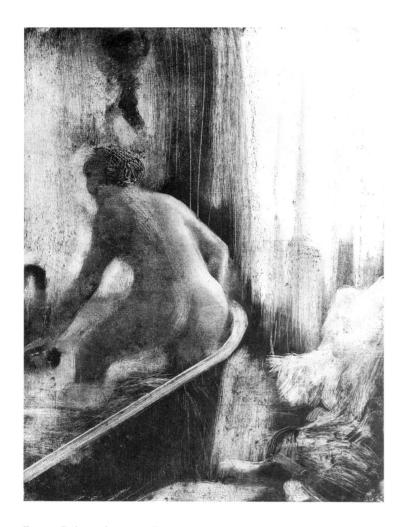

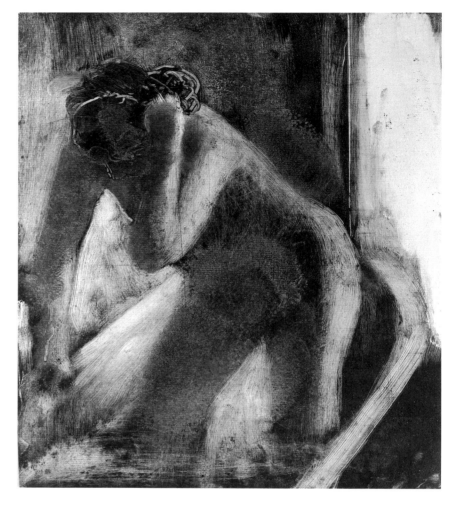

Femme Debout dans une Baignoire
(Woman Standing in a Bathtub). c. 1879–85

La Toilette (Le Bain)
(The Bath). c. 1879–85

OPPOSITE:

Le Bain
(The Bath). c. 1894

Degas often used the second, faint impression of a monotype as the base for another image in pastel. When he first started doing this, the print was used as a kind of underpainting, as in the pastel called Café-Concert, where the printed ink can be seen almost everywhere and the pastel is used to bring out details and set up themes of color. Later his way of working over the print led to radical revisions of the original image. In the pastel Le Bain, *most likely based upon the monotype* Femme Debout dans une Baignoire, *he has brought the bather closer and closer, expanding her form until she touches the edge of the paper and reshaping the bath so that it is anchored firmly at the center of the bottom edge of the sheet and starts a zig-zag movement through the figure that ends where the curtain cuts the top edge.*

The bather's angular limbs and unexpected proportions, in contrast to her soft form in the monotype, indicate that at some point Degas drew from a model. He imagines the bath in a cold early-morning light. Blue floods in through the window, claiming the towel over the chair, the bath, the wall behind it, and—if one can subtract the pink markings that cross her body—the bather herself. It must have been within this nuanced field of blue that Degas manipulated her form, setting her into the hollow of the bath, setting bath and bather into the space of the paper, before he carved her out of the blue with the vertical pink strokes: strokes that are open enough for us plainly to read the blue between.

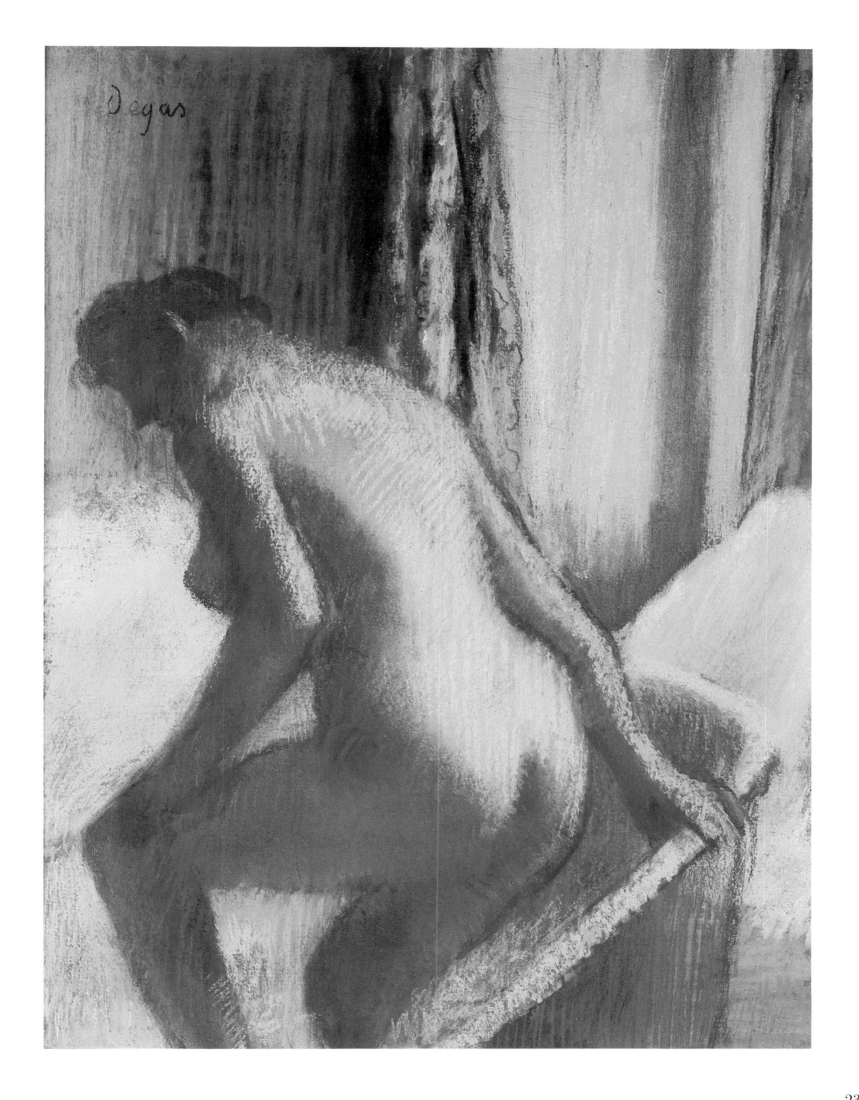

235

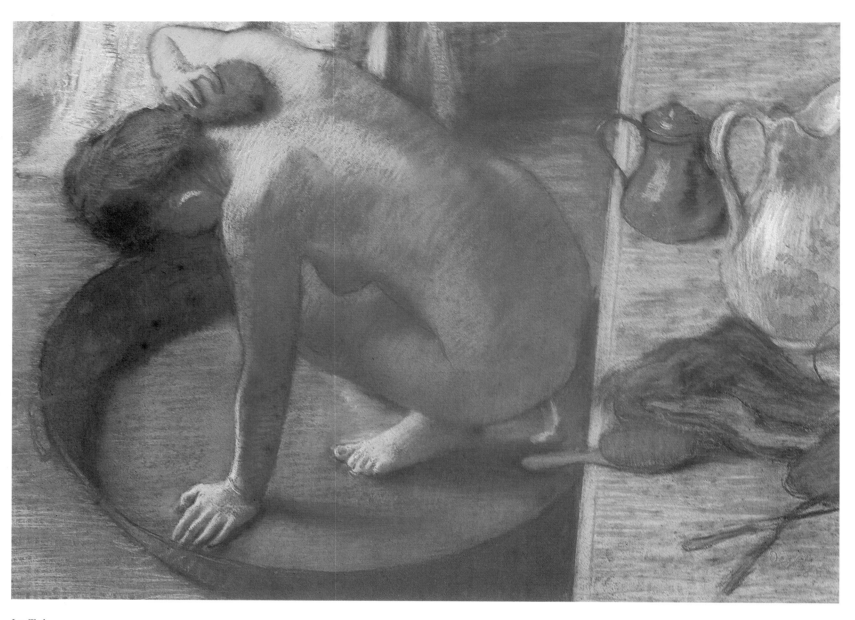

Le Tub
(The Tub). 1886

Critics reacted violently to their first view of the bathers, hurrying to interpret them as illustrations or as social statements. None of the many published accounts describes them for what they were—pictures of models posing. The following excerpt is from Octave Mirbeau's May 21, 1886, review:

The woman crouching in a tub, pressing a sponge to her back, the one bent over, her back horizontal, rubbing her feet—have, in their individuality, the beauty and the strength of gothic statues. Obviously these drawings are not done to inspire a passion for woman, nor a desire for the flesh. Monsieur Degas, in these studies of the nude, has not sought voluptuous or graceful effects; he is not concerned with the sentimental pose which inspires such enthusiastic odes to the arch of the loins, the globes of the breasts, outstretched arms and swanlike necks. Here, on the contrary, there is a certain ferocity which parades contempt of woman and a horror of love. It is the same bitter philosophy, the same proud vision which we recognize in his dancers—those ballet-girls who, from our stalls, in the lilac light of the electric projectors, seem to us so light, so vaporous— half-bird, half cloud! Monsieur Degas, studying them at closer range, decomposing their movements, has given them the alarming character of tormented creatures, straining anatomies distorted by the violent exercises they are compelled to perform. The observation is always harsh, the drawing always pitiless in this great and rare artist, who reduces his subject to her destiny of ridicule and suffering.

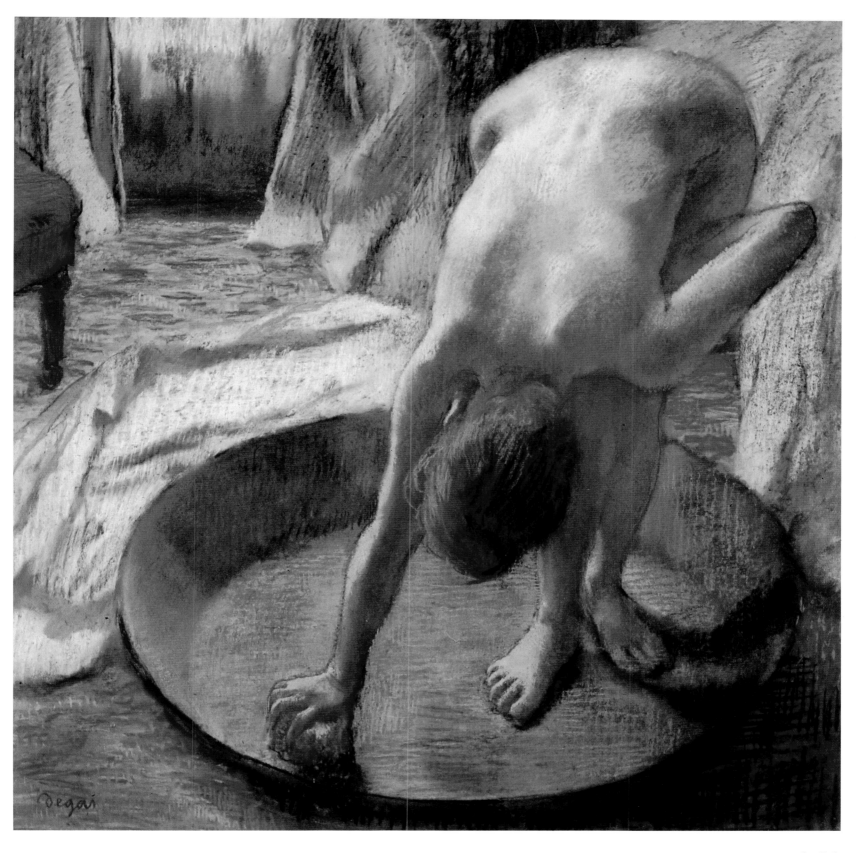

Le Tub
(The Tub). c. 1885–86

237

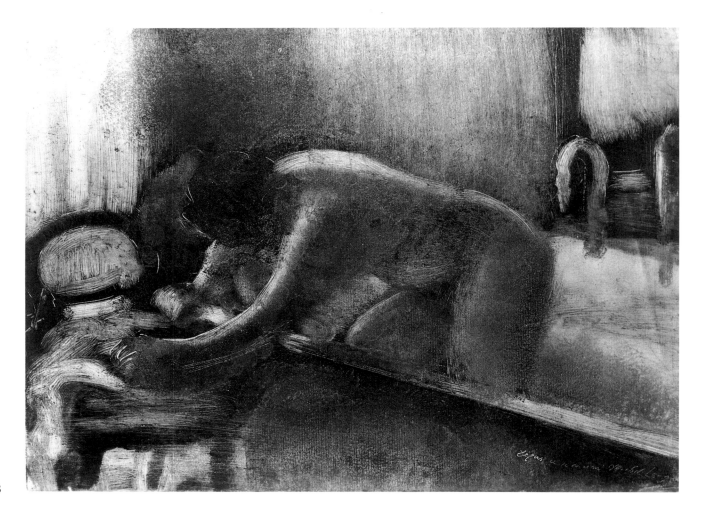

Après le Bain
(After the Bath). c. 1879–83

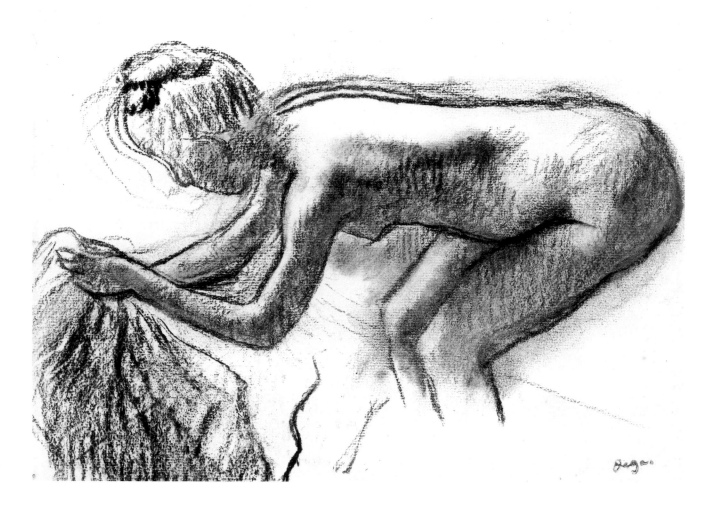

Femme Sortant du Bain,
also known as *Etude de Nu*
(Woman Leaving the Bath).
c. 1886–88

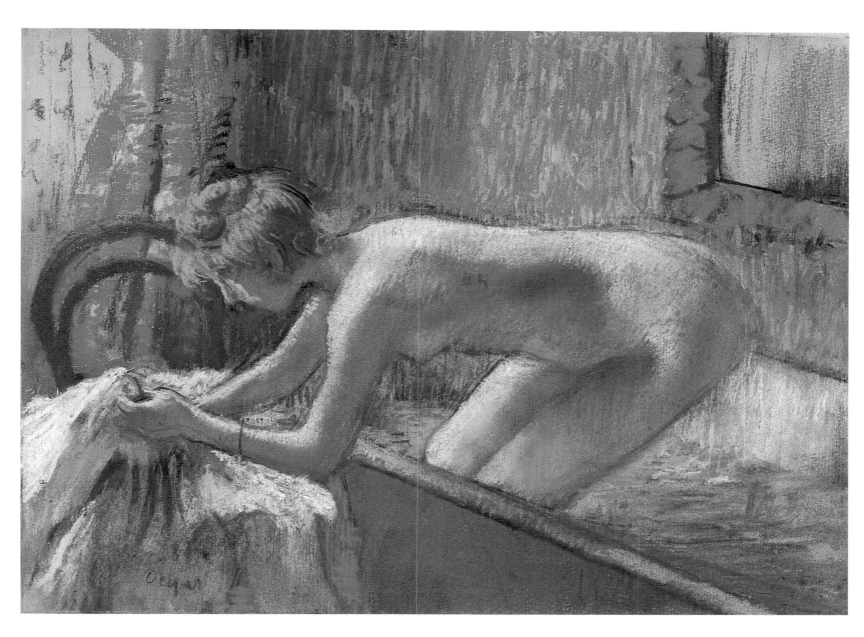

The monotype inscribed to his friend Michel-Lévy is one of a series of very black prints in which Degas
wiped the image directly out of the wet ink. He seems to have lifted ink with a dry brush in some
places—the side of the bath, the lit thigh and back—and in others with a rag perhaps wrapped round
his finger. There is a hint of a smudged fingerprint in the bath. Certain accents around the forearm and
hand and in her hair are scratched out with a sharp point—a toothpick, a pen, or even possibly a
fingernail.

 The bather in Après le Bain herself belongs to that breed of dumpy and slightly monkeyish women that
dwell only in Degas's black monotypes. A young model was able to hold this difficult pose long enough for
Degas to begin the charcoal drawing. Her proportions are distinctive—the long back, the slender neck—
and it is these and her top-knot of red hair that he reconstructs in Femme Sortant du Bain, which he
made over a second printing of the monotype. Although the situation is the same in both, the spirit that
animates the pastel is completely different from that of the print. The lines of the form are concave and
sprightly in contrast to the lugubrious convexities of the monotype.

several trial drawings as well as a study in oil of the naked queen seen from behind, her head fiercely turned.

The glimpse of nakedness, the flashing of that incomparable constellation, a woman's torso, could be dazzling. Several of the brothel monotypes turn the impact of the situation with a joke of a kind that sanctions the expression of deep feelings and even of an idealism that is too vulnerable to be uttered with a straight face. In some of these—among the funniest of all his inventions—he mocks his own voyeuristic longing.

In *Admiration* a long bath fills the foreground. Crouching in the left corner under its lip, which he clutches with a pudgy hand, a dark-suited man, bald and moustached, grinning in wonder, gazes up like a spaniel at the superb torso of the whore that curves up out of the bath, arms raised, drawing in the lamplight a breathtaking parody of classical *déhanchement*: a Venus arising from her shell.

In the pastels, signs of the brothel disappear, and with them the comic element. The voyeuristic situation is absorbed into the structure of the picture. The studio furniture is arranged in *coulisses* down which the observer can glimpse the unconscious bather. Often a temporal reading will be suggested, as in *Le Bain Matinal*; there is an unmade bed in the foreground, and the naked woman climbs away from us and into her bath while a cool morning light dapples the wall behind.

Sometimes screens and furniture underline the ambiguity of our situation. In *Le Bain* the bather is cut off from us and we see a strange curved form, her middle section without head or feet. With the sense of our concealment there comes an emotion that is hard to name, a pang with which we recognize at the same time her vulnerability and a sense of rejection. She does not know we are watching, but still she is turning away from us. The stealth by which we gain sight of her guarantees our loss: that is the way things are.

Many of the brothel poses are clownish—legs in air, rolling and kicking—and this flavor of the grotesque is present in a few of the bather subjects. A woman straddles a bidet. Others climb gracelessly out of their baths or arch their backs and throw out their rumps to towel themselves behind. But as the bather theme develops, this sardonic note evaporates and Degas exposes in these unknown poses a rhythmic architecture of extraordinary and unprecedented beauty. A supreme example is the Phillips Collection's *Femme Sortant du Bain*, where the bather's awkward stance, one leg on the floor, the other half-in, half-out of the bath, the foot going the wrong way, is completely subsumed in a magnificent serpentine arc that flows and flames its way from the chair and clothes in the right corner to the sofa on which she supports her weight on the left.

By far the greatest number of the bathers are seen from behind, and the face is concealed or turned away in those that are not. An exception, the bather in *Femme Nue Se Faisant Coiffer* is not alone but is attended by her maid. The dominant theme is the back; the body seen at its furthest remove from reciprocal address. As the subject of the bathers continues even the notion of the keyhole falls away, and Degas crosses a threshold to a point far beyond ironic audiencehood. The great series of torsos of seated women who dry themselves are viewed from close up, no longer spied out from a distance. Closer by far to sculpture than to illustration, their backs occupy the center of the picture and impart a corporeal wholeness to its entire surface.

The transition can be followed through the sequence of lithographs of a bather who dries her hip, the last printmaking enterprise of Degas's life. In the summer of 1891 he wrote to De Valernes that he intended to make a suite of lithographs, a first series

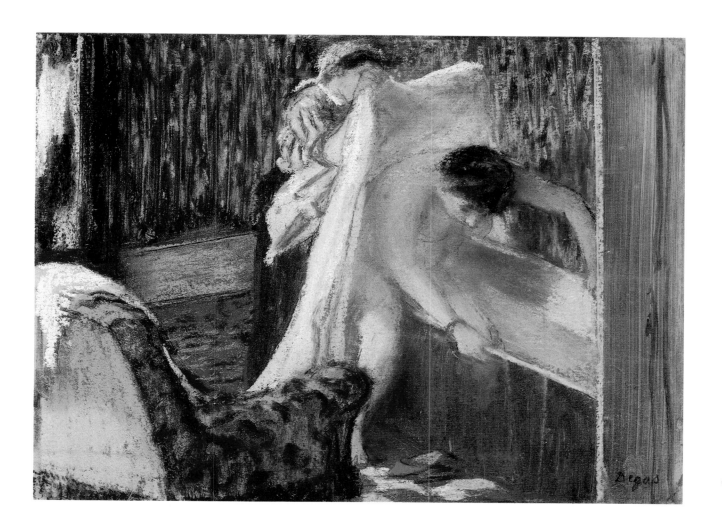

Femme Sortant du Bain
(Woman Leaving the Bath).
1876–77

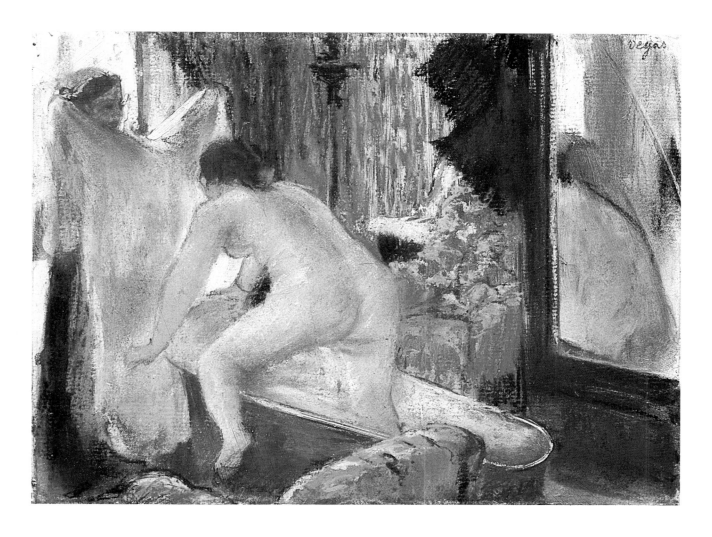

Femme Sortant du Bain
(Woman Getting out
of the Bath). 1876–77

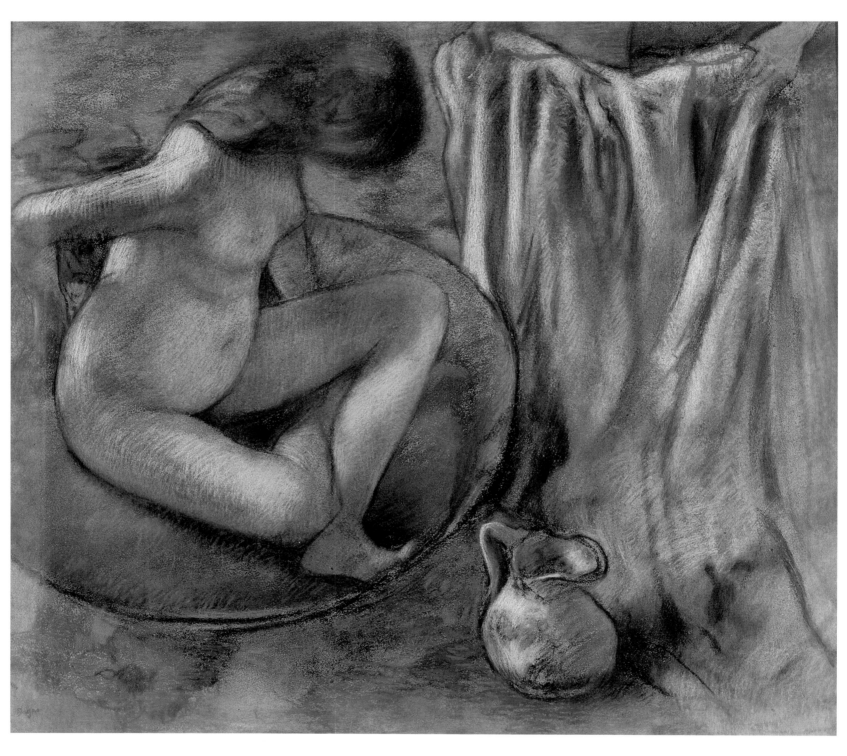

Femme au Tub
(Woman in the Tub). 1884

*This often-quoted remark by Degas is given here by Raymond Bouyer in
the* Gazette des Beaux-Arts *of January 1925:*

*You see how the difference in the times affects us: two centuries ago, I would
have painted* Susannas Bathing. *And now I just paint women in the tub.*

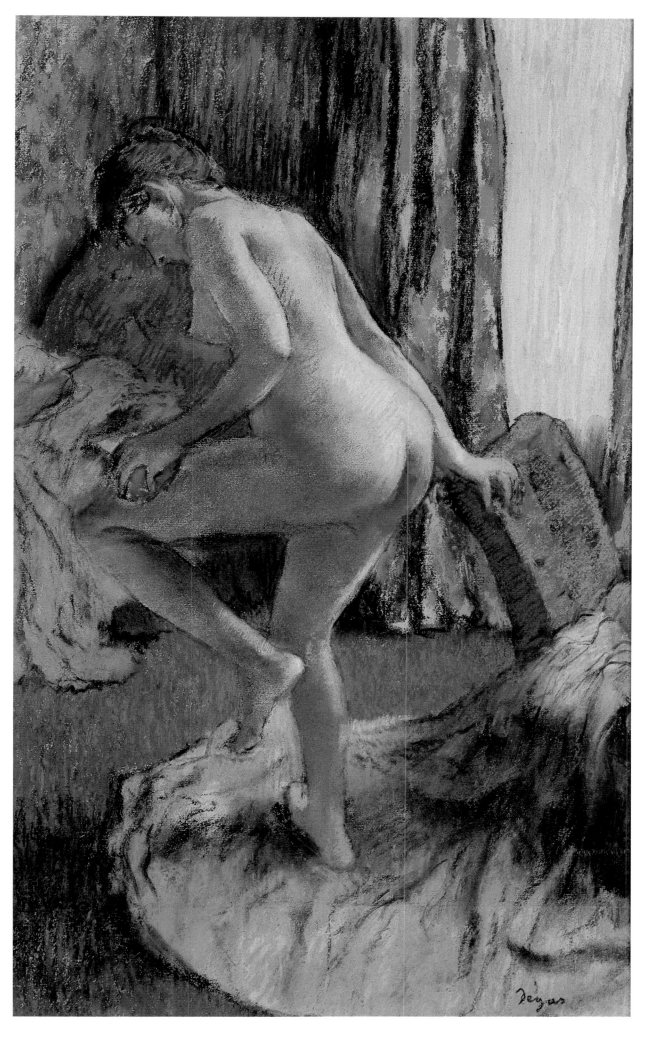

Après le Bain, also known as *Apreš le Tub*
(After the Bath). c. 1883–84

Après le Bain, Femme S'Essuyant
(After the Bath, Woman Drying Herself). c. 1900

Après le Bain
(After the Bath). c. 1900

In his last works, whether they be of dancers or of bathers, Degas allows his eye to move freely across the surface of the drawing, which he sees as a complete organization in which every area plays an equal part. Descriptive detail is ignored; what matters are the way shapes live together and the energy of their interaction. The thickness of the contours and their repetition speak of continual adjustment. It is not just the line of the arched back that he is rehearsing but its extension into the back of the armchair or its conjunction with the curve of the bath. He is thinking of both sides of the line and how it shapes areas beyond the figure as well as the figure itself. In each version the shape of the floor that is cut out by the woman's arm, breast, and leg is a crucial meeting point.

The subject of this leaning figure provokes one idea after another: is it a tall subject or a broad one? Or is it square? Narrow strips of paper have been added to two of these versions, gradually adjusting the page to a square, and beyond.

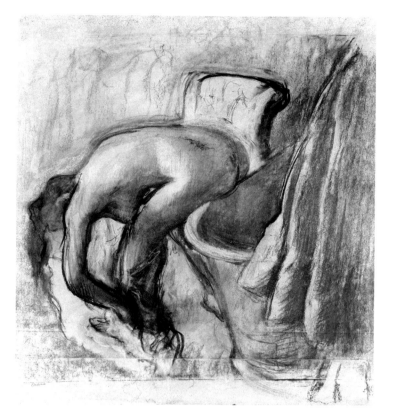
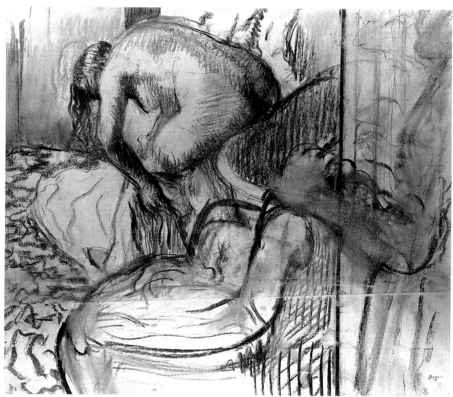

of nude women at their toilet and a second of nude dancers. Only the bathers were
started in earnest. Degas made six separate lithographs, taking each through several
states and transferring some to different stones. They are of great technical interest.
Degas worked with a master printer called Michel Manzi, the director of the print
shop of Boussod & Valadon and an outstanding technician who also ran his own
establishment. Degas took advantage of the situation to give full rein to his passion
for experiment, using a wide range of techniques that included drawing on celluloid
and special transfer papers as well as various photographic processes of transfer.

All six lithographs of the bather show her in the same pose. Seen from behind, she
bends over to dry her hip with a towel. In the first version, *Femme Nue Debout, à Sa
Toilette*, she bends to the left. A padded sofa is in the immediate foreground, cutting
off our view of her legs just below the knees. As the states progress, Degas gives her
longer and heavier tresses of hair until they join with the dark shadows behind her
and complete the arch of her body. The figure is set gracefully within the space
between the sofa and the wall. It is an intimate space, elaborated by suggestions of
discarded clothing thrown over the sofa. In the third version, *Après le Bain (Deuxième
Planche)*, the figure has been reversed, probably by making a tracing in greasy crayon
on celluloid and then transferring it to the stone. Here and in the fourth version,
which grows directly out of the third, Degas revises his relationship to the room. The
figure becomes bulkier, more massive. The sofa in the foreground and the wall behind

245

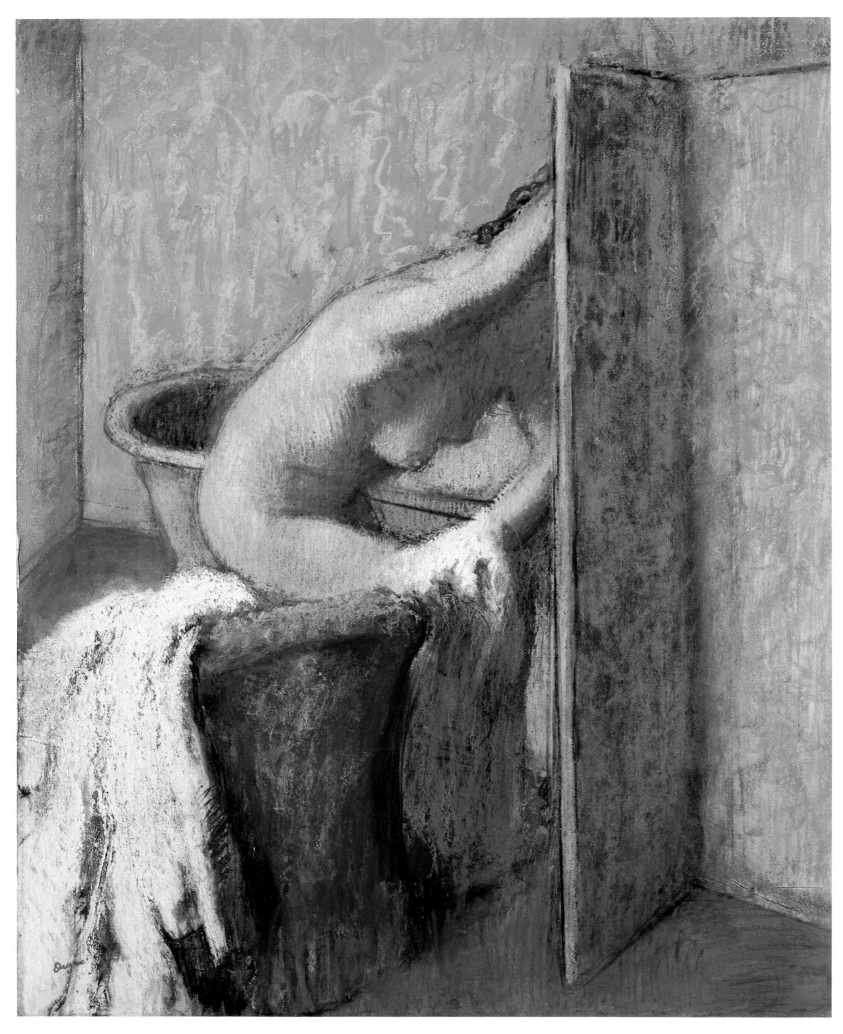

Le Bain, also known as *La Toilette Après le Bain*
(The Bath). c. 1888

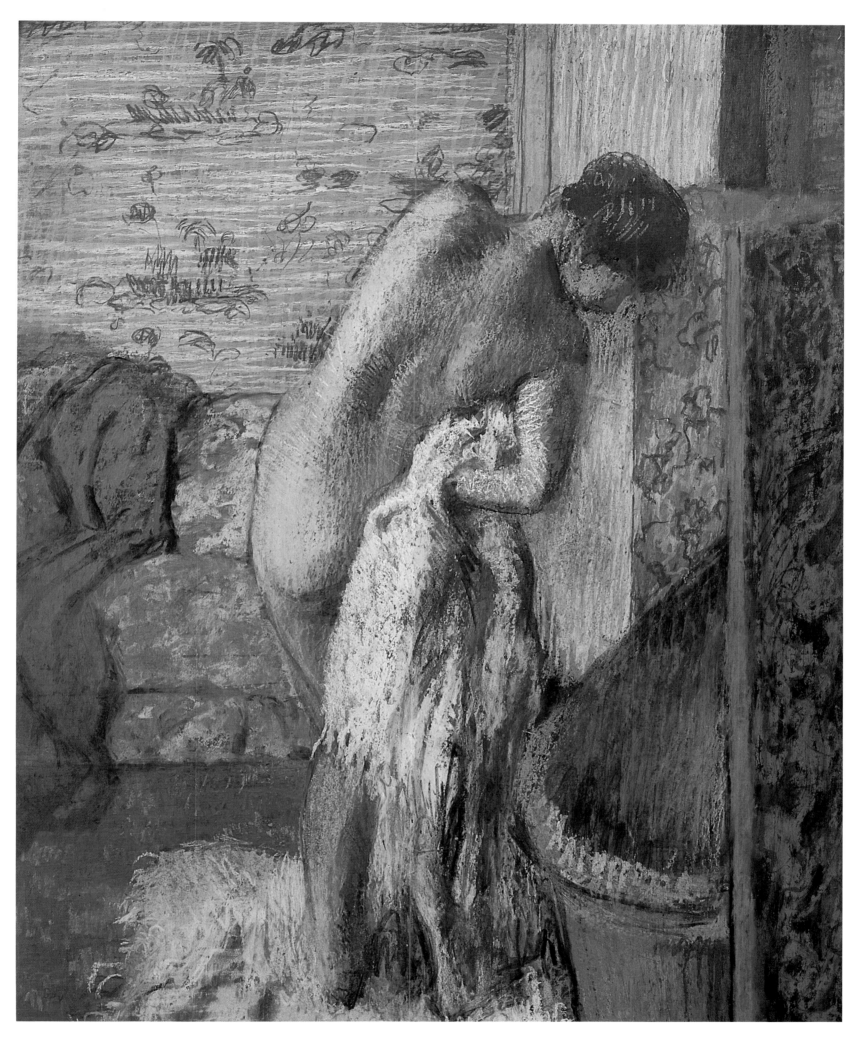

Après le Bain (Femme S'Essuyant)
(After the Bath [Woman Drying Herself]). c. 1882–85

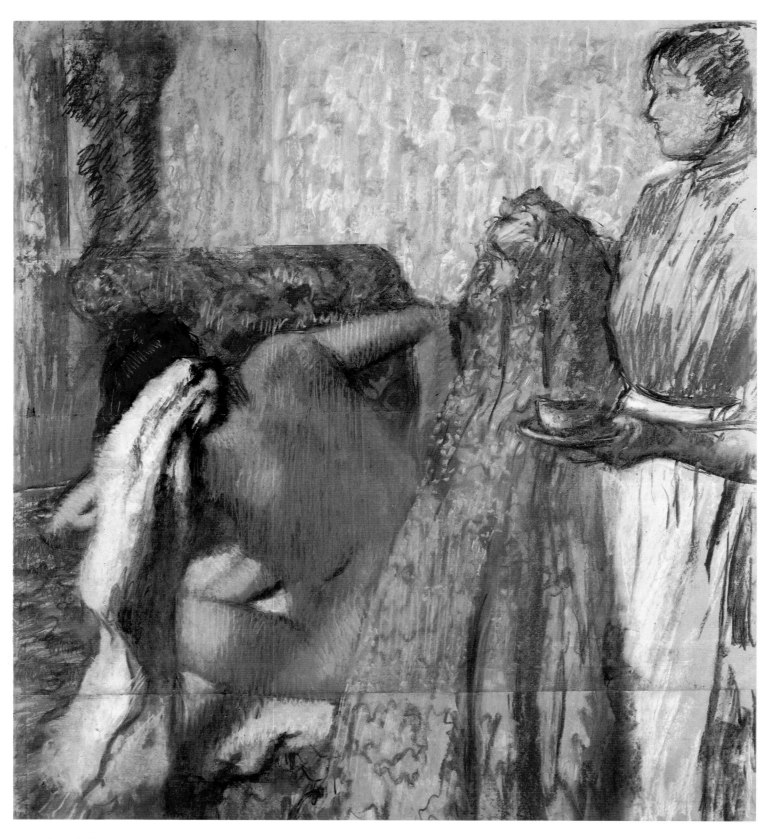

Le Petit Déjeuner Après le Bain
(Breakfast After the Bath). c. 1889

248

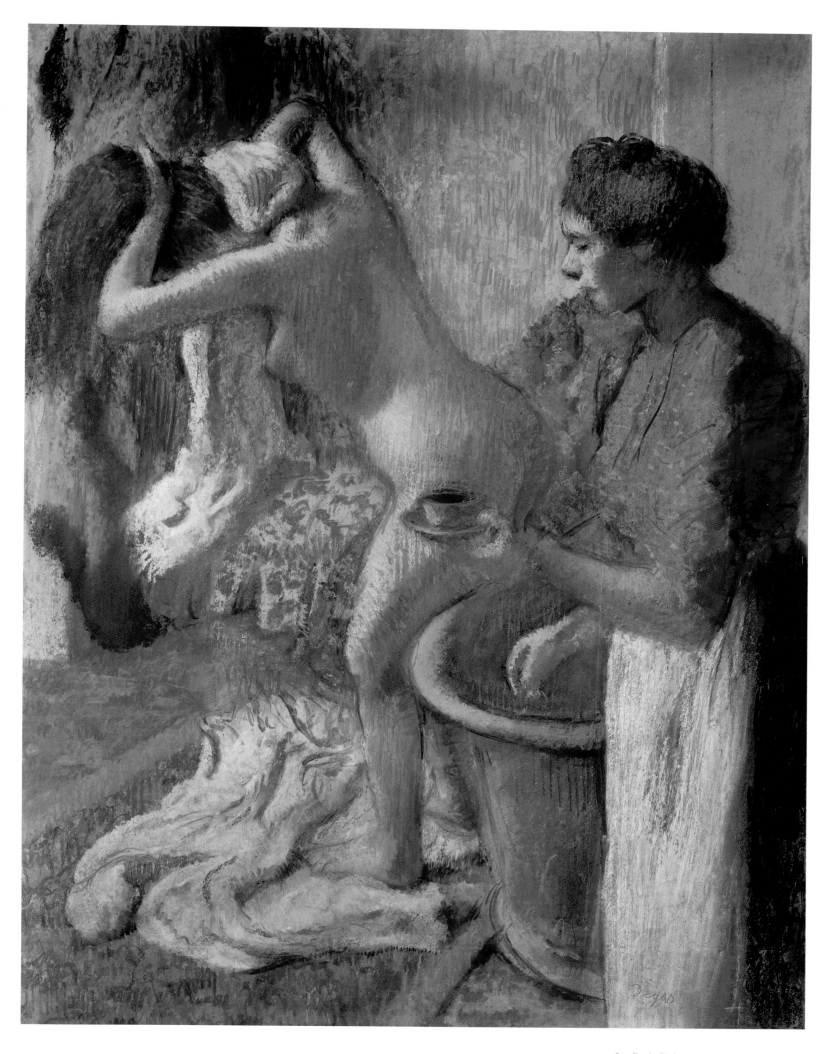

Le Petit Déjeuner à la Sortie du Bain
(Breakfast upon Leaving the Bath). 1895

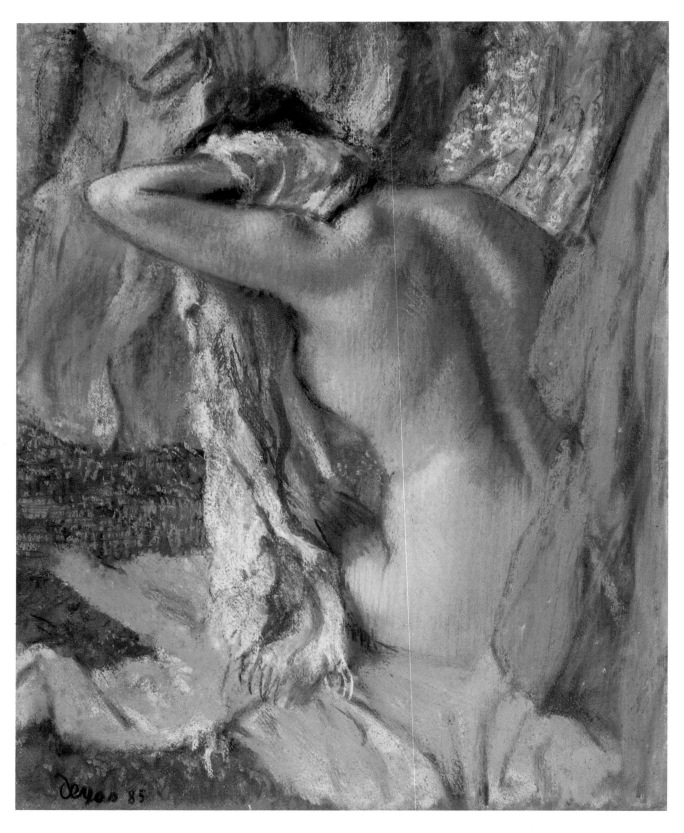

Après le Bain
(After the Bath). 1885

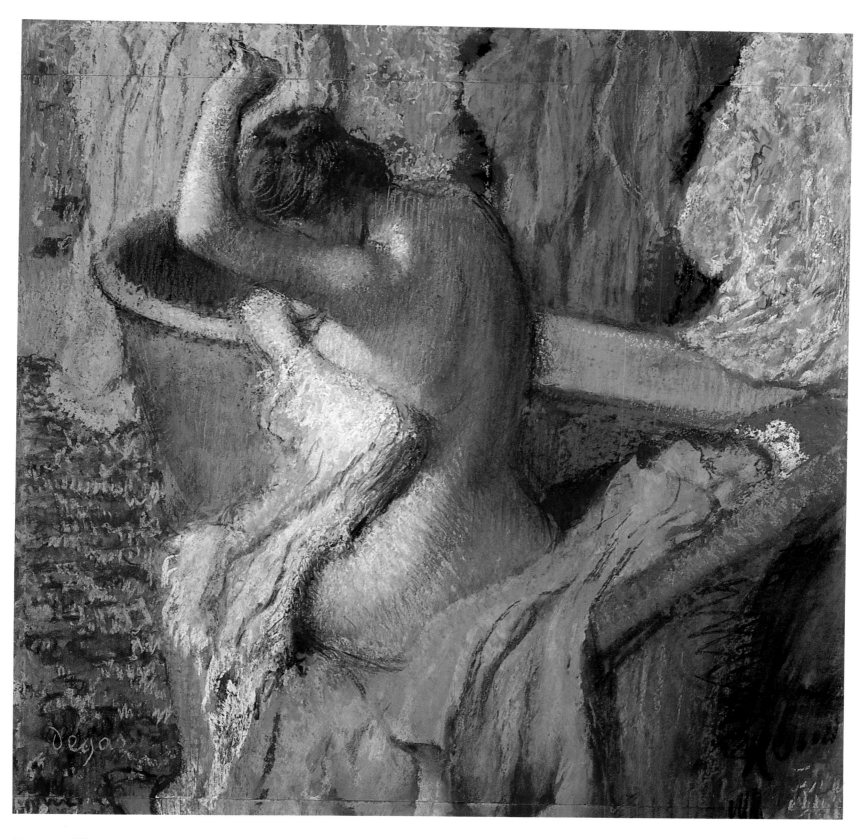

Baigneuse S'Essuyant,
also known as *La Sortie du Bain*
(Seated Bather Drying Herself). c. 1895

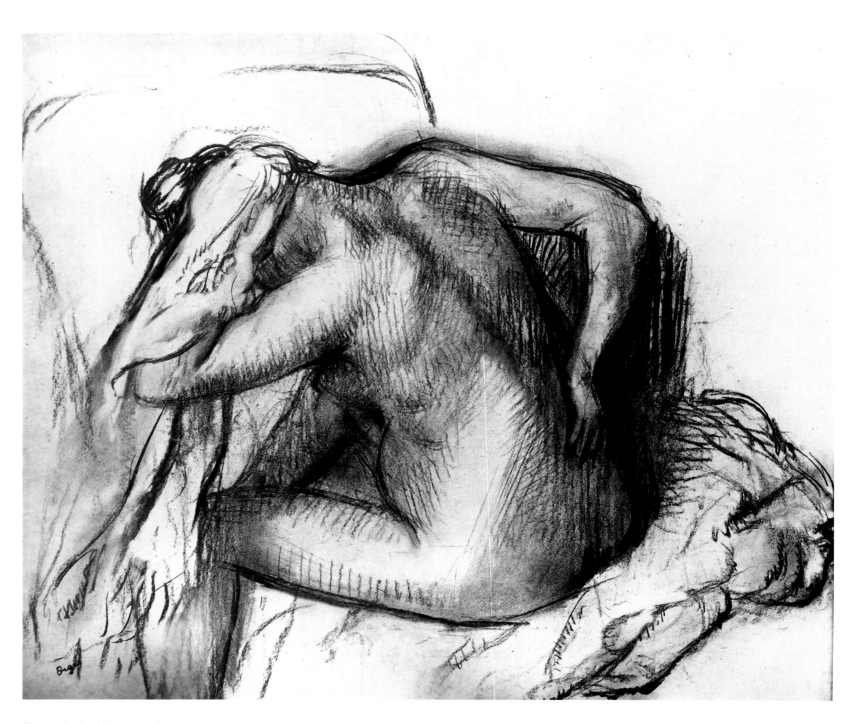

Femme Assise S'Essuyant le Cou, also known as
Après le Bain, Femme S'Essuyant la Tête
(Woman Drying Her Hair). c. 1889

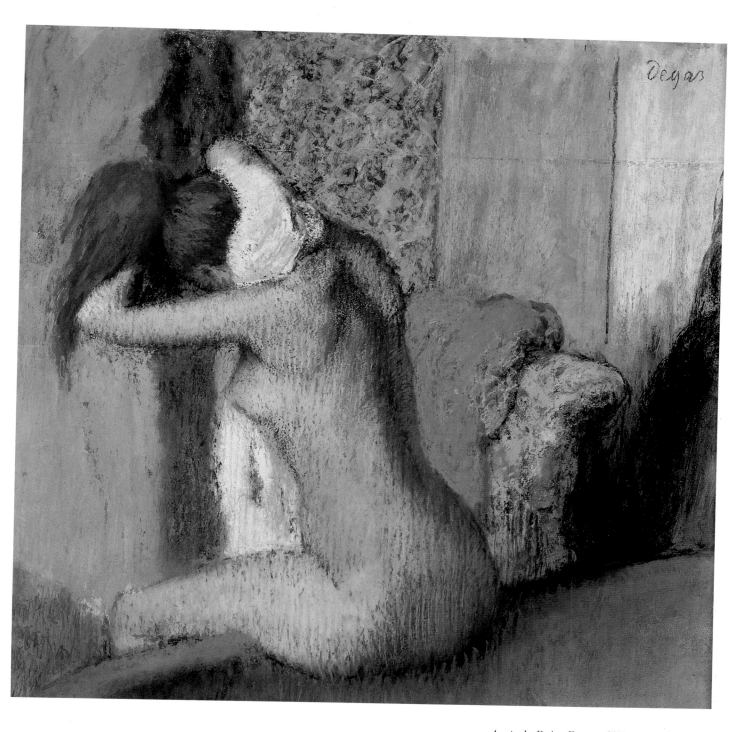

Après le Bain, Femme S'Essuyant la Nuque
(After the Bath, Woman Drying Her Nape). c. 1895

J.-K. Huysmans wrote of Degas in a review of the 1886 exhibition:

A powerful and isolated artist, with no acknowledged forebears, with no valid ancestry, Monsieur Degas still provokes in each of his pictures the sensation of the strange which is yet precise, of the hitherto unseen which is so accurate that you are amazed and almost resentful to be amazed; his work belongs to realism as it could never have been understood by that brute Courbet, but as certain of the Primitives conceived it, which is to say, to an art expressing an expansive or condensed outpouring of the soul in living bodies, in perfect harmony with their surroundings.

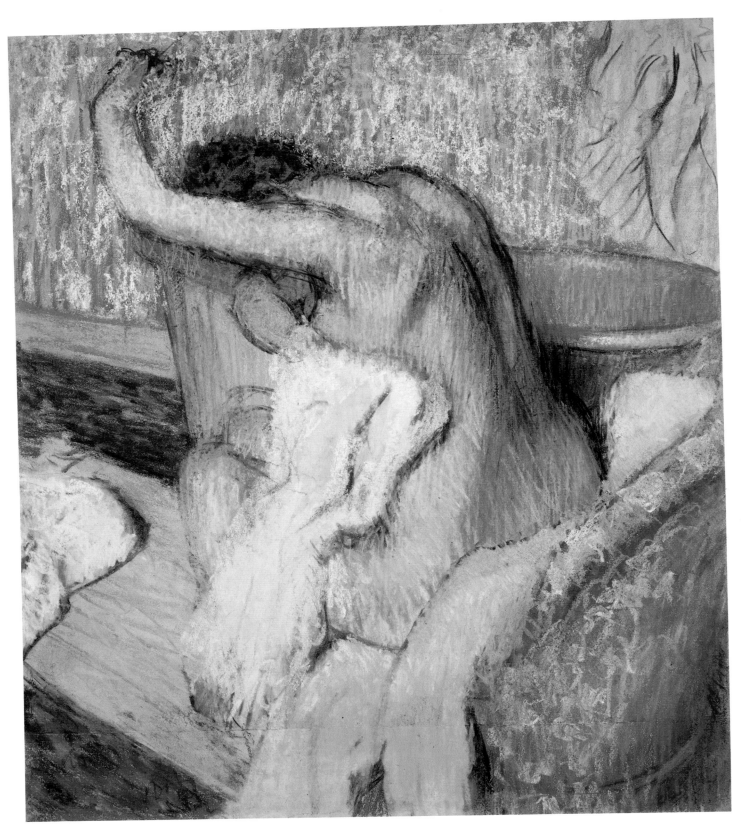

Après le Bain, Femme S'Essuyant la Poitrine
(After the Bath, Woman Drying Herself). c. 1889–90?

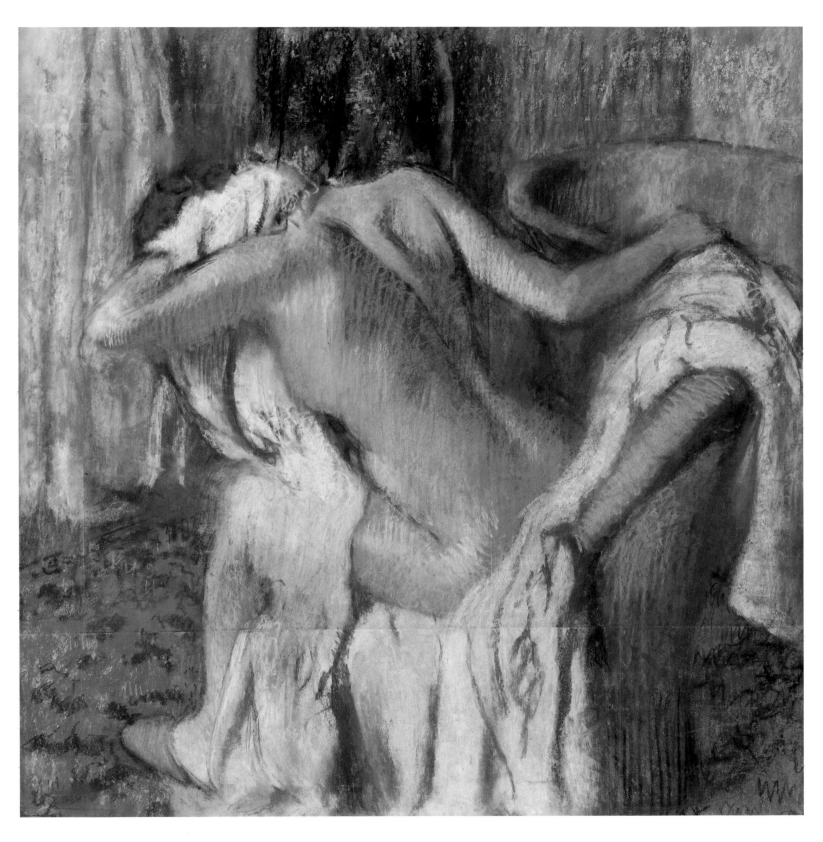

Après le Bain, Femme S'Essuyant
(Woman Drying Herself). c. 1888–92

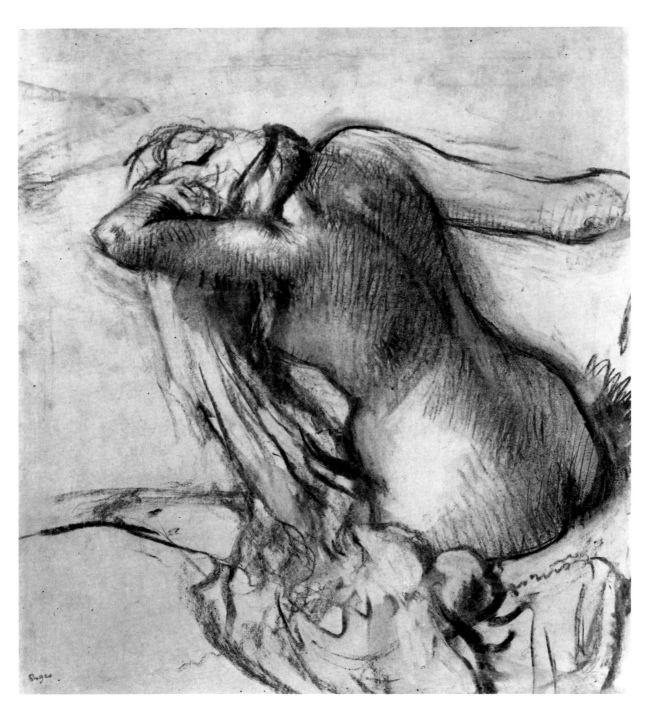

Femme S'Essuyant les Cheveux
(Woman Drying Her Hair). c. 1895–1902

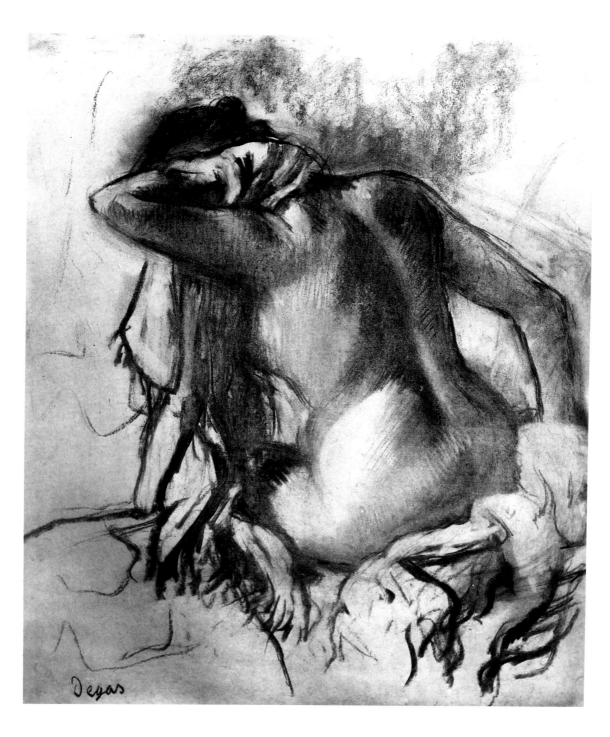

Après le Bain
(After the Bath). c. 1885

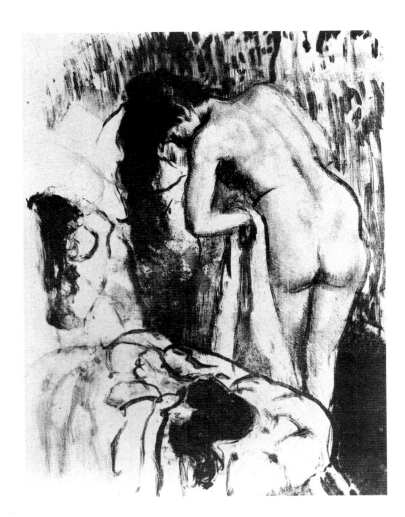
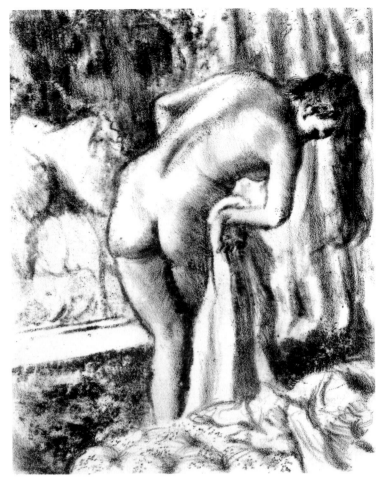

Femme Nue Debout, à Sa Toilette,
also known as
Femme Nue Debout S'Essuyant
(Nude Woman Standing. Drying Herself).
c. 1891

Après le Bain (Deuxième Planche),
also known as *Le Lever, Deuxième Planche*
(After the Bath I). 1891–92

OPPOSITE:
Après le Bain (Première Planche),
also known as *Le Lever, Première Planche*
(After the Bath II). 1891–92

Après le Bain (Première Planche),
also known as *Le Lever, Première Planche*
(After the Bath II). 1891–92

cross her at a flatter angle. The space closes up. Details of the room are suppressed. In the various states of *Après le Bain (Première Planche)* Degas progressively opens the boundaries of the figure, scraping across her form with a sharp instrument, cutting away the contours, letting the light that falls on her radiate out into a haze of white lines that he then carves into with accents of black. In the process her proportions become even more massive, until in the final state the stone seems hardly large enough to hold her. Her glimmering presence has expanded almost to its edge.

In *La Sortie du Bain (Petite Planche)*, the fifth version of the pose, Degas responds to this expansion to the right (which of course reads to the left in the print) by transferring the last state of the previous print to a new, squarer stone. He inserts the figure of a maid holding up a towel, then changes his mind and transfers the bather alone to yet another stone from which he prints another state. In the sixth and last version of the pose, *La Sortie du Bain (Grande Planche)*, he reintroduces the servant.

Although the pose of the bather is the same one that he had started with, its meaning and its claim on us have now changed. Her back had been foreshortened. Now we face it more squarely, and it seems to press toward us instead of twisting back into the darkness of the room. The heavy curve springing from her hips arches over in a slow, monumental movement that cuts across the edge of the towel and is finally closed in its folds. The tresses of her hair cross the towel. The room beyond is expressed only in the pattern of the wallpaper. Both towel and wallpaper close up to the figure like the planes of bas-relief. The servant's head and right hand are compressed between two planes. The top edge of the towel dips in a perfect echo of the curve between the bather's neck and left shoulder. The dark hair curves against

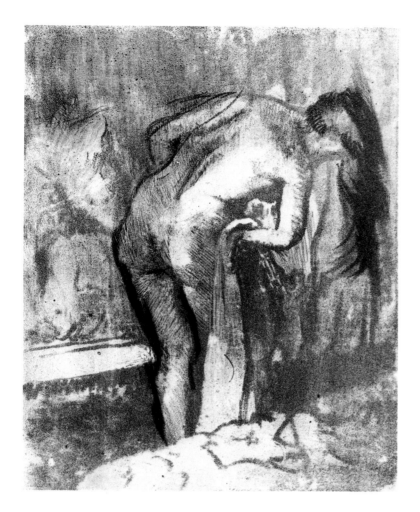
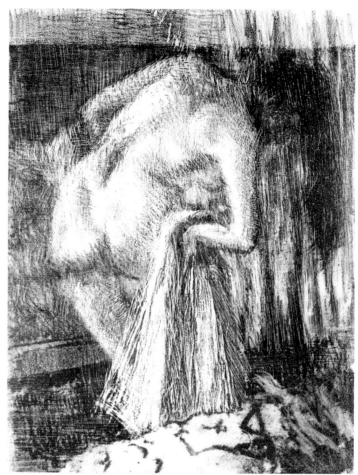

the towel, echoing the line of her left flank. In the final state, textured all over by the granular surface of the transfer papers he had used, his scratchings and scrapings had obliterated drawn lines. The massive back shimmers against the grooved towel. The rhyming of background and foreground shapes is less localized and less insistent. Each shape cut out of the wall behind vibrates in steady exchange with the figure, as though the whole image had become a single fabric and its different forms a kind of lumping and stretching across its warp and woof.

The studio furniture that made Degas's imaginary bedrooms was simple: a round bath and a long one, an armchair or two, a settee, a screen. Fabrics, heavy curtains played an important part.

 The round bath had featured in one of his sculptures, in which he had used a real tin bowl to represent it. The bather is folded into the volume of the bowl as into the basin of a fountain, but there is no sense of a pedestal or of a privileged space. The invitation is to look downward into it and to accept the floor as the base of the sculpture.

 The drawings and pastels of the round bath fix the downward aspect. These of all the bathers are the most extreme in the tendency of their viewpoint. We look down on her crouching unawares. With her back bent, her limbs folded up, her head down, she is at the farthest point from expressive extension, and nearest to an infantile vulnerability.

 The long bath allows for more varied and more dynamic relationships. It is deep and hollow like an architectural niche on its back. The model strides into it in two

Degas's last efforts in printmaking were in the direction of lithography. He announced his plans to Evariste de Valernes in a letter of July 6, 1891:

Ah, eyesight, eyesight! . . . My mind seems duller in the studio than ever before, and the difficulty of seeing stupefies me altogether. And since a man, luckily enough, doesn't know his own strength, I still make plans; I intend to do a series of lithographs, first a series of female nudes, then a series of dancers also in the nude. So one goes on to the end, imagining. . . . Lucky that's the way it is.

Degas to Daniel Halévy, February 14, 1892:

And now at last I can give myself up to black-and-white, which is my passion.

The bather lithographs were made with the assistance of the printer Manzi. Writing to his family in South America in November 1892, Degas described the ideal circumstances:

I would have to have a press in my studio, a skilled workman to prepare and to clean the stones, and no small amount of money ahead of me not to be distracted from the series of proofs. This would finally come to something, but it is getting to be a little late for my brain and for my eyes.

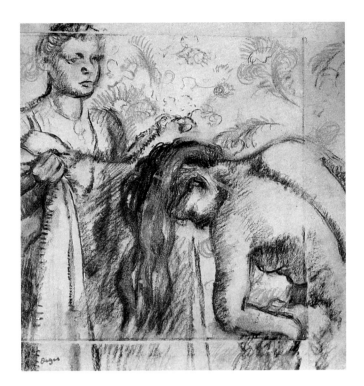

La Toilette Après le Bain,
also known as *Après le Bain*
(After the Bath). c. 1891

wonderful images, *Le Bain Matinal* and *Le Bain.* In *Le Bain Matinal* the compact body is spread and off balance. Her arms and legs are wide, the points of balance are her hands, which she uses to steady herself in this tense, pretended movement, making of her body a wide, flattened arch. In *Le Bain* we see her from the side. Her weight has shifted to the leg inside the bath. She grips the edges, lifting her right leg up from the floor in an unconscious layman's version of an arabesque.

There is a moving exchange between the simple opening of the bath and the vigorous form of the naked woman. The reach and weight of her extended limbs are augmented by the hollow that will receive them. In fantasy we fit the two forms together, convex into concave. The joining hangs timelessly, uncompleted yet sure. In both pictures the action of entry is partly screened by curtains. She will slide behind them, her move measured against their plane.

There are many pictures where the reciprocity between the concave form of the bath and the convex figure becomes the main motif: the jaunty little pastel *Femme Sortant du Bain* or the oil *Femme Assise dans une Baignoire et S'Epongeant le Cou,* for instance. In the latter, the model is perched on the end of the bath and the powerful form of her hips almost fills its curved end. She leans forward as if inviting the closing up of the two forms. Another marvelous motif is discovered when Degas places the model against the rim of the bath and faces her out from it, bending down to dry her legs.

The round armchair is used too to support or enfold the model, playing concave with convex. In *Après le Bain, Femme S'Essuyant* the padded back augments the solidity of the great torso and contains it like a cup at the same time.

These powerful excursions into sculptural form are steadied and modulated and spread by the interaction of flatter surfaces, not just the screens and curtains that divide the room into levels of relief but towels that the models use on their bodies. With them Degas gives concrete expression to an evolution in his drawing by which he celebrates the two-sidedness of every edge. Everything touches. The old hierarchy

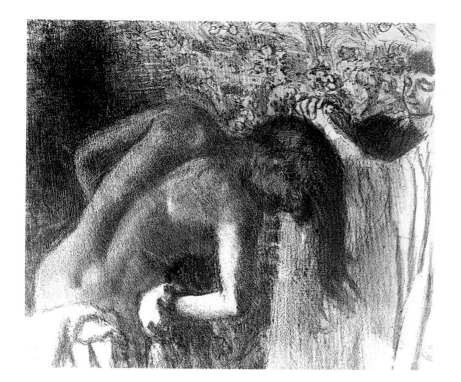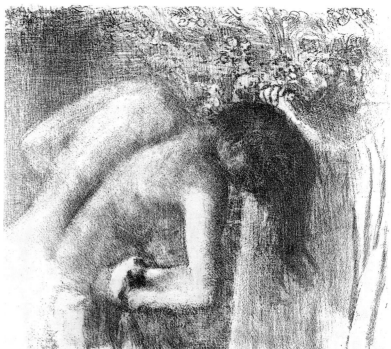

La Sortie du Bain (Grande Planche)
also known as *Après le Bain, Grande Planche*
(After the Bath [Large Version]). 1891–92

La Sortie du Bain (Grand Planche),
also known as *Après le Bain, Grande Planche*
(After the Bath [Large Version]). 1891–92

of the line, by which form was divided off from not-form, is dissolving under the pressure of other priorities. In *Après le Bain, Femme S'Essuyant* the white towel is threaded through the pose, wound over her lifted forearm, under her upper arm, and falling over her thigh. It reveals and conceals, explaining and reinforcing the pose by the way it responds to her form and defines it. The towel is like a bridge between her and her surroundings.

Over the back of the chair another towel falls into vertical folds, as does the curtain beyond, against the wall. Between the two, the bather's towel falls in curves that respond to her. Towels and curtain evoke a fluted colonnade, of which she is a part. The deep channel of her spine and the raised scapulae absorb the steady verticality of the curtain and at the same time impart her presence upon it. The exchange between the body and the falling drapery flows back and forth like the tide, spreading her into every bay and inlet of the picture and, in return, defining her and exposing her. She leans forward into the towel, letting it fill the soft inlet of her breast and stomach and exposing the hard musculature of the shoulders and back. Here, in this exchange, is the epitome of his drawing, a vision of wholeness that goes beyond the wholeness of discrete forms and embraces the final reciprocity of solid and void.

Degas's mastery of pose and gesture in real behavior is engaged to the full in his pictures of bathers. He understands the stroke of a sponge, the weight of a towel, the flow of thick hair against a comb, and how the body thoughtlessly shapes itself to the actions that go with them. But perhaps because they are naked, his bathers' poses transcend their actions and open themselves to other readings. The model who dries her hip in the lithograph could be Diana, dangerously stumbled upon in the forest— or, in the sad falling of her hair and her twisted, down-turned head, a mourning witness to that massacre he had once fantasized in *Les Malheurs de la Ville d'Orléans.*

Among the many drawings that Degas made in connection with the lithographs of the woman who dries her hip is one in charcoal and pastel, *La Toilette Après le Bain,* of the bather and the maid holding the towel. The towel is held so that its top edge

261

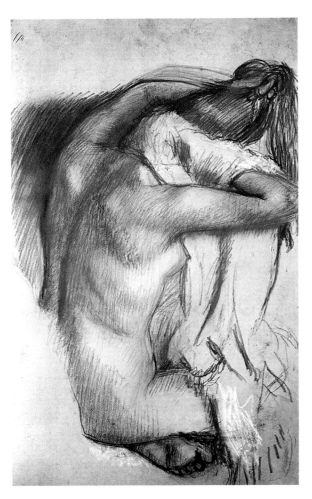

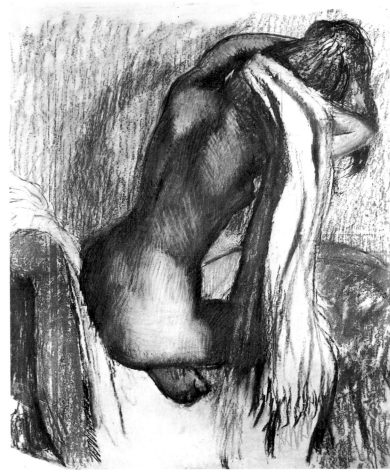

Femme S'Essuyant Après le Bain
(Woman Drying Herself After the Bath). c. 1889

Femme S'Essuyant
(Woman Drying Herself). c. 1905–7

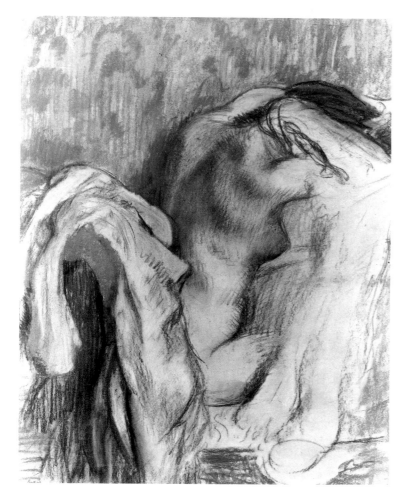
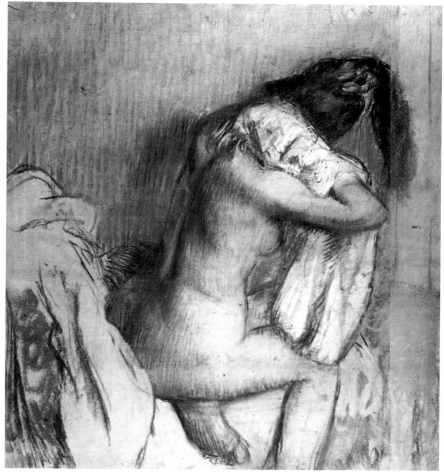

Après le Bain, also known as
Après le Bain, Femme S'Essuyant
(After the Bath). c. 1905–7

Après le Bain (Femme S'Essuyant)
(After the Bath [Woman Drying Herself]).
c. 1889

Line was at the center of Degas's art. He was always searching for shapes that he could define by their edges. During the second half of his working life pastel, often allied with charcoal, became his main tool. Pastel could be both a painting and a drawing medium. Unlike Manet, Degas rarely used pastel flatly, to color with, but kept the linear quality in the forefront. However, by a completely novel transformation of traditional hatching, he developed a way of working the pastel line all the way across the drawing, often cutting it across or at right angles to the direction of the form or carrying it beyond the boundaries of the form into the background. Long lines of color are laid down one on top of another, threaded tightly across the surface of the page in a structure that resembles a fabric on the frame of a loom. Looking at these drawings the eye does not lose sight of the flat surface of the paper, which is emphasized and hardened by the parallel strokes. On the other hand, the forms that Degas represented—the tense back of the bather, the heavy folds of her towel, the curving chair-back—gain a powerful solidity. In so much of his work Degas had focused on flat shape and silhouette; now three-dimensional form seems to press upward out of flatness with the force of carving.

makes a continuous line with the bather's shoulders. The maid's head and shoulders are prominent and her face is fully revealed. Unlike other versions of the maid, she does not look at the bather but stares out of the picture to the right, with rather open eyes. There is a certain formality in her appearance, not easily defined. Her face is heavy and regular, her hair short and tight, her neck a clean-cut cylinder. Although her features are not classicized in any obvious way, there is an unmistakable note of the antique about her. She looks beyond the bourgeois bedroom into larger air: the trivial domestic moment expands into ritual.

Degas's great American collector Louisine Havemeyer once asked him why he painted the ballet so often. "Because, madame," he told her, "it is all that is left us of the combined movement of the Greeks." The poses he had learned from the antique had reappeared throughout his work, and in particular the sculptures are filled with reminiscences: the long, slanting pose of the *Danse Espagnole* has much to do with the Myron *Marsyas;* the dancer who holds the sole of her right foot evokes certain Hellenistic *Aphrodite* figurines. There are some specific quotations. A pastel of a girl on the side of her bed is an exact mirror image of the *Spinero.* The dancers who adjust the straps of their dresses evoke a succession of ancient models from the gesture of modesty that brides make on certain Attic reliefs to later figures like the Louvre *Diana* after Praxiteles who raises her arm and adjusts her peplos at the shoulder.

The spirit in which these features appear could hardly be further from those remnants of neo-Classicism that clung to some of Degas's academic contemporaries like Gérôme; nor has it anything to do with the romanticized Hellenism of painters like Moreau or Albert Moore. More than ever his drawing predicated an immediate engagement, either with the particulars of the model or with the material facts of its making—or both. However complicated or calculated his methods, nothing relaxed his grip on the present. There is no retreat into nostalgia. It is not the classicizing of the surface that we see in his late works but the fruits of a communion with classical form that is so deeply placed that it is like a persistent and scarcely audible bass note.

Classical form is aestheticized and split off from academic protocols. It comes to life anew as drawing stripped of signs. We recognize it as a certain weightiness; but also as spirit, as though the homely models were inhabited by other energies than their own. In the great pastel *Après le Bain*, also known as *La Sortie du Bain* the bather who holds her towel spread behind her has a mysterious kinship with the Aphrodite of the Ludovisi relief, and although reversed in aspect, unconscious, and banal, she too rises from the sea into a timeless light.

Despite the absence of incident, the bathers' poses are tense and often awkward. A leg will jut out at an odd angle or a steadying arm will disrupt the compactness of the pose. In many of the seated torsos the weight is not carried visibly by the pelvis and thighs but by forms external to the body: chairs, towels, curtains that come in front of the model, whose balance and wholeness are organized, so to speak, from the outside.

Jeanniot remembered how Degas drew his attention to an aspect of the Medici *Venus* that made her seem off balance. It was a pose she could not hold if she were alive. It was the sculptor's way of imparting movement while "preserving its calm attitude." In an analogous way Degas cuts off the base of the bather in the *Après le Bain* in the Norton Simon Museum with an orange curtain. We cannot see how she is sitting, and the enormous vigor of her gesture is enhanced by the perception that it is cantilevered

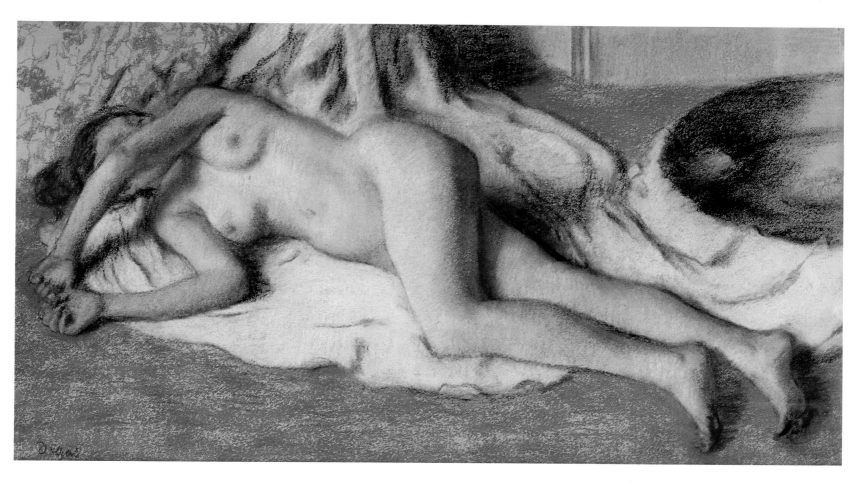

Baigneuse Allongée sur le Sol, also known as *Baigneuse Couchée*
(Bather Reclining on the Floor). 1886–88

Après le Bain (Femme Nue Couchée)
(After the Bath [Female Nude Lying Down]). c. 1895

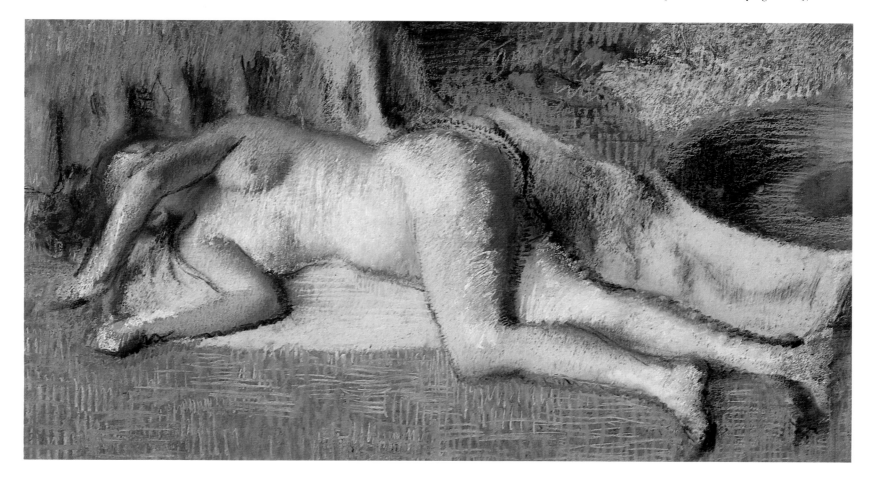

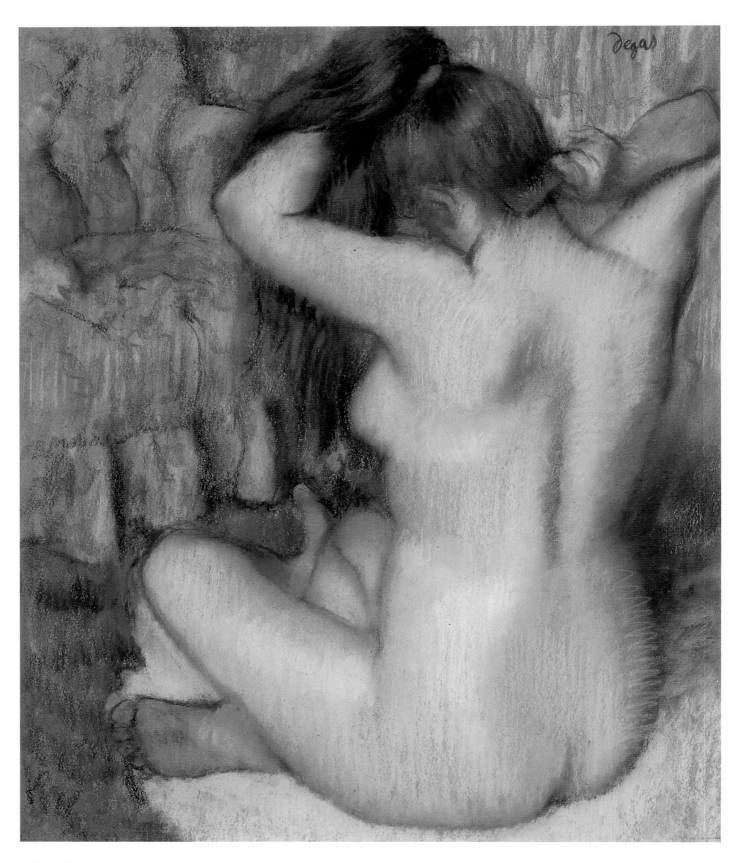

Femme Nue, de Dos, Se Coiffant (Femme Se Peignant)
(Female Nude, from Behind, Combing Her Hair). c. 1886–88

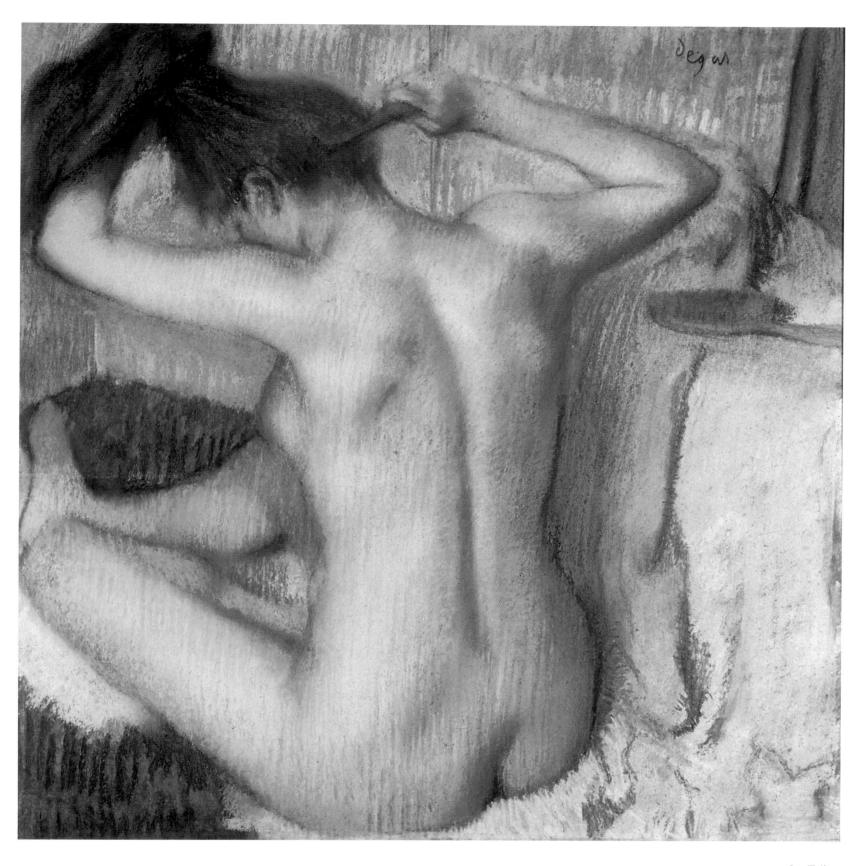

La Toilette
(Woman Combing Her Hair). c. 1884–86

Charles Du Bos, in his "Remarques sur Degas," recognized the strength of the artist's search for form:

Is this woman doing her hair? her curls form a solid mass, motionless and compact: a sort of river of stone. And this back with its emphatic hollow, coarse-grained as the rim of a well; always, in the finest pastels, the grain of the stone. It is out of stone that these monumental nudes of Degas seem hewn—balanced blocks, of an absolute internal coherence—looking as if they would offer an indestructible resistance to any parceling out, any breaking up.

Edmond de Goncourt had another view. He quotes a model: "He's an odd gentleman—he spent the whole four hours of the session combing me."

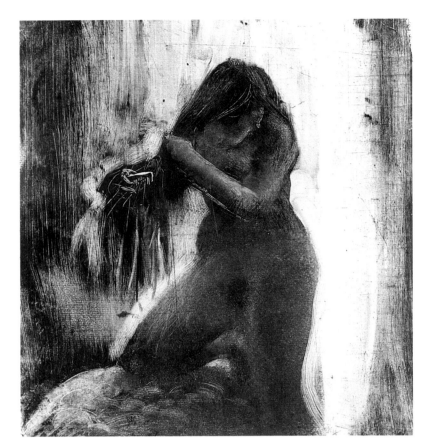

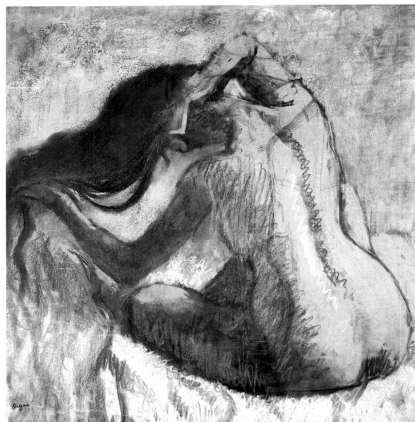

Femme Nue Se Coiffant,
also known as *La Toilette (La Chevelure)*
(Female Nude Combing Her Hair).
c. 1879–85

Femme Se Peignant
(Woman Combing). c. 1897

out from such a slender stem. At the same time, the "calm attitude" is restored by the pink towel on which she is sitting, and its upward-spreading folds.

Every surface is close—the orange curtain that flares out from the right of the picture, the bare woman and the towel threaded over her arm, the deep rose curtain against the wall—all touch and may be touched in the compactness and continuity of bas-relief. His eye can move across the whole surface like a hand. He has lost patience with small forms. The faculties of sight and touch are flowing into each other. "I can scarcely see anymore . . . so I look with my finger," he once said, by way of excusing himself for having embarrassed his friends by stroking a woman's nose in a public place. But his friends knew that he was by no means blind.

Degas's long retreat into his studio, and his fearsome specialization, had brought him to a place that no other artist had been. The bathers, whose raw novelty reasserts itself unblunted at every encounter, are his most extreme works. Yet it is in front of them that Degas's early ambition comes at last fully into focus. In Italy he had reenacted with a full sense of its symbolic density the journey of discovery that every painter before him had made. In his notebooks he had addressed a symmetrical prayer—to a patron saint and to a place, the city where everything would be decided: "Ah! Giotto! let me see Paris, and you, Paris, let me *see* Giotto!" How many artists of any epoch could claim their ambition with such exactness—either in its interpretation of self, or in its perception of a possible route through painting's labyrinth? The double necessity was recognized with absolute intelligence: to redeem the past, to see it freshly, stripped of its coatings, in its present meaning; and to render the present *visible* in some weighty sense, its very fleetingness demanding a ritual sanction, a difficult yet self-evident geometry. The symmetrical cry finds at last its answer here in the studio among the dust, the wrinkled bathrobes, and the filthy zinc bath.

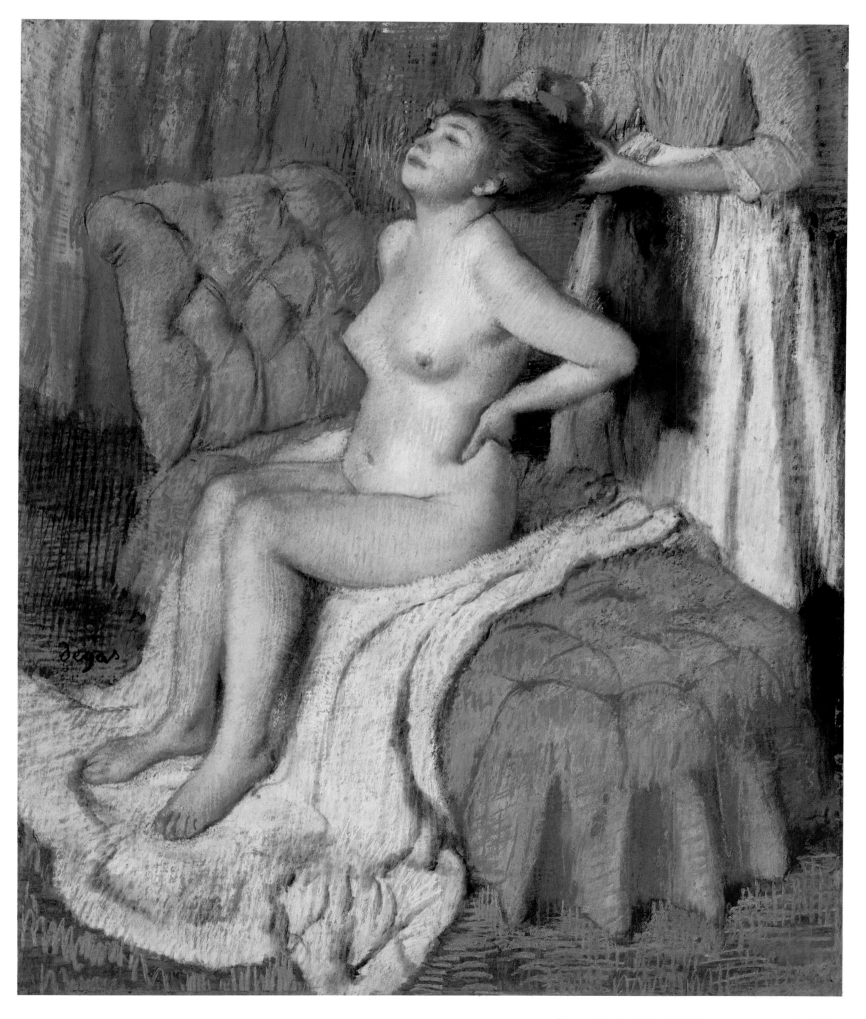

Femme Nue Se Faisant Coiffer, also known as *La Toilette*
(A Woman Having Her Hair Combed). c. 1886–88

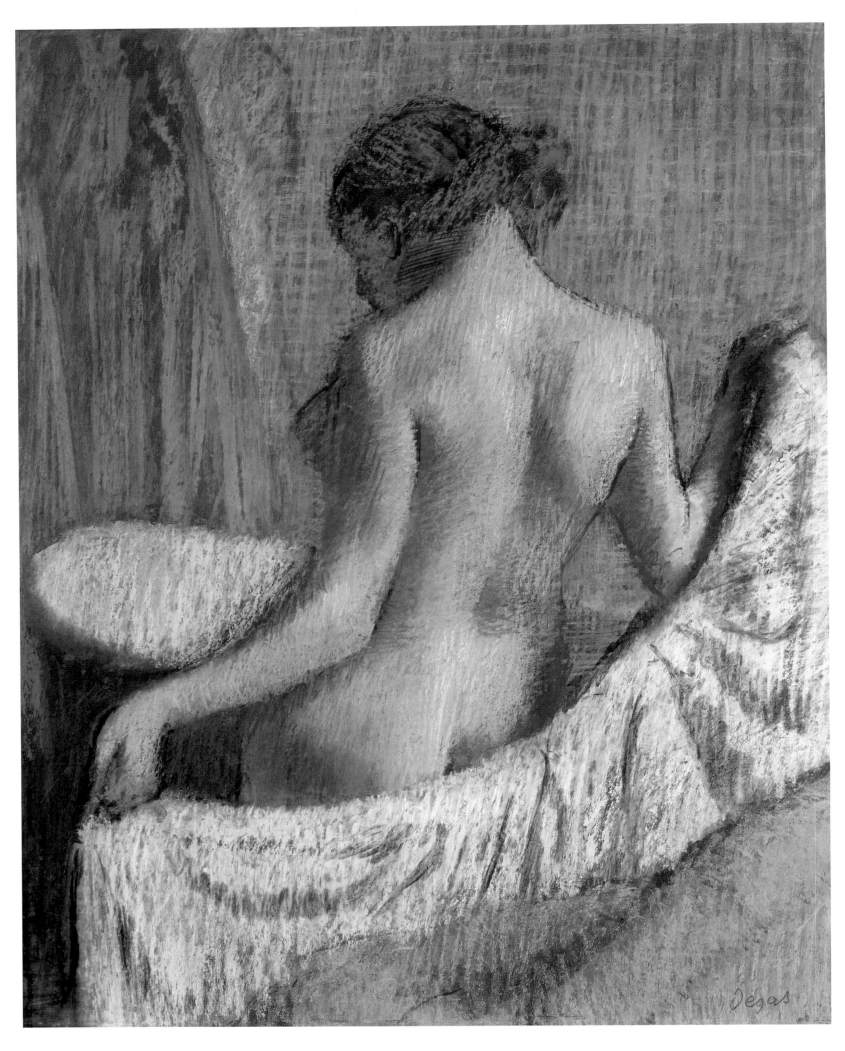

Après le Bain,
also known as *La Sortie du Bain*
(After the Bath). c. 1885–90

During the last part of his life, the faculties of sight and touch were of almost equal importance to Degas. Jeanne Raunay related the following anecdote of an occasion at the theater:

In the next box was Mme. Pierson, her face still beautiful, though much heavier now; Degas . . . kept staring at her. And he was delighted to be introduced to her by the friend who had invited him there. After a few minutes of lively chatter, Degas said to Mme. Pierson: "Madame, would you be so kind as to permit me to touch the line of your nose with my forefinger, from your forehead to the tip? . . ." And as soon as Mme. Pierson, with a laugh, had consented, Degas immediately took advantage of her permission and out in the corridor behind the boxes, you could see the great painter running his forefinger along the line of that perfect nose, without his paying any attention to the smiles of those who were watching him.

Paul Valéry remembered him in his final years:

Still his hands went in search of forms. He groped his way around objects; the sense of touch increasingly predominated, he preferred to describe things in terms of how they felt to his hands; he praised a picture by declaring: "It's flat like good painting," and the gestures of his hand represented that flatness which enchanted him. With the palm and the back of his hand, in alternation, he would endlessly caress an ideal plane, smoothing it as though with a soft brush. When one of his old friends died, he had himself led to the bedside and sought to palp the familiar face with his own fingers.

The eyes which had labored so long good for nothing; the mind lost between absence and despair; the tics and repetitions multiplied; terrible silences which ended with a dreadful: "I think of nothing but death"—nothing could be sadder than the degradation of so noble an existence by great age. A frightful tête-à-tête obsessed him, occupied him, substituted in him for the lively diversity of the great artist's ideas, desires, projects. . . .

Degas had always felt alone, and had been so in all the modes solitude can assume. Solitary by character; solitary by his very distinction and the particularity of his nature; solitary by the pride of his rigor, by the inflexibility of his principles and of his judgments; solitary by his art, which is to say, by what he demanded of himself.

List of Illustrations

PAGE 52:

Petites Filles Spartiates Provoquant des Garçons, also known as *Jeunes Filles Spartiates S'Exerçant à la Lutte* (Spartan Girls Provoking Boys). c. 1860–62. Oil on canvas mounted on board, 19¹¹⁄₁₆ × 12⅝″ (50 × 32 cm.). Private Collection. Photograph Archives Durand-Ruel, Paris

Petites Filles Spartiates Provoquant des Garçons, also known as *Jeunes Spartiates S'Exerçant* (Spartan Girls Provoking Boys). c. 1860–62. Oil on canvas, 25⁵⁄₁₆ × 35¹³⁄₁₆″ (65 × 91 cm.). Private Collection. Photograph Archives Durand-Ruel, Paris

PAGE 53:

Petites Filles Spartiates Provoquant des Garçons, also known as *Jeunes Spartiates S'Exerçant à la Lutte* (Young Spartans). c. 1860. Oil on canvas, 38⅜ × 55⅛″ (97.4 × 140 cm.). The Art Institute of Chicago; Charles H. and Mary F. S. Worcester Fund

PAGE 54:

Petites Filles Spartiates Provoquant des Garçons, also known as *Jeunes Spartiates S'Exerçant à la Lutte* (Study for The Young Spartans Exercising). c. 1860–62. Oil on paper mounted on cardboard and then on wood panel, 8¼ × 11″ (21 × 28 cm.). The Harvard University Art Museums (Fogg Art Museum), Cambridge, Massachusetts; Purchase—Friends of the Fogg Museum, the Alpheus Hyatt Purchasing Fund, the Prichard Fund, and the Francis H. Burr Memorial Fund

PAGE 55:

Petites Filles Spartiates Provoquant des Garçons, also known as *Jeunes Spartiates S'Exerçant à la Lutte* (Young Spartans). c. 1860–62; taken up again before 1880. Oil on canvas, 43 × 60¾″ (109.2 × 154.3 cm.). The National Gallery, London; Purchased by the Trustees of the Courtauld Fund, 1924. Reproduced by courtesy of the Trustees, The National Gallery, London

PAGE 56:

Etude pour Petites Filles Spartiates Provoquant des Garçons (Study for Young Spartans). c. 1860. Pencil on white paper, 11½ × 7¼″ (29.2 × 18.4 cm.). The Detroit Institute of Arts; Bequest of John S. Newberry

Buste de Jeune Homme Nu (Half-Length Study of a Young Male Nude). c. 1860–65. Graphite on gray flecked paper, 7¾ × 8¼″ (19.7 × 21 cm.). Musée du Louvre (Orsay), Paris; Cabinet des Dessins

PAGE 57:

Etude pour Petites Filles Spartiates Provoquant des Garçons (Study for Young Spartans). c. 1860–62. Pencil on paper, dimensions unknown. Private Collection. Photograph Archives Durand-Ruel, Paris

Etude pour Petites Filles Spartiates Provoquant des Garçons (Study for Young Spartans). c. 1860–62. Pencil on paper, dimensions unknown. Private Collection. Photograph Archives Durand-Ruel, Paris

PAGE 58:

Femme Nue, Allongée sur le Dos, étude pour *Scène de Guerre* (Female Nude, Reclining on Her Back, *study for Scène de Guerre*). 1865. Black pencil, 9 × 14″ (22.8 × 35.6 cm.). Musée du Louvre (Orsay), Paris; Cabinet des Dessins

Femme Demi-Nue, Allongée sur le Dos, étude pour *Scène de Guerre* (Female Seminude, Reclining on Her Back, *study for Scène de Guerre*). 1865. Black pencil, 9 × 14″ (22.8 × 35.5 cm.). Musée du Louvre (Orsay), Paris; Cabinet des Dessins

Femme Nue, Allongée sur le Dos, étude pour *Scène de Guerre* (Female Nude, Reclining on Her Back, *study for Scène de Guerre*). 1865. Black pencil, 9 × 14″ (22.9 × 35.6 cm.). Musée du Louvre (Orsay), Paris; Cabinet des Dessins

PAGE 59:

Scène de Guerre au Moyen Age, also known as *Les Malheurs de la Ville d'Orléans* (Medieval War Scene) 1865. Oil colors freely mixed with turpentine (*peinture à l'essence*) on paper mounted on canvas, 31⅞ × 57⅞″ (81 × 147 cm.). Musée d'Orsay, Paris

PAGE 60:

Scène de Steeple-Chase, also known as *Aux Courses, le Jockey Blessé* (Steeplechase—The Fallen Jockey). c. 1866. Oil on canvas, 71 × 59½″ (180.3 × 151.1 cm.). Collection of Mr. and Mrs. Paul Mellon, Upperville, Virginia

PAGE 61:

Portrait de Mlle. E. F., à propos du Ballet de La Source (Mlle. Fiocre in the Ballet *La Source*). 1867–68. Oil on canvas, 51¼ × 57⅛″ (130 × 145 cm.). The Brooklyn Museum; Gift of James H. Post; John T. Underwood; and A. Augustus Healy

PAGE 62:

Examen de Danse (The Dance Class). 1874. Oil on canvas, 33 × 31¾″ (83.8 × 80.6 cm.). The Metropolitan Museum of Art, New York; Bequest of Mrs. Harry Payne Bingham, 1986

PAGE 63:

La Classe de Danse (The Dance Class). Begun 1873, completed 1875–76. Oil on canvas, 33⁷⁄₁₆ × 29½″ (85 × 75 cm.). Musée d'Orsay, Paris. Photograph by Routhier, Studio Lourmel, Paris

PAGE 64:

L'Orchestre de l'Opéra, also known as *Les Musiciens à l'Orchestre* (The Orchestra of the Opera). c. 1870. Oil on canvas, 22¼ × 18³⁄₁₆″ (56.5 × 46.2 cm.). Musée d'Orsay, Paris

PAGE 65:

La Répétition de Danse (The Rehearsal). 1874. Oil on canvas, 23 × 33″ (58.4 × 83.8 cm.). The Burrell Collection; Glasgow Museums & Art Galleries

Répétition de Ballet (Ballet Rehearsal). 1876–77. Pastel and gouache over monotype, 21¾ × 26¾″ (55.2 × 68 cm.). The Nelson-Atkins Museum of Art, Kansas City, Missouri; Acquired through the Kenneth A. and Helen F. Spencer Foundation Acquisition Fund

PAGE 66:

Les Blanchisseuses (Les Repasseuses) (Laundresses [Ironers]). c. 1874–76. Oil on canvas, 32 × 30″ (81.3 × 76.2 cm.). Private Collection. Photograph Christie's London

PAGE 67:

Les Repasseuses (The Ironers). c. 1884–85. Oil on canvas, 32⅜ × 29¾″ (82.2 × 75.6 cm.). Norton Simon Art Foundation, Pasadena

PAGE 68:

Loges d'Actrices (Actresses in Their Dressing Rooms). 1879–85. Pastel over etching on paper, 6½ × 9″ (16.5 × 22.9 cm.). Private Collection. Photograph E. V. Thaw & Co., Inc.

PAGE 69:

Femmes Devant un Café, le Soir, also known as *Femmes à la Terrasse d'un Café, le Soir* (Women in Front of a Café, Evening). 1877. Pastel over monotype in black ink on heavy cream-colored laid paper, 16⅛ × 23⅝″ (41 × 60 cm.). Musée d'Orsay, Paris. Photograph by Routhier, Studio Lourmel, Paris

PAGE 70:

Café-Concert (Cabaret). 1876–77. Pastel over monotype in black ink on white laid paper (the first of two impressions), 9½ × 17½″ (24.2 × 44.5 cm.). Corcoran Gallery of Art, Washington, D.C.; William A. Clark Collection

PAGE 71:

Le Café-Concert—Aux Ambassadeurs, also known as *Café-Concert* or *Le Café-Concert des Ambassadeurs* (The Café des Ambassadeurs). 1876–77. Pastel over monotype in black ink on heavy white laid paper, 14³⁄₁₆ × 11″ (36 × 28 cm.). Musée des Beaux-Arts, Lyon

PAGE 72:

Aux Courses (At the Races). c. 1876–77. Oil on canvas, 7½ × 9⁷⁄₁₆″ (19 × 24 cm.). Collection of Mr. and Mrs. Eugene Victor Thaw, New York. Photograph by Otto Nelson

PAGE 74:

Jockey. 1866–68. Graphite with estompe on tan wove paper, formerly laid down, 12¹⁵⁄₁₆ × 9¹¹⁄₁₆″ (32.8 × 24.6 cm.). The Art Institute of Chicago; Gift of Robert Allerton

Jockey. 1866–68. Pencil on gray paper, 12¾ × 9⅝″ (32.4 × 24.4 cm.). The Detroit Institute of Arts; Bequest of John S. Newberry

PAGE 75:

Gentleman-Rider (Gentleman Rider). 1866–70. Brush with black ink and white, yellow-white, and gray-brown gouache over graphite on pink wove paper, laid down, 17⁵⁄₁₆ × 11″ (44 × 28 cm.). The Art Institute of Chicago; Gift of Mrs. Josephine Albright

Cavalier en Habit Rouge (Horseman in Pink Coat). 1873. Oil colors freely mixed with turpentine (*peinture à l'essence*) with touches of white on salmon-pink paper, 17³⁄₁₆ × 10⅞″ (43.6 × 27.6 cm.). Musée du Louvre (Orsay), Paris; Cabinet des Dessins

PAGE 76:

Le Faux Départ (False Start). 1869–71. Oil on panel, 12⅝ × 15⅞″ (32 × 40.3 cm.). Yale University Art Gallery, New Haven; John Hay Whitney, B.A. 1926, Hon. M.A. 1956 Collection

PAGE 77:

Le Défilé, also known as *Chevaux de Courses, Devant les Tribunes* (The Procession, *also known as* Race Horses Before the Grandstand). c. 1866–68. Oil colors freely mixed with turpentine (*peinture à l'essence*) on paper on canvas, 18⅛ × 24″ (46 × 61 cm.). Musée d'Orsay, Paris. Photograph by Routhier, Studio Lourmel, Paris

PAGE 78:

Jockey à Cheval (Jockey on Horseback). c. 1866–68. Black pencil heightened with pastel, 16⁹⁄₁₆ × 10⅝″ (42 × 27 cm.). Private Collection. Photograph Archives Durand-Ruel, Paris

Jockey. 1866–68. Oil colors freely mixed with turpentine (*peinture à l'essence*) on paper, 13⁹⁄₁₆ × 9⅝″ (34.5 × 24.5 cm.). Private Collection. Photograph Marianne and Walter Feilchenfeldt, Zurich

PAGE 79:

Deux Etudes de Cavalier (Two Studies of a Groom). c. 1875–77. Brown essence (oil colors freely mixed with turpentine) heightened with gouache, on ocher paper prepared with oil, 9⅝ × 13½″ (24.5 × 34.3 cm.). Musée du Louvre (Orsay), Paris; Cabinet des Dessins

PAGE 80:

Avant la Course (Before the Race). 1882. Oil on paper, laid on cradled panel, 12 × 18¾″ (30.5 × 47.6 cm.). Collection of Mrs. John Hay Whitney. Photograph by Otto Nelson

Avant la Course (Before the Race). 1882. Oil on panel, 10⁷⁄₁₆ × 13¾″ (26.5 × 34.9 cm.). Sterling and Francine Clark Art Institute, Williamstown, Massachusetts

PAGE 113:
Intérieur, also known as *Le Viol* (Interior). c. 1868–69. Oil on canvas, 32×45″ (81.3×114.3 cm.). Philadelphia Museum of Art; The Henry P. McIlhenny Collection in Memory of Frances P. McIlhenny. Photograph by Eric Mitchell, Philadelphia

PAGE 114:
La Chanteuse de Café-Concert, also known as *La Chanteuse Verte* (The Singer in Green). c. 1884. Pastel on pale blue paper, 23¾×18¼″ (60.3×46.4 cm.). The Metropolitan Museum of Art, New York; Bequest of Stephen C. Clark, 1960

PAGE 115:
Chanteuse de Café (Singer with a Glove). c. 1878. Pastel and liquid medium on canvas, 21×16⁵⁄₁₆″ (53×41 cm.). The Harvard University Art Museums (Fogg Art Museum), Cambridge, Massachusetts; Bequest Collection of Maurice Wertheim, class of 1906

PAGE 116:
Chanteuse de Café-Concert (Café-Concert Singer). c. 1884. Charcoal heightened with white, 18⅞×12⅝″ (48×32 cm.). Private Collection. Photograph Galerie Schmit, Paris

Deux Etudes de Chanteuses de Café-Concert (Singer at the Café-Concert: Two Studies). 1878–80. Pastel and charcoal on heavy gray paper, attached at the corners to a mount, 17⅞×22⅞″ (45.5×58.2 cm.). Private Collection. Photograph Paul Rosenberg & Co., New York

PAGE 117:
Au Café-Concert: La Chanson du Chien (At the Café-Concert: The Song of the Dog). c. 1876–77. Gouache and pastel on monotype on joined paper: image, 22⅜×17⅞″ (57.5×45.5 cm.); paper, 24¾×20⅛″ (62.7×51.2 cm.). Private Collection. Photograph Sotheby's New York

PAGE 118:
Physionomie de Criminel (Physiognomy of a Criminal). 1881. Pastel on paper, 25³⁄₁₆×29¹⁵⁄₁₆″ (64×76 cm.). Private Collection. Photograph Archives Durand-Ruel, Paris

PAGE 119:
Physionomie de Criminel (Physiognomy of a Criminal). 1881. Pastel on paper, 18⅞×24¹³⁄₁₆″ (48×63 cm.). Private Collection. Photograph Galerie Schmit, Paris

PAGE 120:
La Lorgneuse, also known as *Femme Regardant avec des Jumelles* (Woman Looking Through Field Glasses). c. 1865? Oil colors freely mixed with turpentine (*peinture à l'essence*) and graphite on paper, 12½×7½″ (31.8×19.1 cm.). The Burrell Collection; Glasgow Museums & Art Galleries

Femme Regardant avec des Jumelles, also known as *Femme à la Lorgnette* (Woman with Opera Glasses). c. 1866. Oil paint thinned with turpentine on pink paper, 11×8¹³⁄₁₆″ (28×22.4 cm.). Reproduced by courtesy of the Trustees of the British Museum, London

PAGE 121:
Femme Regardant avec des Jumelles, also known as *Femme à la Lorgnette* (Woman with Opera Glasses). c. 1875–76. Oil on cardboard, 18⅞×12⅝″ (48×32 cm.). Gemäldegalerie Neue Meister; Staatliche Kunstsammlungen Dresden. Photograph by Gerhard Reinhold, Leipzig-Mölkau

PAGE 122:
Miss Cassatt au Louvre (Mary Cassatt at the Louvre). 1880. Pastel on gray wove paper, 25³⁄₁₆×19⁹⁄₁₆″ (64×48.7 cm.). Philadelphia Museum of Art; The Henry P. McIlhenny Collection in Memory of Frances P. McIlhenny

Femme Assise, Tenant un Livre à la Main (Seated Woman, Holding a Book in Her Hands). 1879. Charcoal on gray paper heightened with white pastel, 19×12¼″ (48.3×31.1 cm.). Private Collection. Photograph M. Knoedler & Co., Inc., New York

PAGE 123:
Au Louvre: Musée des Antiques (Mary Cassatt) (Mary Cassatt at the Louvre: The Etruscan Gallery). 1879–80. Softground etching, drypoint, aquatint, and etching on cream, moderately thick, moderately textured, laid paper (fifth state of nine): platemark, 10½×9⅛″ (26.7×23.2 cm.); sheet, 17×11⅞″ (43.2×30.2 cm.). The Toledo Museum of Art; Frederick B. Shoemaker Fund

PAGE 124:
Mary Cassatt au Louvre: La Galerie de Peinture (Mary Cassatt at the Louvre). 1885. Etching, aquatint, drypoint, and *crayon électrique*, heightened with pastel, on tan wove paper: plate, 12×5″ (30.5×12.7 cm.); sheet, 12⁵⁄₁₆×5⅜″ (31.3×13.7 cm.). The Art Institute of Chicago; Bequest of Kate L. Brewster

PAGE 125:
Au Louvre, also known as *Au Musée du Louvre (Miss Cassatt)* (At the Louvre). c. 1879. Pastel on joined paper, 28×21¼″ (71×54 cm.). Private Collection. Photograph Sotheby's New York

PAGE 127:
Portraits en Frise (Portraits in a Frieze). 1879. Black chalk and pastel on gray paper, 19¹¹⁄₁₆×25⁹⁄₁₆″ (50×65 cm.). Private Collection. Photograph Marianne and Walter Feilchenfeldt, Zurich

PAGE 128:
Devant le Miroir (Before the Mirror). c. 1885–86. Pastel, 19⁹⁄₁₆×25³⁄₁₆″ (49×64 cm.). Kunsthalle, Hamburg. Photograph by Ralph Kleinhempel

PAGE 129:
Chez la Modiste (At the Milliner's). c. 1882–84. Pastel, 26½×26½″ (67.3×67.3 cm.) (sight). Collection of Mr. and Mrs. Walter H. Annenberg

PAGE 130:
La Conversation chez la Modiste (Conversation at the Milliner's). c. 1882. Pastel, 25⁹⁄₁₆×33⅜″ (65×86 cm.). Staatliche Museen zu Berlin, Hauptstadt der DDR, Nationalgalerie

PAGE 131:
Chez la Modiste (At the Milliner's). 1882. Pastel, 29⅞×33⅜″ (75.9×84.8 cm.). Thyssen-Bornemisza Collection, Lugano, Switzerland

PAGE 132:
Petites Modistes, also known as *L'Atelier de la Modiste* (Milliners). 1882. Pastel on paper, 19×27″ (48.3×68.6 cm.). The Nelson-Atkins Museum of Art, Kansas City, Missouri; Anonymous Fund

PAGE 133:
Chez la Modiste, also known as *Femme Essayant un Chapeau chez Sa Modiste* (At the Milliner's). 1882. Pastel on pale gray wove paper, 29¾×33¾″ (75.6×85.7 cm.). The Metropolitan Museum of Art, New York; Bequest of Mrs. H. O. Havemeyer, 1929; The H. O. Havemeyer Collection

PAGE 134:
Chez la Modiste, also known as *Modiste Garnissant un Chapeau* (At the Milliner's). c. 1882–84. Charcoal heightened with pastel, 18⅛×23¼″ (46×59 cm.). Private Collection. Photograph Archives Durand-Ruel, Paris

Femme Tenant un Chapeau, also known as *Modiste Garnissant un Chapeau* (Woman Holding a Hat). c. 1882–84. Pastel, 18⅛×23⅝″ (46×60 cm.). Private Collection. Photograph Galerie Schmit, Paris

PAGE 135:
Modiste (The Milliner). c. 1882. Pastel and charcoal on gray laid paper now discolored to buff (watermark: MICHALLET) mounted on dark brown wove paper, 18¾×24½″ (47.6×62.2 cm.). The Metropolitan Museum of Art, New York; Purchase, Rogers Fund and Dikran Khan Kelekian Gift, 1922

PAGE 136:
Portrait de M. Diego Martelli, also known as *Diego Martelli* (Portrait of Diego Martelli). 1879. Oil on canvas, 43⁵⁄₁₆×39⅜″ (110×100 cm.). National Gallery of Scotland, Edinburgh

Portrait de M. Duranty, also known as *Duranty* (Duranty). 1879. Distemper, watercolor, and pastel on linen, 39¾×39½″ (100.9×100.3 cm.). The Burrell Collection; Glasgow Museums & Art Galleries

PAGE 137:
Place de la Concorde. c. 1875. Oil on canvas, 31⅛×46⁷⁄₁₆″ (79×118 cm.). Presumably destroyed during World War II. Photograph Archives Durand-Ruel, Paris

PAGE 138:
Le Coucher (Retiring). c. 1883. Pastel on laid paper, laid down, maximum 14⁵⁄₁₆×16¹⁵⁄₁₆″ (36.4×43 cm.). The Art Institute of Chicago; Bequest of Mrs. Sterling Morton

PAGE 140:
Ellen Andrée, also known as *Buste de Jeune Femme* (Portrait of Ellen Andrée [formerly Portrait of a Woman]). c. 1876. Monotype printed in brown-black ink on ivory wove paper, laid down on ivory laid paper: plate, 8⁷⁄₁₆×6⁵⁄₁₆″ (21.5×16 cm.); sheet, 9¼×7³⁄₁₆″ (23.5×18.3 cm.). The Art Institute of Chicago; Mrs. Potter Palmer Memorial Fund

PAGE 141:
Les Deux Amateurs (The Two Connoisseurs). c. 1878. Monotype printed in dark gray on white wove paper, hinged to old mount: plate, 11¾×10⅝″ (29.8×27 cm.); sheet, maximum 13³⁄₁₆×12″ (33.5×30.5 cm.). The Art Institute of Chicago; Clarence Buckingham Collection

Dans l'Omnibus, also known as *Omnibus de Voyage* (In the Streetcar). c. 1877–78. Monotype in black ink on white wove paper, plate 11×11¹¹⁄₁₆″ (28×29.7 cm.). Musée Picasso, Paris

PAGE 142:
Conversation (Ludovic Halévy et Mme. Cardinal) (Conversation [Ludovic Halévy and Mme. Cardinal]). 1876–77. Monotype in black ink on white laid paper tipped onto a white lightweight cardboard mount by the artist: plate, 8⅜×6¼″ (21.2×15.9 cm.); sheet, 10×7″ (25.4×17.8 cm.). The Cleveland Museum of Art; Gift of the Print Club of Cleveland in honor of Henry Sayles Francis

Pauline et Virginie Cardinal Bavardant avec des Admirateurs (Illustration for "La Famille Cardinal"). 1876–77. Monotype in black ink on heavy china paper tipped onto heavy white wove paper (the first of two impressions): plate, 8⁷⁄₁₆×6⁵⁄₁₆″ (21.5×16 cm.); sheet, 11⅜×7½″ (28.9×19 cm.); mount, 12³⁄₁₆×8¾″ (31×22.2 cm.). The Harvard University Art Museums (Fogg Art Museum), Cambridge, Massachusetts; Bequest—Meta and Paul J. Sachs

PAGE 143:

Le Foyer (In the Green Room). 1876–77. Monotype in black ink on white laid paper: plate, 6⅜ × 4⅝″ (16.2 × 11.8 cm.); sheet, 8⁷⁄₁₆ × 6⁵⁄₁₆″ (21.4 × 16 cm.). Graphische Sammlung; Staatsgalerie Stuttgart

Les Petites Cardinal Parlant à Leurs Admirateurs (The Cardinal Sisters Talking to Admirers). 1876–77. Monotype in black ink on white paper (the first of two impressions), 8¹¹⁄₁₆ × 7″ (22 × 17.8 cm.). Graphische Sammlung; Staatsgalerie Stuttgart

PAGE 144:

Attente (formerly *Le Coucher*)·(Waiting). c. 1879. Monotype printed in blackish brown ink on light gray wove paper: plate, maximum 4⁵⁄₁₆ × 6⁵⁄₁₆″ (10.9 × 16.1 cm.); sheet, 6⁷⁄₁₆ × 7⅜″ (16.3 × 18.8 cm.). The Art Institute of Chicago; Gift of Mrs. Charles Glore

Repos (Rest). 1876–77. Monotype in black ink on china paper, plate, 6¼ × 8¼″ (15.9 × 21 cm.). Musée Picasso, Paris

PAGE 145:

L'Attente, Seconde Version (Waiting, Second Version). 1876–77. Monotype in black ink on china paper, plate, 8½ × 6⁷⁄₁₆″ (21.6 × 16.4 cm.). Musée Picasso, Paris

PAGE 146:

La Fête de la Patronne (Petite) (Saint's Day of the Madame, small version). 1876–77. Monotype in brown ink on white laid paper, plate, 4¾ × 6¼″ (12.1 × 15.9 cm.). Private Collection. Photograph Archives Brame et Lorenceau, Paris

La Fête de la Patronne (Saint's Day of the Madame). 1876–77. Pastel over monotype, plate, 10½ × 11⅝″ (26.6 × 29.6 cm.). Musée Picasso, Paris

PAGE 147:

Conversation. 1876–77. Monotype in black ink on white laid paper, plate, 6¼ × 4¾″ (15.9 × 12.1 cm.). Private Collection. Photograph The Lefevre Gallery, London

L'Entremetteuse (The Procuress). 1876–77. Monotype in black ink on laid paper: plate, 6⁵⁄₁₆ × 4⅝″ (16.1 × 11.8 cm.); sheet, 9⁹⁄₁₆ × 5¹¹⁄₁₆″ (24.3 × 14.4 cm.). Bibliothèque d'Art et d'Archéologie, Universités de Paris (Fondation Jacques Doucet), Paris

PAGE 149:

Femme Nue dans Sa Baignoire, also known as *Femme au Bain* (Female Nude in Her Bathtub). c. 1879–83. Monotype in black ink on heavy white laid paper (the first of two impressions): plate, 7⅞ × 16⅞″ (20 × 42.9 cm.); sheet, 12⁵⁄₁₆ × 20³⁄₁₆″ (31.3 × 51.3 cm.). Private Collection. Photograph Archives Brame et Lorenceau, Paris

Femme dans Son Bain Se Lavant la Jambe (Woman in Her Bath Washing Her Leg). 1883–84. Pastel over monotype in black ink on heavy white laid paper (the second of two impressions), 7¾ × 16⅛″ (19.7 × 41 cm.). Musée d'Orsay, Paris

PAGE 150:

Femme Nue Allongée, also known as *Le Sommeil* (Sleep). c. 1879–85. Monotype in black ink on heavy creamy velum (the first of two impressions); the sheet has been pasted to the museum mount. Plate, 10⅞ × 14⅞″ (27.6 × 37.8 cm.); sheet, 13¹⁵⁄₁₆ × 20¹⁄₁₆″ (35.5 × 51 cm.). Courtesy of the Trustees of the British Museum

Femme Nue Etendue sur un Canapé (Female Nude Reclining on Her Bed). c. 1879–85. Monotype printed in black ink on ivory laid paper (the first of two impressions): plate, 7¹³⁄₁₆ × 16¼″ (19.9 × 41.3 cm.); sheet, 8¹¹⁄₁₆ × 16⁷⁄₁₆″ (22.1 × 41.8 cm.). The Art Institute of Chicago; Clarence Buckingham Collection

PAGE 151:

Liseuse (Reader). c. 1879–85. Monotype in black ink on heavy white laid paper (one of two impressions): plate, 14¹⁵⁄₁₆ × 10¹⁵⁄₁₆″ (38 × 27.8 cm.); sheet, 17⁷⁄₁₆ × 12¹³⁄₁₆″ (44.3 × 32.5 cm.). National Gallery of Art, Washington; Rosenwald Collection

PAGE 152:

La Chanteuse de Café-Concert (The Café-Concert Singer). c. 1876–77. Pastel over monotype in black ink on white laid paper, plate, 6½ × 4¾″ (16.5 × 12.1 cm.). Private Collection. Photograph by Robert Kolbrener

Mlle. Bécat aux Ambassadeurs, also known as *Divette de Café-Concert* (Mlle. Bécat at the Café des Ambassadeurs). c. 1877–78. Pastel over lithograph, 6⁷⁄₁₆ × 4¾″ (16.3 × 12.1 cm.) (sight). Private Collection

PAGE 153:

Mlle. Bécat aux Ambassadeurs, also known as *Aux Ambassadeurs: Mlle. Bécat* (Mlle. Bécat at the Café des Ambassadeurs). 1877–85. Pastel over lithograph, on three pieces of paper joined together, 9 × 7⅞″ (22.8 × 20 cm.). Collection of Mr. and Mrs. Eugene Victor Thaw, New York. Photograph by Otto Nelson

PAGE 154:

Chanteuses de Café-Concert (Café-Concert Singers). 1877–78. Pencil, 6⅜ × 4¹³⁄₁₆″ (16.2 × 12.2 cm.). Private Collection

Chanteuses de Café-Concert (Café-Concert Singers). 1877–78. Pencil, 6⅜ × 4¹³⁄₁₆″ (16.2 × 12.2 cm.). Private Collection

PAGE 155:

Les Blanchisseuses, also known as *Les Blanchisseuses (Le Repassage)* (The Laundresses). 1879–80. Etching and aquatint (fourth state of four), plate, 4⅝ × 6⁵⁄₁₆″ (11.8 × 16 cm.). Bibliothèque Nationale, Paris; Cabinet des Estampes

Les Blanchisseuses, also known as *Les Blanchisseuses (Le Repassage)* (The Laundresses). 1879–85. Pastel over etching and aquatint, plate, 4⅝ × 6⁵⁄₁₆″ (11.8 × 16 cm.). Private Collection. Photograph Archives Brame et Lorenceau, Paris

PAGE 156:

Champ de Blé et Ligne d'Arbres (Wheatfield and Row of Trees). 1890–92. Pastel over monotype in oil colors, on paper, 10 × 13⅝″ (25.5 × 34.5 cm.). Private Collection. Photograph Sotheby's New York

PAGE 157:

Paysage (Landscape). c. 1892. Pastel over monotype on tan paper, 18⅛ × 21⅝″ (46 × 55 cm.). Photograph Galerie Jan Krugier, Geneva

PAGE 158:

Danseuses, Rose et Vert (Pink and Green). 1894. Pastel, 26⅜ × 18¾″ (67 × 47.6 cm.). Private Collection

PAGE 160:

Danseuses à la Barre (Dancers at the Barre). c. 1877–79. Pastel on paper laid down on paper laid down on board, 26 × 20⅛″ (66 × 51 cm.). Private Collection. Courtesy The Acquavella Galleries, Inc., New York. Photograph by Otto Nelson

PAGE 161:

Danseuses à la Barre (Dancers Practicing at the Barre). 1876–77. Mixed media on canvas, 29¾ × 32″ (75.6 × 81.3 cm.). The Metropolitan Museum of Art, New York; Bequest of Mrs. H. O. Havemeyer, 1929; The H. O. Havemeyer Collection

PAGE 162:

Examen de Danse, also known as *Danseuses à Leur Toilette* (The Dance Examination). c. 1879. Pastel and charcoal on thick gray wove paper, 24¹⁵⁄₁₆ × 18¹⁵⁄₁₆″ (63.4 × 48.2 cm.). Denver Art Museum˙ Anonymous gift

PAGE 163:

L'Attente (Waiting). c. 1882. Pastel on paper, 19 × 24″ (48.2 × 61 cm.). The J. Paul Getty Museum and Norton Simon Art Foundation. Photograph Sotheby's New York

PAGE 164:

Danseuse dans Sa Loge, also known as *Loge de Danseuse* (Ballet Dancer in Her Dressing Room). 1878–79. Gouache and pastel on joined paper on cardboard, 23⅝ × 15¾″ (60 × 40 cm.). Oskar Reinhart Collection "Am Römerholz," Winterthur. Photograph by Walter Dräyer

PAGE 165:

Avant l'Entrée en Scène (Before the Entrance on Stage). c. 1880. Pastel on paper, 23¼ × 17¾″ (58 × 44 cm.). Private Collection. Photograph The Acquavella Galleries, Inc., New York

PAGE 166:

Danseuses Derrière le Portant (Dancers in the Wings). c. 1878–80. Pastel and tempera on paper, 27¼ × 19¾″ (69.2 × 50.2 cm.). Norton Simon Art Foundation, Pasadena

PAGE 167:

L'Entrée des Masques (The Entrance of the Masked Dancers). 1879. Pastel on paper, 19⁵⁄₁₆ × 25½″ (49 × 64.7 cm.). Sterling and Francine Clark Art Institute, Williamstown, Massachusetts

PAGE 168:

Danseuses en Blanc (Ballet Girls in White). c. 1878. Pastel, 20 × 25″ (50.8 × 63.5 cm.). Private Collection

PAGE 169:

Ballet à l'Opéra (Ballet at the Paris Opera). 1877. Pastel over monotype on cream-colored laid paper: plate, 13⅞ × 27¹³⁄₁₆″ (35.2 × 70.6 cm.); sheet, 14⅛ × 28⁵⁄₁₆″ (35.9 × 71.9 cm.). The Art Institute of Chicago; Gift of Mary and Leigh Block

PAGE 170:

Danseuse au Bouquet (Dancer with Bouquet). c. 1877–78. Pastel over monotype on paper, 15⅞ × 19⅞″ (40.3 × 50.5 cm.). Museum of Art, Rhode Island School of Design, Providence; Gift of Mrs. Murray S. Danforth

PAGE 171:

Au Théâtre (At the Theater). c. 1880. Pastel on paper, 21⅝ × 18⅞″ (55 × 48 cm.). Private Collection

PAGE 172:

L'Etoile (The Star). 1879–81. Pastel on cream-colored wove paper, laid down, maximum 28⅞ × 22⅝″ (73.3 × 57.4 cm.). The Art Institute of Chicago; Bequest of Mrs. Diego Suarez

PAGE 173:

Etude de Loge au Théâtre, also known as *La Loge* (Study of a Box at the Theater). 1880. Pastel, 26 × 20⅞″ (66 × 53 cm.). Private Collection

PAGE 174:

Danseuse (Vue de Face) (A Ballet Dancer in Position Facing Three-Quarters Front). c. 1872. Graphite and crayon heightened with white chalk on pink wove paper, 16⅛ × 11¼″ (41 × 28.5 cm.). The Harvard University Art Museums (Fogg Art Museum), Cambridge, Massachusetts; Bequest—Meta and Paul J. Sachs

Danseuse (Ballet Dancer Adjusting Her Costume). c. 1873. Pencil, heightened with white on pink paper, 15½ × 10¼″ (39.37 × 26.04 cm.) (sight). The Detroit Institute of Arts; Bequest of John S. Newberry

PAGE 175:

Danseuse Rajustant Son Chausson (Dancer Adjusting Slipper). 1873. Graphite heightened with white chalk on now-faded pink paper, 12⅞ × 9⅝″ (33 × 24.4 cm.). The Metropolitan Museum of Art, New York; Bequest of Mrs. H. O. Havemeyer, 1929; The H. O. Havemeyer Collection

Danseuse (Portrait of Josephine Gaujelin). 1873. Pencil on white paper, mounted, 12¹⁄₁₆ × 7¾″ (30.7 × 19.7 cm.). Museum Boymans-van Beuningen, Rotterdam

PAGE 176:

Danseuse Debout Rattachant Sa Ceinture (Standing Dancer Fastening Her Sash). c. 1873. Lavis and gouache, 21⅝ × 14¹⁵⁄₁₆″ (55 × 38 cm.). Private Collection. Photograph Galerie Schmit, Paris

Danseuse Remettant Son Chausson, also known as *Danseuse Rajustant Son Chausson* (Dancer Adjusting Her Slipper). c. 1873. Oil colors freely mixed with turpentine (*peinture à l'essence*) on pink paper, 15¾ × 12⅝″ (40 × 32 cm.). Private Collection. Photograph Galerie Schmit, Paris

PAGE 177:

Danseuse Debout, de Dos (Standing Dancer, from Behind). c. 1873. Oil colors freely mixed with turpentine (*peinture à l'essence*) on pink paper, 15½ × 10¹⁵⁄₁₆″ (39.4 × 27.8 cm.). Musée du Louvre (Orsay), Paris; Cabinet des Dessins

Deux Danseuses (Two Dancers). 1873. Dark brown wash and white gouache on pink commercially coated wove paper, 24⅛ × 15½″ (61.3 × 39.4 cm.). The Metropolitan Museum of Art, New York; Bequest of Mrs. H. O. Havemeyer, 1929; The H. O. Havemeyer Collection

PAGE 178

Danseuse Debout les Mains Derrière le Dos, also known as *Danseuse, les Mains Croisées Derrière le Dos* (Standing Dancer, Hands Clasped Behind Her Back). 1874. Black and white chalks on gray laid paper, 17¹¹⁄₁₆ × 11¹¹⁄₁₆″ (45 × 29.7 cm.). Photograph Jan Krugier Gallery, New York

Danseuse Vue de Dos (Dancer Seen from Behind). c. 1876. Black chalk heightened with white on gray paper, 18⅞ × 11¹³⁄₁₆″ (48 × 30 cm.). Private Collection

PAGE 179:

Danseuse (Deux Etudes) (Dancer [Two Studies]). c. 1874. Charcoal with touches of white, 11¹³⁄₁₆ × 15¾″ (30 × 40 cm.). Private Collection. Photograph Archives Durand-Ruel, Paris

PAGE 180:

Danseuse Assise (Dancer Adjusting Her Stocking). c. 1880. Black chalk and pastel on cream-colored laid paper, 9⅜ × 12⅝″ (23.8 × 32 cm.). Private Collection

Danseuse Rajustant Son Maillot (Dancer Adjusting Her Tights). c. 1880. Charcoal heightened with pastel, 8¹¹⁄₁₆ × 12³⁄₁₆″ (22 × 31 cm.). Private Collection. Photograph Archives Durand-Ruel, Paris

PAGE 181:

Etude de Danseuse (Study of a Dancer). c. 1880. Charcoal, 12³⁄₁₆ × 9⁷⁄₁₆″ (31 × 24 cm.). Private Collection. Photograph Archives Durand-Ruel, Paris

PAGE 182:

Danseuse Tirant Son Maillot (Dancer Pulling Up Her Tights). c. 1886. Pastel, 23⅝ × 18⅛″ (60 × 46 cm.). Private Collection. Photograph Galerie Schmit, Paris

Danseuse Assise, Rajustant Son Maillot (Seated Dancer, Adjusting Her Tights). c. 1878–79. Charcoal heightened with white, 14¹⁵⁄₁₆ × 11⁷⁄₁₆″ (38 × 29 cm.). Private Collection. Photograph Archives Durand-Ruel, Paris

PAGE 183:

Danseuse Rajustant Son Maillot (Dancer Adjusting Her Tights). c. 1878–79. Charcoal, with touches of white on gray paper, 16⁹⁄₁₆ × 11¹³⁄₁₆″ (42 × 30 cm.). Private Collection. Photograph Galerie Schmit, Paris

Danseuse Assise (Seated Dancer). c. 1878–79. Charcoal, with touches of white, 15⅜ × 10⅝″ (39 × 27 cm.). Private Collection. Photograph Archives Durand-Ruel, Paris

PAGE 184:

Etude de Danseuse (Melina Darde) (Study of a Dancer [Melina Darde]). December 1878. Black pencil, 12³⁄₁₆ × 9¹⁄₁₆″ (31 × 23 cm.). Private Collection. Photograph Archives Durand-Ruel, Paris

Danseuse Ajustant Son Soulier (Dancer Adjusting Her Shoe). c. 1885. Charcoal, 11¹³⁄₁₆ × 9⁷⁄₁₆″ (30 × 24 cm.). Private Collection. Photograph Archives Brame et Lorenceau, Paris

PAGE 185:

Danseuse Rajustant Son Chausson (Dancer Adjusting Her Slipper). 1885–87. Charcoal and touches of white, 11¹³⁄₁₆ × 12⅝″ (30 × 32 cm.). Private Collection. Photograph Galerie Schmit, Paris

Danseuse Rajustant Son Soulier (Dancer Fixing Her Shoe). c. 1885. Charcoal and white pastel on gray paper, 17⅝ × 12¼″ (44.8 × 31.1 cm.). Norton Simon Art Foundation, Pasadena

PAGE 186:

Danseuse Rajustant Son Chausson (Dancer Adjusting Her Slipper). c. 1878–79. Charcoal, heightened with white, 16⅛ × 11¹³⁄₁₆″ (41 × 30 cm.). Private Collection. Photograph Archives Durand-Ruel, Paris

PAGE 187:

Deux Danseuses au Repos (Two Dancers at Rest). c. 1878–79. Charcoal, heightened with white, 12 × 18⅛″ (30.5 × 46 cm.). Private Collection. Photograph Galerie Schmit, Paris

PAGE 188:

Danseuse (Dancer). c. 1878–79. Charcoal heightened with white on tan paper, 12¼ × 22⅞″ (31.1 × 58.1 cm.). Private Collection. Photograph E. V. Thaw & Co., Inc., New York

PAGE 189:

Danseuse, also known as *Danseuse Faisant des Exercises de Jambes* (Dancer). c. 1878–79. Charcoal, with touches of white, 16⁹⁄₁₆ × 11¹³⁄₁₆″ (42 × 30 cm.). Private Collection. Photograph Archives Durand-Ruel, Paris

Etudes de Danseuse (Studies of a Dancer). c. 1878–79. Black and white chalks on green paper squared for transfer, 18⅞ × 11⅝″ (48 × 29.5 cm.). Private Collection. Photograph Archives Durand-Ruel, Paris

PAGE 190:

Etude de Danseuse (Study of a Dancer). c. 1880–82. Charcoal, heightened with white, 18⅞ × 24¹³⁄₁₆″ (48 × 63 cm.). Private Collection. Photograph Archives Durand-Ruel, Paris

Danseuse, also known as *Danseuse Debout* (Dancer). c. 1878–79. Charcoal heightened with pastel, 18⅞ × 20½″ (48 × 52 cm.). Private Collection. Photograph Archives Durand-Ruel, Paris

PAGE 191:

Grande Battement à la Seconde, also known as *Danseuse Debout* (Grande Battement, Second Position). c. 1880–82. Black crayon heightened with pastel and white chalk on brown paper, attached around the edges to a mount, 11¾ × 9½″ (30 × 24 cm.). Collection Herbert Black. Photograph Sotheby's New York

PAGE 193:

Danseuse Rajustant Son Chausson, also known as *Danseuse Assise, Rajustant Sa Chaussure* (Dancer Adjusting Her Slipper). c. 1882–85. Pastel, 19¹¹⁄₁₆ × 24¹³⁄₁₆″ (50 × 63 cm.). Private Collection

PAGE 194:

Danseuse Assise Rattachant Son Chausson (Seated Dancer Tying Her Slipper). c. 1882–85. Pastel, 12⅝ × 16⅛″ (32 × 41 cm.). Private Collection

PAGE 195:

Etude d'un Noeud de Ceinture, also known as *Noeud de Rubans* (Study of a Bow). c. 1882–85. Pastel and charcoal on gray-blue wove paper, 9¼ × 11¹³⁄₁₆″ (23.5 × 30 cm.). Musée d'Orsay, Paris. Photograph by Routhier, Studio Lourmel, Paris

PAGE 196:

Danseuse Ajustant Son Soulier, also known as *Danseuse Ajustant Son Chausson* (Dancer Adjusting Her Shoe). c. 1880. Pastel on gray paper, 19 × 24″ (48.2 × 61 cm.). The Dixon Gallery and Gardens, Memphis

PAGE 197:

Danseuse Attachant Son Chausson (Dancer Adjusting Her Slipper). c. 1880–85. Pastel and black chalk on buff paper mounted at the edges on board, 18⅝ × 16⅞″ (47.2 × 43 cm.). Private Collection. Photograph by Routhier, Studio Lourmel, Paris

PAGE 198:

Danseuse Attachant Son Chausson (Seated Dancer Tying Her Slipper). c. 1880. Pastel on paper, 18⅛ × 24⅛″ (46.5 × 61.3 cm.). Private Collection. Photograph The Acquavella Galleries, Inc., New York

PAGE 199:

Danseuses au Foyer (Dancers in the Green Room). 1879–80. Pastel, 19¹¹⁄₁₆ × 25⁹⁄₁₆″ (50 × 65 cm.). Private Collection. Photograph Archives Durand-Ruel, Paris

PAGE 200:

Danseuse au Tutu Vert (Dancer in Green Tutu). c. 1880–85. Pastel on paper, 18⁷⁄₁₆ × 13″ (46.9 × 33 cm.). Private Collection. Photograph The Lefevre Gallery, London

PAGE 202:

Danseuses Montant un Escalier (Dancers Climbing a Flight of Stairs). 1885–90. Oil on canvas, 15⅜ × 35⁵⁄₁₆″ (39 × 89 cm.). Musée d'Orsay, Paris

Danseuses au Foyer, also known as *La Contrebasse* (Dancers in the Rehearsal Room, with a Double Bass). c. 1882–85. Oil on canvas, 15⅜ × 35¼″ (39 × 89.5 cm.). The Metropolitan Museum of Art, New York; Bequest of Mrs. H. O. Havemeyer, 1929; The H. O. Havemeyer Collection

PAGE 203:

La Leçon de Danse (The Dancing Lesson). c. 1880. Oil on canvas, 15½ × 34¹³⁄₁₆″ (39.4 × 88.4 cm.). Sterling and Francine Clark Art Institute, Williamstown, Massachusetts

Le Foyer de la Danse, also known as *Dans une Salle de Répétition* (Before the Ballet). 1890–92. Oil on canvas, 15¾ × 35″ (40 × 89 cm.). National Gallery of Art, Washington; Widener Collection

La Salle de Danse (Ballet Rehearsal). c. 1885–90. Oil on canvas, 14⅛ × 34½″ (35.9 × 87.6 cm.). Yale University Art Gallery, New Haven; Gift of Duncan Phillips, B.A. 1908

PAGE 205:

Trois Etudes d'une Danseuse en Quatrième Position (Three Studies of a Dancer in Fourth Position). 1879–80. Charcoal and pastel with estompe, over graphite, heightened with white chalk, on buff laid paper, 18⅞ × 24¼″ (48 × 61.6 cm.). The Art Institute of Chicago; Bequest of Adele R. Levy

Etudes de Danseuse (Three Studies of a Dancer). 1879–80. Black chalk heightened with white on pink paper, 18⅞ × 24¹³⁄₁₆″ (48 × 63 cm.). Private Collection. Photograph Marianne and Walter Feilchenfeldt, Zurich

PAGE 206:
Two views of *Petite Danseuse de Quatorze Ans* (The Little Dancer of Fourteen Years). 1879–81. Bronze, partially colored, cotton skirt, satin ribbon, wooden base, height, 39″ (99.1 cm.). The Metropolitan Museum of Art, New York; Bequest of Mrs. H. O. Havemeyer, 1929; The H. O. Havemeyer Collection

PAGE 207:
Petite Danseuse de Quatorze Ans (The Little Dancer of Fourteen Years). 1879–81. Yellow wax, cotton skirt, satin ribbon, wooden base, height, 39″ (99.1 cm.) (without base). Collection of Mr. and Mrs. Paul Mellon, Upperville, Virginia

Third view of *Petite Danseuse de Quatorze Ans* (The Little Dancer of Fourteen Years). The Metropolitan Museum of Art, New York; Bequest of Mrs. H. O. Havemeyer, 1929; The H. O. Havemeyer Collection

PAGE 208:
Grande Arabesque, Troisième Temps (Grande Arabesque, Third Time [two views]). c. 1882–95. Bronze, "*Modèle*" cast, height, 15⅞″ (40.3 cm.). Norton Simon Art Foundation, Pasadena. Photographs by Jack Nadelle

PAGE 209:
Danse Espagnole (Spanish Dance). c. 1882–95. Bronze height, 17″ (43.2 cm.). The Metropolitan Museum of Art, New York; Bequest of Mrs. H. O. Havemeyer, 1929; The H. O. Havemeyer Collection

Danse Espagnole (Spanish Dance). c. 1882–95. Bronze, height, 17″ (43.2 cm.). Photograph Leonard von Matt

PAGES 210–11:
Danseuse Regardant la Plante de Son Pied Droit (Dancer Looking at the Sole of Her Right Foot [two views]). c. 1882–95. Bronze, height, 18¼″ (46.4 cm.). Photographs Marlborough Fine Art (London) Ltd.

PAGE 212:
Un Coin de la Scène Pendant le Ballet, also known as *Danseuses en Scène* (Ballet Dancers on the Stage). 1883. Pastel on paper, 25½ × 20″ (64.8 × 50.8 cm.). Dallas Museum of Art; Lent by Mr. and Mrs. Frank Bartholow

PAGE 213:
Danseuses Basculant, also known as *Danseuse Verte* (Green Dancer). c. 1880. Pastel and gouache, 26 × 14³⁄₁₆″ (66 × 36 cm.). Collection Thyssen-Bornemisza, Lugano, Switzerland

PAGE 214:
Deux Danseuses au Repos (Two Dancers at Rest). c. 1896. Charcoal on paper, 23¼ × 16½″ (59.1 × 41.9 cm.). Private Collection. Photograph Archives Brame et Lorenceau, Paris

Deux Danseuses au Repos (Two Dancers at Rest). c. 1896. Charcoal, 29⅛ × 30⅞″ (74 × 78.5 cm.). Private Collection. Photograph Galerie Schmit, Paris

PAGE 215:
Danseuse (Dancer). c. 1899. Pastel, 20⅞ × 15⅜″ (53 × 39 cm.). Private Collection. Photograph Archives Durand-Ruel, Paris

PAGE 216:
Danseuses an Foyer, also known as *Danseuses* (Dancers in the Green Room). c. 1896. Pastel, 20⅛ × 15¾″ (51 × 40 cm.). Private Collection

PAGE 217:
Deux Danseuses aux Corsages Jaunes (Two Dancers with Yellow Bodices). c. 1902. Pastel, 32¾ × 27½″ (83.2 × 69.9 cm.). Private Collection. Photograph The Lefevre Gallery, London

PAGE 218:
Danseuse (Dancer). c. 1895–1900. Pastel over charcoal on ivory laid paper, pieced at top, 15⅛ × 10⁵⁄₁₆″ (38.4 × 26.2 cm.) (sight). Private Collection. Photograph M. Knoedler & Co., Inc., New York

Quatre Danseuses à Mi-Corps (Four Dancers, Half-Length Studies). c. 1899. Charcoal and pastel, 27½ × 28⅜″ (69.8 × 72 cm.). Private Collection. Photograph, M. Knoedler & Co., Inc., New York

PAGE 219:
En Attendant l'Entrée en Scène, also known as *Quatre Danseuses* (Four Dancers). c. 1896–98. Oil on canvas, 59½ × 71″ (151.1 × 180.2 cm.). National Gallery of Art, Washington; Chester Dale Collection 1962

PAGE 220:
Danseuses (Dancers). 1899. Pastel, 23⅝ × 24¹³⁄₁₆″ (60 × 63 cm.). Private Collection

PAGE 221:
Danseuses (The Dancers). c. 1899. Pastel on paper, 24½ × 25½″ (62.2 × 64.8 cm.). The Toledo Museum of Art; Gift of Edward Drummond Libbey

PAGE 222:
Etude de Nu (Nude Study). 1896. Oil on canvas, 30¼ × 32⅝″ (77 × 83 cm.). Private Collection. Photograph by Otto Nelson

PAGE 224:
Femme Debout dans une Baignoire (Standing Woman in a Bathtub). 1876–77. Monotype in black ink on laid paper, dimensions unknown. Private Collection. Photograph Archives Brame et Lorenceau, Paris

Admiration. 1876–77. Monotype in black ink heightened with red and black pastel on heavy white laid paper (the first of two impressions): plate, 8⁷⁄₁₆ × 6⅜″ (21.5 × 16.2 cm.); sheet, 12⅜ × 8⅞″ (31.5 × 22.5 cm.). Bibliothèque d'Art et d'Archéologie, Universités de Paris (Fondation Jacques Doucet), Paris

PAGE 225:
Femme Nue Se Coiffant (Nude Woman Combing Her Hair). c. 1876–77. Pastel over monotype in black ink on white laid paper: plate, 8⁷⁄₁₆ × 6⅜″ (21.5 × 16.2 cm.); sheet, 11¼ × 9⅛″ (28.6 × 23.1 cm.). Private Collection

PAGE 226:
La Sortie du Bain (Leaving the Bath). 1876–77. Pastel over monotype in black ink on china paper, plate, 8¼ × 6¼″ (21 × 15.9 cm.). Private Collection. Photograph E. V. Thaw & Co., Inc., New York

PAGE 227:
Femme à Sa Toilette (Woman at Her Toilette). c. 1876–77. Pastel over monotype, 18 × 23¾″ (45.7 × 60.3 cm.). The Norton Simon Foundation, Pasadena

PAGE 228:
La Toilette (La Cuvette) (The Washbasin). c. 1879–85. Monotype in black ink on heavy white laid paper (the first of two impressions): plate, 12⁵⁄₁₆ × 10¾″ (31.3 × 27.3 cm.). sheet, 19¹⁄₁₆ × 13⅞″ (48.4 × 35.2 cm.). Sterling and Francine Clark Art Institute, Williamstown, Massachusetts

PAGE 229:
La Toilette. c. 1884–86. Pastel over monotype (the second of two impressions), 12 × 12″ (30.5 × 30.5 cm.) (sight). Private Collection

PAGE 230:
La Toilette. c. 1897. Pastel on joined paper mounted on board, 23⅜ × 24″ (59.3 × 61 cm.). Private Collection. Photograph The Acquavella Galleries, Inc., New York

PAGE 231:
Femme à Sa Toilette (Woman at Her Toilette). c. 1897. Pastel, 20¹⁄₁₆ × 18⅛″ (51 × 46 cm.). Private Collection

PAGE 232:
Le Bain (The Bath). c. 1895. Oil on canvas, 32 × 46¼″ (81.3 × 117.5 cm.). The Carnegie Museum of Art, Pittsburgh; Acquired through the generosity of Mrs. Alan M. Scaife

PAGE 233:
Le Bain Matinal (The Morning Bath). c. 1895. Pastel on off-white laid paper mounted on board, maximum 26⁵⁄₁₆ × 17¹¹⁄₁₆″ (66.8 × 45 cm.). The Art Institute of Chicago; Potter Palmer Collection

PAGE 234:
Femme Debout dans une Baignoire (Standing Woman in a Bathtub). c. 1879–85. Monotype in black ink on heavy cream-colored laid paper, discolored slightly (the first of two impressions): plate, 14¹⁵⁄₁₆ × 10⅝″ (38 × 27 cm.); sheet, 20⅜ × 13⅞″ (51.7 × 35.3 cm.). Musée du Louvre (Orsay), Paris; Cabinet des Dessins

La Toilette (Le Bain) (The Bath). c. 1879–85. Monotype printed in black-brown ink on cream laid paper (the first of two impressions): plate, maximum 12⅜ × 10¹⁵⁄₁₆″ (31.4 × 27.8 cm.); sheet, 20¼ × 13⅞″ (51.4 × 35.2 cm.). The Art Institute of Chicago; Clarence Buckingham Collection

PAGE 235:
Le Bain (The Bath). c. 1894. Pastel over monotype, 14¹⁵⁄₁₆ × 11″ (38 × 28 cm.). Private Collection

PAGE 236:
Le Tub (The Tub). 1886. Pastel on cardboard, 23⅝ × 32¹¹⁄₁₆″ (60 × 83 cm.). Musée d'Orsay, Paris. Photograph by Routhier, Studio Lourmel, Paris

PAGE 237:
Le Tub (The Tub). c. 1885–86. Pastel, 27½ × 27½″ (69.9 × 69.9 cm.). Hillstead Museum, Farmington, Connecticut

PAGE 238:
Après le Bain (After the Bath). c. 1879–83. Monotype in black ink on heavy white laid paper (the first of two impressions), plate, 11 × 14¾″ (28 × 37.5 cm.). Private Collection. Photograph Archives Brame et Lorenceau, Paris

Femme Sortant du Bain, also known as *Etude de Nu* (Woman Leaving the Bath). c. 1886–88. Charcoal heightened with pastel, 9⁷⁄₁₆ × 12³⁄₁₆″ (24 × 31 cm.). Private Collection. Photograph Thomas Agnew & Sons, Ltd, London

PAGE 239:
Femme Sortant du Bain (Woman Leaving the Bath). 1886–88. Pastel over monotype in black ink on paper, mounted on canvas, 10⅞ × 14¾″ (27.5 × 37.5 cm.). Collection of Mr. and Mrs. Thomas Gibson

PAGE 241:
Femme Sortant du Bain (Woman Leaving the Bath). 1876–77. Pastel over monotype in black ink on heavy white laid paper, 6⁵⁄₁₆ × 8⁷⁄₁₆″ (16 × 21.5 cm.). Musée d'Orsay, Paris. Photograph by Routhier, Studio Lourmel, Paris

Femme Sortant du Bain (Woman Getting out of the Bath). 1876–77. Pastel over monotype on laid paper, 6⁵⁄₁₆ × 8⁷⁄₁₆″ (16 × 21.5 cm.). Norton Simon Art Foundation, Pasadena

PAGE 242:

Femme au Tub (Woman in the Tub). 1884. Pastel, 33⅞ × 29¹⁵⁄₁₆″ (86 × 76 cm.). Private Collection

PAGE 243:

Après le Bain, also known as *Après le Tub* (After the Bath). c. 1883–84. Pastel on paper, 20½ × 12⅝″ (52 × 32 cm.). Private Collection

PAGE 244:

Après le Bain, Femme S'Essuyant (After the Bath, Woman Drying Herself). c. 1900. Charcoal on tracing paper, mounted on card, 15¾ × 21¼″ (40 × 54 cm.). Graphische Sammlung; Staatsgalerie Stuttgart

Après le Bain (After the Bath). c. 1900. Black chalk, 28¾ × 22¹³⁄₁₆″ (73 × 58 cm.). Private Collection. Photograph Archives Brame et Lorenceau, Paris

PAGE 245:

Après le Bain, Femme S'Essuyant (After the Bath, Woman Drying Herself). c. 1900–1902. Pastel and charcoal with white gouache on tracing paper laid down on canvas, 31½ × 28⅜″ (80 × 72 cm.). Collection of Mr. Gregory Callimanopulos. Photograph The Metropolitan Museum of Art, New York

Après le Bain (After the Bath). c. 1905. Charcoal and pastel on paper, 23½ × 21⅛″ (59.7 × 53.6 cm.). Art Gallery of Ontario, Toronto; Gift of Sam and Ayala Zacks, 1970. On permanent loan to The Israel Museum, Jerusalem

PAGE 246:

Le Bain, also known as *La Toilette Après le Bain* (The Bath). c. 1888. Pastel and charcoal on paper, 35½ × 28⅜″ (90 × 72 cm.). Private Collection. Photograph Sotheby's New York

PAGE 247:

Après le Bain (Femme S'Essuyant) (After the Bath [Woman Drying Herself]). c. 1882–85. Pastel, 28⅞ × 22¹³⁄₁₆″ (72 × 58 cm.). Private Collection

PAGE 248:

Le Petit Déjeuner Après le Bain (Breakfast After the Bath). c. 1889. Pastel on joined buff paper, 47 × 41½″ (119.3 × 105.4 cm.). Kunstmuseum Winterthur; Received in 1979 with a legacy from Henri Friedrich

PAGE 249:

Le Petit Déjeuner à la Sortie du Bain (Breakfast upon Leaving the Bath). 1895. Pastel, 47⅝ × 36¼″ (121 × 92 cm.). Private Collection. Photograph Marlborough Fine Art (London) Ltd.

PAGE 250:

Femme Assise S'Essuyant le Cou, also known as *Après le Bain, Femme S'Essuyant la Tête* (Woman Drying Her Hair). c. 1889. Charcoal on paper, 24⁷⁄₁₆ × 27⁹⁄₁₆″ (62 × 70 cm.). Private Collection. Photograph Paul Rosenberg & Co., New York

PAGE 251:

Baigneuse S'Essuyant, also known as *La Sortie du Bain* (Seated Bather Drying Herself). c. 1895. Pastel on joined paper, 20¾ × 20⅞″ (52.8 × 53 cm.). Collection of Bob Guccione and Kathy Keeton. Photograph by Otto Nelson

PAGE 252:

Après le Bain (After the Bath). 1885. Pastel on paper, mounted on cardboard, 26 × 20¾″ (66 × 52.7 cm.). The Norton Simon Foundation, Pasadena

PAGE 253:

Après le Bain, Femme S'Essuyant (Woman Drying Herself). c. 1888–92. Pastel, 40⅞ × 38¾″ (103.8 × 98.4 cm.). The National Gallery, London; Reproduced by courtesy of the Trustees, The National Gallery, London

PAGE 254:

Après le Bain, Femme S'Essuyant la Poitrine (After the Bath, Woman Drying Herself). c. 1889–90? Pastel on paper, 26⅝ × 22¾″ (67.7 × 57.8 cm.). Courtauld Institute Galleries, London (Courtauld Collection)

PAGE 255:

Après le Bain, Femme S'Essuyant la Nuque (After the Bath, Woman Drying Her Nape). c. 1895. Pastel on cardboard, 24½ × 25⁹⁄₁₆″ (62.2 × 65 cm.). Musée d'Orsay, Paris

PAGE 256:

Femme S'Essuyant les Cheveux (Woman Drying Her Hair). c. 1895–1902. Charcoal on paper, 28¼ × 27⅛″ (71.7 × 68.9 cm.). Private Collection. Photograph The Acquavella Galleries, Inc., New York

PAGE 257:

Après le Bain (After the Bath). c. 1885. Charcoal and pastel on white paper, 26¹⁵⁄₁₆ × 22¼″ (68.5 × 56.5 cm.). Private Collection. Photograph Archives Brame et Lorenceau, Paris

PAGE 258:

Femme Nue Debout, à Sa Toilette, also known as *Femme Nue Debout S'Essuyant* (Nude Woman Standing, Drying Herself). c. 1891. Lithograph, transfer from monotype, crayon, tusche, and scraping. Buff, moderately thick, moderately textured, machine-made, laid paper (wove paper with laid pattern; fourth state of six): image, 13 × 9⅝″ (33 × 24.5 cm.); sheet, 17¹⁵⁄₁₆ × 11⁹⁄₁₆″ (45.5 × 29.3 cm.). Museum of Fine Arts, Boston; Katherine E. Bullard Fund in memory o Francis Bullard and proceeds from sale of duplicate prints

Après le Bain (Deuxième Planche), also known as *Le Lever, Deuxième Planche* (After the Bath I). 1891–92. Lithograph, transfer, and crayon. Off-white, very thin, smooth, Japanese tissue (second state of two): image, 7⅝ × 5¹³⁄₁₆″ (19.3 × 14.7 cm.); sheet (irregular), 10¹¹⁄₁₆ × 8½″ (27.2 × 21.6 cm.). Private Collection. Photograph Museum of Fine Arts, Boston

PAGE 259:

Après le Bain (Première Planche), also known as *Le Lever, Première Planche* (After the Bath II). 1891–92. Lithograph, transfer, crayon, and scraping. White, moderately thick, smooth, wove paper (first state of five): image, 7½ × 5¹³⁄₁₆″ (19 × 14.7 cm.); sheet, 11¹⁵⁄₁₆ × 8⁹⁄₁₆″ (30.3 × 21.8 cm.). Sterling and Francine Clark Art Institute, Williamstown, Massachusetts

Après le Bain (Première Planche), also known as *Le Lever, Première Planche* (After the Bath II). 1891–92. Lithograph, transfer, crayon, and scraping. Off-white, moderately thick, smooth, wove paper (fifth state of five): image, 8¼ × 5¹³⁄₁₆″ (21 × 14.7 cm.); sheet, 11¹⁵⁄₁₆ × 8⅞″ (30.3 × 22.1 cm.). Philadelphia Museum of Art; Given by Henry P. McIlhenny

PAGE 260:

La Toilette Après le Bain, also known as *Après le Bain* (After the Bath). c. 1891. Charcoal and pastel on coated tracing paper, mounted on card: sheet (made up from four separate pieces), 14¹³⁄₁₆ × 13⁹⁄₁₆″. (37.7 × 34.5 cm.). The Burrell Collection; Glasgow Museums & Art Galleries

PAGE 261:

La Sortie du Bain (Grande Planche), also known as *Après le Bain, Grande Planche* (After the Bath [Large Version]). 1891–92. Lithograph, transfer, and crayon. Off-white, thick, smooth, wove paper (fourth state of five): image, 10⅞ × 12⁵⁄₁₆″ (27.7 × 31.3 cm.); sheet (trimmed), 10⅞ × 14³⁄₁₆″ (27.7 × 36 cm.). Museum of Fine Arts, Boston; Katherine E. Bullard Fund in memory of Francis Bullard and proceeds from sale of duplicate prints

La Sortie du Bain (Grande Planche), also known as *Après le Bain, Grande Planche* (After the Bath [Large Version]). 1891–92. From a second stone: lithograph, transfer, and crayon on cream, moderately thick, moderately textured, laid paper (fifth state of five): image, 11¹³⁄₁₆ × 12³⁄₁₆″ (30 × 31 cm.); sheet, 15³⁄₁₆ × 15³⁄₁₆″ (38.5 × 38.5 cm.). National Gallery of Art, Washington; Rosenwald Collection

PAGE 262:

Femme S'Essuyant Après le Bain (Woman Drying Herself After the Bath). c. 1889. Sanguine, with touches of white, 22⁷⁄₁₆ × 13⅜″ (57 × 34 cm.). Private Collection. Photograph Archives Durand-Ruel, Paris

Femme S'Essuyant (Woman Drying Herself). c. 1905–7. Pastel, 37 × 28¾″ (94 × 73 cm.). Private Collection. Photograph Marlborough Fine Art (London) Ltd.

PAGE 263:

Après le Bain, also known as *Après le Bain, Femme S'Essuyant* (After the Bath). c. 1905–7. Pastel and charcoal, 28 × 21¼″ (71 × 54 cm.). Private Collection. Photograph Marlborough Fine Art (London) Ltd.

Après le Bain (Femme S'Essuyant) (After the Bath [Woman Drying Herself]). c. 1889. Pastel, 28¾ × 25⁹⁄₁₆″ (73 × 65 cm.). Private Collection. Photograph Archives Durand-Ruel, Paris

PAGE 265:

Baigneuse Allongée sur le Sol, also known as *Baigneuse Couchée* (Bather Reclining on the Floor). 1886–88. Pastel on beige paper, 18⅞ × 34¼″ (48 × 87 cm.). Musée d'Orsay, Paris. Photograph by Routhier, Studio Lourmel, Paris

Après le Bain (Femme Nue Couchée) (After the Bath [Female Nude Lying Down]). c. 1895. Pastel, 18⅞ × 32¹¹⁄₁₆″ (48 × 83 cm.). Private Collection

PAGE 266:

Femme Nue, de Dos, Se Coiffant (Femme Se Peignant) (Female Nude, from Behind, Combing Her Hair). c. 1886–88. Pastel on paper laid down on board, 27¾ × 23″ (70.5 × 58.5 cm.). Private Collection

PAGE 267:

La Toilette (Woman Combing Her Hair). c. 1884–86. Pastel, 20⅞ × 20½″ (53 × 52 cm.). The Hermitage Museum, Leningrad

PAGE 268:

Femme Nue Se Coiffant, also known as *La Toilette (La Chevelure)* (Female Nude Combing Her Hair). c. 1879–85. Monotype in black ink on heavy cream-colored laid paper (the first of two impressions): plate, 12⁵⁄₁₆ × 11″ (31.3 × 27.9 cm.); sheet, 19⁷⁄₁₆ × 13¾″ (49.4 × 34.9 cm.). Musée du Louvre (Orsay), Paris; Cabinet des Dessins

Femme Se Peignant (Woman Combing). c. 1897. Pastel and charcoal on cardboard, 27¾ × 27¾″ (70.5 × 70.5 cm.). Kunsthaus Zürich

PAGE 269:

Femme Nue Se Faisant Coiffer, also known as *La Toilette* (A Woman Having Her Hair Combed). c. 1886–88. Pastel on light green wove paper, now discolored to gray, affixed to original pulpboard mount, 29⅛ × 23⅜″ (74 × 60.6 cm.). The Metropolitan Museum of Art, New York; Bequest of Mrs. H. O. Havemeyer, 1929; The H. O. Havemeyer Collection

PAGE 270:

Après le Bain, also known as *La Sortie du Bain* (After the Bath). c. 1885–90. Pastel on brown cardboard, 27⅞ × 22½″ (70.8 × 57.2 cm.). The Harvard University Art Museums (Fogg Art Museum), Cambridge, Massachusetts; Gift—Mrs. J. Montgomery-Sears

Bibliography

OEUVRES

Adhémar, Jean, and Françoise Cachin. *Edgar Degas: Gravures et Monotypes.* Paris: Arts et Métiers Graphiques, 1973.

Brame, Philippe, and Theodore Reff. *Degas et Son Oeuvre: A Supplement.* New York and London: Garland Publishing, 1984.

Delteil, Loys. *Edgar Degas.* Le Peintre-Graveur Illustré, vol. 9. Paris: Self-published, 1919.

Janis, Eugenia Parry. *Degas Monotypes.* Cambridge, Mass.: Fogg Art Museum, Harvard Univ., 1968.

Lemoisne, Paul André. *Degas et Son Oeuvre.* 4 vols. Paris: Arts et Métiers Graphiques, 1946–49.

Reed, Sue Welsh, and Barbara Stern Shapiro. *Edgar Degas: The Painter as Printmaker.* Boston: Museum of Fine Arts, 1984.

Reff, Theodore. *The Notebooks of Edgar Degas: A Catalogue of the Thirty-Eight Notebooks in the Bibliothèque Nationale and Other Collections.* 2 vols., rev. ed. New York: Hacker Art Books, 1985.

Rewald, John. *Degas: Works in Sculpture—A Complete Catalogue.* New York: Pantheon Books, 1944.

Rewald, John, and Leonard von Matt. *Degas Sculpture.* New York: Harry N. Abrams, 1956.

CATALOGUES OF SALES AND COLLECTIONS

Catalogue des Tableaux, Pastels et Dessins par Edgar Degas et Provenant de Son Atelier. Paris: Galerie Georges Petit. 1re Vente, May 6–8, 1918; 2me Vente, December 11–13, 1918; 3me Vente, April 7–9, 1919; 4me Vente, July 2–4, 1919.

Catalogue des Tableaux Modernes et Anciens, Aquarelles—Pastels—Dessins . . . Composant la Collection Edgar Degas. Paris: Galerie Georges Petit, March 26–27, 1918.

Catalogue des Estampes Anciennes et Modernes . . . Composant la Collection Edgar Degas. Paris: Hôtel Drouot, November 6–7, 1918.

Catalogue des Tableaux Modernes, Pastels, Aquarelles, Dessins Anciens et Modernes . . . Faisant Partie de la Collection Edgar Degas. Paris: Hôtel Drouot, November 15–16, 1918.

Catalogue des Eaux-Fortes, Vernis-Mous, Aqua-Tintes, Lithographies et Monotypes par Edgar Degas et Provenant de Son Atelier. Paris: Galerie Manzi-Joyant, November 22–23, 1918.

Catalogue des Tableaux, Pastels, Dessins & Estampes par Degas . . . Appartenant a M. X. [Henri Fevre]. Paris: Hôtel Drouot, June 22, 1925.

Catalogue des Tableaux, Pastels, Aquarelles—Dessins—Gravures par Edgar Degas . . . Dépendant de la Succession de M. René de Gas. Paris: Hôtel Drouot, November 10, 1927.

Collection de Mlle. J. Fevre: Catalogue des Tableaux, Aquarelles—Pastels—Dessins—Estampes—Monotypes par Edgar Degas. Paris: Galerie Jean Charpentier, June 12, 1934.

BIOGRAPHIES AND MONOGRAPHS

Alazard, Jean. *Degas.* Lausanne: Editions Jean Marguerat, 1949.

Cabanne, Pierre. *Edgar Degas.* Paris: Editions Pierre Tisné, 1957.

Coquiot, Gustave. *Degas.* Paris: Ollendorff, 1924.

Crespelle, Jean-Paul. *Degas et Son Monde.* Paris: Presses de la Cité, 1972.

Dunlop, Ian. *Degas.* New York: Harper and Row, 1979.

Fosca, François. *Degas.* Paris: Société des Trente, 1921.

———. *Degas.* Geneva, Paris, New York: Editions d'Art Albert Skira, 1954.

Hertz, Henri. *Degas.* Paris: Félix Alcan, 1920.

Hüttinger, Eduard. *Degas.* New York: Crown Publishers, 1977.

Jamot, Paul. *Degas.* Paris: Editions de la Gazette des Beaux-Arts, 1924.

Lafond, Paul. *Degas.* 2 vols. Paris: H. Floury, 1918–19.

Lefébure, Amaury. *Degas.* Paris: Fernand Hazan, 1981.

Lemoisne, Paul André. *Degas et Son Oeuvre.* Paris: Librairie Plon, 1954.

———. *Degas: L'Art de Notre Temps.* Paris: Librairie Centrale des Beaux-Arts [1912].

Manson, James Bolivar. *The Life and Work of Edgar Degas.* Edited by Geoffrey Holme. London: The Studio Limited, 1927.

Mauclair, Camille. *Degas.* Paris: Editions Hypérion, 1937.

McMullen, Roy. *Degas: His Life, Times, and Work.* Boston: Houghton Mifflin Company, 1984.

Meier-Graefe, Julius. *Degas.* London: Ernest Benn, 1923.

Minervino, Fiorella. *Tout l'Oeuvre Peint de Degas.* Paris: Flammarion, 1974.

Pool, Phoebe. *Degas.* London: Spring Books, 1967.

Rebatet, Marguerite. *Degas.* Paris: Editions Pierre Tisné, 1944.

Rich, Daniel Catton. *Degas.* The Library of Great Painters. New York: Harry N. Abrams, 1951.

Rivière, Georges. *Mr. Degas, Bourgeois de Paris.* Paris: Librairie Floury, 1935.

Roberts, Keith. *Degas.* Oxford: Phaidon, 1976.

Sutton, Denys. *Edgar Degas: Life and Work.* New York: Rizzoli, 1986.

Terrasse, Antoine. *Edgar Degas.* Paris: Editions Princesse, 1974.

STYLISTIC AND CRITICAL ANALYSES

Adam, Paul. "Peintres Impressionnistes." *La Revue Contemporaine Littéraire, Politique et Philosophique,* April 1886, pp. 541–51.

Adhémar, Hélène. "Edgar Degas et la 'Scène de Guerre au Moyen Age.'" *Gazette des Beaux-Arts,* 6th ser., vol. 70 (November 1967), pp. 295–98.

Adhémar, Jean. "Before the Degas Bronzes." *ARTnews,* vol. 54, no. 7 (November 1955), pp. 34–35, 70.

Ajalbert, Jean. "Le Salon des Impressionnistes." *La Revue Moderne Politique et Littéraire,* vol. 1, no. 30 (June 20, 1886), pp. 385–93.

Alexandre, Arsène. "Degas: Nouveaux Aperçus." *L'Art et les Artistes,* vol. 29, no. 154 (February 1935), pp. 145–73.

———. "Essai sur Monsieur Degas." *Les Arts,* no. 166 (1918), pp. 1–24.

André, Albert. *Degas.* Paris: Editions Braun [1934].

Aubry, Yves. "Degas et la Photographie." *Zoom,* no. 98 (1983), pp. 26–33.

Baker, Kenneth. "Behind the Scenes: Degas's Dancers." *Art in America,* vol. 73, no. 3 (March 1985), pp. 138–45.

Bell, Quentin. *Degas, Le Viol.* Charlton Lectures on Art. Newcastle: Univ. of Newcastle-upon-Tyne, 1965.

Boggs, Jean Sutherland. "Degas at the Museum: Works in the Philadelphia Museum of Art and John G. Johnson Collection." *Philadelphia Museum of Art Bulletin,* vol. 81, no. 346 (Spring 1985).

———. "Degas Notebooks at the Bibliothèque Nationale." *The Burlington Magazine,* vol. 100. I: Group A (1853–58), no. 662 (May 1958), pp. 163–71; II: Group B (1858–61), no. 663 (June 1958), pp. 196–205; III: Group C (1863–86), no. 664 (July 1958), pp. 240–46.

———. "Edgar Degas and Naples." *The Burlington Magazine,* vol. 105, no. 723 (June 1963), pp. 273–76.

———. "Edgar Degas and the Bellellis." *The Art Bulletin,* vol. 37, no. 2 (June 1955), pp. 127–36.

———. "Edgar Degas in Old Age." *Allen Memorial Art Museum Bulletin,* vol. 35, nos. 1–2 (1977–78), pp. 57–67.

———. *Portraits by Degas.* Berkeley and Los Angeles: Univ. of California Press, 1962.

Borel, Pierre. *Les Sculptures Inédites de Degas.* Geneva: Pierre Cailler, 1949.

Bouyer, Raymond. "Degas 'Peintre Classique et Vrai' d'Après un Livre Récent." *Gazette des Beaux-Arts,* 5th ser., vol. 11 (January 1925), pp. 43–49.

Bricon, Etienne. "L'Art Impressionniste au Musée du Luxembourg." *La Nouvelle Revue,* vol. 114 (September 15, 1898), pp. 288–304.

Broude, Norma. "Degas's 'Misogyny.'" *The Art Bulletin,* vol. 59, no. 1 (March 1977), pp. 95–107.

Browse, Lillian. *Degas Dancers.* London: Faber and Faber, 1949.

———. "Degas's Grand Passion." *Apollo,* vol. 85, no. 60 (February 1967), pp. 104–14.

Buerger, Janet F. "Degas' Solarized and Negative Photographs: A Look at Unorthodox Classicism." *Image,* vol. 21, no. 2 (June 1978), pp. 17–23.

Buerger, Janet, and Barbara Stern Shapiro. "A Note on Degas' Use of Daguerreotype Plates." *The Print Collector's Newsletter,* vol. 12, no. 4 (September–October 1981), pp. 103–6.

Burnell, Devin. "Degas and His 'Young Spartans Exercising.'" *Museum Studies 4,* 1969, pp. 49–65.

Burollet, Thérèse. "Bartholomé et Degas." *L'Information d'Histoire de l'Art,* vol. 12, no. 3 (May–June 1967), pp. 119–26.

Burroughs, Louise. "Degas Paints a Portrait." *The Metropolitan Museum of Art Bulletin,* vol. 21, no. 5 (January 1963), pp. 169–72.

Burty, Philippe. "Exposition de la Société Anonyme des Artistes." *La République Française,* April 25, 1874, pp. 2–3.

———. "Exposition des Oeuvres des Artistes Indépendant." *La République Française,* April 10, 1880, p. 2.

———. "Fine Art: The Exhibition of the Intransigeants.'" *The Academy,* no. 206, (April 15, 1876), pp. 363–64.

Cabanne, Pierre. "Degas et 'Les Malheurs de la Ville d'Orléans.'" *Gazette des Beaux-Arts,* 6th ser., vol. 59 (May–June 1962), pp. 363–66.

Champigneulle, Bernard. *Degas Dessins.* Paris: Editions des Deux Mondes, 1952.

Chaumelin, Marius. "Actualités: L'Exposition des Intransigeants." *La Gazette [des Etrangers],* April 8, 1876, pp. 1–2.

Claretie, Jules. "La Vie à Paris: Les Artistes Indépendants." *Le Temps,* April 5, 1881, p. 3. Reprinted in a revised form in Claretie, Jules. *La Vie à Paris: 1881.* Paris: Victor Havard, 1881.

Clark, T. J. *The Painting of Modern Life: Paris in the Art of Manet and His Followers.* New York: Alfred A. Knopf, 1985.

Cooper, Douglas. *Pastellesvon Edgar Degas.* Basel: Holbein-Verlag, 1952.

Crimp, Douglas. "Positive/Negative: A Note on Degas's Photographs." *October,* 5 (Summer 1978), pp. 89–100.

Dayot, Armand. "Edgar Degas." *La Revue Rhenane,* no. 9 (June 1924), pp. 539–45.

Desclozeaux, Jules. "Chronique: Les Impressionnistes." *L'Opinion,* May 27, 1886, pp. 2–3.

Dormoy, Marie. "Les Monotypes de Degas." *Arts et Métiers Graphiques,* no. 51 (February 15. 1936), pp. 33–38.

Du Bos, Charles. "Remarques sur Degas." *La Revue Critique des Idées et des Livres,* vol. 34, no. 200 (May 1922), pp. 262–77.

Duranty, Edmond. *La Nouvelle Peinture à Propos du Groupe d'Artistes Qui Expose dans les Galeries Durand-Ruel.* Paris: E. Dentu, 1876.

Ephrussi, Charles. "Exposition des Artistes Indépendants." *Gazette des Beaux-Arts,* 2nd ser., vol. 21 (May 1, 1880), pp. 485–88.

———. "Exposition des Artistes Indépendants." *La Chronique des Arts et de la Curiosité,* no. 16 (April 16, 1881), pp. 126–27.

Failing, Patricia. "Cast in Bronze: The Degas Dilemma." *ARTnews,* vol.o. 1 (January 1988), pp. 136–41.

———. "The Degas Bronzes Degas Never Knew." *ARTnews*, vol. 78, no. 4 (April 1979), pp. 38–41.

Fénéon, Félix. "Les Impressionnistes." *La Vogue*, vol. 1, no. 8 (June 13–20, 1886), pp. 261–75.

———. *Oeuvres Plus Que Complètes*, vol. 1. Edited by Joan U. Halperin. Geneva and Paris: Librairie Droz, 1970.

Fèvre, Henry. "L'Exposition des Impressionnistes." *La Revue de Demain*, vol. 1, nos. 3–4 (May–June 1886), pp. 148–56.

Flint, Kate. *Impressionists in England: The Critical Reception.* London: Routledge & Kegan Paul, 1984.

Fontainas, André. "Art Moderne." *Mercure de France*, July 1898, pp. 278–83.

Fourcaud, Louis de. "Le Salon de 1884 (Troisième Article)." *Gazette des Beaux-Arts*, 2nd ser., vol. 30 (July 1, 1884), pp. 50–63.

Fries, Gerhard. "Degas et les Maîtres." *Art de France*, vol. 4 (1964), pp. 352–59.

Geffroy, Gustave. "Degas." *L'Art dans les Deux Mondes*, no. 5 (December 20, 1890), pp. 46–48.

———. "L'Exposition des Artistes Indépendants." *La Justice*, April 19, 1881, p. 3.

———. "Salon de 1886: VIII Hors du Salon—Les Impressionnistes." *La Justice*, May 26, 1886, pp. 1–2

———. *La Vie Artistique*, vol. 3. Paris: E. Dentu, 1894.

Geist, Sidney. "Degas' 'Interieur' in an Unaccustomed Perspective." *ARTnews*, vol. 75, no. 8 (October 1976), pp. 80–82.

George, Waldemar. "Degas et L'Inquiétude Moderne." *L'Art Vivant*, August 1, 1927, pp. 600–602.

———. "Oeuvres de Vieillesse de Degas." *La Renaissance*, vol. 19, nos. 1–2 (January–February 1936), pp. 2–4.

Gerstein, Marc. "Degas's Fans." *The Art Bulletin*, vol. 64, no. 1 (March 1982), pp. 105–18.

Giese, Lucretia H. "A Visit to the Museum." *Bulletin of the Museum of Fine Arts, Boston*, vol. 76 (1978), pp. 42–53.

Gillet, Louis. "A L'Exposition Degas." *Revue des Deux Mondes*, 7th ser., vol. 20 (April 15, 1924), pp. 866–80.

———. "A L'Exposition Degas." *Revue des Deux Mondes*, 8th ser., vol. 38 (April 1, 1937), pp. 686–95.

Goetschy, Gustave. "Exposition des Artistes Indépendants." *Le Voltaire*, April 5, 1881, pp. 1–2.

———. "Indépendants et Impressionnistes." *Le Voltaire*, April 6, 1880, p. 2.

Gonse, Louis. "Les Aquarelles, Dessins et Gravures au Salon de 1877." *Gazette des Beaux-Arts*, 2nd ser., vol. 16 (August 1, 1877), pp. 156–69.

Grappe, Georges. "Edgar Degas." *L'Art et le Beau.* Third year, no. 1, 1908.

Gsell, Paul. "Edgar Degas, Statuaire." *La Renaissance de l'Art Français et des Industries de Luxe*, December 1918, pp. 373–78.

Havard, Henry. "L'Exposition des Artistes Indépendants." *Le Siècle*, April 27, 1879, p. 3.

———. "L'Exposition des Artistes Indépendants." *Le Siècle*, April 3, 1881, p. 2.

Hermel, Maurice. "L'Exposition de Peinture de la Rue Laffitte." *La France Libre*, May 27, 1886, pp. 1–2.

Hoctin, Luce. "Degas Photographe." *L'Oeil*, no. 65 (May 1960), pp. 36–43.

Huysmans, J.-K. *L'Art Moderne.* Paris: G. Charpentier, 1883.

———. *Certains.* Paris: Tresse & Stock, 1889.

Isaacson, Joel. "Impressionism and Journalistic Illustration." *Arts Magazine*, vol. 56, no. 10 (June 1982), pp. 95–115.

Jacques. "Menus Propos: Exposition Impressionniste." *L'Homme Libre*, April 12, 1877, pp. 1–2.

Jamot, Paul. "Degas (1834–1917)." *Gazette des Beaux-Arts*, 4 ser., vol. 14 (April–June 1918), pp. 123–66.

Janis, Eugenia Parry. "Degas and the 'Master of Chiaroscuro.'" *Museum Studies* 7 (1972), pp. 52–71.

———. "The Role of the Monotype in the Working Method of Edgar Degas." *The Burlington Magazine*, vol. 109, no. 766, (January 1967), pp. 20–27; vol. 109, no. 767, (February 1967), pp. 71–81.

Javel, Firmin. "Les Impressionnistes." *L'Evénement*, May 16, 1886, p. 1.

Joly, Anne. "Sur Deux Modèles de Degas." *Gazette des Beaux-Arts*, 6th ser., vol. 69 (May–June 1967), pp. 373–74.

Keyser, Eugénie de. *Degas Réalité et Métaphore.* Louvain-la-Neuve, 1981.

Koshkin-Youritzin, Victor. "The Irony of Degas." *Gazette des Beaux-Arts*, 6th ser., vol. 87 (January 1976), pp. 33–40.

Lalo, Pierre. "Variétés: La Collection Camondo." *Le Temps*, August 4, 1911, pp. 4–5.

Lay, Howard G. "Degas at Durand-Ruel, 1892: The Landscape Monotypes." *The Print Collector's Newsletter*, vol. 9, no. 5 (November–December 1978), pp. 142–47.

Lemoisne, Paul-André. "Les Carnets de Degas au Cabinet des Estampes." *Gazette des Beaux-Arts*, 5th ser., vol. 3 (April 1921), pp. 219–31.

———. "Les Statuettes de Degas." *Art et Décoration*, no. 214 (September–October 1919), pp. 109–17.

Leymarie, Jean. *Les Dessins de Degas.* Paris: Fernand Hazan, 1948.

Lipton, Eunice. "Deciphering a Friendship: Edgar Degas and Evariste de Valernes." *Arts Magazine*, vol. 55, no. 10 (June 1981), pp. 128–32.

———. "Degas' Bathers: The Case for Realism." *Arts Magazine*, vol. 54, no. 9 (May 1980), pp. 94–97.

———. "The Laundress in Late Nineteenth-Century French Culture: Imagery, Ideology and Edgar Degas." *Art History*, vol. 3, no. 3 (September 1980), pp. 295–313.

Lockhart, Anne I. "Three Monotypes by Edgar Degas." *The Bulletin of The Cleveland Museum of Art*, vol. 64 (November 1977), pp. 299–306.

Mantz, Paul. "Exposition des Oeuvres des Artistes Indépendants." *Le Temps*, April 14, 1880, p. 3.

———. "Exposition des Oeuvres des Artistes Indépendants." *Le Temps*, April 23, 1881, p. 3.

———. "L'Exposition des Peintres Impressionnistes." *Le Temps*, April 22, 1877, p. 3.

Martelli, Diego. *Les Impressionnistes et l'Art Moderne.* Paris: Editions Vilo, 1979.

Mauclair, Camille. "Artistes Contemporains: Edgar Degas." *La Revue de l'Art Ancien et Moderne*, vol. 14, no. 80 (November 10, 1903), pp. 381–98.

———. *L'Impressionnisme: Son Histoire, Son Esthétique, Ses Maîtres.* Paris: Librairie de l'Art Ancien et Moderne, 1904.

Mayne, Jonathan. "Degas's Ballet Scene from 'Robert le Diable.'" *Victoria and Albert Museum Bulletin*, vol. II, no. 4 (October 1966), pp. 148–56.

McCarty, John. "A Sculptor's Thoughts on the Degas Waxes." *Essays In Honor of Paul Mellon Collector and Benefactor*, Washington: National Gallery of Art, 1986.

Millard, Charles W. *The Sculpture of Edgar Degas.* Princeton: Princeton Univ. Press, 1976.

Mirbeau, Octave. "Exposition de Peinture (1, rue Laffitte)." *La France*, May 21, 1886, pp. 1–2.

Mitchell, Eleanor. "La Fille de Jephté par Degas: Genèse et Evolution." *Gazette des Beaux-Arts*, 6th ser., vol. 18 (October 1937), pp. 175–89.

Monnier, Geneviève. "La Genèse d'une Oeuvre de Degas: 'Sémiramis Construisant une Ville.'" *La Revue du Louvre et des Musées de France*, vol. 28, nos. 5–6 (1978), pp. 407–26.

Montijoyeux. "Chroniques Parisiennes: Les Indépendants." *Le Gaulois*, April 18, 1879, p. 1.

Nathanson, Carol A., and Edward J. Olszewski. "Degas's Angel of the Apocalypse." *The Bulletin of The Cleveland Museum of Art*, vol. 67, no. 8 (October 1980), pp. 243–55.

Nicolson, Benedict. "Editorial: Degas as a Human Being." *The Burlington Magazine*, vol. 105, no. 723 (June 1963), pp. 239–41.

Norton Simon Museum. *Degas in Motion.* Mount Vernon, N.Y.: The Artist's Limited Edition, 1982.

P., A. "Beaux-Arts." *Le Petit Parisien*, April 7, 1877, p. 2.

Pickvance, Ronald. "'L'Absinthe' in England." *Apollo*, vol. 77, no. 15 (May 1963), pp. 395–98.

———. "Degas as a Photographer." *Lithopinion*, vol. 5, no. 1, issue 17 (Spring 1970), pp. 72–79.

———. "Degas's Dancers: 1872–6." *The Burlington Magazine*, vol. 105, no. 723 (June 1963), pp. 256–66.

———. "A Newly Discovered Drawing by Degas of George Moore." *The Burlington Magazine*, vol. 105, no. 723 (June 1963), pp. 276–80.

———. "Some Aspects of Degas's Nudes." *Apollo*, vol. 83, no. 47 (January 1966), pp. 17–23.

Pickvance, Ronald, and Jaromír Pečírka. *Degas Drawings.* 2nd ed. London: Paul Hamlyn, 1969.

Pool, Phoebe. "Degas and Moreau." *The Burlington Magazine*, vol. 105, no. 723 (June 1963), pp. 251–56.

———. "The History Pictures of Edgar Degas and Their Background." *Apollo*, vol. 80, no. 32 (October 1964), pp. 306–11.

———. "Some Early Friends of Edgar Degas." *Apollo*, vol. 79, no. 27 (May 1964), pp. 391–94.

Reed, Sue Welsh. "Music in the Air." *ARTnews*, vol. 83, no. 10 (December 1984), pp. 108–13.

Reff, Theodore. "Addenda on Degas's Copies." *The Burlington Magazine*, vol. 107, no. 747 (June 1965), pp. 320–23.

———. "'Au Musée du Louvre' by Edgar Degas." *Art at Auction: The Year at Sotheby's 1983–84.* London: Sotheby Publications, 1984.

———. "The Chronology of Degas's Notebooks." *The Burlington Magazine*, vol. 107, no. 753 (December 1965), pp. 606–16.

———. "Copyists in the Louvre, 1850–1870." *The Art Bulletin*, vol. 46, no. 4 (December 1964), pp. 552–59.

———. "Degas: A Master Among Masters." *The Metropolitan Museum of Art Bulletin*, vol. 34, no. 4 (Spring 1977).

———. "Degas and de Valernes in 1872." *Arts Magazine*, vol. 56, no. 1 (September 1981), pp. 126–27.

———. "Degas's Copies of Older Art." *The Burlington Magazine*, vol. 105, no. 723 (June 1963), pp. 241–51.

———. *Degas: The Artist's Mind.* New York: The Metropolitan Museum of Art and Harper & Row, 1976.

———. "Edgar Degas and the Dance." *Arts Magazine*, vol. 53, no. 3 (November 1978), pp. 145–49.

———. "Edgar Degas' 'Little Ballet Dancer of Fourteen Years.'" *Arts Magazine*, vol. 51, no. 1 (September 1976), pp. 66–69.

———. "An Exhibition of Drawings by Degas." *The Art Quarterly*, vol. 30, no. 3–4 (1967), pp. 252–63.

———. "Further Thoughts on Degas's Copies." *The Burlington Magazine*, vol. 113, no. 822 (September 1971), pp. 534–43.

———. "The Landscape Painter Degas Might Have Been." *ARTnews*, vol. 75, no. 1 (January 1976), pp. 41–43.

———. "New Light on Degas's Copies." *The Burlington Magazine*, vol. 106, no. 735 (June 1964), pp. 250–59.

Relin, Lois. "La 'Danseuse de Quatorze Ans' de Degas, Son Tutu et Sa Perruque." *Gazette des Beaux-Arts*, 6th ser., vol. 104 (November 1984), pp. 173–74.

Rewald, John. *The History of Impressionism.* 4th rev. ed. New York: The Museum of Modern Art, 1973.

———. *Studies in Impressionism.* New York: Harry N. Abrams, 1986.

———. *Studies in Post-Impressionism.* New York: Harry N. Abrams, 1986.

Rivière, Georges. "L'Exposition des Impressionnistes." *L'Impressioniste*, no. 1 (April 6, 1877), pp. 2–6.

Roberts, Keith. "The Date of Degas's 'The Rehearsal' in Glasgow." *The Burlington Magazine*, vol. 105, no. 723 (June 1963), pp. 280–81.

Rosenberg, Jakob. *Great Draughtsmen from Pisanello to Picasso.* Cambridge, Mass.: Harvard Univ. Press, 1959.

Rouart, Denis. *Degas: A la Recherche de Sa Technique.* Paris: Floury, 1945.

———. *E. Degas Monotypes.* Paris: Quatre Chemins-Editart, 1948.

———. *The Unknown Degas and Renoir in the National Museum of Belgrade.* New York: McGraw-Hill, 1964.

Scharf, Aaron. "Painting, Photography, and the Image of Movement." *The Burlington Magazine*, vol. 104, no. 710 (May 1962), pp. 186–95.

Sérullaz, Maurice. *L'Univers de Degas.* Paris: Henri Scrépel, 1979.

Shapiro, Michael. "Degas and the Siamese Twins of the Café-Concert: The Ambassadeurs and the Alcazar d'Eté." *Gazette des Beaux-Arts*, 6th ser., vol. 95 (April 1980), pp. 153–64.

Sizeranne, Robert de la. "Degas et L'Impressionnisme." *Revue des Deux Mondes*, 6th ser., vol. 42 (November 1, 1917), pp. 36–56.

Sloane, Joseph C. *French Painting Between the Past and the Present: Artists, Critics, and Traditions, from 1848 to 1870.* Princeton: Princeton Univ. Press, 1951.

Sutton, Denys, and Jean Adhémar. "Lettres Inédites de Degas à Paul Lafond et Autres Documents." *Gazette des Beaux-Arts*, 6th ser., vol. 109 (April 1987), pp. 159–80.

Tatlock, R. R. "Degas Sculptures." *The Burlington Magazine*, vol. 42, no. 240 (March 1923), pp. 150–53.

Terrasse, Antoine. *Degas et la Photographie.* Paris: Denoël, 1983.

Thiébault-Sisson, François. "La Vie Artistique: Degas Sculpteur." *Le Temps*, May 25, 1921, p. 3.

Thomson, Richard. *Degas: The Nudes.* New York: Thames and Hudson, 1988.

———. "Degas's Nudes at the 1886 Impressionist Exhibition." *Gazette des Beaux-Arts*, 6th ser., vol. 108 (November 1986), pp. 187–90.

Trianon, Henry. "Sixième Exposition de Peinture par un Groupe d'Artistes." *Le Constitutionnel*, April 24, 1881, pp. 2–3.

Tucker, William. "Gravity, Rodin, Degas." *Studio International*, vol. 186, no. 957 (July–August 1973), pp. 25–29.

Van Liere, Eldon N. "Solutions and Dissolutions: The Bather in Nineteenth-Century French Painting." *Arts Magazine*, vol. 54, no. 9 (May 1980), pp. 104–14.

Varnedoe, Kirk. "The Artifice of Candor: Impressionism and Photography Reconsidered." *Art in America*, vol. 68, no. 1 (January 1980), pp. 66–78.

———. "The Ideology of Time: Degas and Photography." *Art in America*, vol. 68, no. 6 (Summer 1980), pp. 96–110.

———. "On Degas' Sculpture." *Arts Magazine*, vol. 52, no. 3 (November 1977), pp. 116–19.

Venturi, Lionello. *Les Archives de l'Impressionnisme.* 2 vols. Paris and New York: Durand-Ruel, 1939.

Villars, Nina de. "Variétés: Exposition des Artistes Indépendants." *Le Courrier du Soir*, April 23, 1881, p. 2.

Vitali, Lamberto. "Three Italian Friends of Degas." *The Burlington Magazine*, vol. 105, no. 723 (June 1963), pp. 266–73.

Walker, John. "Degas et les Maîtres Anciens." *Gazette des Beaux-Arts*, 6th ser., vol. 10 (September 1933), pp. 173–85.

Wasserman, Jeanne L. "I Never Seem to Achieve Anything with My Blasted Sculpture." *Harvard Magazine*, vol. 80, no. 2 (November–December 1977), pp. 36–43.

Wells, William. "Who Was Degas's Lyda?" *Apollo*, vol. 95, no. 120 (February 1972), pp. 129–34.

Werner, Alfred. *Degas Pastels.* New York: Watson-Guptill, 1977.

Wick, Peter A. "Degas' Violinist." *Bulletin Museum of Fine Arts, Boston*, vol. 57, no. 310 (1959), pp. 87–101.

Zola, Emile. *Salons.* Edited by F. W. J. Hemmings and Robert J. Niess. Geneva and Paris: E. Droz and Minard, 1959.

WITNESS ACCOUNTS

Barazzetti, S. "Degas et Ses Amis Valpinçon." *Beaux-Arts*, no. 190 (August 21, 1936), pp. 1, 3; no. 191 (August 28, 1936), pp. 1, 4; no. 192 (September 4, 1936), pp. 1–2.

Baudot, Jeanne. *Renoir: Ses Amis, Ses Modèles.* Paris: Editions Littéraires de France, 1949.

Bergerat, Emile. "Edgar Degas (Souvenirs)." *Le Figaro*, May 11, 1918, p. 1.

Blanche, Jacques-Emile. "Notes sur la Peinture Moderne. (A Propos de la Collection Rouart)." *La Revue de Paris*, vol. 115, no. 1 (January 1, 1913), pp. 27–50; no. 2 (January 15, 1913), pp. 369–92.

———. *Propos de Peintre De David A Degas.* Paris: Emile-Paul Frères, Editeurs, 1919.

De Nittis, Joseph. *Notes et Souvenirs du Peintre Joseph De Nittis.* Paris: Librairies-Imprimeries Réunies, 1895.

Fevre, Jeanne. *Mon Oncle Degas.* Geneva: Pierre Cailler, 1949.

Goncourt, Edmond and Jules de. *Journal: Mémoires de la Vie Littéraire,* 22 vols. Edited by Robert Ricatte. Monaco: Les Editions de L'Imprimerie Nationale de Monaco, 1956–58.

Halévy, Daniel. *Degas parle. . . .* Paris and Geneva: La Palatine, 1960.

———. *Pays Parisiens.* Paris: Emile-Paul Frères, 1929.

———. *Pays Parisiens.* Paris: Bernard Grasset, 1932.

Havemeyer, Louisine W. *Sixteen to Sixty: Memoirs of a Collector.* New York: Privately printed for the family of Mrs. H. O. Havemeyer and The Metropolitan Museum of Art, 1961.

Jeanniot, Georges. Letter to Clément-Janin in the Bibliothèque d'Art et d'Archéologie (Fondation Jacques Doucet), Paris, inv. 363 (143).

———. "Souvenirs sur Degas." *La Revue Universelle*, vol. 55, nos. 14–15 (October 15 and November 1, 1933), pp. 152–74, 280–304.

Lalo, Pierre. "Grands Artistes d'Autrefois et d'Aujourd'hui: Degas." *Le Temps*, October 22, 1941, p. 3.

Manet, Julie. *Journal (1893–1899).* Paris: Librairie C. Klincksieck, 1979.

Michel, Alice. "Degas et Son Modèle." *Mercure de France*, vol. 131 (February 1 and 16, 1919), pp. 457–78, 623–39.

Moore, George. "Degas: The Painter of Modern Life." *The Magazine of Art*, vol. 13 (1890), pp. 416–25.

———. "Memories of Degas." *The Burlington Magazine*, vol. 32, nos. 178 and 179 (January and February 1918), pp. 22–29, 63–65.

Moreau-Nélaton, Etienne. "Deux Heures avec Degas: Interview Posthume." *L'Amour de l'Art*, no. 7 (July 1931), pp. 267–70.

Mycho, André. "Degas." *Gil Blas*, December 18, 1912, p. 1.

Natanson, Thadée. *Peints à Leur Tour.* Paris: Editions Albin Michel, 1948.

Poniatowski, Prince. *D'un Siècle à l'Autre.* Paris: Presses de la Cité, 1948.

Raunay, Jeanne. "Degas: Souvenirs Anecdotiques." *La Revue de France*, 11th year, vol. 2, no. 6 (March 15, 1931), pp. 263–82; no. 7 (April 1, 1931), pp. 469–83; no. 8 (April 15, 1931), pp. 619–32.

Romanelli, Pietro. "Comment J'ai Connu Degas: Souvenirs Intimes." *Le Figaro Littéraire*, March 13, 1937, pp. 5–6.

Rouart, Denis, ed. *Correspondance de Berthe Morisot.* Paris: Quatre Chemins-Editart, 1950.

Rouart, Ernest. "Degas." *Le Point*, February 1937, pp. 5–30.

Rouault, Georges. *Souvenirs Intimes.* Paris: Galerie des Peintres Graveurs E. Frapier, 1926.

Sickert, Walter. "Degas." *The Burlington Magazine*, vol. 31, no. 176 (November 1917), pp. 183–91.

Silvestre, Armand. *Au Pays des Souvenirs: Mes Maîtres et Mes Maîtresses.* Paris: Librairie Illustrée, 1892.

Thiébault-Sisson, François. "Degas Sculpteur Raconté par Lui-Même." *Le Temps*, March 23, 1921.

———. "La Vie Artistique: Edgar Degas—L'Homme et l'Oeuvre." *Le Temps*, May 18, 1918, p. 3.

Valéry, Paul. *Degas Danse Dessin.* Paris: Gallimard, 1938.

Van Vorst, Marie, and Piero Romanelli. "Degas." *Catholic World*, vol. 134, no. 799 (October 1931), pp. 50–59.

Vollard, Ambroise. *Degas (1834–1917).* Paris: G. Crès et Cie. 1924.

———. *Souvenirs d'un Marchand de Tableaux.* Paris: Albin Michel, 1937.

Zillhardt, Madeleine. "Monsieur Degas, Mon Ami (1885–1917)." *Arts*, September 2, 1949, pp. 1, 4, 5; September 9, 1949, pp. 4–5; September 16, 1949, pp. 4–5.

———. "Souvenirs et Portraits." *La Revue de Paris*, vol. 4, no. 13 (July 1, 1930), pp. 95–115.

ADDITIONAL RELATED WORKS

Barthélemy, Abbé Jean-Jacques. *Voyage du Jeune Anacharsis en Grèce,* vol. 2. Paris: De Burel'aîné, 1788.

Berhaut, Marie. *Gustave Caillebotte: Sa Vie et Son Oeuvre, Catalogue Raisonné des Peintures et Pastels.* Paris: Bibliothèque des Arts, 1978.

Breeskin, Adelyn Dohme. *Mary Cassatt: A Catalogue Raisonné of the Oils, Pastels, Watercolors, and Drawings.* Washington: Smithsonian Institution Press, 1970.

Caradec, François, and Alain Weill. *Le Café-Concert.* Paris: Atelier Hachette/Massin, 1980.

Cennini, Cennino. *The Book of the Art of Cennino Cennini.* Translated by Christiana J. Herringham. London: George Allen, 1899.

Charles, Etienne. "Les Mots de Degas." *La Renaissance de l'Art Français et des Industries de Luxe*, vol. 1, no. 2 (April 1918), pp. 3–7.

Claretie, Jules. "M. Paul Renouard et l'Opéra." *Gazette des Beaux-Arts*, 2nd ser., vol. 23 (May 1, 1881), pp. 435–55.

Correspondance de Camille Pissarro, vol. 1, 1865–85. Edited by Janine Bailly-Herzberg. Paris: Presses Universitaires de France, 1980.

Crouzet, Marcel. *Un Méconnu du Réalisme: Duranty (1833–1880).* Paris: Librairie Nizet, 1964.

Degas. Vingt Dessins 1861–1896. Paris: Boussod, Manzi, Joyant & Cie, 1896–98.

Degas. Paris: Galerie A. Vollard, 1914, and Bernheim-Jeune & Cie, 1918.

Degas, Edgar. *Huit Sonnets d'Edgar Degas.* Paris: La Jeune Parque, 1946.

Delaborde, Henri. *Ingres: Sa Vie, Ses Travaux, Sa Doctrine.* Paris: Henri Plon, 1870.

Duranty, Edmond. "Confession d'un Peintre Agé de Quarante-Cinq Ans." *Réalisme*, November 15, 1856, pp. 10–11. Reprint L'Arche du Livre, 1970.

———. "Sur la Physionomie." *Revue Libérale Politique, Littéraire, Scientifique & Financière*, vol. 2 (July 25, 1867), pp. 499–523.

France, Anatole. "La Vie Littéraire: Les Cafés-Concerts (l'Alcazar d'Eté)." *Le Temps*, July 3, 1887, p. 2.

Gauguin, Paul. *The Intimate Journals of Paul Gauguin.* Translated by Van Wyck Brooks. London: William Heinemann, 1923.

———. *Lettres de Paul Gauguin à Georges Daniel de Monfried.* Paris: Plon, 1930.

Gimpel, René. *Journal d'un Collectionneur, Marchand de Tableaux.* Paris: Calmann-Lévy, 1963.

Guérin, Marcel, ed. *Degas Letters*. Translated by Marguerite Kay. Oxford: Bruno Cassirer, 1947.

———. *Lettres de Degas*. Paris: Editions Bernard Grasset, 1945.

Guérin, Marcel, and P.-A. Lemoisne. *Dix-Neuf Portraits de Degas par Lui-même*. Paris: Marcel Guérin, 1931.

Halévy, Ludovic. *Madame et Monsieur Cardinal*. Paris: Michel Lévy Frères, 1872.

———. *Les Petites Cardinal*. Paris: Calmann Lévy, 1880.

Jean-Aubry, Georges. "Une Visite à Giverny: Eugène Boudin et Claude Monet." *Havre-Eclair*, August 1, 1911.

Kris, Ernst, and Otto Kurz. *Legend, Myth, and Magic in the Image of the Artist*. New Haven and London: Yale Univ. Press, 1979.

Mathews, Nancy Mowll, ed. *Cassatt and Her Circle: Selected Letters*. New York: Abbeville Press, 1984.

Maur, Karin V. "Edmond de Goncourt et les Artistes de la Fin du XIXe Siècle." *Gazette des Beaux-Arts*, 6th ser., vol. 72 (November 1968), pp. 209–28.

Meilhac, Henry, and Ludovic Halévy. *La Cigale Comédie en Trois Actes*. Paris: Calmann Lévy, 1877.

Mondor, Henri, and Lloyd James Austin, eds. *Stephane Mallarmé Correspondance*. 11 vols. Paris: Gallimard, 1959–85.

Newhall, Beaumont. "Degas, Photographe Amateur: Huit Lettres Inédites." *Gazette des Beaux-Arts*, 6th ser., vol. 61 (January 1963), pp. 61–64.

Paulus [pseud.]. *Trente Ans de Café-Concert: Souvenirs Recueillis par Octave Pradels*. Paris: Société d'Edition et de Publications, 1908.

Pittaluga, Mary, and Enrico Piceni. *De Nittis*. Milan: Bramante Editrice, 1963.

Raimondi, Riccardo. *Degas e la Sua Famiglia in Napoi 1793–1917*. Naples: SAV, 1958.

Reff, Theodore. "More Unpublished Letters of Degas." *The Art Bulletin*, vol. 51, no. 3 (September 1969), pp. 281–89.

———. "Some Unpublished Letters of Degas." *The Art Bulletin*, vol. 50, no. 1 (March 1968), pp. 87–94.

Rivière, Henri. *Les Dessins de Degas Reproduits en Fac-simile*, 2 vols. Paris: Editions Demotte, 1922–23. All the illustrations are reproduced in *Degas' Drawings*. New York: Dover Publications, 1973.

Sevin, Françoise. "Degas à Travers Ses Mots." *Gazette des Beaux-Arts*, 6th ser., vol. 86 (July–August 1975), pp. 17–46.

Taboureux, Emile. "Claude Monet." *La Vie Moderne*, June 12, 1880, pp. 380–82.

Van Gogh, Vincent. *Correspondance Complète de Vincent van Gogh*. Paris: Gallimard/Grasset, 1960.

Veuillot, Louis. *Les Odeurs de Paris*. Paris: Palmé, 1867.

Vollard, Ambroise. *Auguste Renoir (1841–1919)*. Paris: G. Crès, 1920.

Wechsler, Judith. *A Human Comedy: Physiognomy and Caricature in 19th Century Paris*. Chicago: Univ. of Chicago Press, 1982.

Weitzenhoffer, Frances. *The Havemeyers: Impressionism Comes to America*. New York: Harry N. Abrams, 1986.

Zeldin, Theodore. *France 1848–1945: Ambition and Love*. Oxford: Oxford Univ. Press, 1979.

Zola, Emile. *Thérèse Raquin*. Paris: Librairie Internationale, 1867.

EXHIBITIONS

1892 Paris, Galerie Durand-Ruel. Exhibition of landscapes by Degas.

1911 Cambridge, Mass., Fogg Art Museum. *A Loan Exhibition of Paintings and Pastels by H. G. E. Degas*.

1921 Paris, Galerie A.-A. Hébrard. *Exposition des Sculptures de Degas*.

1922 New York, The Grolier Club. *Prints, Drawings, and Bronzes by Degas*.

1924 Paris, Galerie Georges Petit and Galerie Marcel Guiot et Cie. *Exposition Degas*.

1926 Munich, Galerie Thannhauser. *Edgar Degas Pastelle/Zeichnungen das Plastische Werk*.

1931 Paris, Musée de l'Orangerie. *Degas. Portraitiste, Sculpteur*.

1936 Philadelphia, Pennsylvania Museum of Art. *Degas 1834–1917*.

1937 Paris, Orangerie des Tuileries. *Degas*.

New York, Durand-Ruel Galleries. *Exhibition of Masterpieces by Degas*.

1939 Paris, Galerie André Weil. *Degas: Peintre du Movement*.

1945 New York, Buchholz Gallery. *Edgar Degas: Bronzes, Drawings, Pastels*.

1947 Cleveland, The Cleveland Museum of Art. *Works by Edgar Degas*.

Washington, Phillips Memorial Gallery. *Loan Exhibition of Drawings and Pastels by Edgar Degas 1834–1917*.

1948 Minneapolis, The Minneapolis Institute of Arts. *Degas' Portraits of His Family and Friends*.

Copenhagen, Ny Carlsberg Glyptotek. *Edgar Degas 1834–1917*.

1949 New York, Wildenstein. *A Loan Exhibition of Degas*.

1951–52 Berne, Kunstmuseum. *Degas*.

1952 Amsterdam, Stedelijk Museum. *Edgar Degas*.

London, The Tate Gallery. *Degas*.

Paris, Gazette des Beaux-Arts. *Degas dans les Collections Françaises*.

1955 New York, M. Knoedler & Co. *Edgar Degas 1834–1917, Original Wax Sculptures*.

1958 Los Angeles, Los Angeles County Museum of Art. *An Exhibition of Works by Edgar Hilaire Germain Degas*.

London, The Lefevre Gallery. *Degas Monotypes, Drawings, Pastels, Bronzes*.

New York, Charles E. Slatkin Galleries. *Renoir, Degas: A Loan Exhibition of Drawings, Pastels, Sculptures*.

1959 Williamstown, Mass., Sterling and Francine Clark Art Institute. *Degas*.

Beverly Hills, Frank Perls Gallery. *Twenty-Six Original Copperplates Engraved by Degas*.

1960 New York, Wildenstein. *Loan Exhibition: Degas*.

Paris, Galerie Durand-Ruel. *Edgar Degas 1834–1917*.

1962 Baltimore, The Baltimore Museum of Art. *Manet, Degas, Berthe Morisot and Mary Cassatt*.

1964 Chicago, The Renaissance Society at the University of Chicago. *An Exhibition of Etchings by Edgar Degas*.

Paris and New York, L'Oeil, Galerie d'Art, and E. V. Thaw & Co. *9 Monotypes de Degas*.

1965 New Orleans, Isaac Delgado Museum of Art. *Edgar Degas. His Family and Friends in New Orleans*.

1967 Saint Louis and Lawrence, Kansas; Steinberg Hall, Washington University, and The Museum of Art, The University of Kansas. *Lithographs by Edgar Degas*.

Saint Louis, Philadelphia, and Minneapolis; City Art Museum of Saint Louis, Philadelphia Museum of Art, and The Minneapolis Society of Fine Arts. *Drawings by Degas*.

1968 New York, Wildenstein. *Degas' Racing World*.

Cambridge, Mass., Fogg Art Museum, Harvard University. *Degas Monotypes*.

Richmond, Virginia Museum of Fine Arts. *Degas*.

1969 Nottingham, University Art Gallery. *Degas. Pastels and Drawings*.

Paris, Orangerie des Tuileries. *Degas: Oeuvres du Musée du Louvre. Peintures, Pastels, Dessins, Sculptures*.

1970 Williamstown, Mass., Sterling and Francine Clark Art Institute. *An Exhibition of the Works of Edgar Degas (1834–1917)*.

London, The Lefevre Gallery. *Edgar Degas 1834–1917*.

1974 Boston, Museum of Fine Arts. *Edgar Degas: The Reluctant Impressionist*.

1974–75 Paris and New York, Grand Palais and The Metropolitan Museum of Art. *Centenaire de l'Impressionnisme*.

Detroit, Institute of Arts. *Works by Degas in the Detroit Institute of Arts*.

1975 Nancy, Musée des Beaux-Arts. *Impressionisme en Lorraine*.

Paris, Galerie Schmit. *Exposition Degas 1834–1917*.

1976 London, The Lefevre Gallery. *The Complete Sculptures of Degas*.

1976–77 Tokyo, Kyoto, and Fukuoka; Seibu Museum of Art, Museum of the City of Kyoto, and Cultural Center of Fukuoka. *Degas*.

1977 New York, The Metropolitan Museum of Art. *Degas in the Metropolitan*.

1978 Richmond, Virginia Museum of Fine Arts. *Degas*.

New York, Acquavella Galleries. *Edgar Degas*.

1979 Northampton, Mass., Smith College Museum of Art. *Degas and the Dance*.

Edinburgh, National Gallery of Scotland. *Degas 1879*.

1980 Paris, Musée Marmottan. *Degas. La Famille Bellelli: Variations Autour d'un Chef-d'Oeuvre*.

1980–81 New York and Boston, The Metropolitan Museum of Art and the Museum of Fine Arts. *The Painterly Print: Monotypes from the Seventeenth to the Twentieth Century*.

1983 Copenhagen, Ordrupgaard. *Degas og Familien Bellelli*.

London, David Carritt Limited. *Edgar Degas 1834–1917*.

1984 Tübingen and Berlin, Kunsthalle and Nationalgalerie. *Edgar Degas: Pastelle, Olskizzen, Zeichnungen*.

London, The National Gallery. *Helene Rouart in Her Father's Study*.

Chicago, The Art Institute of Chicago. *Degas in The Art Institute of Chicago*.

1984–85 Paris, Centre Culturel du Marais. *Degas, la Modelé et l'Espace*.

Boston, Philadelphia, and London; Museum of Fine Arts, Philadelphia Museum of Art, and Hayward Gallery. *Edgar Degas: The Painter as Printmaker*.

Washington, National Gallery of Art. *Degas: The Dancers*.

Rome, Villa Medici. *Degas et l'Italia*.

1985 Philadelphia, Philadelphia Museum of Art. *Edgar Degas in Philadelphia Collections*.

London, Hayward Gallery. *Degas Monotypes*.

1986 Washington and San Francisco, National Gallery of Art and The Fine Arts Museums of San Francisco. *The New Painting. Impressionism 1874–1886*.

1987 Manchester and Cambridge, Whitworth Art Gallery and Fitzwilliam Museum. *The Private Degas*.

1988–89 Paris, Ottawa, and New York; Galeries Nationales du Grand Palais, Musée des Beaux-Arts du Canada, and The Metropolitan Museum of Art. *Degas*.

Acknowledgments

A book is a vision that requires the belief and assistance of many people to become reality, and I would like to give thanks to those individuals who have stood by me: Andrew Forge, my coauthor, with whom I have the honor to work; Valentine Abdy; Bill Acquavella and his associate Joan Menken; Rutgers Barclay; Bill Beadleston; Huguette Berès; Valerie Beston and Rebecca Llewellyn; Ernst Beyeler and his assistant, Claudia Neugebauer; Marc Blondeau; Philippe and Françoise Brame, Bernard Lorenceau, and their assistant, Armelle Taillemitte, for their friendship and for allowing me to consult their extensive archives; Lillian Browse; Beverly Carter; Jean Cau; Wendell and Dorothy Cherry; Desmond Corcoran, Martin Summers, and Jacquie Cartwright for their wisdom and good counsel; Pamela Critelli; curators at the Bibliothèque Nationale and the Bibliothèque d'Art et d'Archéologie (Fondation Jacques Doucet); Marianne Delafond; Ernie Dieringer; Douglas Druick, Suzanne Folds McCullagh, and Anselmo Carini; the late Charles Durand-Ruel, his daughter Caroline Godfroy, and their assistant, France Daguet, for so graciously permitting me to conduct research in and publish a considerable number of photographs from their archives; Charles Eiben; my family—Esther and Norman Rosenberg, Edward and Dorothy Gordon, Joseph Freidlin, and Ron, Stephanie, Jeremy, and Miranda Gordon; Beverly Fazio, for her skill and dedication as an editor as well as for her friendship, and her colleagues at Harry N. Abrams, Inc., Sam Antupit, Paul Gottlieb, Barbara Lyons, Judith Michael, Robert Morton, Margaret Rennolds, Robert Supree, Harriet Whelchel, and Shun Yamamoto; Richard Feigen and his associate Frances F. L. Beatty; Marianne and Walter Feilchenfeldt for their guidance; Rafael Fernandez, Alexandra R. Murphy, Martha Asher, and Art Evans; Michael Findlay; David Fox and Claire Keefe; Thomas Gibson; Noëlle Giret; Alice Goldet; Bob Guccione and Kathy Keeton; Mr. and Mrs. Nathan L. Halpern; David Hamilton; Jean and Francine Hecquet; Richard Howard for the superb quality of his translations; Didier Imbert; Darryl Isley; Jane and Marcus Julian; Philip Juwig; Dennis Kiel; Elizabeth S. Kujawaski; Aki Lehman; Leslie for her beauty and the poetry of her dance; Nancy Little; Katherine Maclean; my very lovely Mary Jo; Jill Mathews; Agnes Mongan; David Nash, his assistant Diana Hamilton-Jones, and their colleague Robert Wooley; Otto and Marguerite Nelson for their exceptional photography; Anne M. P. Norton; Veronica Pastel; Pat Peyser; Mr. and Mrs. Joseph Pulitzer, Jr.; Kathy Raich and David Jones; Joseph Rishel; Monsieur and Madame Jérome-Antoine Rony-Braquaval; the late Alexandre Rosenberg and his wife, Mrs. Elaine Rosenberg; Mme. Denis Rouart; Georges Routhier, his wife, Andrée, their son Jean-Michel, and their assistant Myrthis Bonijol; Angelica Rudenstine; Mrs. Janet Salz; Herbert Schimmel; Robert and Manuel Schmit for their generosity; Arlette Serullaz; Barbara Stern Shapiro; Dr. Lisbeth Stähelin and her assistant, Daisy Rodare; Michel Strauss and his assistant, Lucy Dew; Eugene Victor Thaw and his assistants, Patricia Tang and Caroline Hicks; Dr. Juan Alvarez de Toledo; Anne van der Jagt; Mrs. John Hay Whitney and her assistant, Kathryn Ritchie; Marian Young; and the many private collectors who welcomed us into their homes and granted us permission to reproduce their pictures.

Robert Gordon

My first thanks are to my coauthor, who conceived this book and guided my often stumbling steps through the mountains of Degas material, and of course to my wife, Ruth, for her wisdom and patience.

In writing the text—necessarily from a nonhistorical point of view—I have leaned heavily on the work of scholars in the field of Degas studies. I must acknowledge with gratitude my debt to Jean Sutherland Boggs, Richard Brettell, Ronald Pickvance, George Shackelford, and Richard Thomson, as well as John Rewald and Theodore Reff. I am particularly indebted to the late Roy McMullen, whose biography of Degas, which he did not live to see in print, has been an inspiring source.

Andrew Forge

In the index both French and English titles for works of art are listed. All works are by Degas unless otherwise indicated. Collection credits in abbreviated form have been added to some entries in order to distinguish them from other works that share the same title. Text references are in roman type; references to illustrations are in *italic*.